A LONG WAY FROM HOME

Books by Claude McKay

SONGS OF JAMAICA

SPRING IN NEW HAMPSHIRE

HARLEM SHADOWS

HOME TO HARLEM

BANJO

GINGERTOWN

BANANA BOTTOM

A LONG WAY FROM HOME

HARLEM: NEGRO METROPOLIS

SELECTED POEMS

CLAUDE McKAY

A Long Way from Home

INTRODUCTION BY ST. CLAIR DRAKE

A Harvest Book
Harcourt Brace & Company
San Diego New York London

To my friends everywhere

INTRODUCTION

by St. Clair Drake

•

CLAUDE McKAY came to this country from Jamaica in 1912, four years before Marcus Garvey, the organizer of the Universal Negro Improvement Association. He, like Garvey, had left the West Indies in search of wider opportunities for self-expression. Garvey's destiny led him toward a mass-leadership role, then to imprisonment and deportation to Jamaica. Claude McKay eventually won international acclaim as a writer; then came poverty, chronic illness, and finally his death—almost unnoticed.

His autobiography has contemporary relevance for a number of reasons. Black intellectuals are still involved in the quest for an identity and an ideology, and under circumstances similar to those of the period through which McKay lived. Present-day pilgrimages of black Americans, West Indians, and Africans to China and Cuba are reminiscent of the Moscow journeys of an earlier period. The dilemmas and contradictions that accompany attempts to reconcile Marxism and black nationalism are as perplexing to the intellectuals of the 1960s as they were to those of the 1920s and 1930s. Stokely Carmichael, Eldridge Cleaver, and James Forman find themselves confronted with the same type of problems that faced Paul Robeson, Richard Wright, and Langston Hughes. McKay came to grips with them earlier than any of the others, and his autobiography documents the processes of discovery, growth, inner conflict, and disillusionment that

all sensitive black intellectuals experience in a world where racism is a pervasive reality.

A Long Way from Home, like the autobiographies of other black writers since World War I, falls into a literary tradition that begins with the narratives of runaway slaves, including *The Life and Times of Frederick Douglass,* and continues in Booker T. Washington's *Up from Slavery* and W. E. B. Du Bois' *Dusk of Dawn.* The genre is one in which more intimate aspects of the autobiographer's personal experience are subordinated to social commentary and reflections upon what it means to be a Negro in a world dominated by white men. There have been no black Marcel Prousts and André Gides. The traumatic effects of the black experience seem to have made confessional writing an intellectual luxury black writers cannot afford.

McKay's narrative is unique in one aspect. Other accounts by prominent black men of their encounter with America have been written by those who were born and bred in the United States. Claude McKay was one of the more talented individuals in the stream of immigrants from the British West Indies who have been seeking their fortune in the United States since the turn of the century. They were refugees from a poverty exacerbated by overpopulation, and from a social system in which British settlers and their mixed-blood descendants had kept most blacks in a subordinate position. During the twenties and thirties West Indians played an active role in the hectic politics of Harlem, a phenomenon that has been analyzed with insight and perception (and also some bias) by Harold Cruse in *The Crisis of the Negro Intellectual.*

McKay's life was a single episode in the 500-year-old drama of the black diaspora, that massive dispersal of millions of men and women out of the great African homeland to the

Caribbean islands and onto the American continents. He symbolizes their wanderings backward and forward between Africa and the New World, and from both of these areas to Britain and Europe. They have become detribalized in the process and have developed a pan-African consciousness. McKay does not emphasize his West Indianness but rather his blackness, his solidarity with Afro-Americans and Africans. He was keenly conscious of being a child of the diaspora, revealing sentiments similar to those in the Negro spiritual: "Sometimes I feel like a motherless child, a long way from home."

McKay was twenty-one years old when he arrived in the United States, soon after his first volume of poetry, *Songs of Jamaica*, had been published. He came ostensibly to study agriculture. After a few years he cast off the student role and began to wander and wonder, as he phrased it, taking menial jobs and writing in his spare time. The work of a black American had a decisive influence upon his life; of W. E. B. Du Bois' book, *The Souls of Black Folks*, he wrote ". . . it shook me like an earthquake."

Between 1912 and 1918 McKay wrote continuously but published only a few poems and these under a pseudonym. Then, while "running on the road" as a dining-car waiter, writing poetry in the men's room in transit and in his Harlem lodgings during brief periods of respite from work, he obtained an interview with Frank Harris, the Irish-American publisher and critic, who launched him into the literary world under his own name. Later he met Max Eastman, the Jewish radical editor, who was to affect his life profoundly. He had virtually no association at the time with what E. Franklin Frazier dubbed "the black bourgeoisie," but he had been in very close contact with what his left-wing friends referred to as the

Negro working-class. Yet his own literary heroes were writers of conventional works. The sonnet was his favorite mode of expression, though some of his best poetry (of which examples appear in *A Long Way from Home*) is in a freer style.

In 1919 Claude McKay made his way to London, where he not only met some of the literary figures he admired, including George Bernard Shaw, but also began to read Karl Marx for the first time and to play an active part in radical politics, taking a job on a left-labor journal. He expresses his surprise and disillusionment over the obtuse prejudices displayed by some prominent Labor Party personalities where their relations with colored people were involved. His book of poems *Spring in New Hampshire* was published while he was in England, and some of the reviews were patronizing and implicitly racist. Frank Harris, though a helpful friend, had not been entirely free of such attitudes. McKay concluded that among the British race prejudice is "almost congenital." When he had experienced enough of it, he came back to New York.

Max Eastman and his associates accepted Claude McKay as a peer and a friend. He was appointed associate editor of *The Liberator*. Here he functioned not as "the Negro poet" but as a responsible colleague helping to select and edit a wide range of material for publication. (He remembers passing judgment upon some of E. E. Cummings' early work.) This was, no doubt, one of the happiest periods in his life. He kept in close contact with Harlem, where a black literary movement had just emerged—what came to be called "the Negro Renaissance" or "the New Negro movement." Although Harlem litterateurs respected him, they did not claim him as one of their own. His roots were downtown in white radical circles.

During 1921, factional fights within the left resulted in the withdrawal of Max Eastman and his sister, Crystal, from *The Liberator,* and a more doctrinaire brand of Marxists took control of the magazine. McKay, proud and jealous of his intellectual independence and integrity, lost his temporary "home." If he had been of a different temperament, he might have found a new home with the strident and chauvinistic black nationalists in Garvey's burgeoning movement, whose publication he occasionally wrote for. But he could no more follow the line of the Universal Negro Improvement Association than he could that of the Communist Party.

Nevertheless, his sympathies were with the oppressed, and despite his differences with the Communist Party in the United States, he felt he should see the results of the Russian Revolution for himself, to get the feel of it and to assess its implications for black men. He was determined, however, to visit the Soviet Union as an independent, unaffiliated writer, so he proceeded to raise some money by his own efforts. James Weldon Johnson, the Negro writer and NAACP leader, assisted him in selling copies of his recently published *Harlem Shadows,* and Crystal Eastman helped him to secure contributions from friendly individuals. The leaders of the Negro Renaissance now considered him enough of their own to attend a bon-voyage party for him at James Weldon Johnson's home, and both W. E. B. Du Bois and Walter White of the NAACP were there. The guests would have been embarrassed had they known that the next morning Claude McKay went into the engine room of a steamer to work his way across the Atlantic as a stoker.

The year spent in Russia was both a high point and turning point in McKay's life. Asian and European Communists assured the Russians that he was neither a spy nor a counter-

revolutionary and smoothed the way for him to secure a visa to attend the Fourth Congress of the Communist International. The Russians embraced him as a symbol of oppressed but heroic blackness. His seven chapters on "The Magic Pilgrimage" recreate the confusion and excitement of the revolution, and of his own enjoyment of a situation where being black was an asset rather than a handicap. But the mixture of high purpose and self-seeking, of idealism and chicanery, within the international Communist movement repelled him.

The Russian experience left a permanent mark upon his life—and his body. He returned to Paris ill and with the American Communists hostile toward him for refusing to join their ranks and submit to party discipline. In his book he charges them with spreading scurrilous slanders about him. The polemical and defensive tone of this section and of the one following it, "The Cynical Continent," became the dominant mood in the next book he wrote, *Harlem: Negro Metropolis*, much of which is devoted to what McKay conceived of as an exposé of Communist tactics. It was meant as a warning to the black community. He must have felt vindicated when younger Negro writers who did join the Party, such as Richard Wright, left it during World War II and defined the object of their former devotion as "the God that failed." But the anti-Communism of *A Long Way from Home* has a tone of sadness and irony touched with humor, rather than the crusading thrust of the later work.

McKay's experiences with British Laborites and liberals and his feud with the American Communists brought him somewhat closer to the culture-conscious segment of the black bourgeoisie, a number of whom were in Paris during the summer of 1923 when he was also there. But neither they nor the white expatriates in Gertrude Stein's entourage were satisfying

associates. Several years earlier, after returning to Harlem from his trip to Britain, he had written of the pleasure of being "just one black among many." This time, after his visit to the Soviet Union and Paris, he went to a French seaport to recapture something of that same feeling. In the chapter "Marseilles Motley," he writes of ". . . a great gang of black and brown humanity. Negroids from the United States, the West Indies, North Africa and West Africa, all herded together in a warm group." And he writes that "It was good to feel the strength and distinction of a group and the assurance of belonging to it." Later he went to Morocco, and reports the satisfaction he felt in a country where Islamic-Arabic culture and the cultures and people of the black world interpenetrated without overtones of racism. But neither southern France nor North Africa was home. He did not have a chance to travel below the Sahara in the ancestral homeland, which he romanticized in some of his poetry.

McKay's friends were always urging him to try his hand at prose. During the twenties he wrote his first novel, *Home to Harlem,* which brought him international praise from white critics. The black literary establishment, however, felt the book confirmed the stereotype of Negroes as rough, crude, and immoral. Yet after *Banjo,* his second novel, they could not ignore McKay and they began to claim him as a member of the New Negro movement. McKay's attitude toward *them* comes through in calm though bitter passages here and there, and in fascinating profiles of individuals in his chapters on "The New Negro in Paris" and "On Belonging to a Minority Group." (He names names in some cases, and leaves the reader to depend upon "the grapevine" for identification in others.) During the Depression he ignored the black bourgeoisie and they ignored him.

After 1932 McKay—like most other young writers, black and white—was earning his living on a Federal Writers' Project. From this perspective, he looks back on the Negro Renaissance when white patrons like Carl Van Vechten and Nancy Cunard were "discovering" black talent and trying to mold the minds and tastes of their protégés, and when philanthropic foundations were doling out the small sums they felt were needed to nurture black scholars, writers, and artists until they could break into the mainstream. They, like the black bourgeoisie and the Communists, repelled Claude McKay by their attempts to exercise control over black writers and artists.

Throughout a span of thirty years McKay had written poetry about the Jamaica he never ceased to love—of "Bananas ripe and green, and ginger-root," of ". . . dewy dawns and mystical blue skies," and of how ". . . hungry for the old, familiar ways,/I turned aside and bowed my head and wept." But in the period following the publication of *A Long Way from Home* his poetry reveals a sense of deep, sometimes bitter, alienation. Gone is the proud, defiant, resilient spirit of an earlier poem:

> *Although she feeds me bread of bitterness,*
> *And sinks into my throat her tiger's tooth,*
> *Stealing my breath of life, I will confess*
> *I love this cultured hell that tests my youth!*

Now, in his late fifties, sick in body and emotionally tired, watching a second World War erupt, he writes of America as "You whited sepulcher . . . worm-infested, rotten through within," fighting Germans and Japanese "While fifteen million Negroes on their knees/Pray for salvation from the Fascist yoke/Of these United·States."

At the same time that McKay was questioning a government that fought fascism abroad but not at home, he was also reflecting about the goals worthy of struggle and about his own life. In "The Negro's Friend," for instance, he expresses an anti-integrationist view that would have had little popularity at the beginning of the civil-rights movement.

> *Must fifteen million blacks be gratified,*
> *That one of them can enter as a guest,*
> *A fine white house—the rest of them denied*
> *A place of decent sojourn and a rest?*
> *Oh, Segregation is not the whole sin,*
> *The Negroes need salvation from within.*

Yet by 1965 this had become the dominant mood within the black communities of the United States.

McKay was a complex man who himself had enjoyed the hospitality of many a "fine white house." Compassionate and valuing his relations with specific white friends, he realized the danger of racial solidarity sliding over into hate, but he thought it was a risk that had to be taken. The last chapter of the autobiography is a plea for black unity, and it led him to the position that Dr. Du Bois had espoused in 1934 at the cost of his position on the board of the NAACP, and that the youth in the civil-rights movement came to thirty years later. We have no way of knowing how he would have reacted to the Deacons for Defense, Malcolm X's Afro-American Unity Organization, the Black Panthers, or the Republic of New Africa. But what he has to say about the general forms of organization that black communities should adopt have a startlingly contemporary ring.

The slogans within black communities today are: "Define

yourselves for yourselves!" "Get yourselves together!" "Take care of business!" The verbal symbols are new but the content is the same. This is the message of McKay's chapter "On Belonging to a Minority Group." The patterns of activity are the same, too, as in the twenties and the thirties—persistent protest and petition, and a blending of violent and non-violent action. The problems of the identity quest have not changed— the struggle for positive acceptance of the body-image, of negroidness, and the need to come to grips with the African reality after centuries of derogatory propaganda have defined the continent and its peoples as "backward," "savage," and "primitive." McKay's chapters "When a Negro Goes Native" and "Hail and Farewell to Morocco" document a pioneering venture in the search for African roots years before it became popular to wear Afro hairdos and dashikis, or to demonstrate in favor of Swahili in the high-school curriculum. He was emphasizing the status that black men had under Islam and pointing out that a black poet, Antar, was deemed the greatest in the Arabic world many years before Malcolm X and Cassius Clay made Islam a factor in their personal integration and Mr. Muhammed became a respected personality among the black masses. The "black is beautiful" theme suffuses all of McKay's work.

Eldridge Cleaver's *Soul on Ice* raised some disturbing questions in the middle-class mind over problems of black-white miscegenation. This is one of the most hotly debated subjects among young black militants, too. All the issues they raise are covered in McKay's vivid vignette of a discussion between two West Africans at a bar in Marseilles about white women and Negro leaders. Claude McKay faced the whole matter of relations between black men and white women, and white men and black women, in *A Long Way from Home*, at a

period when it was felt that such things might best be kept out of print. That they are now openly discussed does not mean that they are any less sensitive topics or any nearer to resolution.

Another issue that remains a constant in black-white relations in America is the continuous struggle for autonomy against the well-meant efforts of "white friends" to decide what blacks should do and should not do and how they should do it. Another is the problem of resisting manipulation of black individuals, organizations, and movements by white power centers—economic and political. Touched upon in *A Long Way from Home,* these issues became the central theme of Claude McKay's later book, *Harlem: Negro Metropolis.* Issues such as these lie at the root of the conflict today between a leader like Eldridge Cleaver, who feels that coalitions with white radicals are necessary for the black minority in the U.S.A., and Stokely Carmichael, who feels that the organization of the black community is not yet strong enough to withstand white pressures within such coalitions. Coalitions within black communities—black alliances, black caucuses, black united fronts—are groping toward a goal visualized by McKay and stated in his verse as well as in the last chapter of his autobiography.

Claude McKay was concerned over the tendency of educated elites of African descent throughout the black world to pull away from the masses. Today, with new occupational opportunities and a relaxation of caste pressures throughout the country in commercial establishments and schools, and in some areas of social participation, this tendency may be accelerated. Only the tenacity of the pattern of residential segregation has slowed it down. At the cultural level as well as the level of social action, the quest for both "identity" and

"black power" become complicated by cross-pulls toward "integration" and "black solidarity." McKay was not a racist in reverse, nor did he hate white people, as individuals, yet his observations on the need for racial solidarity are uncompromising.

The last years of McKay's life were also a time of search for a spiritual "home." Frank Harris had expressed amazement when McKay told him that he became a freethinker at the age of fourteen. He had grown up in a Jamaican environment that blended orthodox Christianity and African religions into a variety of denominations and cults, and even though he moved toward the "left," he reports that after a discussion with George Bernard Shaw he could never enter a cathedral without feeling a sense of awe. For years he carried a copy of Thompson's *Hound of Heaven* with him, and he quotes from it in *A Long Way from Home*. One poem of that final period asks the agonizing question

> *Lord, shall I find it in thy holy church?*
> .
> *I found it not in years of Unbelief,*
> *In science stirring life like budding trees,*
> *In Revolution like a dazzling thief—*
> *Oh, shall I find it on my bended knees?*

And in another poem of the period, he expressed certitude that he is on the road home:

> *Around me roar and crash the pagan isms*
> *To which most of my life was consecrate,*
> *Betrayed by evil men and torn by schisms*
> *For they were built on nothing more than hate!*

. .

And so to God I go to make my peace,
Where black nor white can follow to betray.
My pent-up heart to Him I will release
And surely He will show the perfect way . . .

Eventually he became a Catholic convert. He died in Chicago
in 1948, while teaching in one of the schools of his newly
adopted faith.

Claude McKay withdrew from both the class struggle and
the active fight for racial equality as he prepared for death,
which he seems to have sensed was near. But he left a legacy
to the black world from an earlier period in his life. He was
best known among Negroes for his poem "If We Must Die,"
written during the race riots of 1919, which expressed their
mood of the moment. In this autobiography he describes the
dramatic circumstances that evoked the sonnet and reveals his
feeling of deep satisfaction over its favorable reception:
". . . the Negro people unanimously hailed me as a poet.
Indeed that one grand outburst is their sole standard of ap-
praising my poetry." But McKay always insisted that there
be no double standard of appraising black men's literary
products, including his own. His daemon, as he called it,
urged him toward the mainstream, and there he went. But he
never ceased to "think black." What he wrote and the black
middle-class of his day rejected, the New Negroes of the
sixties and seventies will treasure when they rediscover him.

CONTENTS

INTRODUCTION BY ST. CLAIR DRAKE ix

PART ONE
AMERICAN BEGINNING
CHAPTER PAGE

 I A GREAT EDITOR 3

 II OTHER EDITORS 26

 III WHITE FRIENDS 35

 IV ANOTHER WHITE FRIEND 45

PART TWO
ENGLISH INNING

 V ADVENTURING IN SEARCH OF GEORGE BERNARD SHAW 59

 VI PUGILIST VS. POET 66

 VII A JOB IN LONDON 73

 VIII REGARDING REACTIONARY CRITICISM 86

PART THREE
NEW YORK HORIZON

 IX BACK IN HARLEM 95

 X A BROWN DOVE COOING 116

 XI A LOOK AT H. G. WELLS 121

 XII "HE WHO GETS SLAPPED" 130

 XIII "HARLEM SHADOWS" 147

CONTENTS

PART FOUR

THE MAGIC PILGRIMAGE

CHAPTER PAGE

XIV THE DOMINANT URGE 153

XV AN INDIVIDUAL TRIUMPH 167

XVI THE PRIDE AND POMP OF PROLETARIAN POWER 172

XVII LITERARY INTEREST 185

XVIII SOCIAL INTEREST 191

XIX A GREAT CELEBRATION 206

XX REGARDING RADICAL CRITICISM 226

PART FIVE

THE CYNICAL CONTINENT

XXI BERLIN AND PARIS 237

XXII FRIENDS IN FRANCE 253

XXIII FRANK HARRIS IN FRANCE 265

XXIV CINEMA STUDIO 272

XXV MARSEILLES MOTLEY 277

PART SIX

THE IDYLLS OF AFRICA

XXVI WHEN A NEGRO GOES NATIVE 295

XXVII THE NEW NEGRO IN PARIS 306

XXVIII HAIL AND FAREWELL TO MOROCCO 324

XXIX ON BELONGING TO A MINORITY GROUP 342

PART ONE

•

AMERICAN BEGINNING

•

I

A Great Editor

•

THAT run was the most exciting I ever made on the railroad. After three days away from New York, our dining car was returning again, feeding a morning train out of Philadelphia. A three-days' run was a long one and our crew was in a happy getting-home mood. In the pantry cooks and waiters joked mainly about women, as always, wives and sweethearts; some chanted, "Someone else may be there when I'm gone."

But something more than the mere physical joy of getting back to the city that was home had uplifted my heart. Like a potful of good stew a mixed feeling of happiness, hope and eagerness was bubbling inside of me. For in my pocket there was a letter from a great editor and critic advising me that I should pay him a visit as soon as it was possible. The letter had been delivered just as I was leaving on that three-days' trip and there had been time only to telephone and make an appointment for this day of our return.

Was ever a waiter more impatient for a run to end? And yet for all my impatience it was my happiest railroad itinerary. For I had made it buoyant with the hope that at last I was about to make my appearance before an American audience. A first appearance on the American stage—one important point of the vast stage of life upon which all of us must appear, some to play in a big scene, some in a little scene, and each preoccupied with the acting of his own particular part.

3

I was intent on my own rôle—I a waiter—waiting for recognition as a poet. It was seven years since I had arrived in the States from Jamaica, leaving behind me a local reputation as a poet. I came to complete my education. But after a few years of study at the Kansas State College I was gripped by the lust to wander and wonder. The spirit of the vagabond, the daemon of some poets, had got hold of me. I quit college. I had no desire to return home. What I had previously done was done. But I still cherished the urge to creative expression. I desired to achieve something new, something in the spirit and accent of America. Against its mighty throbbing force, its grand energy and power and bigness, its bitterness burning in my black body, I would raise my voice to make a canticle of my reaction.

And so I became a vagabond—but a vagabond with a purpose. I was determined to find expression in writing. But a vagabond without money must live. And as I was not just a hard-boiled bum, it was necessary to work. So I looked for the work that was easy to my hand while my head was thinking hard: porter, fireman, waiter, bar-boy, houseman. I waded through the muck and the scum with the one objective dominating my mind. I took my menial tasks like a student who is working his way through a university. My leisure was divided between the experiment of daily living and the experiment of essays in writing. If I would not graduate as a bachelor of arts or science, I would graduate as a poet.

So the years had sped by—five of them—like a rivulet flowing to feed a river. I had accumulated much, and from the fulness of my heart I poured myself out with passion of love and hate, of sorrow and joy, writing out of myself,

waiting for an audience. At last my chance had come. My ambition was about to be realized.

The editor had written enthusiastically: "Come in to see me and let us know one another. . . ."

Wonderful day! Marvelous riding! Everybody happy, going home, but I was the happiest. Steward and men commented on my exuberant spirit and joked about the possible cause. But I kept it a sweet secret. None of them knew that I was a scribbler. If they did, instead of my being just one of them, "pal" and "buddy," they might have dubbed me "professor."

Roar louder and louder, rushing train and whistle, beautiful engine whistle, carry me along, for I myself am a whistle tuned to the wind that is blowing through me a song of triumph. . . .

Pennsylvania Station! It was early in the morning. Our steward telephoned to the commissary for our next itinerary. We were ordered to double out again that afternoon. Another diner had been switched from its regular course, and ours was put in its place.

That was an extraordinary order, after a long and tiring trip. But in those days of 1918, life was universally extraordinary and we railroad men were having our share of it. The government was operating the railroads, and Mr. McAdoo was Director-General. The lines were taxed to their capacity and the trains were running in a different way. Coaches and dining cars of one line were hitched up indiscriminately to the engines of another. Even we waiters were all mixed up on the same level! Seniority didn't count any more; efficiency was enough. There were no special crews for the crack trains; new men replaced the old-timers, expertly swinging trays to the rocking of the train and feeding lawmakers to the amazement of the old élite of the crews. The regular sched-

ules were obsolete, for the dining cars were always getting out of line, there were so many special assignments. One day our dining car would be detailed to serve a group of Allied officers going on a secret rendezvous. Another day it had to cater to a foreign mission traveling to Washington. And other days there was the feeding of detachment upon detachment of hungry soldiers.

"Why should a doubling-out be wished on us?" one waiter growled. "Ask Mr. McAdoo, it's his business," another hilariously replied. In my disappointment (for now I had no time to see the editor) I cursed my luck and wished we were again working under the old régime. But that was merely a momentary reaction, for under the new system we were getting better wages and pay for overtime.

I telephoned the editor that I was obliged to work and could not keep the appointment. He answered graciously: "Whenever you are free, telephone me, and I'll see that we get together." And he gave me his private telephone number and address.

That night our crew slept in Harrisburg. The next afternoon we were in Pittsburgh, and free until the following morning. We went to the sleeping quarters in Wylie Avenue and checked in for our beds, after which the crew split up. A good distance from Wylie Avenue the colored folk had managed to maintain a café and cabaret on the edge of a section of the white district downtown. I decided to go there.

I wish I were one of those persons who have a sense of premonition, so that I might have stuck to quarters that afternoon. But I had a desire to be away from my fellows and off by myself, even if it were in a crowd. My mind was full of the rendezvous with that editor in New York. And as I couldn't talk to any of the fellows about it, it was better to

find elsewhere excitement that would keep me from thinking too much.

I found the café in a hectic state. The police had just combed it, rounding up draft dodgers and vagrants. I learned that there was a police net thrown around Pittsburgh that day, and many men who were not slackers at all, but who had left their papers at home, had been picked up. I had no papers, for I had lost my registration card, so I decided to get back right away to the cover and protection of the crew's quarters.

I hurried off, but two blocks away from the café a black man and a white came across the street and straight at me. Bulls! Immediately I was aware. As I had no papers, the detectives arrested me and started for the jail. My protest that I was importantly employed on the railroad was of no avail. The detectives wrote down my name, appearing very wise and knowing, and I wondered if I had been listed as a draft dodger. I had moved from the address from which I had registered and had never received any notification.

At the jail I tried to get permission to telephone to the steward of our dining car. But the perplexed officials had no time to give to the personal requests of the host of prisoners. The police had corralled more than they could handle. The jails were overcrowded, with more men being brought in every minute and no place to accommodate them. Some of the local prisoners had their papers at home. Relatives, learning of their plight, brought them the papers and they were discharged. But all the non-residents were held. Three of us, two colored, one white, were put into a cell which was actually a water closet with an old-fashioned fetid hole. It was stinking, suffocating. I tried to overcome the stench by breath-

ing through my mind all the fragrant verse I could find in the range of my memory.

At last dawn came, bringing some relief. At nine o'clock we were marched to the court, a motley gang of men, bums, vagrants, pimps, and honest fellows, all caught in the same net. The judge handed out five- and ten-day sentences like souvenirs. When my turn came, I told the judge that my registration card was mislaid somewhere in New York, but that I was working on the railroad, had arrived in Pittsburgh only the day before, and should be working at that hour. I said that nearly every day I was serving soldiers and that my being absent from the dining car that morning would cripple the service, because I was the chief waiter and we were running short of a full crew.

To my surprise, as soon as I had finished, the judge asked me if I were born in Jamaica. I said, "Yes, Sir," and he commented: "Nice place. I was there a couple of seasons ago." And, ignoring my case and the audience, the judge began telling me of his trip to Jamaica and how he enjoyed it, the climate, the landscape, and the natives. He mentioned some of the beauty spots and I named those I knew. "I wish I were there instead of here," he said. "I wish I were there too," I echoed him. I could quite understand how he felt, for who would not like to escape from a winter in steely, smoky, stone-faced Pittsburgh!

Turning to my case again, the judge declared that I was doing indispensable work on the railroad and he reprimanded the black detective who had pressed the charge and said the police should be more discriminate in making arrests and endeavor to ascertain the facts about their victims. My case was dismissed. I seized the opportunity to tell the judge that, my dining car having already left, the local railroad officials

would have to send me back to New York, and asked for a paper to show that I had been wrongfully detained by the police. Very willingly the judge obliged me and dictated a statement to a clerk, which he signed. As he handed me the slip, he smiled and said: "You see, I could place you by your accent." I flashed back a smile of thanks at him and resolved henceforth to cultivate more my native accent. So excellent was the paper the judge gave me, I was able to use it for the duration of the war without worrying about a new registration card.

Hurrying to the railroad station, I found that my dining car was already gone. I reported to the commissary department. Later in the afternoon they put me on another dining car going to Harrisburg. The next day I arrived in New York, and as soon as I got off the train telephoned to the editor at his office. He invited me to his house that evening.

Frank Harris's friendly letter, warm with enthusiasm for my poetry, and inviting me to visit him, was the kind of thing that might turn the head of a young writer bitten by the bug of ambition, and sweep him off his feet. But when a fellow is intoxicated with poetry and is yet able to keep a sober head and steady feet to swing a tray among impatient crowds of passengers in a rocking train, he ought to be able to hold himself in under any other excitement.

Frank Harris appeared to me then as the embodiment of my idea of a romantic luminary of the writing world. He stirred me sometimes like Byron and Heine, Victor Hugo and Rimbaud. I had read his writings avidly ever since he returned to America during the World War and stamped his personality upon the pages of *Pearson's Magazine*. His pro-

nunciamento when he took over the editorship was impressed on my memory. He had said that the purpose of *Pearson's* was to reach and discover the obscure talents of America who were perhaps discouraged, engaged in uncongenial labor when they might be doing creative work. I took his moving message personally, for I was one of those talents.

It was nine o'clock when I got to Frank Harris's house in Waverly Place. Opening the door for me himself he said the butler had gone home. I was surprised by his littleness. I knew that he was small of stature, but did not expect him to be as diminutive as he was. But his voice was great and growling like a friendly lion's with strength and dignity and seemingly made him larger than he actually was. "You are the poet," his voice rolled as he gripped my hand. He stepped back and scrutinized me before indicating a seat. He explained that he was speculating whether I reminded him of any special African type, for he had traveled in South Africa, West Africa, East Africa and the Soudan.

The door opened and a woman, wearing a rich-looking rose-colored opera cloak, stood poised on the threshold like a picture. I stood up and Frank Harris said: "This is the Negro poet." She nodded slightly and vanished.

"My wife is going to the opera," Harris explained. "She adores it but I don't care a rap about the opera. Of all the arts of the theater it is the tinseliest. A spectacle mainly for women." I said I liked the opera rather well, such of it as I had seen, especially the chorus and the dancing. Frank Harris said he was surprised that I should, because the art of the opera was the most highly artificial of the civilized arts.

He excused himself to go downstairs for wine. He returned with two bottles and glasses. It was my first taste of Rhenish wine and I enjoyed the pleasure of sampling it even more

than the actual taste. Frank Harris glowed in praise of the wine. He was concerned about his diminishing stock and said that because of the war, Rhine wine was becoming difficult to get and more costly. Seeing that I was ignorant of the qualities of Rhine wine, he proceeded to enlighten me, saying that the grapes from which the wine was made could not be duplicated elsewhere because of the original nature of the soil in which they grew, and that even in the Rhine country the grapes grown in one district produced a different brand from that of the grapes grown in another, and that this was very important to the local viticulturists. He recalled the pleasure he had experienced when traveling through the Rhineland tasting the peculiar sourish grapes and testing the wine. "Pour me a glass of any real Rhine wine," he said, "and I can tell exactly from where it came without seeing the label."

As he filled the glasses again he said: "You are a real poet, my lad." He sifted the group of poems I had sent to him and said: "You have some excellent pieces here." He picked out "The Park in Spring" and "Harlem Shadows." "These are excellent," he said. "You have the classical feeling and a modern way of expressing it. But where did you get it?" He strode over to me and pressed his fingers upon my forehead, as if to take the measure of what was there: "Tell me, how did you begin writing? What was your early influence?"

Briefly, I told the story of my West Indian background. My peasant childhood in a mountain country of a few hundred villages widely scattered over the hills. The missionary who built the first mission—a Mr. Hathaway who claimed kinship to the Shakespeare Hathaways, and who started my school-teacher brother (the eldest) on the road to college and gave him his first complete set of Shakespeare.

My boyhood spent in various villages with that brother, spanned by the years between the Diamond Jubilee of Queen Victoria and her death: the indelible years of my first reading of anything that was thrilling just for the thrill—the Waverley novels; Dickens in small sardine-packed words, bound in thin blue covers; the tomes of Mrs. Henry Wood, Charlotte M. Braeme, Miss Braddon, Mrs. Southworth, Marie Corelli. . . . And suddenly like a comet the discovery of the romance of science in Huxley's *Man's Place in Nature* and Haeckel's *The Riddle of the Universe.*

Frank Harris was a little surprised at my coming by free-thought at such an early age—before I was fourteen. So I explained that my brother was a free-thinker (although at the same time a denominational school-teacher and lay preacher), and that when he became aware of my omnivorous reading he put his free-thought literature in my way. Thus I grew up without religious instruction at home, I told him. Also, I was not free-thinking alone. In one high mountain village there were ten of us boys in a free-thought band, and most of them were heathen from their own primitive thinking, without benefit of books. Frank Harris thought that that was a remarkable thing to happen in a remote and backward colony.

"But when did you actually begin writing verses?" he asked. "When I was ten, as I remember," I said, "the first was a rhymed acrostic for our school gala."

After a while I made a gesture of going, for I was apprehensive of trespassing upon the man's time and kindness. I felt it to be such a genuine human kindness. That loud roar rising out of him seemed to proclaim: My body may be little and insignificant, but my heart is great and sincere.

Frank Harris laughed at my worrying about his time. He

said that since there had been so much difficulty about our getting together, we should make the most of it now. He had a lot to say yet, he said. But first he wanted to know how I got beyond the jingle-rhyme stage of verse-making. He remarked upon the fact that though I began verse-writing early, I had not been attracted by poetry in my early reading. It was the story in the plays that had carried me through Shakespeare.

And I related to him the story of my adolescence: my meeting with one Mr. Jekyll, an English gentleman who became my intellectual and literary mentor and encouraged me to continue writing verses in the Negro dialect. I told him something of this man who had gone among the peasants and collected their field-and-yard songs (words and music) and African folk tales and published them in a book called *Jamaica Song and Story;* of how he became interested when he first saw my verses—enthusiastic really—and said that they sounded like the articulate consciousness of the peasants. I had corresponded with and visited him over a period of five years and written many songs. His interest in me was general at first. I was merely a literate phenomenon among the illiterate peasants whose songs and tales he was writing. Then in time there was a subtle change from a general to an individual interest and he became keen about my intellectual development and also in my verse as real poetry.

I told Harris how, with this man's excellent library at my disposal, I read poetry: *Childe Harold, The Dunciad, Essay on Man, Paradise Lost,* the Elizabethan lyrics, *Leaves of Grass,* the lyrics of Shelley and Keats and of the late Victorian poets, and how he translated and we read together pieces out of Dante, Leopardi, and Goethe, Villon and Baudelaire. During those years also Mr. Jekyll was translating

Schopenhauer and I read a lot from his translation. Then he suggested Spinoza's *Ethics,* which I read, skipping the mathematical hypotheses, and for a time considered myself a pantheist. Also at that time the Rationalist Press of London was publishing six-penny reprints of Herbert Spencer's works, which I devoured greedily as they appeared.

I related to Frank Harris how I experienced a specially piquant human interest in reading Herbert Spencer and also George Eliot, because Mr. Jekyll had told me that he had seen them both, and that George Eliot lived near the Jekyll country place. He or his people (I am not sure which) made overtures to get acquainted with her. But she rejected them, saying she preferred not to make any new friends.

Mr. Jekyll had also shown me a letter from Herbert Spencer, which he regarded as a rare treasure. He (Mr. Jekyll) had discovered a mistake in computation, which he considered important, in one of Spencer's books and had written to him pointing it out. Herbert Spencer, replying, acknowledged the mistake, but said that, since it was already published, he did not think it was important enough to change. I am not even sure if that was the exact nature of the reply. I was so immature that I did not even grasp the significance of the matter, nor what exactly it was about. What amazed me then was that a great philosopher had permitted an error, which had been brought to his notice, to remain—that he had not corrected it. For in those burgeoning days I was a zealot for the truth as something absolute. But Mr. Jekyll had smiled at my reaction. He was satisfied that Herbert Spencer had sent him a private and courteous acknowledgment.

At this point Frank Harris exploded so hard that he frightened me. "Exactly like Herbert Spencer," he cried. "I knew

him well. You may not know it, but the letter you mention is a key to his character. I wish I had it in my hands. He was a narrow, bigoted, self-opinionated and typical John-Bullish unscientific Englishman. Fancy his acknowledging an error in his book and yet refusing to correct it! Putting his personal vanity above scientific fact. A purely Anglo-Saxon disregard for logic. No French intellectual would be capable of such a thing!"

Frank Harris said that he had written, or was writing, a portrait of Herbert Spencer. "And I wish I had that letter," he cried. "It would illuminate my portrait and prove my point that he was an old humbug. He was the philosopher of British Philistinism—self-righteous and smug. I told him once that I thought that certain of his deductions were untenable and he said he could not stand contradiction. Think of that! He refused to listen. He did not want to be contradicted, not even by the truth."

I mentioned Mr. Jekyll's joking about the matter and re-marking that it was better that the mistakes of the great should remain, so that the world could see and know that the great are not infallible and are subject to error like any-body else. How also he had pointed out Byron's famous grammatical error in *Childe Harold* as an example. Frank Harris said the comparison was far-fetched, but he could not forbear to seize the moment to make his own: "Byron was a great poet and a rebel to boot, like myself, and he was hated and hunted by English society. But they accepted a little man like Herbert Spencer as a great philosopher, because he made a virtue of their lowest predatory instincts. The survival of the fittest: a smug, mediocre, comfortable, middle-class inter-pretation of Darwin's great theory, making it pleasant for the Imperialist grabbers and the conscienceless British shop-

keepers. Survival of the fittest indeed! What would become of the better-class litter if they were not sheltered and protected from birth? What if they had to fend for themselves like the children of the have-nots?"

Becoming less violently emphatic, Frank Harris wondered if Mr. Jekyll would be willing to furnish a copy of the Herbert Spencer letter. I said I had no idea whether he would, but that I was willing to sound him. And I pointed out again that at the time when Mr. Jekyll showed me the letter he really thought more of Herbert Spencer's sending him a private and courteous reply than of the importance of the mistake that he had discovered.

"Just like an Englishman," said Frank Harris, "putting nice manners and all its bloody ritual above veracity and logic." [Later I wrote to Mr. Jekyll, stating Frank Harris's request and sending him some copies of *Pearson's*. But he gave a flat refusal and said that although Frank Harris's writings were "very clever," I should beware of him because he was insincere and pro-German!]

I finished telling all I could about my reading and writing, and then got my portfolio and showed Harris the little volume of my *Songs of Jamaica* that was published in 1912; also a bulky scrapbook full of reviews from London and Manchester, Glasgow, Dublin and Cardiff, Melbourne, Sydney and Auckland, Sierra Leone, Lagos, and even Capetown— from all over the English-language world, excepting America.

Frank Harris opened the book and read the dedication, which was for Governor Olivier of Jamaica [now Lord Olivier], and exclaimed: "Sydney Olivier! Oh yes, he did become governor of some colony. I knew him quite well— one of the most brilliant and practical of the Fabians. Was he interested in you?" I said that Governor Olivier had be-

come interested in my verse through Mr. Jekyll, and had accepted the dedication.

My scrapbook interested Frank Harris. It was crowded with the souvenirs of adolescence: pictures of famous literati cut from English and American magazines, unusual newspaper items, letters from Mr. Jekyll about my verse. . . . He came upon a cutting from *T. P.'s Weekly* with a prize poem of mine. This prompted him to say that he was well acquainted with T. P. O'Connor, whom he described as a successful Irishman whom the English liked because he never possessed an idea.

There was also a letter from Lord Stamfordham, the private secretary of King George, to Mr. Jekyll about my book. Mr. Jekyll and Lord Stamfordham had been friends from their youth and Mr. Jekyll had told me that he was trying to get a copy of *Songs of Jamaica* on the King's table. He said that even though the book was not read, if it were mentioned in a London drawing-room of consequence and reviewed by society, it might have a sale as a curiosity!

With his thumb on Lord Stamfordham's letter, Frank Harris said: "That's big."

"What's big?" I asked.

"Bigge," said Frank Harris, spelling the name. "That's Stamfordham's family name. I knew him quite well when he was just Bigge and secretary to Queen Victoria. I suppose he was not smart enough for King Edward, but he came back with King George, naturally. And did he do anything for your book?" I said that I didn't think so. "I am sure it would not have done you any good even if your poems had been put on the King's table," said Frank Harris. "A literary talent is not like that of a prima donna. Yet that Mr. Jekyll friend of yours is a remarkable person in a way. A man that it must

have been a great experience to know. I can trace his influence in your poetry. Good, but you must go beyond that, my lad. I should have liked to match my intellect against his. I had also a great teacher-friend in Byron Smith." And Frank Harris's noble roar was modulated by a fine note of tenderness as he spoke a little about the teacher of his American university days. It interested him that I also had gone to school in Kansas.

And now he began to talk of his beginnings in Kansas, monologuing, launching out like a perfect little boat riding the great waves. Frank Harris thundered and roared and boomed and trumpeted, striding across the floor and creating action to match the color and vigor of his outpouring. Like a god laying down the commandments of literature and life he talked. Like a wizard he evoked the notable contemporary figures of the latter nineteenth and early twentieth century and paraded them in all their accoutrements, articulate, gesturing and posturing like the personages of Madame Tussaud's.

When Mrs. Harris returned from the opera and looked in, Frank flung her a darling phrase and she retired. Interrupted, he noticed that the wine was finished, and went downstairs for more. And when he returned he again gave his attention to my dialect verse and the scrapbook. "But why have you been silent all these six years?" he demanded. "For six years you were silent in the night, like James Thomson, who wrote *The City of Dreadful Night.*" He quoted from that great poem:

> *Because he seemed to walk with an intent*
> *I followed him; who shadow-like and frail,*
> *Unswervingly though slowly onward went,*
> *Regardless, wrapped in thought as in a veil;*

Thus step for step with lonely sounding feet
We travelled many a long dim silent street.

And then the sonorous rich refrain like a fugue pouring through the great pipes of an organ:

As I came through the desert, thus it was,
As I came through the desert: Eyes of fire
Glared at me throbbing with a starved desire;
The hoarse and heavy and carnivorous breath
Was hot upon me from deep jaws of death;
Sharp claws, swift talons, fleshless fingers cold
Plucked at me from the jungle, tried to hold;
 But I strode on austere,
 No hope could have no fear.

"A great poem; a sad sick poet," said Frank Harris. "I knew him. He was a hopeless drunkard." His mention of James Thomson and quotation from *The City of Dreadful Night* moved me sadly. I remembered it was one of the first book of poems that Mr. Jekyll presented to me and that for a long time I was haunted by the spirit of the strange music of the desert song and the pessimistic feeling of the whole poem, which acted like a damper on my naturally happy disposition. Yet I did love the poem, finding it as lyrically rich and totally beautiful even as *Omar Khayyám*.

"Perhaps you too have a *City of Dreadful Night* pent up in you as a result of your six silent years?" Frank Harris asked. I said that I had not been really silent at all. It had been necessary for me to do some practical thing to exist. And it had been a big experience, finding out about America and knowing the commonalty of American Negroes. I had con-

tinued all along to write at intervals and rewrite to make my writing better, I said.

"You must write prose," Frank Harris said. I demurred. "Yes, you must and you will," he went on. "Now you must write something about yourself to preface these poems. I am sure you will write prose some day. Poetry comes first; prose follows with maturity. And this is an age of prose and not of poetry. Poetry was the unique literary expression of the feudal and semi-feudal age: the romantic periods. But this is the great machine age, inventions upon inventions bringing a thousand new forces and objectives into life. Language is loosening and breaking up under the pressure of new ideas and words. It requires the flexibility of prose to express this age.

"Now, tell me frankly," he said, turning the pages of my scrapbook, "what was the real underlying urge that forced you to come to America, after you had achieved a local success in your home? Was it merely to study?" I admitted that back in my mind there had really been the dominant desire to find a bigger audience. Jamaica was too small for high achievement. There, one was isolated, cut off from the great currents of life.

"I knew that," Frank Harris said triumphantly. "Your ambition was to break into the larger literary world—a fine ambition. But literature is the hardest career for a man without any competence. I think that if I had chosen politics, as I was inclined to at first, I might have done better. However, you have excellent stuff in you and deserve success. And you can attain it if you work hard. You will get there. You have a rare talent. I always pick a winner. I picked Bernard Shaw when he was unknown and started him in the theater on the way to his great success. I picked H. G.

Wells and Joseph Conrad and others. You are an African. You must accomplish things, for yourself, for your race, for mankind, for literature. But it must be literature. Now in this sonnet, 'The Lynching,'[1] you have not given of your best. A sonnet like this, after reading the report of the St. Louis Massacre, which I published in *Pearson's*, sounds like an anticlimax. You should have risen to the heights and stormed heaven like Milton when he wrote 'On the Late Massacre in Piedmont':

> *Avenge, O Lord! thy slaughtered Saints whose bones*
> *Lie scattered on the Alpine mountains cold. . . .*

There you have the sublime human cry of anguish and hate against man's inhumanity to man. Some day you will rip it out of your guts."

It was nearly an all-night séance. We had drunk up the rest of the wine. Frank Harris's hand had grown shaky as we drank, and he had spilled some of it as he poured. But it seemed to me that it was more with memories and words that he was intoxicated; that the wine was a tonic only to them. At last he permitted me to go with these parting words: "I think I have taught you more in five hours than your Mr. Jekyll did in five years, but that was easy, for my experience is so much greater. I have never retired from life, but have always been in the thick of it, where it was most exciting. I have made enemies right and left and they pursue me with hatred, but I have never been afraid, I defy them as Byron:

> *I have not loved the world, nor the world loved me;*
> *I have not flatter'd its rank breath, nor bowed*
> *To its idolatries a patient knee. . . ."*

[1] This poem was published years later in *Harlem Shadows*.

I had no desire for sleep. I was too uplifted by Frank Harris's grand voice, roaring like a waterfall in my head. I had listened to many voices that were lovely before, but very often it was the association of the individual with the speech that made the voice fine to me. With Frank Harris it was different. It was the voice of itself only, like a disembodied element.

Oh, what an amazing evening it was! I had gone expecting less than an hour's interview, merely the formal thing that editors and publishers consider it their business to grant sometimes. And this man had made one splendid night of it, talking for the beauty of talking, talking exquisitely, talking sensibly. Unforgettable experience. And certainly it was not an attitude on his part, no selfish motive, no desire to make an impression upon me, for there was really no reason. And the extraordinary spontaneity and length of our conversation that night was as surprising to Frank Harris as it was to me. Years later he said so, after I had traveled abroad and we came together again at a little party in Nice.

But then, that night, rather that early morning, returning to the job again, exhilarated, feeling as though I could do the work of all five waiters, with the stimulant of Frank Harris's voice agitating me to action, my mind was a rare element (quite dissociated from the technical work of my hands), savoring the essence of that great conversation, estimating the personalities that had been evoked for me, until I thought that it might have been someone like Frank Harris who inspired Browning to say:

> *Ah, did you once see Shelley plain,*
> *And did he stop and speak to you,*
> *And did you speak to him again?*
> *How strange it seems and new. . . .*

Some weeks later I saw Frank Harris again at his office in Union Square. He had inspired me toward a new achievement—the writing of prose. And I was determined to accomplish it. I had labored through a personal story that had taken me weeks to do it. It was much easier to create and scribble a stanza of poetry in the interval between trains than to write a paragraph of prose.

Frank Harris took me into his sanctum and sat down with me over the sheets. He impressed me quite differently than he had on the night of our memorable meeting: there was something boulevardier about his dress and manner which seemed a little funny. I had no great confidence in what I had written, and said so. He said that the fact that I was aware was a good sign. He glanced over the sheets rapidly. His forehead grew wrinkles and he shook his head. Then he said that what I had written was like a boat full and sinking with water, but that when it was baled out it would be seaworthy enough. With a butt of red pencil he underscored the essential. It was fascinating to watch him expertly, quickly, picking out the salient facts.

Suddenly he said something like this: "I am wondering whether your sensitivity is hereditary or acquired." I said that I didn't know, that perhaps it was just human. He saw that I was ruffled. I really had a sensation of spurs sprouting on my heels.

"Don't misunderstand me," he said. "Your sensitivity is the quality of your work. Your 'The Park in Spring' sonnet is a remarkable achievement. I read it to a very refined woman and she could not hold back her tears. It takes me back to the humanists of the eighteenth century, touching me like Hood or even something of Wordsworth's. What I mean is, the stock from which you stem—your people—are not sensi-

tive. I saw them at close range, you know, in West Africa and the Sudan. They have plenty of the instinct of the senses, much of which we have lost. But the attitude toward life is different; they are not sensitive about human life as we are. Life is cheap in Africa. . . ."

I kept silent.

"Now please don't misunderstand me," he said again. "We have great disparities in Europe also, despite more than a thousand years of civilization. For example, the attitude toward life in Eastern Europe is not the same as in Western Europe. And again, the French are by far more highly cultured than the Teutons and Anglo-Saxons. But the French have no poetry, so to speak. English and German poetry is infinitely higher. Yet, the English are barbarians compared to the French. Heine marveled that Shakespeare was an Englishman and Jesus a Jew. Ah Jesus, Jesus! Our Lord and Master! That is the secret of the difference between the peoples of Africa and of Asia and the people of Europe. Jesus: it is his religion that makes the difference."

And, strangely to me, Frank Harris began preaching Jesus. Which seemed so incongruous with his boulevardier dress and manner. He did it beautifully, but unconvincingly. There was something about the man's personality, so pugnacious (a fine pugnaciousness that I admired when he expatiated upon his profane experiences and because he was physically small and rebellious), that made him appear a little ridiculous preaching the self-denialism of Jesus. When he paused I said I thought the adoption of the Christ cult by Western civilization was its curse: it gave modern civilization a hypocritical façade, for its existence depended on force and positive exploitation, whereas Jesus was weak and negative. Frank Harris said that there was a great deal of truth in my

point, but nevertheless he preferred Jesus above all the great teachers, and thought civilization the better because of his religion.

In his rôle as a Jesus preacher the stature of Frank Harris diminished perceptibly before my mind; the halo around him that night when he talked as a rationalist and rebel became less glamorous. Perhaps I judged him too severely, because my childhood was so singularly free of the influence of supernatural religion. I suppose that people who are nurtured in revealed religion, even though they discard their god when they are intellectually grown up, are prone to attribute more of the godly qualities to their own deity than to the gods of other peoples. And Frank Harris was raised an Irish Catholic.

Abruptly he said "Now to work," and called in his secretary. She was a little blonde from a Western town. He said that she had written imploring him to let her come to New York to serve "the master" in any capacity. Every week he received dozens of such letters, which he had to ignore, he said, but there had been something so original about hers that he had invited her to come even without requesting her photograph beforehand. And fortunately he had found in her a perfect disciple.

II

Other Editors

•

IT was a great moment when my first poems were published in *Pearson's*, although they were not actually the first to be published in America. In December of 1917, *Seven Arts*, which was edited by James Oppenheim and Waldo Frank, published two of my sonnets over the nom de plume of Eli Edwards. The nom de plume was adapted from my mother's name. I used it because at the time when the poems were submitted, I was a waiter in a women's club. The members were students of the arts. Some were literary aspirants and were always reading and discussing the new and little magazines. As I was a good enough waiter I did not care to be discovered as a poet there.

When my poems appeared in *Pearson's* I received many letters of encouragement and suggestion. And one of them started an interesting correspondence which resulted in my traveling to Europe the following year.

I was particularly excited about appearing in *Pearson's*, because there was no doubt that Frank Harris was a truly great critic. And many were my dismal disappointments in rejection slips and letters of half-hearted praise, until he fortified me with his frank, hearty and noble voice of encouragement. "The White Fiends," which *Pearson's* published, had been rejected previously by *The Crisis*, a Negro magazine.

Some months before, I had sent some poems to William Stanley Braithwaite, who was highly placed as a critic on the

Boston *Evening Transcript*. Mr. Braithwaite was distinguished for his literary dialogues in the Literary Supplement of the *Transcript,* in which the characters were intellectual Bostonians with Greek names and conversed in lofty accents that were all Greek to me.

In Mr. Braithwaite's writings there was not the slightest indication of what sort of American he might be. And I was surprised one day to read in the Negro magazine, *The Crisis,* that he was a colored man. Mr. Braithwaite was kind enough to write me, a very interesting letter. He said that my poems were good, but that, barring two, any reader could tell that the author was a Negro. And because of the almost insurmountable prejudice against all things Negro, he said, he would advise me to write and send to the magazines only such poems as did not betray my racial identity.

There was sincerity in Mr. Braithwaite's letter, a sincerity that was grim and terrible to me. He was a poet himself, but I was unacquainted with his poetry. I went in search of him in his poetry at the Forty-second Street Library. I found a thin volume containing some purely passionless lyrics, only one line of which I have ever remembered (I quote from memory):

I kissed a kiss on a dead man's brow. . . .

So, I thought, that was what Boston made of a colored intellectual. But thinking a little deeper, I thought that it was not Boston only. Mr. Braithwaite perhaps stood for what almost any man of color who possessed creative talent desired to be at that time. Mr. Braithwaite is now a professor of literature in Atlanta University, one of the leading Negro schools. In appreciation of him our foremost Negro historian has written:

"The most remarkable writer of Negro blood since Dunbar is William Stanley Braithwaite, who as a writer is not a Negro. . . . Mr. Braithwaite has by his literary production and criticism . . . his poems, his annual publication, *The Anthology of Magazine Verse,* demonstrated that the Negro intellect is capable of the same achievements as that of the whites. . . ."

Need I say that I did not entertain, not in the least, Mr. Braithwaite's most excellent advice? I couldn't even if I had felt certain about that mess of pottage that is such a temptation to all poor scribblers. My poetic expression was too subjective, personal and tell-tale. Reading a selection of it, a discerning person would become immediately aware that I came from a tropical country and that I was not, either by the grace of God or the desire of man, born white.

I felt more confidence in my own way because, of all the poets I admire, major and minor, Byron, Shelley, Keats, Blake, Burns, Whitman, Heine, Baudelaire, Verlaine and Rimbaud and the rest—it seemed to me that when I read them—in their poetry I could feel their race, their class, their roots in the soil, growing into plants, spreading and forming the backgrounds against which they were silhouetted. I could not feel the reality of them without that. So likewise I could not realize myself writing without conviction.

Because of my eclectic approach to literature and my unorthodox idea of life, I developed a preference for the less conservative literary organs. *The Masses* was one of the magazines which attracted me when I came from out West to New York in 1914. I liked its slogans, its make-up, and above all, its cartoons. There was a difference, a freshness in its social information. And I felt a special interest in its

sympathetic and iconoclastic items about the Negro. Sometimes the magazine repelled me. There was one issue particularly which carried a powerful bloody brutal cover drawing by Robert Minor. The drawing was of Negroes tortured on crosses deep down in Georgia. I bought the magazine and tore the cover off, but it haunted me for a long time. There were other drawings of Negroes by an artist named Stuart Davis. I thought they were the most superbly sympathetic drawings of Negroes done by an American. And to me they have never been surpassed.

I remember receiving a couple of "So sorry" rejection slips from *The Masses. The Masses* was crucified and had been resurrected as *The Liberator* before a poem was accepted. I received a note from the managing editor, Crystal Eastman, inviting me to call at the office. One afternoon when I was free in New York I telephoned *The Liberator* and was asked to come down. Crystal Eastman was in conference with the business manager when I got there, but she suspended it to talk to me. The moment I saw her and heard her voice I liked Crystal Eastman. I think she was the most beautiful white woman I ever knew. She was of the heavy or solid type of female, and her beauty was not so much of her features, fine as they were, but in her magnificent presence. Her form was something after the pattern of a splendid draft horse and she had a way of holding her head like a large bird poised in a listening attitude.

She said she liked my poems in *Pearson's* and some of those submitted to *The Liberator,* but that she was not a poet or critic and therefore not a good judge. She would arrange for me to meet her brother, Max Eastman, who was the chief editor and had the final word on all contributions. She chatted awhile with me. Was it difficult for me to work on

the railroad and write poetry? Did I have any regular time to write? I told her that sometimes I carried lines in my thoughts for days, waiting until I found time to write them down. But also it wasn't always like that. And I related this incident: For many days I was possessed with an unusually lyrical feeling, which grew and increased into form of expression until one day, while we were feeding a carload of people, there was a wild buzzing in my head. The buzzing was so great that it confused and crowded out all orders, so much so that my mechanical self could not function. Finally I explained to the steward that I had an unbearable pain in my belly. He excused me and volunteered to help the fourth waiter with my two tables. And hurrying to the lavatory I locked myself in and wrote the stuff out on a scrap of paper.

"Got rid of your birth pains," Crystal Eastman said, and we both laughed. She had to resume her conference, but before leaving a tentative appointment was made for me to get in touch with Max Eastman. Just as I was going, Floyd Dell, who was assistant editor of *The Liberator,* came in and we were introduced.

The rendezvous with Max Eastman was to be at his study-room, somewhere in or near St. Luke's Place. I got there first and was about to ring when my attention was arrested by a tall figure approaching with long strides and distinguished by a flaming orange necktie, a mop of white hair and a grayish-brown suit. The figure looked just as I had imagined the composite personality of *The Masses* and *The Liberator* might be: colorful, easy of motion, clothes hanging a little loosely or carelessly, but good stuff with an unstylish elegance. As I thought, it was Max Eastman.

We went up into a high room and he lounged lazily on a couch and discussed my poems. I had brought a batch of new

ones. Naturally I was impressed at once by the contrast be-
tween Max Eastman and Frank Harris. There was nothing
of the "I" first person in Max Eastman's manner. Nor did
he question me to any extent about myself, my antecedents,
and the conditions under which I lived and wrote at the time.
He was the pure intellectual in his conversation and critical
opinion.

Among my new poems there was a sonnet entitled "If We
Must Die." It was the most recent of all. Great events had
occurred between the time when I had first met Frank Harris
and my meeting with Max Eastman. The World War had
ended. But its end was a signal for the outbreak of little
wars between labor and capital and, like a plague breaking
out in sore places, between colored folk and white.

Our Negro newspapers were morbid, full of details of
clashes between colored and white, murderous shootings and
hangings. Traveling from city to city and unable to gauge
the attitude and temper of each one, we Negro railroad men
were nervous. We were less light-hearted. We did not separate
from one another gaily to spend ourselves in speakeasies and
gambling joints. We stuck together, some of us armed, going
from the railroad station to our quarters. We stayed in our
quarters all through the dreary ominous nights, for we never
knew what was going to happen.

It was during those days that the sonnet, "If We Must
Die," exploded out of me. And for it the Negro people
unanimously hailed me as a poet. Indeed, that one grand
outburst is their sole standard of appraising my poetry. It
was the only poem I ever read to the members of my crew.
They were all agitated. Even the fourth waiter—who was the
giddiest and most irresponsible of the lot, with all his motives
and gestures colored by a strangely acute form of satyriasis—

even he actually cried. One, who was a believer in the Marcus Garvey Back-to-Africa Movement, suggested that I should go to Liberty Hall, the headquarters of the organization, and read the poem. As I was not uplifted with his enthusiasm for the Garvey Movement, yet did not like to say so, I told him truthfully that I had no ambition to harangue a crowd.

That afternoon with Max Eastman was spent in a critical estimation of my verse. He decided to publish a page of it. When I departed I left some of the verses but took with others the "If We Must Die" sonnet. I wanted Frank Harris, whom I had not seen for many months, to see it. I had always remembered his criticism and rejection of "The Lynching," and now I wanted to know if in "If We Must Die" I had "risen to the heights and stormed heaven," as he had said I should.

At that time *Pearson's Magazine* had its office in the same building as *The Liberator*. Frank Harris had me ushered in as soon as I was announced. "And where have you been and what doing all this time, my lad?" he roared, fixing me with a lowering look. All his high exhibitionism could not conceal the frank friendliness and deep kindliness that were the best of him. "Now what have you done to be called a real poet, to join the ranks of the elect? Have you written a GREAT poem yet?" I produced "If We Must Die." He read it at once. Then he slapped his thigh and shouted, "Grand! Grand! You have done it. That *is* a great poem, authentic fire and blood; blood pouring from a bleeding heart. I shall be proud to publish it in *Pearson's*."

I said that I was sorry, but the poem had already been accepted by *The Liberator*. "What? It belongs to me," Frank Harris thundered. "*The Liberator* be damned! I gave you the inspiration to write that sonnet and I want to have the credit

of publishing it. In the next number of *Pearson's.* I'll play it up big."

But I said I couldn't do that; I would have to ask Max Eastman's permission. "No, you won't," roared Frank Harris. "Do you think I am the kind of man to accept a favor from Max Eastman? Why did you bring your poem here, after showing it to him?" Because I wanted him to see what I had done, I said, because I valued his opinion so highly, perhaps more than any other critic's, because his unforgettable words that memorable night of our first meeting were like a fire alive in me, because I so much desired to know if he considered what I had written as an achievement. I was excited and spoke quickly and earnestly. Frank Harris melted a little, for what I said had pleased him. But he was none the less angry.

He informed me then that he had had a fight with *The Liberator.* He had published in *Pearson's* an article about Lenin in which the Russian dictator was portrayed as a cosmopolitan *bon vivant.* It was a very exaggerated and wrong picture, and *The Liberator,* which had more accurate information about Lenin's private life from individuals who knew him, had severely criticized Frank Harris. He was sore about the criticism. He said that he and Max Eastman were both radical editors, and if he had made a mistake, *The Liberator* might have asked him to correct it in *Pearson's,* instead of both editors denouncing each other in public. He said he was so disgusted that he was seeking other premises for his magazine, because he was uncomfortable housed in the same building as *The Liberator* and all the time meeting its editor, even riding in the same elevator with him.

That incident alone was a revelation of the real Frank Harris under the hard protective shell, and shows that he

was not such a natural buccaneer as some of his critics assert. He was so sensitive that he could not stand being in the same building with another editor, because they had quarreled.

I had not read the controversial articles then and knew nothing about the quarrel, and so I was very embarrassed, realizing that it was a mistake to show the poem to Frank Harris before it was published in *The Liberator*. I was keen about that poem appearing in *The Liberator*, because of that magazine's high literary and social standard. Although I esteemed Frank Harris as a great critic, *Pearson's* was *his* magazine only, a one-man magazine, smashingly critical, daringly so about social problems, yet having no constructive social program. But *The Liberator* was a group magazine. The list of contributing editors was almost as exciting to read as the contributions themselves. There was a freeness and a bright new beauty in those contributions, pictorial and literary, that thrilled. And altogether, in their entirety, they were implicit of a penetrating social criticism which did not in the least overshadow their novel and sheer artistry. I rejoiced in the thought of the honor of appearing among that group.

Nevertheless I deferred a little to Frank Harris, and when I mailed the set of poems to Max Eastman a few days later, I kept back the "If We Must Die" sonnet. I figured that if Max Eastman overlooked its absence, I could conscientiously give it to Frank Harris. But Max Eastman sent me a telegram requesting the immediate return of the sonnet. The magazine had already gone to press and he wished to include it in the selection. I sent it in and "If We Must Die" appeared in *The Liberator*.

III

White Friends

●

THE phrase "white friend" used by a Negro among
Negroes is so significant in color and emotion, in cre-
ating a subtle feeling of social snobbery and superiority,
that I have sometimes wondered what is the exact effect
of "colored friend" when employed by a white among whites.
I mean the sophisticated. I know the reactions and their
nuances must be very different within the two groups. An
experiment carried out in both groups to determine this would
be as rarely illuminating as a scientific discovery to this Negro.
But alas, what a pity that it is an impossibility, even as it is
for a white reader to share with a black reader the magic
inhering in "white friend" with all its implications. It may
be partially understood only by comparing it with certain
social honors and class distinctions which make for prestige,
but it cannot be fully realized.

The peasants of Jamaica were always fond and faithful in
friendships. Every boy and every man had a best friend, from
whom he expected sympathy and understanding even more
than from a near relative. Such a friend shared in confidences
which were not revealed even to a brother. Early friendships
were encouraged by our parents. And sometimes it was the
friendship of youngsters that developed a fraternal feeling
among the families of both.

There were few white friends in the social life of the peas-
ants. The white colony agglomerated in the towns and the
peasants were 80 per cent of a population of a million. And

so the phrase "mah white folks" could not have the signif-
icance for a Jamaica peasant that it has for a southern Negro.
There were a few settlements of poor whites in the land. They
were mainly of German descent. Like the natives, they eked
out a living as agriculturists and artisans, sharing in the com-
mon community life. The blacks were not sycophantic to
them because of their pigmentation, nor did they treat them
with contempt as "poor white trash."

Those were the social conditions in the country. In our only
city they were different. In the city there were subtle social
distinctions between white and light-colored and between
light-colored and black. These distinctions were based upon
real class differences which were fixed by the distribution of
positions. Generally the whites were the ruling and upper
class, the light-colored were the shop-keeping and clerical
class, the blacks were the working class.

A peasant would be proud of a white friend who was in-
fluential. But from a social-asset point of view, he would
place much more value upon the friendship of a light-colored
person of the wealthy and educated class or of a black who
had risen up out of the peasantry than he would upon that
of an undistinguished "poor white."

My father was the trusted friend of Mr. Hathaway, the
missionary who built up the first mission of our region. I re-
member my first impression of my father: a tall, graying man
with an impressive luxuriantly kinky head. He was a pros-
perous enough peasant and settled on his own land. He
was senior deacon of the church and something of a patriarch
of the mountain country. My memory retains an unforget-
table picture of him, often sitting out upon our barbecue and
endeavoring to settle differences between the poorer peasants.
For the peasants loved litigation and enjoyed bringing one

another into the white man's court for very trivial offenses. My father always said: Try to settle your differences out of court, for the courts cost more than the cases are worth.

For the best part of my boyhood I was away from home going to school under my school-teacher brother. And when I had grown up a little and returned to the homestead I found my father estranged from the church. For five years he had never set foot on the church premises. After Mr. Hathaway there had been about five other missionaries, but the sixth, a Scotchman, turned out a bad egg, after seeming white and good outside. They said he was tricky and canny in petty things. He had falsified the church accounts and appropriated money that was intended for foreign missions. And he had discharged the native teacher and given the job to his wife.

My father quit the church. It went down to the devil. And the mountain country became a hell for that missionary. Even the children jeered at him along the roads when he went riding by. One by one his fellow missionaries turned from him, refusing to visit the mission, until he was isolated. At last he was compelled to go. When he was leaving, he came to my father's house and offered to shake hands. My father refused. He said the missionary had not acknowledged his error and he did not think his hands were clean just because they were white. But my mother cried and went out to the gate to the missionary's wife and they embraced.

I make this digression about white friendship and my father, because, like him, I have also had some white friends in my life, friends from the upper class, the middle class, the lower and the very lowest class. Maybe I have had more white than colored friends. Perhaps I have been impractical in putting the emotional above the social value of friendship, but neither the color of my friends, nor the color of their

money, nor the color of their class has ever been of much significance to me. It was more the color of their minds, the warmth and depth of their sensibility and affection, that influenced me.

Apropos of white friendship, way back in 1912, when my *Songs of Jamaica* was published, I received a letter from a man in Singapore praising my effort. This person had been corresponding with Mr. Jekyll about a scheme to establish an international utopian colony for intellectuals and creative talents. Mr. Jekyll, an individualistic aristocrat of the English squirearchy had rejected the idea for himself, saying he had no faith in sentimental and visionary nostrums. But he had carried on a correspondence with several persons who were interested.

Six years later, when my poems appeared in *Pearson's Magazine,* I heard from my Singapore correspondent again. He had arrived in San Francisco from Japan. He was intending to come to New York and hoped we would meet. In a few weeks he came and I was shocked out of my skin by the appearance of the apostle of the international cultural life. In my young romantic naïveté in the hill-top of Jamaica I had imagined him to be the personification of a knight-errant of esthetics, lustily fighting against conventionalism for a freer cultural and artistic expression. But the apostle was lank and limp and strangely gray-eyed and there was a grayness in his personality like the sensation of dry sponge. He appeared like an object out of place in space, as if the soul of existence had been taken out of his form and left him a kind of mummy. His voice sounded as if it were trained to suppress all emotion. And he walked like a conventionalized mannikin. I thought that man's vanity must be vastly greater than his

intelligence when such an individual could imagine himself capable of being the inspirer of an international colony of happy humanity.

Mr. Gray's parentage was international—a mixture of Italian, German and other Nordic strains. He was born in the Orient. When the World War broke, he and his inseparable sister were living in a utopian colony of Europeans of different nationalities. But the colony had to be disbanded because the territory belonged to one of the Allied powers and some of the members were Germans, and there were national quarrels over the cause of the war.

I invited the Grays up to Harlem. They were interested in seeing the big Black Belt, but they did not like Harlem. They did not like New York. Mr. Gray said he was glad to locate me through *Pearson's,* and that he enjoyed the magazine as a whole. I said that Frank Harris would be delighted to hear that and he said he would like to meet Frank Harris. I promised him an introduction.

Mr. Gray praised me highly for my new poems. He thought them stronger and riper than the Jamaican dialect rhymes. And also he thought I should have enough leisure to write more. He thought it might be salutary if I could get away from the Black Belt for awhile. And he suggested a plan for me to make a trip abroad.

My surprise over the prompt proposal gave Mr. Gray a kind of self-satisfied amusement. I could tell by his faint sophisticated smile. From my background of hard routine realistic living, idealistic actions did not appear as simple to me as they did to Mr. Gray, who lived by them. His practical life was his lifelong interest in creative talents, the world leadership of intellectual idealists and the establishment of model colonies, out of which he expected a modern Utopia

to develop. The World War had confused and disillusioned him a little, but he was still full of hope.

Yet much as I was ready for a holiday from Harlem and though the idea was a vast surprise, I did not accept it right away. I was interested to know the details. Mr. Gray's plan was that I should be the guest of himself and his sister on a trip to Spain, where I could spend a year, or even two, writing. They had lived in Spain before and thought that living there after the war would be more agreeable than in any other European country, because Spain had kept out of the World War.

Miss Gray's resemblance to her brother was striking. They looked like twins. She was almost as tall, but she was physically stronger and more prepossessing. Much as I wanted that holiday, I had my doubts that I could be comfortable, much less happy, as their guest. So I said that I would like some time to think the matter over. And they agreed that I should first do a little thinking. But the tone of their voices and of their faces seemed to show that they were certain that I would finally say yes.

I had recently quit my job as waiter on the Pennsylvania Railroad, when the Grays arrived in New York. Thus I had plenty of time to spend with them. I was fortunate in not needing to worry about the expense of food. We ate in Harlem and downtown in the Automat restaurants. I visited them in their rooms in their downtown hotel. When I appeared at the desk, the clerk spoke before I did: "Oh, yes, you are the colored visitor from abroad. Mr. Gray is expecting you, just step into the elevator."

I had lots of time and opportunity to find out whether I would enjoy being a long-time guest of the Grays. And re-

luctantly I came to the conclusion that I couldn't. For their ideals I had the highest esteem and I was touched by their generosity. But between them and me there was a great disparity of temperament and outlook, a vast difference in seeing and in feeling the colors of life. I felt convinced that a long intimate association would strain disastrously, and perhaps break, our friendship.

Yet I was tantalized by the thought of a vacation in Spain. For West Indians it is the romantic European country, which gave the Caribbean islands their early names and terribly exciting tales of caribs and conquistadors, buccaneers and golden galleons and sugar-cane, rum and African slaves.

I thought I would try taking a little advice. At that time I knew nobody among the Negro intellectuals, excepting Hubert Harrison. Hubert Harrison was a lecturer on the sidewalks of Harlem. He lectured on free-thought, socialism and racialism, and sold books. He spoke precisely and clearly, with fine intelligence and masses of facts. He was very black, compact of figure, and his head resembled an African replica of Socrates.

He came from one of the Virgin Islands. He used to lecture in Wall Street. A group of Jews became interested and brought him to lecture in a hall in One Hundred Twenty-fifth Street. For a time he was the black hope of the Socialists. Then he gave up Socialism for the Garvey pan-African movement.

I explained my dilemma to Harrison and he said I was a fool to hesitate; that I was too conscientious. In civilized life it was not necessary for one to like one's hosts, he pointed out. Harrison said he would like to talk the plan over with me and Mr. Gray. So I got him and Mr. Gray together at

dinner at a little South Carolina cookshop which was good for its special hog food.

Harrison talked to Mr. Gray mostly about the pan-African movement. He had a similar idea, he said, but Garvey, being more spectacular, had run away with it. He told Mr. Gray that he was performing a gracious act by taking me to Europe; that he himself had lived abroad in Denmark and Japan, and the experience had helped him in his later work. He avoided any mention of my real feelings about taking the trip, and I didn't know how to express what I really felt. Finally Harrison got a personal donation of fifty dollars from Mr. Gray to help in the work of black enlightenment.

I had to fall back upon myself in making a decision. When I did, informing Mr. Gray of all my doubts about the project, he was as surprised as I had been when he first mentioned the subject. Our contacts were all so easy and pleasant, he had not reckoned on the objections. I tried to make him see as I did that a close association would be quite a different thing from polite social contact.

When I told Hubert Harrison what I had done, he exclaimed that I was an impossible poet. But soon after I received a letter from Mr. Gray. He said that both he and his sister appreciated my frankness, especially because of the duplicity they had experienced in their efforts to found a community of free spirits. As an alternative he offered me a brief vacation abroad, regretting that the decrease of his income because of the war did not permit him to make it a long vacation. As the Grays were going to Spain and I did not want to appear as if I were deliberately avoiding traveling with them, I chose going to England.

I had promised Mr. Gray an introduction to Frank Harris, and we were invited to his house one afternoon. Frank Harris in his sitting room was obscured by the bulk of another visitor who resembled an enormous slug. Every gesture he made, every word he uttered, was a gesture of crawling at the feet of Harris, whom he addressed as "Master, Dear Master." And Frank Harris appeared pleased like a little boy who takes all the credit for a brave deed that others helped him to perform. The scene disconcerted me. I could not understand how a man so forthright in his opinion as Frank Harris could swallow all of that thick cloying syrup of insincerity. But he certainly did, and with relish, rubbing his hands and nodding his head. The phrases poured heavily out of the huge man's boneless jaws, nauseating the atmosphere: "Dear master, you are the world's greatest teacher and martyr since Jesus. The pharisees are against you, Master, but your disciples are loyal." Frank Harris said that he was quite aware of that. If he were in France he would be called universally *cher maître,* like Anatole France, but a true king had no honor among the Anglo-Saxon peoples.

Frank Harris then spoke of his long and unsuccessful fight against injustice, and he emphasized the Boer War, the Oscar Wilde case, and the World War. And whenever he paused the disciple filled in with "Yes, Master . . . dear Master."

The visit ended with Mr. Gray being sold a set of Frank Harris's books and his taking out a year's subscription for *Pearson's.*

But before I left Frank Harris asked if there were anything he could do for me in London. He could not do much by way of personal introduction he said, because all his

friends there had become enemies. I said the only person I was keen about meeting was Bernard Shaw. Well chosen, Frank Harris said, and gave me a letter introducing me to Bernard Shaw.

IV

Another White Friend

•

I HAD already bought my ticket, when a few days before the date of sailing I received a letter containing a soiled scrap bearing one of my poems, which had been reprinted in the New York *Tribune*. The letter was from another white friend, quite different from those before mentioned.

Ours was a curious friendship and this was the way it came about. Coming off the dining car one night, I went with another waiter to his home in one of the West Forties. His wife had company and we played cards until a late hour.

When I left I went to eat in a Greek place on Sixth Avenue. While I was waiting for the steak and looking at a newspaper, a young fellow came in, sat down at my table, and taking my cap from the chair, put it on. Before I could say a word about such a surprising thing, he said in a low, nervous voice: "It's all right, let me wear your cap. The bulls are right after me and I am trying to fool them. They won't recognize me sitting here with you, for I was bareheaded."

The Greek came with my steak and asked what the fellow wanted. He said, "A cup of coffee." He was twenty-three, of average height and size, and his kitelike face was decent enough. I saw no bulls, but didn't mind his hiding against me at all if he could get away that way. Naturally, I was curious. So I asked where the bulls had got after him, and why. He said it was down in the subway lavatory, when he was attempting to pick a man's pocket. He was refreshingly

frank about it. There were three of them and he had escaped by a ruse that cannot be told.

He was hungry and I told him to order food. He became confidential. His name was Michael. He was a little pickpocket and did his tricks most of the time in the subways and parks. He got at his victims while they were asleep in the park or by getting friendly with them. He told me some illuminating things about the bulls, and so realistically that I saw them like wild bulls driving their horns into any object.

When I was leaving the restaurant, Michael asked if he could come up to Harlem, just to get away from downtown. I said that it was all right with me. Thus Michael came to Harlem.

The next morning when Manda, my girl friend, pushed the door open and saw Michael on the couch she exclaimed: "Foh the land's sake! I wonder what will happen next!" That was the most excitable state I had ever seen her in since our friendship began. I told her Michael was a friend in trouble and I was helping him out for awhile. She accepted the explanation and was not curious to know what the trouble was about. Like most colored southerners, she was hostile to "poor white trash," and the situation must not have been to her liking, but she took it as she did me. There was always a certain strangeness between Manda and me. Perhaps that helped our getting along comfortably together.

Manda was a pleasant placid girl from the Virginia country. She also was the result of a strange meeting. One late evening, when I got off the train, I ran into two of the fellows (an elevator runner and a waiter) who had worked with me at the women's club. We decided to give an impromptu party. It was too late to get any nice girls. So we said, "Let's go down to Leroy's and pick up some." Leroy's was the

famous cellar cabaret at the corner of One Hundred Thirty-fifth Street and Fifth Avenue, and Harlem called it "The Jungle." Leroy's was one of the cabarets where you could make friends. Fellows could flirt with girls and change tables to sit with them. In those days the more decorous cabarets would not allow visiting between tables.

We knew the kind of girls to approach. In the Harlem cabaret of that time (before Van Vechten's *Nigger Heaven* and prohibition made the colored intelligentsia cabaret-minded) there were generally three types of girls. There were the lady entertainers who flirted with the fellows impersonally to obtain nice tips and get them to buy extra drinks to promote the business of the house. Some of them were respectably married and had husbands who worked in the cabarets as waiters or musicians.

Another class of girls was more personally business-like in flirting. They didn't make the fellows spend too much in the cabaret, and had a preference for beer as a treat, for they expected them to spend on the outside. They were easily distinguishable by the confederate looks that passed between them and their protectors, who usually sat at separate tables.

And there were the lonely girls, the kitchen maids, laundresses and general day workers for New York's lower middle classes, who came for entertainment and hoping to make a friend from some casual acquaintance they might pick up.

Five of us went down to Leroy's. We noticed three girls of the last-mentioned type sitting together, chummy over large glasses of beer. We got their eyes. They were friendly, and we went over to their table. A waiter brought more chairs. We ordered a round of drinks, and, without palavering, we told the girls that we were seeking partners for a

party. They were willing to join us. As we got up to go, we noticed at a neighboring table another girl all alone and smiling at us. She had heard our overtures. She was different from the girls who were going with us, not chic, brown with a plump figure, and there was a domestic something about her which created the impression of a good hen.

The elevator operator, who was a prankish fellow, challenged the girl's smile with a big grin and said: "Let's ask her too." The three girls giggled. The other girl was so odd—her clothes were dated and the colors didn't match. But she wanted to come, and that astonished them. We thought she was a West Indian, and were surprised to find out that she was from the South.

We all went to my room in One Hundred Thirty-first Street, where we had a breakdown. In the party Manda was as different as she looked. She lacked vivacity, and since the other fellows preferred the nimbler girls, I had to dance with her most of the time. As host, I did not want her to feel out of the fun. She made herself useful, though, washing the glasses when they got soiled and mixed up, and squeezing lemons for the gin.

By dawn we were tired and everybody was leaving. But Manda said she would stay awhile and clean up. She wasn't going to work that day and I wasn't either. From then on we became intimate friends. She was a real peasant type and worked as a laundress in a boarding house. She always came to look me up when I got in from a trip. She had a room in One Hundred Thirty-third Street near Fifth Avenue, but I went there only once. I didn't like its lacey and frilly baby-ribboned things and the pink counterpane on the bed.

We didn't have a lot to say to each other. When she tidied the room she was careful about the sheets of paper on which

I was writing. And if she came when I was writing or read-
ing she would leave me alone and go into the basement to
cook. There is always an unfamiliar something between
people of different countries and nationalities, however inti-
mate they may become. And that something between me and
Manda helped rather than hindered our relationship. It made
her accept little eccentricities on my part—such as the friend-
ship with Michael, for instance. And so we sailed smoothly
along for a couple of years. Manda was a good balance to my
nervous self.

The cabarets of Harlem in those days enthralled me more
than any theater downtown. They were so intimate. If they
were lacking in variety they were rich in warmth and native
excitement. At that time the hub of Harlem was One Hun-
dred Thirty-fifth Street between Fifth Avenue and Seventh.
Between Seventh Avenue and Eighth the population was still
white. The saloons were run by the Irish, the restaurants by
the Greeks, the ice and fruit stands by the Italians, the grocery
and haberdashery stores by the Jews. The only Negro busi-
nesses, excepting barber shops, were the churches and the
cabarets. And Negro Harlem extended from One Hundred
Thirtieth to One Hundred Forty-fifth Streets, bounded on the
East by Madison Avenue and on the West by Seventh Ave-
nue. There, coming off the road like homing birds, we
trainmen came to rest awhile and fraternize with our friends
in the city—elevator runners and porters—and snatch from
saloon and cabaret and home a few brief moments of
pleasure, of friendship and of love.

On the morning after my meeting with Michael, Manda
said she had been to see me twice the night before. She had
telephoned the commissary and was told that my dining car
was in. She went to the kitchen in the basement and prepared

a big breakfast of ham and eggs and fried potatoes with coffee. I asked Mr. Morris, my landlord, to join us, for I wanted to introduce Michael to him.

He, too, had no liking for "poor white trash." He was a strapping light-brown man and doing well with the lease of two private houses and an interest in one of the few Negro-owned saloons. He came from the South, but had been living many years in the North. When he was a young man in the South, he had "sassed" a white man. And for that he was struck. He struck back, and barely escaped with his life. He was a kind landlord and a pleasant mixer, especially in saloons. But he could be bitter when he got to talking about the South. He was decent to Michael, who was a northerner, for my sake. I had been his tenant for a long time and I exercised the freedom of a friend in that house. We drank together and I got my friends sometimes to patronize his saloon (thus contributing my little to help Negro business).

So Michael came to make Harlem his hideout, while he performed his petty tricks downtown. I told Mr. Morris and Manda that he was the ne'er-do-well son of a former boss, and had taken a liking to me. Whatever they really thought of him I never knew, for they never said. But they were aware that our relationship was not a literary one; they knew that he was not one of those white folks who were interested in the pattern of words I was always making. For Michael made no pretense of being intellectual. However, they liked him, for there was a disarming cleanliness and wholesomeness about his appearance, so that they never imagined that he was what he was. And it would never have occurred to them that I could be friendly with a crook. One never can tell about appearances, and so we all make mistakes by it. For example, when some of my strutting railroad

friends came to know Manda, they couldn't believe their eyes: seeing is less penetrating than feeling.

When I was away on the railroad, Michael used my place if he needed it. He did not have a key, but I instructed Morris to let him in. I never felt any concern about anything, although I had some dandy suits in my closet and three Liberty Bonds in my trunk. Michael was profoundly sentimental about friendship, the friends of his friend, and anyone who had befriended him. He could even feel a little sorry for some of his victims after he had robbed them. That was evident from the manner in which he talked about their embarrassment. His deep hatred was directed against the bulls, and his mind was always occupied with outwitting and playing tricks on them. There were two classes of them, he said: the burly-brute, heavy-jawed type, which was easy to pick out, and the dapper college-student type, which was the more dangerous. He said that the best victims to single out were men in spectacles, but that sometimes the bulls disguised themselves and looked Harold Lloydish.

When Michael had no money he ate at the house. The landlord and Manda were sympathetic. At least they could understand that a wild and perhaps disinherited scion might be reduced to a state of hunger. The tabloids often carried sentimental stuff about such personages. When Michael had something he was extravagant. I remember one day when he brought in a fine ham. Manda cooked it in delicious Virginia style, thinking, as she said, that Michael's father had relented and that we were eating a slice of his inheritance. Michael and I exchanged looks. I felt like saying something impish to stir up Manda's suspicion. But Michael was now well established as a disinherited son instead of a "poor white trash" and I decided not to risk upsetting his position.

Also I was fond of Manda and had no desire to disturb her black Baptist conscience. She was a good woman. When she did my shirt and things in the laundry of the house where she worked, she bought her own soap and utilized her own spare time. And she would never take home any discarded rags or scraps of food that were not actually given to her.

Michael didn't hit it off so well with the fellows from the railroad, though, except for the lackadaisical one, who liked everybody. Michael was not a boozer, nor hard-boiled. In appearance he was like a nice college student. He was brought up in a Catholic home for boys which was located somewhere in Pennsylvania. He was put in there when he was about nine and kept there for twelve years. . . . Oh yes, and besides bulls, he hated priests and the Catholic Church.

I liked him most when he was telling about his escapades. There was that big-time representative of an ancient business who had his bags checked in the Grand Central Terminal. Michael managed to get the ticket away from him and refused to give it back unless the man paid twenty-five dollars. The man did not have the money on him and was afraid of a scandal. He had to telephone a friend for it and was even ashamed to do that. He walked along Broadway with Michael until they found a drugstore from which he could telephone. And he begged the lad to remain out of sight, so that his friend should not think the money was for him. "Gee!" Michael said. "And I was scared crazy all the time, thinking he would call a cop and have me arrested. But I faced it out and got the dough. The big stiff."

And there was the circus performer who had all his money at home. So Michael went along with him to get his. But when the actor got in, he sent his wife out, and she chased Michael with a rolling pin.

One afternoon, as I was dressing to go to work, I was suddenly made self-conscious by Michael remarking: "If I had your physique, I wouldn't work."

"What would you be, then," I asked, "a boxer?"

"Hell, no, that's too much bruising work, and only the big fists are in the money."

"Well, you should worry," I said, "if you haven't a swell physique. You don't work anyway."

"Oh, I'm different; but you—well, it's queer, you liking a woman like Manda."

"Why, I thought you liked her," I said. "She's nice to you."

"I know she is, and she's a fine one all right; but that's not what I mean. I mean she's so homely, she couldn't do any hustling to help you out. See what I mean?"

"Ugly is but lovely does," I said.

"That's nothing," he said.

"A whole lot more than you think," I said.

"Money is everything," he said. "When I have money I get me a pretty woman."

"Every man has his style and his limit," I said. "I prefer my way to yours."

"I know that without your saying so. Say, you don't like the way I live, eh? Be frank."

"I never said anything about that," I said.

"But you wouldn't live the way I do, would you?"

"Perhaps because I can't. One must find a way somehow between the possible and the impossible."

"But ain't it hell to be a slave on a lousy job?"

When I made no answer he went on: "Do you think you'll ever get a raise out of your writing?"

"I don't know. I might. Anyway, my writing makes it possible for me to stand being a slave on a lousy job."

Weeks passed sometimes and I never saw Michael, although he was often in Harlem, for usually when I was in he was out. He was as busy at his job as I was on mine, with shiploads of soldiers returning from Europe and the railroad service engaged to its utmost capacity. Doubling-out became like a part of the regular schedule, there was so much of it.

One day when I was in the city Michael dropped in. Seeing a revolver on the table, he asked what was the meaning of it. I said that the revolver had been in my possession for some years, ever since I used to manage an eating place in a tough district of Brooklyn. But why was I carrying it, he asked, when it might get me into trouble with the police? He never carried one himself, although his was a dangerous trade, for he was safer without it if he were picked up by the bulls.

I explained that I, like the rest of my crew, was carrying the revolver for self-defense, because of the tightened tension between the colored and the white population all over the country. Stopping-over in strange cities, we trainmen were obliged to pass through some of the toughest quarters and we had to be on guard against the suddenly aroused hostility of the mob. There had been bloody outbreak after outbreak in Omaha, Chicago, and Washington, and any crazy bomb might blow up New York even. I walked over to a window and looked out on the back yard.

Michael said: "And if a riot broke in Harlem and I got caught up here, I guess I'd get killed maybe."

"And if it were downtown and I was caught in it?" said I, turning round.

Michael said: "And if there were trouble here like that in Chicago between colored and white, I on my side and you on yours, we might both be shooting at one another, eh?"

"It was like that during the war that's just ended," I said, "brother against brother and friend against friend. They were all trapped in it and they were all helpless."

I turned my back again and leaned out of the window, thinking how in times of acute crisis the finest individual thoughts and feelings may be reduced to nothing before the blind brute forces of tigerish tribalism which remain at the core of civilized society.

When I looked up Michael was gone.

There was nearly three months' silence between us after that. It was broken at last by the pencilled scrawl and newspaper clipping which I mentioned earlier. Immediately I wrote to Michael, telling him that I had quit the railroad and was going abroad and that I would like to see him before leaving.

He came one evening. Manda made a mess of fried chicken, and we had a reunion with my landlord and Hubert Harrison, who was accompanied by a European person, a radical or bohemian, or perhaps both.

Hubert Harrison entertained us with a little monologue on going abroad. He was sure the trip would do me good, although it would have been wiser for me to accept the original proposal, he said. He asked me to send him articles from abroad for the *Negro World* (the organ of the Back-to-Africa Movement) which he was editing.

At first Michael was uneasy, listening to our literary conversation. He had never heard me being intellectual. And he was quite awed by the fact that it was pure poetry and not a fine physique that had given me a raise so quickly. He thought that that poem in the New York *Tribune* had had something to do with it. And with a little more liquor he relaxed and amused us by telling of his sensations when

he saw that poem over my name in the newspaper. And then he surprised me by saying that he was thinking about getting a job.

The European woman was charmed by the novel environment and she idealized Michael as an American proletarian. She thought that Michael was significant as a symbol of the unity of the white and black proletariat. But when she asked Michael what division of the working class he belonged to, he appeared embarrassed. After dinner we went for awhile to Connor's Cabaret, which was the most entertaining colored cabaret in Harlem at that time.

Michael came down to the boat the day I sailed. Mr. Gray also was at the pier. I introduced them. Mr. Gray was aware that Michael was poor, and whispered to me, asking if he might give him something. I said, "Sure." He gave Michael ten dollars.

As the boat moved away from the pier, they were standing together. And suddenly I felt alarmed about Mr. Gray and wondered if I should not have warned him about Michael. I thought that if I were not on the scene, Michael might not consider himself bound by our friendship not to prey upon Mr. Gray. But my fear was merely a wild scare. Michael was perfect all the way through and nothing untoward happened.

PART TWO

•

ENGLISH INNING

•

V

Adventuring in Search of George Bernard Shaw

WHEN I was a lad I wrote a rhyme about wanting to visit England and my desire to see the famous streets and places and the "factory chimneys pouring smoke." Later, when I began reading the Bernard Shaw plays, *Pleasant and Unpleasant,* and the sparkling prefaces, I added Shaw to the list of people and things that I wanted to see. Shortly before I left Jamaica for the United States, Shaw arrived in the island on a visit to the Governor, the Fabian Socialist, Sydney (Lord) Olivier, who was his friend. As my friend Mr. Jekyll was well acquainted with the Governor, I urged him to invite the Governor to bring Bernard Shaw up to Jekyll's cottage in the Blue Mountains. But Mr. Jekyll refused. He said he was opposed to the pursuit of celebrities as if they were public property, and that if Bernard Shaw was visiting Jamaica on a quiet tropical holiday, he, Jekyll, wouldn't be the first Englishman to attempt to intrude upon him. And so I had to be content with reading Shaw's one interview in the local paper, in which he said that the Governor was big and capable enough to boss the colony alone. Mr. Jekyll was amused by that and remarked that when Socialists obtained power, they would be more autocratic than capitalists.

Now that I had grown up in America and was starting off to visit England, I realized that I wasn't excited any more about the items I had named in my juvenile poem. Only the item that I had added mentally remained of lasting interest— Bernard Shaw. With the passing years he had grown vastly

bigger in my eyes. I had read most of his published works and seen two of his plays in New York. And my admiration had increased. I considered Bernard Shaw the wisest and most penetrating intellectual alive.

And so it was a spontaneous reply, when Frank Harris asked me what person I would like most to meet in London, and I said "Bernard Shaw." I really never thought of anybody else. Perhaps because the purpose of my voyage was a poetical vacation and I hadn't been thinking about meeting people.

In that season of 1919–20 in London, Shaw was triumphant in the theater. There were three of his plays drawing full houses: *Arms and the Man, You Never Can Tell* and *Pygmalion.* After seeing *Arms and the Man,* I forwarded Frank Harris's letter of introduction to Shaw. Soon I received a reply inviting me to his house.

Besides knowing Frank Harris and *Pearson's Magazine,* Shaw was acquainted with the old *Masses* and also *The Liberator,* in which my poems had been featured. Anything he had to say on any subject would be interesting to me, as it would be to thousands of his admirers everywhere. For Shaw was a world oracle. And the world then was a vast theater full of dramatic events. The capital of the Empire was full of British and Allied officers and soldiers. And they and the newspapers impressed upon one the fact that the world was passing through a universal upheaval.

Shaw received me one evening alone in his house in Adelphi Terrace. There was an elegance about his reedlike black-clothed figure that I had not anticipated, nor had I expected such a colorfully young face and complexion against the white hair and beard. I told Shaw that Frank Harris had been extremely kind to me and that when he gave me the

letter to him, he had said that Shaw was perhaps the only friend he had left in London.

Shaw said that Harris was a remarkable man, but a difficult character, that he chafed under the manners of ordinary society, and even his voice seemed to have been trained as a protest. He then asked me how I came to know Frank Harris. I told him, saying that Harris was the first editor to introduce me to the public. Shaw said that Harris was a good hand at picking possibilities.

I reminded Shaw of his visit to Jamaica. He said he had enjoyed visiting his friend, Lord Olivier. Then he mentioned some of the interesting exotic persons with whom he had come in contact. He told me about a Chinese intellectual who had come all the way from China to visit him, and wanted to talk only about Irish politics. He laughed, thinking it was funny. And I laughed too, yet I could understand a little why an educated Chinaman could have the Irish situation on his subtle Oriental mind. Shaw also mentioned an Indian who had brought him a play, which he said had a fine idea and excellent situations in it, only it couldn't fit into the modern theater.

After Shaw had recalled his Indian and his Chinaman he turned to his Negro visitor and said: "It must be tragic for a sensitive Negro to be a poet. Why didn't you choose pugilism instead of poetry for a profession?" he demanded. "You might have developed into a successful boxer with training. Poets remain poor, unless they have an empire to glorify and popularize like Kipling." I said that poetry had picked me as a medium instead of my picking poetry as a profession.

As Shaw had mentioned the theater, I told him that I had seen his plays and also two of Galsworthy's and one of Arnold

Bennett's. Shaw said that Galsworthy was a good playwright, a craftsman; but that Arnold Bennett wasn't, and that he had no sense of the theater. "But," said I, "Arnold Bennett's play, *Sacred and Profane Love,* was a big success." Shaw admitted that it was, but nevertheless it was not excellent theater, he said, adding that the play was badly constructed. I thought I understood. I remembered the most sentimental scene as the most unreal—the one in which the hero plays the piano to the thrilled woman. The actor could not play the piano, at least not enough for anyone to consider him a pianist, and one felt that the scene did not belong on the stage, although it might have been the *pièce de résistance* of a novel.

Shaw said that writing a play was much more difficult than writing a novel, and I agreed, although I had not yet tried my hand at either. But the technique of the theater seemed naturally harder to me. Shaw said many writers thought it was easy until they tried to master it. His friend, Lord Olivier, for example, who compiled excellent Socialist treatises, once wrote a play and thought it was excellent. He showed it to Shaw, who read it and said he could not understand what it was all about. Yet Lord Olivier insisted that *anybody* could understand it!

When Shaw discovered that I was not particularly interested in Irish or world politics, because my social outlook was radical, and that I was not expecting him to say something wise about the colored people in a white-controlled world, he turned to an unexpected subject—cathedrals. He spoke of their architectural grandeur, the poetry in their spires and grand arches, and the prismatic beauty of their great windows. He said there were fine cathedrals outside of London, structures full of poetry and music, which I ought to see—Salisbury, Lincoln, Canterbury, York, Winchester—as

interesting in their style as St. Sophia, Rheims and Cologne, although people did not talk so much about them. And he informed me that the best way to get at the essential beauty of a cathedral was to stand in the center and look up.

I was enchanted with this monologue on cathedrals. It was so different from Shaw's hard direct hammering writing. It was soft, poetic. And Shaw's voice is like a poem, it is so finely modulated. Once he mentioned the World War, and let out a whinny which sounded exactly like a young colt in distress or like an accent from his great drama, *Heartbreak House*. I felt at once that in spite of his elegant composed exterior, the World War must have had a shattering effect on him. Perhaps, prior to 1914 he had thought, as did other Fabian Socialists, that a wholesale war of slaughter and carnage between the civilized nations was impossible; that the world was passing gradually from the cutthroat competitive to a co-operative stage. I myself, under the influence of the international idealistic thought of that period, used to think that way. I remember when I was a school boy in Jamaica that the local militia was disbanded by the Governor, Lord Olivier, Shaw's friend and the most brilliant statistician of the Fabian Socialists. The local paper printed his statement that "such training for citizens is not necessary in an age of established peace, and anyway the people of the West Indies could not be concerned in any imaginary war of the future." Seven years later conscription was declared in Jamaica, the most intensely British of West Indian colonies, before it became effective in England, and West Indian contingents served in France, Egypt, and Arabia.

I had read such a lot about Shaw's athletic appearance and his interest in boxing, and his photographs made him look so strikingly vigorous that I was surprised by his actual

physique. Shaw looked healthy, but not like the ordinary healthy rugged man. Under his fine white hair, his complexion was as soft and rosy as a little child's. And there was something about him that reminded me of an evergreen plant grown indoors.

As an animal he suggested an antelope to my mind. And his physique gave an impression of something brittle and frail that one would want to handle with care, like chinaware. I thought that it was perhaps his vegetarian diet that gave him that remarkably deceptive appearance.

Some time after my visit with Shaw I went to hear him lecture at Kingsway Hall, where he unreservedly declared himself a believer in Lenin. I was present with William Gallacher, now Communist member of Parliament. At question time Gallacher said that it was all right for Shaw to come out in theoretical praise of Lenin, but that the workers needed practical action. Shaw replied that action was all right, but that he was getting old and so he would have to leave action to younger men like Gallacher. Yes, indeed, I had a vast admiration for the purely animal cunning and cleverness that lay underneath that great Shavian intellect.

Shaw was helpful in recommending me so that I could obtain a reader's ticket for the British Museum. That may seem easy enough for an ordinary person to acquire, but try, as a stranger in London, to find the responsible householder to sponsor you according to the regulations!

Some months later, when I was getting out my little book of poetry, *Spring in New Hampshire,* my publisher tried to get Shaw to write a foreword for it. But he refused, saying that my poetry should stand on its own. I did not mind, even though a short foreword by Shaw might have helped the selling of the book. But I could never visualize Shaw as

a poet or a subtle appreciator of the nuances of profound poetry. As a poet, I preferred the prefatory note which was contributed by Professor I. A. Richards of Cambridge University.

However, that Bernard Shaw discourse on cathedrals was an exceptional thing. I haven't discovered anything like it in any of his writings. The only writing of his with which I could compare it is the play, *Candida*. It is pregnant with poetry. As different from his other writings as the innumerable caricatures of Shaw are from his real self. I like to look at a great piling cathedral from the outside. And also I love the vast spaciousness of the inside when it is empty. During the many years I spent on the continent of Europe, I never stopped in a cathedral town without visiting the cathedral. I have spent hours upon hours meditating about modern movements of life in the sublime grandeur of cathedral silence. And as I stood in the nave of those concrete miracles of the medieval movement of belief and faith, transported by the triumphant arches of Gothic glory, often I felt again the musical vibrations of Shaw's cathedral sermon.

VI

Pugilist vs. Poet

•

HAD I been a black Diogenes exploring the white world with my African lamp, I could have proclaimed: I saw Bernard Shaw! Otherwise I did not get a grand thrill out of London. And I felt entirely out of sympathy with the English environment. There was the climate, of course, which nobody likes. In my young poetic exuberance in the clean green high hills of Jamaica, I had chanted blithely and naïvely of "chimney factories pouring smoke."

But after working in a factory in New York and getting well acquainted with the heat and smoke of railroad kitchens and engines, I was no longer romantic about factory smoke. And London was enveloped in smoke most of the time. When I was a boy in the tropics I always rejoiced in the periodic fogs which rose up out of the rivers like grand masses of fine fleecy clouds coming out of the belly of the earth and ascending to the sky. But the fog of London was like a heavy suffocating shroud. It not only wrapped you around but entered into your throat like a strang ng nightmare. Yet the feeling of London was so harshly unfriendly to me that sometimes I was happy in the embrace of the enfolding fog. London was the only great northern city in which I was obliged to wear an overcoat all the year round.

However, it was more than the climate that made London uncongenial. I lived for months in Brittany and it rained all the time, unceasingly. Yet I loved the environment, because the Bretons were such a sympathetic people. Like the quiet

66

brown fields and the rugged coasts, even like the unending fishermen's nets everywhere, the unceasing rain was a charming part of the whole harmony of their way of living. But the English as a whole were a strangely unsympathetic people, as coldly chilling as their English fog.

I don't think I could have survived the ordeal of more than a year's residence in London if I had not had the freedom of two clubs. The membership of both clubs was overwhelmingly foreign. And perhaps that was why I felt most of the time that I was living on foreign instead of English soil.

One club was for colored soldiers. It was situated in a basement in Drury Lane. There was a host of colored soldiers in London, from the West Indies and Africa, with a few colored Americans, East Indians, and Egyptians among them. A West Indian student from Oxford introduced me to the club. I went often and listened to the soldiers telling tales of their war experiences in France, Egypt, and Arabia. Many were interested in what American Negroes were thinking and writing. And so I brought to the club copies of American Negro magazines and newspapers: *The Crisis, The Messenger, The Negro World,* the Pittsburgh *Courier* and the Chicago *Defender.* A soldier from Jamaica invited me on a holiday trip to the camp at Winchester.

I wrote a series of articles about the colored soldiers and their club, which Hubert Harrison featured in the *Negro World,* the organ of the Garvey Back-to-Africa Movement. In due time the *Negro World* with the first article arrived at the Drury Lane club. The Englishwoman in charge of the club took exception to the article. I think she was the widow of a sergeant major who had served England in India. She had given me an interview, telling about her "colored boys" and their virtues, if white people knew how to manage them.

And I had quoted her and said she had a patronizing white maternal attitude toward her colored charges. The English-woman did not like that. And so, being *persona non grata,* I transferred most of my attention to the other club.

The International Club was full of excitement, with its dogmatists and doctrinaires of radical left ideas: Socialists, Communists, anarchists, syndicalists, one-big-unionists and trade unionists, soap-boxers, poetasters, scribblers, editors of little radical sheets which flourish in London. But foreigners formed the majority of the membership. The Jewish element was the largest. The Polish Jews and the Russian Jews were always intellectually at odds. The German Jews were aloof. There were also Czechs, Italians, and Irish nationalists, and rumors of spies.

For the first time I found myself in an atmosphere of doctrinaire and dogmatic ideas in which people devoted them-selves entirely to the discussion and analysis of social events from a radical and Marxian point of view. There was an uncompromising earnestness and seriousness about those radicals that reminded me of an orthodox group of persons engaged in the discussion of a theological creed. Only at the International Club I was not alienated by the radicals as I would have been by the theologians. The contact stimulated and broadened my social outlook and plunged me into the reading of Karl Marx.

There was so much emphasis placed upon Marxian intel-lects and un-Marxian minds, the Marxian and non-Marxian way of approach to social organization, that I felt intellec-tually inadequate and decided to educate myself. One thing seemed very clear to me: the world was in the beginning of passing through a great social change, and I was excited by the possibilities. These people believed that Marx was

the true prophet of the new social order. Suppose they were
not wrong! And if not altogether right, suppose they were
nearly right? History had taught me that the face of the
world had been changed before by an obscure prophet. I had
no reason to think that the world I lived in was permanent,
solid and unshakable: the World War had just come to a
truce.

So I started reading Marx. But it wasn't entertaining read-
ing. Much of it was like studying subjects you dislike, which
are necessary to pass an examination. However, I got the essen-
tial stuff. And a Marx emerged from his pages different from
my former idea of him as a torch-burning prophet of social
revolution. I saw the picture of a man imprisoned by walls
upon walls of books and passionately studying the history
and philosophy and science of the world, so that he might
outline a new social system for the world. I thought that
Marx belonged even more to the institutions of learning than
to the street corners from which I had so often heard his
gospel preached. And I marveled that any modern system
of social education could ignore the man who stood like a
great fixed monument in the way of the world.

If there was no romance for me in London, there was
plenty of radical knowledge. All the outstanding extreme
radicals came to the International Club to lecture and I heard
most of them—Walton Newbold, the first Communist Mem-
ber of Parliament; Saklatvala, the Indian Parsee and first
unofficial Communist Member of Parliament; A. J. Cook of
the Miners' Federation, who later became its secretary; Guy
Aldred, an anarchist editor; Jack Tanner, a shop steward
committee leader; Arthur McManus and William Gallacher,
the agitators from the Clyde; George Lansbury, the editor

of the *Daily Herald;* and Sylvia Pankhurst, who had deserted the suffragette for the workers' movement.

I was the only African visiting the International Club, but I soon introduced others: a mulatto sailor from Limehouse, a West Indian student from Oxford, a young black minister of the Anglican church, who was ambitious to have a colored congregation in London, a young West Indian doctor from Dulwich, three soldiers from the Drury Lane club, and a couple of boxers. The minister and the doctor did not make a second visit, but the others did.

The club had also its social diversions and there was always dancing. The manager, desiring to offer something different, asked the boxers to put on an exhibition match. The boxers were willing and a large crowd filled the auditorium of the club to see them.

One was a coffee brown, the other bronze; both were strapping broad-chested fellows. Their bodies gleamed as if they were painted in oil. The darker one was like a stout bamboo, smooth and hairless. They put on an entertaining act, showing marvelous foot and muscle work, dancing and feinting all over the stage.

Some weeks later the black boxer gave me a ticket for his official fight, which was taking place in Holborn. His opponent was white and English. I was glad of the opportunity to see my friend in a real fight. And it was a good fight. Both men were in good form, possessing powerful punches. And they fully satisfied the crowd with the brutal pleasure it craved. In the ninth round, I think, the black man won with a knock-out.

Some fellows from the Drury Lane club had come to encourage their comrade. After the match we grouped around him with congratulations. We proposed to go to a little

colored restaurant off Shaftesbury Avenue to celebrate the event. At that moment, a white man pushed his way through to the boxer and putting out his hand said: Shake, Darkey, you did a clean job; it was a fine fight. The boxer shook hands and thanked his admirer quietly. He was a modest type of fellow. Then he turned to a little woman almost hidden in the group—a shy, typically nondescript and dowdy Englishwoman, with her hat set inelegantly back on her head —and introduced her to his white admirer: "This is my wife." The woman held out her hand, but the white man, ignoring it, exclaimed: "You damned nigger!" The boxer hauled back and hit him in the mouth and he dropped to the pavement.

We hurried away to the restaurant. We sat around, the poor woman among us, endeavoring to woo the spirit of celebration. But we were all wet. The boxer said: "I guess they don't want no colored in this damned white man's country." He dropped his head down on the table and sobbed like a child. And I thought that that was *his* knock-out.

I thought, too, of Bernard Shaw's asking why I did not choose pugilism instead of poetry for a profession. He no doubt imagined that it would be easier for a black man to win success at boxing than at writing in a white world. But looking at life through an African telescope I could not see such a great difference in the choice. For, according to British sporting rules, no Negro boxer can compete for a championship in the land of cricket, and only Negroes who are British subjects are given a chance to fight. These regulations have nothing to do with the science of boxing or the Negro's fitness to participate. They are made merely to discourage boxers who are black and of African descent.

Perhaps the black poet has more potential scope than the pugilist. The literary censors of London have not yet decreed that no book by a Negro should be published in Britain—not yet!

VII

A Job in London

•

YET London was not wholly Hell, for it was possible
for me to compose poetry some of the time. No place
can be altogether a God-forsaken Sahara or swamp in which
a man is able to discipline and compose his emotions into
self-expression. In London I wrote "Flame-heart."

So much I have forgotten in ten years,
So much in ten brief years! I have forgot
What time the purple apples come to juice,
And what month brings the shy forget-me-not.
I have forgot the special, startling season
Of the pimento's flowering and fruiting;
What time of year the ground doves brown the fields
And fill the noonday with their curious fluting.
I have forgotten much, but still remember
The poinsettia's red, blood-red in warm December.

I still recall the honey-fever grass,
But cannot recollect the high days when
We rooted them out of the ping-wing path
To stop the mad bees in the rabbit pen.
I often try to think in what sweet month
The languid painted ladies used to dapple
The yellow by-road mazing from the main,
Sweet with the golden threads of the rose-apple.
I have forgotten—strange—but quite remember
The poinsettia's red, blood-red in warm December.

73

What weeks, what months, what time of the mild year
 We cheated school to have our fling at tops?
What days our wine-thrilled bodies pulsed with joy
 Feasting upon blackberries in the copse?
Oh some I know! I have embalmed the days,
 Even the sacred moments when we played,
All innocent of passion, uncorrupt,
 At noon and evening in the flame-heart's shade.
We were so happy, happy, I remember,
Beneath the poinsettia's red in warm December.

And then I became acquainted with Sylvia Pankhurst. It happened thus. The *Daily Herald,* the organ of British organized labor and of the Christian radicals, had created a national sensation by starting a campaign against the French employment of black troops in the subjection of Germany.

The headlines were harrowing:

"Black Scourge in Europe," "Black Peril on the Rhine," "Brutes in French Uniform," "Sexual Horrors Let Loose by France," "Black Menace of 40,000 Troops," "Appeal to the Women of Europe."

The instigator of the campaign was the muckraker E. D. Morel, whose pen had been more honorably employed in the exposure of Belgian atrocities in the Congo. Associated with him was a male "expert" who produced certain "facts" about the physiological peculiarities of African sex, which only a prurient-minded white man could find.

Behind the smoke screen of the *Daily Herald* campaign there were a few significant facts. There was great labor unrest in the industrial region of the Rhineland. The Communists had seized important plants. The junkers were opposing the Communists. The Social-Democratic government was

impotent. The French marched in an army. The horror of German air raids and submarine warfare was still fresh in the mind of the British public. And it was not easy to work up and arouse the notorious moral righteousness of the English in favor of the Germans and against the French. Searching for a propaganda issue, the Christian radicals found the colored troops in the Rhineland. Poor black billy goat.

I wrote a letter to George Lansbury, the editor of the *Daily Herald,* and pointed out that his black-scourge articles would be effective in stirring up more prejudice against Negroes. I thought it was the duty of his paper as a radical organ to enlighten its readers about the real reasons why the English considered colored troops undesirable in Europe, instead of appealing indirectly to illogical emotional prejudices. Lansbury did not print my letter, but sent me a private note saying that he was not personally prejudiced against Negroes. I had no reason to think that Lansbury was personally prejudiced. The previous summer, when colored men were assaulted by organized bands of whites in the English ports and their bedding and furniture hurled into the streets and burned, Lansbury had energetically denounced the action. But I didn't consider the matter a personal issue. It was the public attitude of the *Daily Herald* that had aroused me. An English friend advised me to send the letter to Sylvia Pankhurst, who was very critical of the policies of the *Daily Herald*. I did, and Sylvia Pankhurst promptly printed my letter in her weekly, the *Workers' Dreadnought.*

Maybe I was not civilized enough to understand why the sex of the black race should be put on exhibition to persuade the English people to decide which white gang should control the coal and iron of the Ruhr. However, it is necessary to

face the fact that prejudices, however unreasonable they may be, are real—individual, national and racial prejudices. My experience of the English convinced me that prejudice against Negroes had become almost congenital among them. I think the Anglo-Saxon mind becomes morbid when it turns on the sex life of colored people. Perhaps a psychologist might be able to explain why.

Sylvia Pankhurst must have liked the style of my letter, for she wrote asking me to call at her printing office in Fleet Street. I found a plain little Queen-Victoria sized woman with plenty of long unruly bronze-like hair. There was no distinction about her clothes, and on the whole she was very undistinguished. But her eyes were fiery, even a little fanatic, with a glint of shrewdness.

She said she wanted me to do some work for the *Workers'* *Dreadnought.* Perhaps I could dig up something along the London docks from the colored as well as the white seamen and write from a point of view which would be fresh and different. Also I was assigned to read the foreign newspapers from America, India, Australia, and other parts of the British Empire, and mark the items which might interest *Dreadnought* readers. In this work I was assisted by one Comrade Vie. Comrade Vie read the foreign-language papers, mainly French and German.

The opportunity to practice a little practical journalism was not to be missed. A little more schooling, a few more lessons —learning something from everything—keeping the best in my mind for future creative work.

The association with Pankhurst put me in the nest of extreme radicalism in London. The other male-controlled radical groups were quite hostile to the Pankhurst group and its rather hysterical militancy. And the group was perhaps

more piquant than important. But Pankhurst herself had a personality as picturesque and passionate as any radical in London. She had left the suffragette legion for the working-class movement, when she discovered that the leading ladies of the legion were not interested in the condition of working women.

And in the labor movement she was always jabbing her hat pin into the hides of the smug and slack labor leaders. Her weekly might have been called the Dread Wasp. And wherever imperialism got drunk and went wild among native peoples, the Pankhurst paper would be on the job. She was one of the first leaders in England to stand up for Soviet Russia. And in 1918 she started the Russian Information Bureau, which remained for a long time the only source of authentic news from Russia.

Comrade Vie was a very young foreigner with a bare bland innocent face. He read and spoke several languages. I did not know his nationality and refrained from asking. For the Pankhurst organization, though small, was revolutionary, and from experience the militant suffragettes knew a lot about conspiracy. However, I suspected that Comrade Vie was a foreign revolutionist. The Pankhurst secretary, a romantic middle-class young woman, had hinted to me that Comrade Vie was more important than he appeared to be.

Comrade Vie wrote also and we often compared articles. I criticized his English and he criticized my point of view, showing me how I could be more effectively radical.

Soon after I became associated with the *Workers' Dreadnought,* a sawmill strike broke out in London. Most of the sawmills were in the East End, where also the publishing office of the *Dreadnought* was located. One mill was directly opposite the *Dreadnought* office. I was assigned to do an

article on the strike. A few of the sawmill workers were sympathetic to the *Dreadnought* organization, and one of the younger of them volunteered to take me round.

There were some sixty sawmills in London, one of the most important of which was either owned or partly controlled by George Lansbury, Labor Member of Parliament and managing editor of the *Daily Herald*. Some of the strikers informed me that the Lansbury mill had in its employ some workers who were not members of the sawmill union and who were not striking. Technically, such workers were scabs. The strikers thought it would make an excellent story for the militant *Dreadnought*. So did I.

The name of Lansbury was symbolic of all that was simon-pure, pious and self-righteous in the British Labor movement. As the boss of the *Daily Herald,* he stood at the center like an old bearded angel of picturesque honesty, with his right arm around the neck of the big trade-union leaders and Parliamentarians and his left waving to the Independent Labor partyites and all the radical Left. Like a little cat up against a big dog, the *Workers' Dreadnought* was always spitting at the *Daily Herald*.

I thought the story would give the *Dreadnought* some more fire to spit. Here was my chance for getting even with the *Daily Herald* for its black-scourge-in-Europe campaign. Comrade Vie helped me put some ginger into my article. When I showed the article to Miss Smyth, the upper-middle-class person who was Pankhurst's aid, she gasped and said: "But this is a scoop." Her gentle-lady poker face was lit as she read.

Finally the article reached Sylvia Pankhurst. She summoned me and said: "Your article is excellent but I'm so sorry we cannot print it." "Why?" I asked. "Because," said she, "we owe Lansbury twenty pounds. Besides, I have borrowed paper

from the *Daily Herald* to print the *Dreadnought.* I can't print that."

It is possible that Miss Pankhurst acted more from a feeling of personal loyalty. Although Lansbury was centrist and she was extreme leftist, they were personal friends, ever since they had been associated in the suffrage cause. And after all, one might concede that there are items which the capitalist press does not consider fit to print for capitalist reasons, and items which the radical press does not consider fit to print for radical reasons.

That summer Sylvia Pankhurst made the underground trip to Russia to attend the Second Congress of the Third International.

Early in September, 1920, I was sent down to Portsmouth to report the Trades Union Congress for the *Dreadnought.* There were gathered at the Congress some of the leaders who later became members of the British Labor Government: J. H. Thomas, J. R. Clynes, Arthur Henderson, A. A. Purcell, Herbert Morrison, Frank Hodges, and Margaret Bonfield. The most picturesque personage of them all was Frank Hodges, the secretary of the Miners' Federation, who in his style and manner appeared like a representative of the nobility. I mentioned this to A. J. Cook, who was a minor official of the Federation, and he informed me that Hodges was always hunting foxes with the lords.

At the press table I met Scott Nearing, who, after listening to clever speeches by the labor leaders, whispered to me that England would soon be the theater of the next revolution. The speeches were warm; Labor was feeling its strength in those times. Even J. H. Thomas was red, at least in the face, about Winston Churchill, who had declared that "Labor was not fit to govern."

As a *Dreadnought* reporter, I had been instructed to pay little attention to the official leaders, but to seek out any significant rank-and-filers and play them up in my story. I was taken up by delegates from the Rhondda Valley in South Wales, which was the extreme leftist element of the Miners' Federation. One of them, A. J. Cook, was exceptionally friendly and gave me interesting information about the British Labor movement. He was very proud that it was the most powerful in the world and included every class of worker. He said he believed the labor movement was the only hope for Negroes because they were in the lowest economic group. He pointed out that J. R. Clynes' General Union of Workers consisted of the lowest class of people (domestic servants and porters and hotel workers) and yet it was extremely important in the councils of the Trades Union Congress.

At that time I could not imagine Cook becoming a very influential official. He was extremely loquacious, but his ideas were an odd mix-up of liberal sentiment and socialist thought, and sentimental to an extreme. He was also a parson, and divided his time between preaching and the pit. However, the radical miners told me they were going to push Cook forward to take the place of Hodges, whom they could no longer stomach. And sure enough, in a few brief years Cook became the radical secretary of the Miners' Federation.

But the labor official at the Congress who carried me away with him was Robert Smillie, the president of the Miners' Federation. Crystal Eastman had given me a note to him and he had said a few wise words to me about the necessity of colored labor being organized, especially in the vast European colonies, for the betterment of its own living standard and to protect that of white organized labor. Smillie was like a powerful ash which had forced itself up, coaxing nourishment out

of infertile soil, and towering over saplings and shrubs. His face and voice were so terribly full of conviction that in comparison the colleagues around him appeared theatrical. When he stood forth to speak the audience was shot through with excitement, and subdued. He compelled you to think along his line whether or not you agreed with him. I remember his passionate speech for real democracy in the Congress, advocating proportional representation and pointing out that on vital issues the united Miners' Federation was often outvoted by a nondescript conglomeration like J. R. Clynes' General Union of Workers for example. You felt that Smillie had convinced the Congress, but when the vote was taken it went against him.

I wrote my article on the Trades Union Congress around Smillie because his personality and address were more significant in my opinion than any rank-and-filer's. It was featured on the front page of the *Dreadnought*. But when Pankhurst returned from Russia, she sharply reproved me for it, saying that it wasn't the policy of the *Dreadnought* to praise the official labor leaders, but to criticize them. Naturally, I resented the criticism, especially as Pankhurst had suppressed my article on Lansbury.

Just before leaving for the Trades Union Congress I was introduced to a young English sailor named Springhall. He was a splendid chap. He had been put into the British navy as a boy and had developed into a fine man, not merely physically, but intellectually. Springhall was a constant reader of the *Dreadnought* and other social propaganda literature and he said that other men on his ship were eager for more stuff about the international workers' movement. At that time there was a widespread discontent and desire for better wages among the rank and file of the navy. Springhall came to the

Dreadnought publishing office in the Old Ford Road and we gave him many copies of the *Dreadnought*. The *Dreadnought* was legally on sale on the newsstands, so he had the legal right to take as many as he desired. Before he left he promised to send me some navy news for the paper.

When I returned to London I found a letter from the young sailor, Springhall, with some interesting items for the paper and the information that he was sending an article. The article arrived in a few days and it was a splendid piece of precious information. But its contents were so important and of such a nature that I put it away and waited for Pankhurst to return and pass it.

Pankhurst returned late in September. I turned over Springhall's document to her. She was enthusiastic, edited the document, and decided to give it the front page. We used a nom de plume and a fictitious name for a battleship. Only Pankhurst and myself knew who the author was. The intelligence of the stuff was so extraordinary that she did not want to risk having the youth's identity discovered by the authorities. And she thought he could serve the social cause more excellently by remaining at his post.

A couple of days after the issue appeared, the *Dreadnought* office was raided by the police. I was just going out, leaving the little room on the top floor where I always worked, when I met Pankhurst's private secretary coming upstairs. She whispered that Scotland Yard was downstairs. Immediately I thought of Springhall's article and I returned to my room, where I had the original under a blotter. Quickly I folded it and stuck it in my sock. Going down, I met a detective coming up. They had turned Pankhurst's office upside down and descended to the press-room, without finding what they were looking for.

"And what are you?" the detective asked.

"Nothing, Sir," I said, with a big black grin. Chuckling, he let me pass. (I learned afterward that he was the ace of Scotland Yard.) I walked out of that building and into another, and entering a water closet I tore up the original article, dropped it in, and pulled the chain. When I got home to the Bow Road that evening I found another detective waiting for me. He was very polite and I was more so. With alacrity I showed him all my papers, but he found nothing but lyrics.

Pankhurst was arrested and charged with attempting to incite dissatisfaction among His Majesty's Forces. She was released on bail and given time to straighten out her affairs before she came up for trial. She received many messages of sympathy and among them was a brief telegram from Bernard Shaw asking: "Why did you let them get you?"

Pankhurst's arrest was the beginning of a drive against the Reds. For weeks the big press had carried on a campaign against Red propaganda and alien agitators and Bolshevik gold in Britain. Liberal intellectuals like Bertrand Russell and Mrs. Snowden had visited Russia, and labor men like Robert Williams and George Lansbury. There was an organized labor and liberal demand to end the Russian blockade. And when the press broadcast the fact that $325,000 of Bolshevik capital had been offered to the *Daily Herald,* it must have struck Scotland Yard like a bomb.

Within a week of Pankhurst's arrest, Comrade Vie was seized just as he was leaving England to go abroad. He was arrested as he was departing from the house of a member of Parliament who was a Communist sympathizer. The police announced that he was a Bolshevik courier. They discovered on his person letters from Pankhurst to Lenin, Zinoviev and other members of the Bolshevik Politbureau; also notes in

cipher, documents of information about the armed forces, the important industrial centers, and Ireland, a manual for officers of the future British Red army and statements about the distribution of money. Comrade Vie was even more important than I had suspected.

One evening when I got back home from Fleet Street I was surprised to find Springhall, the sailor, there. He had come up to London to see Pankhurst. He said his ship was leaving England and he would like to talk to her. He was on one of the crack battleships. I begged him for God's sake to leave at once, that he could not see Pankhurst, who had been enjoined from political activity by the court and was undoubtedly under police surveillance. Also, as editor of the *Dreadnought,* she had taken the full responsibility for his article, and her difficult situation in the movement would be made worse if the police should get him too.

Springhall returned to his ship. But he was bold with youthful zeal and extremely incautious. I remember his actively participating in his uniform in the grand demonstration in Trafalgar Square for the hunger-striking and dying mayor of Cork. And he marched with the crowds upon the prison and fought with the police and got severely beaten up. He wanted to quit the navy, believing that he could be a better agitator outside. But his friends on the outside thought that he could be of more importance at his post. Anyway he must have acted indiscreetly and created suspicion against himself, for when his ship arrived at its next port, he was summarily dismissed. However, his revolutionary ardor did not handicap him in being clever enough to maneuver his dismissal and steer clear of a court-martial. A few years after he visited Russia, and later I was informed that he subsequently became an active leader of the British Communist Youth Movement.

Comrade Vie was convicted under the simple charge of alien non-registration. He was sentenced to six months' imprisonment and to pay the costs of his trial and deportation. Upon his release, Pankhurst's secretary followed him to Russia, where they were married. Apparently it was his preoccupation with his love affair that enabled the detectives to trap Comrade Vie. Three years later I saw them again in Moscow, but he did not seem to be importantly employed.

VIII

Regarding Reactionary Criticism

•

MY little brown book of verse, *Spring in New Hampshire,* appeared in the midst of the radical troubles in the fall of 1920. I had not neglected the feeling of poetry, even while I was listening to Marxian expositions at the International Club and had become involved in radical activities. A little action was a nice stimulant for another lyric.

C. K. Ogden, the author of *Basic English* and *The Foundation of Esthetics,* besides steering me round the picture galleries and being otherwise kind, had published a set of my verses in his *Cambridge Magazine.* Later he got me a publisher.

But I was so anxious about leaving London for America that I hardly felt the excitement I should about the first book I had done since I left Jamaica. The Pankhurst group had been disrupted by the police raids. Many of the members were acquainted with Comrade Vie, but unaware of his real identity. His unexpected arrest and the disclosures of the police that he was a Bolshevik agent had started lots of rubberneck gossip. Some asserted that Comrade Vie had been deliberately betrayed. And members accused other members of being spies and traitors. A dissident group, headed by Edgar Whitehead, the secretary of the organization, desired to bring Pankhurst herself to a private trial and I also had to give an accounting of my activities.

One evening, when I visited the International Club the secretary showed me an anonymous letter he had received,

accusing me also of being a spy. I declare that I felt sick and
was seized with a crazy craving to get quickly out of that
atmosphere and far away from London. But I had used up
all of my return fare. All I had received from the *Dread-
nought* was payment for my board. The organization was
always in need of money.

My little book had brought me no money. I hadn't been
banking on it. I had stopped writing for the *Negro World*
because it had not paid for contributions. An English friend,
and I. W. W. who had lived in America (I think he had
been deported thence), undertook to find a group of friends
to put up the fare to get me back there.

While I was hotly preparing my departure, Sylvia Pank-
hurst was sentenced to six months' imprisonment. Pank-
hurst was a good agitator and fighter, but she wasn't a leader.
She possessed the magnetism to attract people to her organiza-
tion, but she did not have the power to hold them. I remem-
ber a few of them: William Gallacher, Saklatvala (the Indian
M. P.), A. J. Cook, who became the secretary of the Miners'
Federation, and that very brilliant and talented writing couple,
Eden and Cedar Paul. And I was informed that before my
time there had been others even more brilliant among the Left
literary and artistic set. I remember saying to Springhall
that it was a pity the organization was too small for him. It
was a one-woman show, not broad-based enough to play a
decisive rôle in the labor movement.

At last, when I was safely fixed in my third-class bunk, I
had time to read and ponder over the English reviews of my
book. If it is difficult to ascertain the real attitude of the com-
mon people of any country regarding certain ideas and things,
it should be easy enough to find out that of the élite by writ-

ing a book. The reviews will reveal more or less the mind of the better classes.

In most of the reviews of my poems there was a flippant note, either open or veiled, at the idea of a Negro writing poetry. After reading them I could understand better why Bernard Shaw had asked me why I did not go in for pugilism instead of poetry. I think I got as much amusement out of reading them from my own angle as the reviewers had in writing from theirs.

But more than all there was one that deserves special mention. It was the review published in the *Spectator,* the property, I think, of the Strachey family, and the organ of the Tory intellectuals. There can be little doubt that the *London Spectator* represents the opinion of that English group, which, because of its wealth and power, its facilities for and standards of high education, and its domination of most of the universe, either directly or indirectly, is the most superior in the world.

Said the *Spectator* critic: "*Spring in New Hampshire* is extrinsically as well as intrinsically interesting. It is written by a man who is a pure-blooded Negro . . . Perhaps the ordinary reader's first impulse in realizing that the book is by an American Negro is to inquire into its good taste. Not until we are satisfied that his work does not overstep the barriers which a not quite explicable but deep instinct in us is ever alive to maintain can we judge it with genuine fairness. Mr. Claude McKay never offends our sensibilities. His love poetry is clear of the hint which would put our racial instinct against him, whether we would or not."

So there it bobbed up again. As it was among the élite of the class-conscious working class, so it was among the aristocracy of the upper class: the bugaboo of sex—the African's sex, whether he is a poet or pugilist.

Why should a Negro's love poetry be offensive to the white man, who prides himself on being modern and civilized? Now it seems to me that if the white man is really more civilized than the colored (be the color black, brown or yellow), then the white man should take Negro poetry and pugilism in his stride, just as he takes Negro labor in Africa and fattens on it.

If the critic of the organ of British aristocracy had used his facilities for education and knowledge and tolerance (which the average black student has not) to familiarize himself with the history and derivations of poetry he might have concluded that the love poetry of a Negro might be in better taste than the gory poetry of a civilized British barbarian like Rudyard Kipling.

It seems to me that every European white lover of lyric and amatory poetry should be informed that one of the greatest, if not the greatest, poets of love, was a Negro named Antar. And that European or white man's love poetry today probably owes much of its inspiration to Antar, who was the son of a Negro woman and an Arabian chieftain.

One of the big surprises of my living in North Africa was the discovery that even the illiterate Moor is acquainted with the history and the poetry of Antar. Often in the Arab cafés (which I haunted like a *loco,* because of the native music), when I was especially enthralled by the phrasing of a song, I was informed that it was an *Antari* (a song from Antar). When I was introduced as a poet there was not a suspicion of surprise among the natives. Instead I was surprised by their flattering remarks: "A poet! *Mezziane! Mezziane!* Our greatest poet, Antar, was a Negro."

W. A. Clouston, who writes with authority on Arabian poetry, says: "It is far from impossible that the famous ro-

mance of Antar produced the model for the earliest of the romances of chivalry." Certainly it was the Arabian poets who, upon the Arab conquest of Spain, introduced lyric feeling into the rude and barbaric accents of the Europeans. The troubadours of southern Europe stem directly from the Arabian poets. The Arab poets and musicians were the original troubadours. And happily they exist today exactly as they did thirteen centuries ago, wherever Moslem culture holds sway.

Says Sismondi, the famous scholar: "It is from them that we have derived that intoxication of love, that tenderness and delicacy of sentiment and that reverential awe of woman, by turns slaves and divinities, which have operated so powerfully on our chivalrous feelings."

But it should not be necessary for me in this place to attempt to enlighten the English gentlemen. I am not a scholar and this book is not scholarly. The English gentleman has the means and the material to educate himself that no Negro has. If he does not make the proper use of them it must be because he is spoiled by his modern civilization. The story of Antar was translated from the Arabian into English way back in 1820, and by an Englishman named Terrick Hamilton.

Antar is as great in Arabian literature as Homer in Greek. Said the founder of Islam: "I have never heard an Arab described whom I should like to have seen so much as Antar." In the universal white system of education the white school boy learns about Homer and Virgil and their works, even if he does not read Greek and Latin. He learns nothing of Antar, although it is possible that European poetry derives more from Antar than from Homer. Yet the white child is so rich in its heritage that it may not be such a great loss to him if he grows up in ignorance of the story and poetry of Antar. The Negro child, born into an inferior position in the over-

whelming white world, is in a different category. He should know something of the Antar who was born a slave, who fought for his liberation, who loved so profoundly, passionately and chastely that his love inspired and uplifted him to be one of the poets of the Arabian pleiades.

Behold the sport of passion in my noble person!
But I have thanked my forebearance, applauded my reso-
* lution.*
And the slave has been elevated above his master;
For I have concealed my passion and kept my secret,
I will not leave a word for the railers, and I will not ease
* the hearts of my enemies by the violation of my honor.*
I have borne the evils of fortune, till I have discovered its
* secret meaning . . .*
I have met every peril in my bosom,
And the world can cast no reproach on me for my
* complexion:*
My blackness has not diminished my glory.

* * * * * * * * * *

My mother is Zebeeda,
I disavow not her name and I am Antar,
But I am not vainglorious . . .
Her dark complexion sparkles like a sabre in the shades of
* night*
And her shape is like the well-formed spear . . .

To me these verses of Antar written more than twevle centuries ago are more modern and full of meaning for a Negro than is Homer. Perhaps if black and mulatto children knew more of the story and the poetry of Antar, we might have better Negro poets. But in our Negro schools and colleges we learn a lot of Homer and nothing of Antar.

PART THREE

•

NEW YORK HORIZON

•

IX

Back in Harlem

•

LIKE fixed massed sentinels guarding the approaches to the great metropolis, again the pyramids of New York in their Egyptian majesty dazzled my sight like a miracle of might and took my breath like the banging music of Wagner assaulting one's spirit and rushing it skyward with the pride and power of an eagle.

The feeling of the dirty steerage passage across the Atlantic was swept away in the immense wonder of clean, vertical heaven-challenging lines, a glory to the grandeur of space.

Oh, I wished that it were possible to know New York in that way only—as a masterpiece wrought for the illumination of the sight, a splendor lifting aloft and shedding its radiance like a searchlight, making one big and great with feeling. Oh, that I should never draw nearer to descend into its precipitous gorges, where visions are broken and shattered and one becomes one of a million, average, ordinary, insignificant.

At last the ship was moored and I came down to the pavement. Ellis Island: doctors peered in my eyes, officials scrutinized my passport, and the gates were thrown open.

The elevated swung me up to Harlem. At first I felt a little fear and trembling, like a stray hound scenting out new territory. But soon I was stirred by familiar voices and the shapes of houses and saloons, and I was inflated with confidence. A wave of thrills flooded the arteries of my being, and I felt as if I had undergone initiation as a member of my tribe. And I was happy. Yes, it was a rare sensation again to

be just one black among many. It was good to be lost in the shadows of Harlem again. It was an adventure to loiter down Fifth and Lenox avenues and promenade along Seventh Avenue. Spareribs and corn pone, fried chicken and corn fritters and sweet potatoes were like honey to my palate.

There was a room for me in the old house on One Hundred Thirty-first Street, but there was no trace of Manda. I could locate none of my close railroad friends. But I found Sanina. Sanina was an attractive quadroon from Jamaica who could pass as white. Before prohibition she presided over a buffet flat. Now she animated a cosy speakeasy. Her rendezvous on upper Seventh Avenue, with its pink curtains and spreads, created an artificial rose-garden effect. It was always humming like a beehive with brown butterflies and flames of all ages from the West Indies and from the South.

Sanina infatuated them all. She possessed the cunning and fascination of a serpent, and more charm than beauty. Her clients idolized her with a loyalty and respect that were rare. I was never quite sure what was the secret of her success. For although she was charming, she was ruthless in her affairs. I felt a congeniality and sweet nostalgia in her company, for we had grown up together from kindergarten. Underneath all of her shrewd New York getting-byness there was discernible the green bloom of West Indian naïveté. Yet her poise was a marvel and kept her there floating like an imperishable block of butter on the crest of the dark heaving wave of Harlem. Sanina always stirred me to remember her dominating octoroon grandmother (who was also my godmother) who beat her hard white father in a duel they fought over the disposal of her body. But that is a West Indian tale. . . . I think that some of Sanina's success came from her selectiveness. Although there were many lovers mixing up their lov-

ing around her, she kept herself exclusively for the lover of
her choice.

I passed ten days of purely voluptuous relaxation. My fifty
dollars were spent and Sanina was feeding me. I was uncom-
fortable. I began feeling intellectual again. I wrote to my
friend, Max Eastman, that I had returned to New York. My
letter arrived at precisely the right moment. The continuation
of *The Liberator* had become a problem. Max Eastman had
recently resigned the editorship in order to devote more time
to creative writing. Crystal Eastman also was retiring from
the management to rest and write a book on feminism. Floyd
Dell had just published his successful novel, *Moon Calf*, and
was occupied with the writing of another book.

Max Eastman invited me to Croton over the week-end to
discuss the situation. He proposed to resume the editorship
again if I could manage the sub-editing that Floyd Dell did
formerly. I responded with my hand and my head and my
heart. Thus I became associate editor of *The Liberator*. My
experience with the *Dreadnought* in London was of great
service to me now.

The times were auspicious for the magazine. About the
time that I was installed it received a windfall of $11,000
from the government, which was I believe a refund on mail-
ing privileges that had been denied the magazine during
the war.

Soon after taking on my job I called on Frank Harris, I
took along an autographed copy of *Spring in New Hamp-
shire*, the book of verses that I had published in London. The
first thing Frank Harris asked was if I had seen Bernard
Shaw. I told him all about my visit and Shaw's cathedral
sermon. Harris said that perhaps Shaw was getting religion
at last and might die a good Catholic. Harris was not as well-

poised as when I first met him. *Pearson's Magazine* was not
making money, and he was in debt and threatened with sus-
pension of publication. He said he desired to return to Europe
where he could find leisure to write, that he was sick and tired
of the editor business. He did not congratulate me on my new
job. The incident between him and *The Liberator* was still a
rancor in his mind. He wasn't a man who forgot hurts easily.

But he was pleased that I had put over the publication of a
book of poems in London. "It's a hard, mean city for any
kind of genius, he said, and that's an achievement for you."
He looked through the little brown-covered book. Then he
ran his finger down the table of contents closely scrutinizing.
I noticed his aggressive brow become heavier and scowling.
Suddenly he roared: "Where is the poem?"

"Which one?" I asked with a bland countenance, as if I
didn't know which he meant.

"You know which," he growled. "That fighting poem,
'If We Must Die.' Why isn't it printed here?"

I was ashamed. My face was scorched with fire. I stam-
mered: "I was advised to keep it out."

"You are a bloody traitor to your race, sir!" Frank Harris
shouted. "A damned traitor to your own integrity. That's
what the English and civilization have done to your people.
Emasculated them. Deprived them of their guts. Better you
were a head-hunting, blood-drinking cannibal of the jungle
than a civilized coward. You were bolder in America. The
English make obscene sycophants of their subject peoples. I
am Irish and I know. But we Irish have guts the English
cannot rip out of us. I'm ashamed of you, sir. It's a good thing
you got out of England. It is no place for a genius to live."

Frank Harris's words cut like a whip into my hide, and I
was glad to get out of his uncomfortable presence. Yet I felt

relieved after his castigation. The excision of the poem had been like a nerve cut out of me, leaving a wound which would not heal. And it hurt more every time I saw the damned book of verse. I resolved to plug hard for the publication of an American edition, which would include the omitted poem. "A traitor," Frank Harris had said, "a traitor to my race." But I felt worse for being a traitor to myself. For if a man is not faithful to his own individuality, he cannot be loyal to anything.

I soon became acquainted and friendly with *The Liberator* collaborators and sympathizers: Art Young, Boardman Robinson, Stuart Davis, John Barber, Adolph Dehn, Hugo Gellert, Ivan Opfer, Maurice Becker, Maurice Sterne, Arturo Giovanitti, Roger Baldwin, Louis Untermeyer, Mary Heaton Vorse, Lydia Gibson, Cornelia Barnes, Genevieve Taggard. William Gropper and Michael Gold became contributing editors at the same time that I joined *The Liberator* staff.

* * * * * * * * * *

The Liberator was frequently honored by visitors, many of them women, some beautiful and some strange. Of course they all wanted to see the handsome editor-in-chief. But Max Eastman was seldom in the office. He usually came in when it was nearly time to make up the magazine for publication. Then he worked quickly with devilish energy, sifting and scrapping material, titling articles and pictures. And the magazine was always out on time. Eastman had a lazy manner and there was a general idea (which apparently pleased him) that he was more of a playboy than a worker. But he was really a very hard and meticulous worker. I know of no other writer who works so sternly and carefully, rewriting, chiseling and polishing his phrases.

There were amusing incidents. One day a wild blonde of

unkempt frizzly hair dashed into the office and declared she had an urgent desire to see Max Eastman. We said he wasn't there, but she wouldn't believe us. So she went hunting all over the building, upstairs and downstairs, opening every door and peeping behind them and even into drawers. Finally she invaded the washroom, and when she left she locked it up and carried away the key.

But we had more composed visitors, also. Crystal Eastman brought Clare Sheridan. They were a striking pair to look at. Two strapping representatives of the best of the American and English types. They were interesting to contrast, the one embodying in her personality that daring freedom of thought and action—all that was fundamentally fine, noble and genuine in American democracy; the other a symbol of British aristocracy, a little confused by the surging movement of new social forces, but sincerely trying to understand.

In 1920 Clare Sheridan had accompanied Kamenev, the Bolshevik emissary in London, to Russia. She was the first woman of the British aristocracy to visit that country after the revolution. She had published a series of articles from her diary in the London *Times*. I had read them eagerly, for they were like a romance, while I was in London. Her incisive etchings of the Bolshevik leaders stuck in my memory. She had summed up Zinoviev, "fussy and impatient, with the mouth of a petulant woman," and when I went to Russia and met Zinoviev, each time I heard him prate in his unpleasant falsetto voice, I thought of Clare Sheridan's deft drawing of him.

Clare Sheridan had a handsome, intelligent and arrogant face. She was curious about *The Liberator,* its staff and contributors and free radical bohemian atmosphere. I asked her why a similar magazine could not exist in London with the

same free and easy intercourse between people of different classes and races. She said that social conditions and traditions in London were so different. And I knew from experience that she was telling me the truth. (She did not know that I had recently returned from London.)

She said that she would like to sculpt my head. But she never got around to it. Instead she wrote in her *American Diary* (after seeing *The Emperor Jones* with Crystal Eastman, Ernestine Evans, *et al.*): "I see the Negro in a new light. He used to be rather repulsive to me, but obviously he is human, has been very badly treated. . . . It must be humiliating to an educated colored man that he may not walk down the street with a white woman, nor dine in a restaurant with her. . . . I wonder about the psychology of the colored man, like the poet, McKay, who came to see me a few days ago and who is as delightful to talk to as any man one could meet. . . ."

Unexpectedly, Elinor Wylie was ushered into my little office one afternoon. She was accompanied by her sister and I rushed out to find an extra chair. Mrs. Wylie's eyes were flaming and I was so startled by her enigmatic beauty and Park Avenue elegance that I was dumb with confusion. She tried to make me feel easy, but I was as nervous as a wild cat caught indoors. I knew very little about her, except that she had published a little book of verse. I had read some of her pieces in *The New Republic,* and I remembered one memorable thing called, "The Lion and the Lamb," which was infused with a Blakelike imagery and beauty. She promised to send *The Liberator* a poem, but I don't think she ever did. Perhaps I did not show enough enthusiasm. I had no idea, at the time, that I was speaking to one of the few great women poets of the English language.

I always felt that the real object of these visits was Max Eastman, who was an ikon for the radical women. And so I acted like a black page, listening a lot and saying very little, but gratefully acknowledging all the gifts of gracious words that were offered to *The Liberator*.

Lewis Gannett called one day and invited me to lunch with Carl Van Doren, somewhere down around Park Row. Mr. Van Doren was then one of the editors of *The Nation*. He did most of the talking. He was very practical-minded in the pleasant canny Yankee way. For one who was a college professor he was remarkably well informed about the different phases of American social and industrial life. He said that the Italians and the Negroes were interesting to him as the two most special groups of workers in America. He considered the Italians a hardier and a harder-working group. His idea was thought-provoking and I was struck by the comparison he made between Italians and Negroes. It was fresh and novel, especially as Negroes themselves generally compare their status with that of the Jews. I thought myself that the comparison frequently made between the Jewish group and the Negro group was mainly psychological, while the point that Mr. Van Doren scored was sociological.

One day I had sorted and read until my brain was fagged and I hadn't found a single startling line. Then I picked up a thin sheaf and discovered some verses which stimulated me like an elixir. They were mostly sonnets, a little modernistic, without capitals, a little voluptuous, yet restrained and strangely precise, with a flavor of Latin eroticism and decadence. They were signed, E. E. Cummings.

I didn't know anything about the author, but I wrote a note asking him to come in and see Max Eastman. He dropped by one day, a stripling in a fawn-colored suit and resembling

a fawn, with his head cocked up to one side and a smile which looked like a curiously-wrought icicle.

Max Eastman was not in. He had not been in the office since I had written to the author, nor had he seen the poems. So I talked to Cummings and dared to argue with him about a couple of the sonnets. I was particularly excited by one called *"Maison."* It created something like an exquisite miniature palace of Chinese porcelain. The palace was so real that it rose up out of the page, but the author had also placed in it a little egg so rotten that you could smell it. I argued about that egg, but Cummings said that that was exactly what he wanted to do. I understood and apologized.

I wanted to make a spread of the verses in *The Liberator,* but Robert Minor was substituting as editor-in-chief that month and he had a violent reaction against the verses. I remember Minor's saying to me that if I liked such poems I was more of a decadent than a social revolutionist. I protested that the verses were poetry, and that in any work of art my natural reaction was more for its intrinsic beauty than for its social significance. I said that my social sentiments were strong, definite and radical, but that I kept them separate from my esthetic emotions, for the two were different and should not be mixed up.

Robert Minor said he could not visualize me as a real Negro. He thought of a Negro as of a rugged tree in the forest. Perhaps Minor had had Negro playmates like that in Texas and he could not imagine any other type. Minor himself always gave me the impression of a powerful creature of the jungle. His personality seemed to exude a kind of blind elemental brute force. He appeared to me like a reincarnation of Richard Cœur de Lion—a warrior who had found the revolutionary road to heaven and who would annihilate even the

glorious ineffectual angels if he found them drifted and stranded on his warpath.

I kept the Cummings verses for the following month when the editorship was resumed by Max Eastman. Eastman recognized their distinctive quality, but not in my enthusiastic way. So we didn't make a special spread of them as we often did with unusual verse. We printed a couple or more—but not very prominently.

The delirious verses of the Baroness von Freytag Loringhoven titillated me even as did her crazy personality. She was a constant visitor to see me, always gaudily accoutred in rainbow raiment, festooned with barbaric beads and spangles and bangles, and toting along her inevitable poodle in gilded harness. She had such a precious way of petting the poodle with a slap and ejaculating, "Hund-bitch!"

She was a model, and in marvelous German-English she said: *"Mein* features not same, schön, but *mein* back, *gut.* The artists love to paint it." The Baroness's back was indeed a natural work of art.

One day she entertained me by reading, in her masculine throaty voice, a poem she called *"Dornröschen":*

> *Stab for me*
> *lip set intensity.*
> *press to my bower—*
> *my nook, my core*
> *I wait for thee*
> *numb breathlessly.*
> *messir*
> *since yore. . . .*

I liked the thing so much, I appropriated it for *The Liberator.* Down in Greenwich Village they made a joke of the

Baroness, even the radicals. Some did not believe that she was an authentic baroness, listed in Gotha. As if that really mattered, when she acted the part so magnificently. Yet she was really titled, although she was a working woman. The ultra-moderns of the Village used to mock at the Baroness's painted finger nails. Today all American women are wearing painted finger nails.

How shockingly sad it was to meet Frau Freytag a few years later in the Kurfurstendamm in Berlin, a shabby wretched female selling newspapers, stripped of all the rococo richness of her clothes, her speech, her personality. She went from Berlin to Paris and death. Poor brave Baroness von Freytag Loringhoven.

* * * * * * * * * *

Our bookkeeper was an Englishman named Mylius. He was an equivocal type, soft and sinister, with a deceptive deferential manner. Dickens would have found him admirable for the creation of Uriah Heep. Mylius had won international notoriety as the man who was prosecuted for libeling His Majesty, King George of England. He had circulated a story that George V had contracted a morganatic marriage. Mylius liked to come into my office to talk. He was a money-fool. He presented me with a copy of a worthless book he had written called, *The Socialization of Money*. He seemed to think that money was entirely the invention of governments and bankers, an evil thing having no relationship to other commodities. I got it out of Mylius that his father, who was I believe a Greek Jew, was a banker and had left him a fortune when he died. And he had gambled away every penny of that fortune at Monte Carlo.

One day Mylius pushed into my office with a fake fright-

ened expression. He said there was a criminal-looking man outside who wanted to see me. I went downstairs and found Michael. I brought him up to my office. Michael had read in a newspaper that I was working on *The Liberator* and he had looked up the address and called to see me. In two years Michael had changed almost beyond recognition. The college-lad veneer had vanished. A nasty scar had spoiled his right eyebrow and his face was prematurely old, with lines like welts. After I went abroad he had landed a job as a street-car conductor. He had worked a few months and becoming disgusted, he drifted back to petty banditry. He was copped and jailed in a local prison, where he made criminal friends more expert than himself. Now he was in with a gang.

We chatted reminiscently. I related my radical adventures in London. I exhibited what I had accomplished by way of literature on the side. And I presented him with a signed copy of the book. Michael looked with admiration at the frontispiece (a photograph of myself) and at me.

"Jeez," he said, "you did do it, all right. You're a bird."

"What species?" I asked.

Michael laughed. "What are you wanting me to say? You are an eagle?"

"Oh no," I said, "that's a white folk's bird. Blackbird will do."

"There you're starting again," Michael said. "You know I haven't been in Harlem since you left."

I said that I was living in the same place and invited him to come up. I told him that my landlord, Mr. Morris, had asked after him.

Michael shook his head. "It ain't like before. I'm in with a rotten gang. We'se all suspicious of one another. If I came

around to see you, they'd soon get wise to it and want to mess around there, thinking there was something to make."

I said I wouldn't care, since there was nothing. And knowing them might be another exciting diversion, I thought.

Michael's face became ugly. "No, you're better off without knowing that gang. They couldn't understand you like me. They're just no good. They're worse than me. And lookit that guy what send you out to me. He was looking at me as if I wasn't human. I know that my mug ain't no angel's since that wop bastard gashed me, but all the same I ain't no gorilla."

"Couldn't you find another job and start working again?" I asked.

He shook his head. "It's too late now. I can't get away or escape. I'm not like you. Perhaps if I had had some talent, like you."

I knew that he was doomed. I had a pocket edition of Francis Thompson's "Hound of Heaven" on my desk. It was one of my favorite things. Michael looked at it. I said that Thompson was an Irish poet.

"I read a lot, whenever I get a chance," he said, "newspapers and magazines."

I read a little from "The Hound":

I fled Him, down the nights and down the days;
I fled Him, down the arches of the years;
I fled Him, down the labyrinthine ways
Of my own mind; and in the mist of tears
I hid from Him, and under running laughter.
Up vistaed hopes I sped;
And shot, precipitated,
Adown Titanic glooms of chasmèd fears,
From those strong Feet that followed, followed after. . . .

In the rash lustihead of my young powers,
I shook the pillaring hours
And pulled my life upon me; grimed with smears,
I stand amid the dust o' the moulded years—
My mangled youth lies dead beneath the heap. . . .

I told Michael something of the writer's way of living. And I gave him the book.

"Can you spare it?" he asked. I said I was always "sparing" books, dropping them everywhere, because they were too heavy to tote.

"I guess when the gang sees me with these here," said Michael, "they'll be thinking that I'm turning queer."

As I opened the door to let him out, I saw Mylius acting as if he were just passing by on the way upstairs to his office. He had been listening at the keyhole. Michael went on out. Mylius said, "I was scared he was going to assassinate you in there."

"He isn't a criminal," I said. "He's just an old college friend down on his luck." Mylius was interested and wanted to talk some more, but I was seized by such a loathsome feeling for the big white reptile, I turned my back and shut my door.

I never saw Michael again. Just before I left for Europe the following year I received a pathetic scrawl informing me that he had been caught in a hold-up and sentenced to prison for nine years. . . .

THE HARLEM INTELLIGENTSIA

I had departed from America just after achieving some notoriety as a poet, and before I had become acquainted with the Negro intellectuals. When I got the job of assistant editor on *The Liberator*, Hubert Harrison, the Harlem street-

corner lecturer and agitator, came down to Fourteenth Street to offer his congratulations.

I introduced him to Robert Minor, who was interested in the activities of the advanced Negro radicals. Harrison suggested a little meeting that would include the rest of the black Reds. It was arranged to take place at the *Liberator* office, and besides Harrison there were Grace Campbell, one of the pioneer Negro members of the Socialist Party; Richard Moore and W. A. Domingo, who edited *The Emancipator,* a radical Harlem weekly; Cyril Briggs, the founder of the African Blood Brotherhood and editor of the monthy magazine, *The Crusader;* Mr. Fanning, who owned the only Negro cigar store in Harlem; and one Otto Huiswood, who hailed from Curaçao, the birthplace of Daniel Deleon. Perhaps there were others whom I don't remember. The real object of the meeting, I think, was to discuss the possibility of making the Garvey Back-to-Africa Movement (officially called the Universal Negro Improvement Association) more class-conscious.

I remember that just as we ended our discussion, Max Eastman unexpectedly popped in to see how the *Liberator* office was running. Jokingly he said: "Ah, you conspirators," and everybody laughed except Robert Minor. Minor had recently renounced his anarchism for Communism and he was as austere-looking as a gaunt Spanish priest.

It was interesting to meet also some of the more conservative Negro leaders, such as the officials of the National Association for the Advancement of Colored People. Dr. W. E. B. DuBois, the author of *The Souls of Black Folk* and editor of *The Crisis,* had me to luncheon at the Civic Club. Of Dr. DuBois I knew nothing until I came to America. It was a white woman, my English teacher at the Kansas State

College, who mentioned *The Souls of Black Folk* to me,
I think. I found it in the public library in Topeka. The book
shook me like an earthquake. Dr DuBois stands on a pedestal
illuminated in my mind. And the light that shines there comes
from my first reading of *The Souls of Black Folk* and also
from the *Crisis* editorial, "Returning Soldiers," which he pub-
lished when he reurned from Europe in the spring of 1919.

Yet meeting DuBois was something of a personal disap-
pointment. He seemed possessed of a cold, acid hauteur of
spirit, which is not lessened even when he vouchsafes a smile.
Negroes say that Dr. DuBois is naturally unfriendly and self-
ish. I did not feel any magnetism in his personality. But I
do in his writings, which is more important. DuBois is a
great passionate polemic, and America should honor and
exalt him even if it disagrees with his views. For his passion
is genuine, and contemporary polemics is so destitute of the
pure flame of passion that the nation should be proud of a man
who has made of it a great art.

Walter White, the present secretary of the National Asso-
ciation for the Advancement of Colored People, possessed a
charming personality, ingratiating as a Y. M. C. A. secretary.
One felt a strange, even comic, feeling at the sound of his
name and the sight of his extremely white complexion while
hearing him described as a Negro.

The White stories of passing white among the crackers
were delightful. To me the most delectable was one illustra-
ting the finger-nail theory of telling a near-white from a pure-
white. White was traveling on a train on his way to inves-
tigate a lynching in the South. The cracker said, "There are
many yaller niggers who look white, but I can tell them
every time."

"Can you really?" Walter White asked.

"Oh sure, just by looking at their finger nails." And taking White's hand, he said, "Now if you had nigger blood, it would show here on your half-moons."

That story excited me by its paradox as much as had the name and complexion of Walter White. It seemed altogether fantastic that whites in the South should call him a "nigger" and whites in the North, a Negro. It violates my feeling of words as pictures conveying color and meaning. For whenever I am in Walter White's company my eyes compose him and my emotions respond exactly as they do in the case of any friendly so-called "white" man. When a white person speaks of Walter White as a Negro, as if that made him a being physically different from a white, I get a weird and impish feeling of the unreality of phenomena. And when a colored person refers to Walter White as colored, in a tone that implies him to be physically different from and inferior to the "pure" white person, I feel that life is sublimely funny. For to me a type like Walter White is Negroid simply because he closely identifies himself with the Negro group— just as a Teuton becomes a Moslem if he embraces Islam. White is whiter than many Europeans—even biologically. I cannot see the difference in the way that most of the whites and most of the blacks seem to see it. Perhaps what is reality for them is fantasy for me.

James Weldon Johnson, song writer, poet, journalist, diplomat and professor, was my favorite among the N. A. A. C. P. officials. I liked his poise, suavity, diplomacy and gentlemanliness. His career reveals surprises of achievement and reads like a success story. When a Negro makes an honorable fight for a decent living and succeeds, I think all Negroes should feel proud. Perhaps a day will come when, under a different social set-up, competent Negroes will be summoned

like other Americans to serve their country in diplomatic posts. When that time comes Negroes may proudly cite as a precedent the record of James Weldon Johnson, Negro pioneer of the American diplomatic service, who performed his duties conscientiously and efficiently under unusually difficult conditions.

Jessie Fauset was assistant editor of *The Crisis* when I met her. She very generously assisted at the Harlem evening of one of our *Liberator* prayer meetings and was the one fine feature of a bad show. She was prim, pretty and well-dressed, and talked fluently and intelligently. All the radicals liked her, although in her social viewpoint she was away over on the other side of the fence. She belonged to that closed decorous circle of Negro society, which consists of persons who live proudly like the better class of conventional whites, except that they do so on much less money. To give a concrete idea of their status one might compare them to the expropriated and defeated Russian intelligentsia in exile.

Miss Fauset has written many novels about the people in her circle. Some white and some black critics consider these people not interesting enough to write about. I think all people are interesting to write about. It depends on the writer's ability to bring them out alive. Could there be a more commendable prescription for the souls of colored Americans than the bitter black imitation of white life? Not a Fannie Hurst syrup-and-pancake hash, but the real meat.

But Miss Fauset is prim and dainty as a primrose, and her novels are quite as fastidious and precious. Primroses are pretty. I remember the primroses where I lived in Morocco, that lovely melancholy land of autumn and summer and mysterious veiled brown women. When the primroses spread themselves across the barren hillsides before the sudden sum-

mer blazed over the hot land, I often thought of Jessie Fauset
and her novels.

What Mary White Ovington, the godmother of the
N. A. A. C. P., thought of me was more piquant to me per-
haps than to herself. Her personality radiated a quiet silver
shaft of white charm which is lovely when it's real. She was
gracious, almost sweet, when she dropped in on *The Liberator*.
But as I listened to her talking in a gentle subjective way I
realized that she was emphatic as a seal and possessed of a
resolute will.

She told me about her reaction to Booker T. Washington,
the officially recognized national leader of the Negroes. Miss
Ovington had visited Tuskegee informally. Booker T. Wash-
ington had disregarded her, apparently under the impression
that she was a poor-white social worker. When he was in-
formed that she originated from a family of high-ups, he be-
came obsequious to her. But she responded coldly. By her
austere abolitionist standard she had already taken the meas-
ure of the universally popular and idolized Negroid leader.

I repeated the story to my friend Hubert Harrison. He ex-
ploded in his large sugary black African way, which sounded
like the rustling of dry bamboo leaves agitated by the wind.
Hubert Harrison had himself criticized the Negro policy of
Booker T. Washington in powerful volcanic English, and sub-
sequently, by some mysterious grapevine chicanery, he had
lost his little government job. He joined the Socialist Party.
He left it. And finally came to the conculsion that out of the
purgatory of their own social confusion, Negroes would
sooner or later have to develop their own leaders, independent
of white control.

Harrison had a personal resentment against the N. A. A.
C. P., and nick-named it the "National Association for the

Advancement of Certain People." His sense of humor was ebony hard, and he remarked that it was exciting to think that the N. A. A. C. P. was the progeny of black snobbery and white pride, and had developed into a great organization, with DuBois like a wasp in Booker Washington's hide until the day of his death.

And now that I was legging limpingly along with the intellectual gang, Harlem for me did not hold quite the same thrill and glamor as before. Where formerly in saloons and cabarets and along the streets I received impressions like arrows piercing my nerves and distilled poetry from them, now I was often pointed out as an author. I lost the rare feeling of a vagabond feeding upon secret music singing in me.

I was invited to meetings in Harlem. I had to sit on a platform and pretend to enjoy being introduced and praised. I had to respond pleasantly. Hubert Harrison said that I owed it to my race. Standing up like an actor to repeat my poems and kindle them with second-hand emotions. For it was not so easy to light up within me again the spontaneous flames of original creative efforts for expectant audiences. Poets and novelists should let good actors perform for them.

Once I was invited to the Harlem Eclectic Club by its president, William Service Bell. Mr. Bell was a cultivated artistic New England Negro, who personally was very nice. He was precious as a jewel. The Eclectic Club turned out in rich array to hear me: ladies and gentlemen in *tenue de rigueur*. I had no dress suit to wear, and so, a little nervous, I stood on the platform and humbly said my pieces.

What the Eclectics thought of my poems I never heard. But what they thought of me I did. They were affronted that I did not put on a dress suit to appear before them. They

thought I intended to insult their elegance because I was a radical.

The idea that I am an enemy of polite Negro society is fixed in the mind of the Negro élite. But the idea is wrong. I have never had the slightest desire to insult Harlem society or Negro society anywhere, because I happen not to be of it. But ever since I had to tog myself out in a dress suit every evening when I worked as a butler, I have abhorred that damnable uniform. God only knows why it was invented. My esthetic sense must be pretty bad, for I can find no beauty in it, either for white or colored persons. I admire women in bright evening clothes. But men! Blacks in stiff-starched white façades and black uniforms like a flock of crows, imagining they are elegant—oh no!

X

A Brown Dove Cooing

•

*T*HE LIBERATOR staff had an extra extraordinary
moment one afternoon when Max Eastman walked in
with Charlie Chaplin. The great little man gave his hand to
all of us and touched our hearts. And after looking over the
place he perched like a Puck atop of a desk.

Chaplin informed me that he liked some of my poems
which had appeared in *The Liberator*. I was glad, and gave
him a copy of *Spring in New Hampshire*. In his book, *My
Trip Abroad*, he put this one, "The Tropics in New York":

> *Bananas ripe and green and ginger-root,*
> *Cocoa in pods and alligator pears,*
> *And tangerines and mangoes and grape fruit,*
> *Fit for the highest prize at country fairs.*
>
> *Set in the window, bringing memories*
> *Of fruit-trees laden by low-singing rills.*
> *And dewy dawns and mystical blue skies*
> *In benediction over nun-like hills.*
>
> *My eyes grew dim, and I could no more gaze;*
> *A wave of longing through my body swept,*
> *And, hungry for the old, familiar ways,*
> *I turned aside and bowed my head and wept.*

Chaplin came up to Croton one evening of a week-end
when I was there with Max Eastman, Crystal Eastman,

Eugen Boissevain, Boardman Robinson, and the danseuse, Tamiris. He astounded us with some marvels of comedian tricks. They were swift and sure like the sharp lines of Goya. Not a suggestion in them of that clowning which he uses so lavishly on the screen. With an acute gesture of hands and feet he performed a miracle. With one flick of his hair and a twist to his face, his features were entirely translated into another person's. Deftly manipulating a coat, he transformed his dapper little self until he looked like a weirdly tall undertaker hanging against the wall. The only thing of Charlie Chaplin on the screen which suggested anything like his magnificent spontaneous personal appearance that night is the incomparable "Shoulder Arms." Pictures like "The Kid" and "The Gold Rush" are great, but elaborate and lavish. "Shoulder Arms" is a feat of rapid economical design, as startling as the best of Goya's grotesqueries.

Another evening when I was at Croton, Chaplin drove up unexpectedly. He was accompanied by Neysa McMein, an exotic person and a fashionable artist. She possessed an archaic beauty and poise which were strangely arresting in those days when women were cultivating a more athletic style in beauty. Miss McMein was very popular among the smart set of New York's literati. She was a southerner, and she was shocked cold when she realized that I was a guest and not a servant in Max Eastman's house. I must record to her honor that she did not precipitate a crisis. She merely acted like a perfect *grande dame* who was not amused. But our party was frost-bitten. It was a relief when she departed.

Some time after, Max Eastman seized an opportunity to read some of my poems to Miss McMein, without disclosing my identity. She expressed great appreciation and a desire to buy a book of them. Max Eastman then revealed that I was

the author. She was surprised. But she did not like the verses any less or the idea of my equal association with whites any more.

However, I did assist at one unforgettable and uninhibited little-brown-jug-from-down-home party with Charlie Chaplin. It was in Greenwich Village at the house of Eugen Boissevain. It was a small gathering with Max and Crystal Eastman, Dudley Field Malone and Doris Stevens, a leader of the Woman's Movement, William Gropper, myself and a couple of others. Charlie Chaplin had met Hubert Harrison at my office and admired his black Socratic head and its precise encyclopedic knowledge. He had expressed a desire that Harrison should be included in the party.

I thought it was a happy idea to have another Negro. Hubert Harrison asked if I was thinking of taking a colored girl. I said I didn't think I would, for the only girls in Harlem I knew intimately were Sanina's maids of honor and I was afraid they wouldn't fit in. Harrison agreed and I suggested that, as he was acquainted with the élite of Harlem, he might bring down a beautiful brown. Harrison promised to do that.

The party was warming up with Jamaica rum cocktails and snatches of radical gossip when Harrison arrived. Clinging coyly to his arm was an old brown girl who was neither big nor little, short nor fat, or anything. Nothing about her was exciting, voice, or clothes, or style—simply nothing. I was amazed, and wondered why of all Harlem Harrison had chosen her. If she were his wife or his mistress I could understand, but the lady herself quickly announced that she was nothing to Harrison at all. And so she was introduced round the room. Harrison never explained why he brought that kind of woman. Erotically he was very indiscriminate and I

suppose that descending from the soap-box, he remembered the party and invited the first pick-up he met to accompany him.

At this intimate little party there was no white shadow and no black apprehension, no complexes arising out of conscious superiority or circumstantial inferiority. We were all in a spirit of happy relaxation, like children playing merrily together and, absorbed in the games, forgetful of themselves. Harrison was a little stiff at first with his starched bosom—his was the only dress suit in the group—but his simple Sudanese soul soon came up laughing in spite of it.

Suddenly I was excited. I saw Charlie Chaplin hopping from one end of the room to the other, and I thought he was about to improvise some treat again, as he had up at Croton. But no, it wasn't that. He was trying to escape. Harrison's brown dove was fluttering in pursuit of Chaplin and filling the room with a crescendo of coo-coo-cooing, just as if she were down home in the bushes. She had at last discovered that the Mr. Chaplin to whom she had been introduced was indeed the authentic Charlie Chaplin, lord of the cinema. And importunately she was demanding his autograph, "so I kin tell it in Harlem about my adventure."

But Chaplin was determined not to turn our informal little soirée into an autograph evening. And oh, it was delicious to see the king of the comics skipping hither and thither and declaring he had no pen. The brownie flew into the anteroom and returned triumphant with her vanity case containing card and pencil and announced that she always kept herself provided with the right things for her customers.

I diverted her attention from her quarry by pouring her a tumbler of Jamaica rum, and we started a game. Soon the

little brown jug was full and running over and chasing every-body. She said that she was aware that I was the contact man between Harlem and the Village. And I felt so flattered to be taken as a sweetman that I tried to imitate the famous Harlem strut. To Crystal Eastman, who was acting as hostess and who was as usual distinctively dressed, the brown jug confided that she would like to exchange visitors between Harlem and Greenwich Village. And soon she was passing out her cards. But I noticed that the address was crossed out. She explained that she was rooming temporarily, but said she would let us have her new address as soon as she was fixed up. Her last place had recently been raided by the police!

Well, that was one evening, a surprise party that nobody had dreamed about, something really different and delightful. Parties are so often tediously the same thing: swilling and scrappy unsatisfactory smart talk. I had a good time, which stirred me to thoughts of Philadelphia when I was railroading. I felt sure that none of the whites there had ever before had the pleasure of a brown madam at a bohemian party.

When I told the story of the party to some of the élite of Harlem, I was simply dumbfounded by their violent reaction. They insisted that the Negro race had been betrayed, because a little brown jug from Harlem had provided a little innocent diversion in Greenwich Village.

I didn't know what to say. So I hummed an old delicious ditty of my pre-blasé period: "Little brown jug, don't I love you. . . ."

XI

A Look at H. G. Wells

•

WHEN H. G. Wells came over here to the Naval Conference as a star reporter for the liberal New York *World* and the neo-Tory London *Daily Mail*, his restless curiosity urged him to find time from his preoccupation with high international politics to bestow a little attention on *The Liberator*. Max Eastman had him to dinner at his home in Greenwich Village, and later there was an informal reception for the *Liberator* staff and collaborators.

I had stumbled upon Wells at about the same time that I began reading Bernard Shaw. While I admired Shaw for the hammering logic of his prefaces and his sparkling wit, I liked in H. G. Wells those qualities I like in Dickens—the sentimental serving of his characters with a vast sauce of provincial humor.

During my residence in London I had followed Wells's popular *Outline of History* as it appeared in instalments, and upon returning to America I read in the published volume the instalments that I had missed.

If it is worth recording, I may say here that I took a violent prejudice again Mr. Wells's *History*. I felt something flippant in the style and I did not like Mr. Wells's attitude toward colored people in general and Africa and Negroes in particular. In the League of Free Nations book he put out in 1918 he said: "Africa is the great source upon which our modern comforts and conveniences depend. . . . The most obvious danger of Africa is the militarization of the black. . . . The

Negro makes a good soldier, he is hardy, he stands the sea and he stands the cold. . . ."

I suppose the average white reader will exclaim: "And what's wrong with that? It is wise and sane and humanitarian." But he should remember that I am Negro and think that the greatest danger of Africa is not the militarization of the black, but the ruthless exploitation of the African by the European. There is also something to be said in favor of native comforts and conveniences. Before the arrival of the European with gunpowder the African was accustomed to protecting his rights with arrow and spear. Now, against modern civilization, he must needs learn the use of modern methods and weapons. The liberal apologists of the European grip on Africa may be very unctious and sentimental about native rights. But the conditions indicate that if the natives must survive, they must themselves learn and practice the art of self-protection.

Mr. Wells always seems to be shouting about his unusually scientific mind. Yet I must confess that I was shocked by the plan of his large tome outlining world history. Because it appears there as if Africa and Africans have not been of enormous importance in world history. Mr. Wells mentions Africa in his language-formation section and leaves Africa there as if nothing more developed. One learns more of Africa from earlier historians than Mr. Wells, who did not know so much about science. Herodotus gives us some remarkable information that he acquired by traveling four hundred years before Jesus Christ. And Ptolemy, the Egyptian geographer, has rendered a remarkable description of Central Africa in the second century after Christ, although I learned as a school boy that it was discovered by David Livingstone. And as late as the fifteenth century, in the high tide

of the European renaissance, Leo the African adventured below the Sahara to give the world historical facts about the Negro nations.

Mr. Wells gives a large outline of the nations of Europe and a not-so-large one of the nations of Asia. He makes no mention of the great Negro nations of Western Africa and the Western Sudan before and after the Moslem invasion; of the Negroid nations of Songhoy and Ghana, Fezzan and Timbuctu, Yoruba and Benin, Ashanti and Dahomey, which were arrested in their growth and finally annihilated by the slave traffic and European imperialism, nor of the Senegalese who played a dominant part in the history of Morocco and the conquest of Spain.

Yes indeed, Africa and its blacks are of foundational importance in the history of the world, ancient and modern, and in the creating of European civilization. However, Mr. Wells's ignoring of the African civilizations in his *Outline of History* may be deliberate. In his marvelous *World of William Clissold,* he speculates whether the Negro could participate in "common citizenship in a world republic." Says he: "The Negro is the hardest case . . . yet . . . in the eighteenth century he was the backbone of the British navy. . . ." It is entirely too funny to think—seven years after the appallingly beastly modern white savagery of 1914-18—of Mr. Wells naïvely wondering whether the Negro is capable of becoming a civilized citizen of a world republic. He cites the precedent of Negroes in his British navy. He might have gone farther back and mentioned the Negro contingent in the army of Xerxes the Great (when Britons were savages) and about which Herodotus so glowingly writes.

But even if Mr. Wells likes to take a popular crack at history, he is none the less a first-rate novelist in the tradition

of Charles Dickens and I don't think he imagines himself a historian any more than I do, so one must be tolerant if his *Outline* has the earmarks of a glorified *Research Magnificent.*

Also, I did not like Mr. Wells's inspired articles on the Naval Conference. Paradoxically, I found myself sympathizing with the *Daily Mail,* which rebuked him for his offensive against Japan. Mr. Wells injected much violent prejudice into what should have been unbiased reporting. While Mr. Wells was outlining history, he might have reserved a little of his English sentimentality for Japan, from the knowledge that Japan might not have been a "yellow peril" today if the white powers hadn't broken open her door and forced their civilization upon her.

Wells's little *Liberator* reception was a question-time picnic for the *Liberator* collaborators—especially for the ladies, to whom Wells is exceptionally attractive. They asked him many questions about the war and the peace and the aftermath, about Russia and Europe, Japan and America and universal peace. Mr. Wells smilingly and slickly disposed of all problems to the satisfaction of all.

William Gropper, the artist, and I had concocted a plan to ask some impish questions. But everybody was very pleasant. It was a nice party. So we said nothing. I was standing, leaning against the mantelpiece, and Mr. Wells approached me in a sly way as if he desired a close-up scrutiny of me without my knowing it. I seized the opportunity to take a good quick look at Mr. Wells's eyes. Journalists always write about the jolly twinkle in Mr. Wells's eyes. I didn't like them. They made me think of a fox.

Some years later, after my trip to Russia and returning to France, I met Frank Harris in Nice. I was in the company of a brilliant American writer who was meeting Frank Harris

for the first time. We went to the Taverne Alsacienne for our drinks. Mr. Wells had recently published his William Clissold, which we had all read and were discussing.

Frank Harris said that what amazed him about H. G. Wells was the fact that the more he tried consciously to expand his writings on a world scale, the more provincial they became. I said, "The higher a monkey climbs, the more he shows his tail." Frank Harris roared. Then he said that perhaps Wells himself was not aware that his early novels of fantasy and sentiment were his most universal things.

The American writer, said that an English gentleman had remarked to him in London that Wells as a writer was a cockney. I didn't like the reference to class, especially as I had at least two very dear cockney friends. Harris said that Wells wasn't a cockney as a writer; that he was a fifth-form public school boy, the same as Kipling. I said I always thought of Kipling as the bugler of the British Empire, and that perhaps Wells was the sub-officer.

It was interesting, after another little lot of years had passed along, to read what Wells had to say about Harris in his *Experiment in Autobiography*. Wells's first encounter with Frank Harris interested me, especially because of the fact that my own meeting with Harris was one of the high spots of my life. But it appears as if Wells could not forgive Harris for once being a big and successful editor and discovering him a poor and unknown writer. He writes of Harris's roar receding with the years until it sounded something like a bark. But a lion may lose its voice through age and worry. Wells mentions one interesting fact, which must be one of the reasons why Harris was such a great editor. The first story he sent to Harris was excellent; the second, Wells admits, was bad. And Harris summoned and gave him a loud

talking to over the bad one. Yet when Harris became editor of another magazine, he remembered only the good story and wrote to Wells asking him to become one of his special contributors. And that gave Wells his real start. The point is that many editors wouldn't remember at all, or if they did, they would remember only that the second contribution was bad.

The American writer left us for Cannes, and Harris invited me to drink champagne with him. We went to the terrace of a café on the Promenade. Harris was not a steady free drinker as he was when I had known him seven years before in New York. His skilful hands trembled under the weight and accumulated cares of three-score years. His hair was dyed, and from the heat of the Midi and of alcohol some of the color had disssolved and mixed with the perspiration oozing from the deep lines of his face, which resembled an antique many-grooved panel with some of the paint peeled off.

Again Frank Harris talked reminiscently and interestingly as always of his acumen in perceiving greatness in Bernard Shaw and H. G. Wells and getting them to write for him when they were unknown. "But I am prouder of Shaw," he said. "Shaw is really a great genius. I don't always agree with what he says, and he went wrong about the War, but his 'Common Sense' was a great piece of polemic. Shaw has intellectual integrity. But I don't think Wells understands what intellectual integrity means. He is too full of vanity to be a serious intellect. He is a modernistic fiction writer who is discontented with his talent and wants to be a social philosopher. But he is impossible because he has never learned to think."

I said I thought it was a marvelous thing, something like second-sight, for a man to pick a genius by his first inadequate

efforts. Harris said that it took a genius like himself to discover geniuses, and that as an editor, he never played favorites. When he found good stuff he accepted it. But he didn't go back-slapping and printing bad verses by pretty women. He had had great temptations, but he never let his desires interfere with his intellectual judgment.

His manner was boastful but not offensively so, for I think Frank Harris had something to boast about. After all, he was Gaelic, and I preferred his manner to the hypocritical English way of boasting by studied understatement. And when he spoke of the enormous financial as well as artistic success of Shaw and Wells, there was no envy, but I could detect a shade of personal defeat and frustration in his voice.

Frank Harris's phrase, "intellectual integrity," kept agitating my thoughts like a large blue-bottle against a window pane. For a long long time I had carried something on my mind which I had hesitated to get off. But now, with the champagne working in my head and a warm and mellow feeling suffusing me, and with Frank Harris's features softening a little, I was emboldened to let go.

During my second year as assistant editor on *The Liberator* a woman called to see me one day bringing a little book of poems. She offered me ten dollars if I would review it in *The Liberator*. I said that *The Liberator* did not accept money for printing reviews, but if her poems seemed worth while, we would review them. She said that she had paid Frank Harris a thousand dollars to get the book printed, yet he hadn't even reviewed it in *Pearson's*. And afterward, she said, she had seen a literary agent who informed her that the cost of printing was about two hundred dollars. She thought that Frank Harris had swindled her. I did not review the verses, because to my mind, they were not worth while.

Also, I had heard stories of Frank Harris posing as an art connoisseur and palming off fake pictures as old masters, and of his getting material for his magazine from writers who thought they would be paid and then not paying them—tales of petty racketeering that were more funny than vicious. And so, being champagne drunk with Harris on a café terrace looking out on the calm blue Mediterranean, and feeling elastic and free, I, who admired the extraordinary ways of Frank Harris more than any other intellectual of my acquaintance, was interested to hear from himself the truth. I told him the story of that woman who had visited *The Liberator* and complained about him.

Frank Harris was wonderful to look at under the influence of the champagne, his lion-roaring, his face like a pirate's, yet with a sublime gleam of genuine kindliness in his eyes! What I said he did not affirm or deny. He just exploded with a mighty sermon about the artist and intellectual integrity. He said that the way of the artist was hard, for if he had a talent that appealed to popular imagination, everybody desired to use him—women and men, politicians, philanthropists, reformers, revolutionists, organizations, governments. Many artists won success by sacrificing their intellectual integrity. He himself had had large success. But whenever he felt the urge and the bounden duty to declare his opinion, he could not restrain himself, and so he had not remained successful. He had not been a puritan about life. Perhaps he had done things that Jesus would not have done. But he had not given his soul entirely to Mammon. Perhaps he had taken gifts from persons who thought they had been swindled and who were better off perhaps, if they were. But whatever he did he had reserved intact his intellectual integrity.

It was a great sermon and I felt that Frank Harris was

greater because of it. He was no hypocrite. He had no social pretensions, although he delighted in the company of smart and fashionable people. He was aware that there was plenty of dross inseparable from the gold of life, and he embraced the whole. Nobody could deny that he was indeed a follower of the Jesus who dominated his mind, that he sincerely believed in sin and redemption.

XII

"He Who Gets Slapped"

•

MY radical days on *The Liberator* were sometimes rosy with romance. Friends vied with friends in giving me invitations to their homes for parties and car rides and in offering tickets for plays and concerts. And even more. I remember I had a pressing debt of honor to settle. And one day a staunch friend of *The Liberator*, Elizabeth Sage Hare, handed me a check for five hundred dollars. She also invited me to tea at her house in Park Avenue or Fifth, I don't quite remember, but it was somewhere in the exclusive Faubourg Bourgeoisie.

Liberator friends introduced me to a few of those Greenwich Village tearooms and gin mills which were not crazy with colorphobia. And I reciprocated by inviting some of them up to the cabarets and cozy flats of Harlem. I did not invite my friends to the nice homes of the Negro élite, simply because I did not have an entrée.

Once Sanina condescended to entertain I think four friends —all men. When we arrived we found Sanina set in a circle of dark-brown girls, all cunningly arranged to heighten her quadroon queenliness. It was an exciting tableau, with a couple of sweetmen decorating the background.

But Sanina knew that I held a genteel position, sitting in an editor's chair among the whites downtown. (She was a faithful reader of *True Stories*.) So more than ever that night Sanina invested her unique position in Harlem with majesty. She was the antithesis of the Little Brown Jug of Charlie

Chaplin's party. She brought out a bottle of rum for the glory of Jamaica, and holding it like a scepter, she poured royally. I believe my friends were thinking that they also would have to pay royally. But the evening was Sanina's affair. She provided everything free and formally and with the air of a colored queen of respectability and virtue. Meanwhile her shrewd brown eyes seemed to be saying: "I'll show you white folks!" She was a different Sanina to me. Indeed, she was a creature of two races that night, with the blood of both warring in her veins.

Our editor-in-chief possessed none of the vulgar taste for cellar cabarets. Yet one evening Max Eastman said he would like to go on a cabaret party to Harlem. He was accompanied by another friend. We were welcomed at Barron's, where white people were always welcome and profitable business. Barron was a big man in Tammany politics. But I wanted particularly to go with my white friends to Ned's Place on Fifth Avenue. Ned and I had been friends when I had run a restaurant in Brooklyn some years previously. He was living in Brooklyn and often dropped in at my place to eat. Then my business went bankrupt and we lost sight of each other. A few years later, when I was waitering on the railroad, I discovered Ned operating a cabaret on Fifth Avenue in Harlem. I introduced all of my railroad friends to the place. Our crew used to rendezvous there and unload ourselves of our tips.

Ned's Place was a precious beehive of rare native talent and customers. A big black girl from Brooklyn with a mellow flutelike voice was the high feature. And there was an equivocal tantalizing boy-and-girl dancing team that I celebrated in *Home to Harlem*. When that boy and girl started to shake together they gave everybody the sweet shivers. The

place was small and Ned was his own master of ceremonies. With a few snappy flashes he could start everybody swaying together in a merry mood, like a revival leader warming up his crowd.

Ned's was one place of amusement in Harlem in which white people were not allowed. It was a fixed rule with him, and often he turned away white slummers. This wasn't entirely from pride-of-race feeling, but because of the white unwritten law which prohibits free social intercourse between colored and white. The big shots of the amusement business in Harlem, such as Barron, got by the law, for they were Tammany men. But even they were surprised and messed up sometimes by the vice squads. Ned said he preferred to run a "small and clean business" rather than to start treading in the quicksands of bribes.

However, I had become so familiar with Max Eastman, and his ideas and ways were so radically opposed to the general social set-up of white-without-black, that it was impossible to feel about him as a black does about a white alien. And I was such a good and regular customer of Ned's that I thought he would waive his rule for me. But I thought wrong that time.

We arrived at the door of the cabaret, from where Max Eastman could get a glimpse inside. He was highly excited by the scene, and eager to enter. But the doorman blocked the way. I beckoned to Ned, but his jovial black face turned ugly as an aard-vark's and he acted as if I was his worst enemy. He waved his fist in my face and roared: "Ride back! Ride back, or I'll sick mah bouncers on you-all!"

Max Eastman and his friend and I made a quick retreat. Eastman didn't mind. He said he was happy that there was one place in Harlem that had the guts to keep white people

out. There are no such places left today. Harlem is an all-white picnic ground and with no apparent gain to the blacks. The competition of white-owned cabarets has driven the colored out of business, and blacks are barred from the best of them in Harlem now.

* * * * * * * * * *

Always I was inflamed by the vision of New York as an eye-dazzling picture. Fascinated, I explored all points in my leisure moments, by day and by night. I rode all the ferries. I took long trips, from the Battery to the Bowery, from Broadway through Harlem to the Bronx. I liked to walk under the elevated tracks with the trains clashing and clanging overhead. There was excitement when the sudden roaring of the train abruptly blotted out conversation. Even the clothes suspended in the canyon tenements appeared endowed with a strange life of their own. In the stampeding hours of morning, noon, and evening, when the crowds assumed epic proportions, I was so exalted by their monster movement that I forgot that they were white.

I particularly remember some nocturnal wanderings with Adolf Dehn, the artist, spanning blocks upon blocks along the East River, and the vast space-filling feeling of the gigantic gas tanks. One loves in New York its baroque difference from the classic cities, the blind chaotic surging of bigness of expression. I remember how, when I worked in the West Eighties and spent my rest time loitering along Riverside Drive, the black giants of the New York Central, belching flame and smoke and dust along the façades of the fine palaces, created a picture like a caravan of modern pirates coming home in a rolling cloud of glory. The grim pioneer urge of the great pragmatic metropolis was a ferment in my feeling.

Often I was possessed with the desire to see New York as

when I first saw it from the boat—one solid massive mammoth mass of spiring steel and stone. And I remember one weekend when Eugen Boissevain offered a ride over to Jersey, whence one could see New York in that way. Max Eastman was with us. We drove up to a summit commanding a grand view of the city. We stood there a long time drinking in the glory of the pyramids. Afterward we drove aimlessly around the country. Finally we became hungry. We stopped at several hotels and restaurants, but none would serve the three of us together. At last one place offered to serve us in the kitchen. So, being hungry, all three of us went into the kitchen. The cooks were frying and roasting at the stove. Kitchen help were peeling potatoes, washing dishes, cleaning up garbage. We sat down at the servants' table, where a waiter served us.

It was one of the most miserable meals I ever ate. I felt not only my own humiliation, but more keenly the humiliation that my presence had forced upon my friends. The discomfort of the hot bustling kitchen, the uncongenial surroundings—their splendid gesture, but God! it was too much. I did not want friends to make such sacrifices for me. If I had to suffer in hell, I did not want to make others suffer there too. The physical and sensual pleasures of life are precious, rare, elusive. I have never desired to restrict the enjoyment of others. I am a pagan; I am not a Christian. I am not white steel and stone.

On many occasions when I was invited out by white friends I refused. Sometimes they resented my attitude. For I did not always choose to give the reason. I did not always like to intrude the fact of my being a black problem among whites. For, being born and reared in the atmosphere of white privilege, my friends were for the most part unconscious of black

barriers. In their happy ignorance they would lead one into the traps of insult. I think the persons who invented discrimination in public places to ostracize people of a different race or nation or color or religion are the direct descendants of medieval torturers. It is the most powerful instrument in the world that may be employed to prevent *rapprochement* and understanding between different groups of people. It is a cancer in the universal human body and poison to the individual soul. It saps the sentiment upon which friendliness and love are built. Ultimately it can destroy even the most devoted friendship. Only super-souls among the whites can maintain intimate association with colored people against the insults and insinuations of the general white public and even the colored public. Yet no white person, however sympathetic, can feel fully the corroding bitterness of color discrimination. Only the black victim can.

It was at this time that I wrote a series of sonnets expressing my bitterness, hate and love. Some of them were quoted out of their context to prove that I hate America. Mr. Lothrop Stoddard was the chief offender in his *The Rising Tide of Color*.

Here are the sonnets:

BAPTISM

Into the furnace let me go alone;
Stay you without in terror of the heat.
I will go naked in—for thus 'tis sweet—
Into the weird depths of the hottest zone.
I will not quiver in the frailest bone,
You will not note a flicker of defeat;
My heart shall tremble not its fate to meet,
My mouth give utterance to any moan.

The yawning oven spits forth fiery spears;
Red aspish tongues shout wordlessly my name.
Desire destroys, consumes my mortal fears,
Transforming me into a shape of flame.
I will come out, back to your world of tears,
A stronger soul within a finer frame.

THE WHITE CITY

I will not toy with it nor bend an inch.
Deep in the secret chambers of my heart
I brood upon my hate, and without flinch
I bear it nobly as I live my part.
My being would be a skeleton, a shell,
If this dark Passion that fills my every mood,
And makes my heaven in the white world's hell,
Did not forever feed me vital blood.
I see the mighty city through a mist—
The strident trains that speed the goaded mass,
The fortressed port through which the great ships pass,
The tides, the wharves, the dens I contemplate,
Are sweet like wanton loves because I hate.

THE WHITE HOUSE

Your door is shut against my tightened face,
And I am sharp as steel with discontent;
But I possess the courage and the grace
To bear my anger proudly and unbent.
The pavement slabs burn loose beneath my feet,
And passion rends my vitals as I pass,
A chafing savage down the decent street,
Where boldly shines your shuttered door of glass.

Oh I must search for wisdom every hour,
Deep in my wrathful bosom sore and raw,
And find in it the superhuman power
To hold me to the letter of your law!
Oh I must keep my heart inviolate,
Against the poison of your deadly hate!

AMERICA

Although she feeds me bread of bitterness,
And sinks into my throat her tiger's tooth,
Stealing my breath of life, I will confess
I love this cultured hell that tests my youth!
Her vigor flows like tides into my blood,
Giving me strength erect against her hate.
Her bigness sweeps my being like a flood.
Yet as a rebel fronts a king in state,
I stand within her walls with not a shred
Of terror, malice, not a word of jeer.
Darkly I gaze into the days ahead,
And see her might and granite wonders there,
Beneath the touch of Time's unerring hand,
Like priceless treasures sinking in the sand.

* * * * * * * * * *

The Liberator was gaining strength in its stride. We were always receiving praiseful letters and faithful promises of support. And we were preparing to celebrate our struggling through to a happy New Year. But suddenly the magazine was knocked off its feet. Our bookkeeper, Mylius, disappeared, and with him went the four thousand dollars left from *The Liberator's* government bonds. Unfortunately Mylius had been intrusted with the key to the bank's vault

in which they were kept. I always felt that I could have trusted my friend, Michael, the gangster, with my life, while I wouldn't have trusted Mylius with my shadow.

Max Eastman was discouraged. Always worried about the raising of money to run the magazine, he had never had the necessary leisure for his own creative writing. Most of the money he raised came from liberal *rentiers*. And now that the magazine editorially had taken a stand for Lenin and Trotsky and the Bolshevik revolution, it was less easy to obtain money from these *rentiers,* whose class had been ruthlessly expropriated in Russia.

Max Eastman wanted to relinquish the editorship and go abroad to live and write as he desired. We called a meeting of *Liberator* artists and writers and sympathizers. All of us wanted to carry on with the magazine. But money mocked at us. None of us had Eastman's combination of talents for the money-raising job. That had been no picnic for him, either, in spite of his fine platform personality and attractive presence.

The only person at that meeting who felt that *The Liberator* could carry on without Max Eastman was Michael Gold. Gold was always critical about the way in which the magazine was run. He thought that Eastman was too much of an esthete, too Baudelaire-like in his poetic expression. He maintained that *The Liberator* should express more of the punch and the raw stuff of life and labor. Max Eastman had made up his mind to get out from under. We decided that all the collaborators should endeavor to keep the magazine going as a collective enterprise. And upon Eastman's suggestion, Michael Gold and myself were appointed executive editors. There could have been no worse combination, because per-

sonally and intellectually and from the first time we met, Michael Gold and I were opposed to each other.

Michael Gold's idea of *The Liberator* was that it should become a popular proletarian magazine, printing doggerels from lumberjacks and stevedores and true revelations from chambermaids. I contended that while it was most excellent to get material out of the forgotten members of the working class, it should be good stuff that could compare with any other writing.

I knew that it was much easier to talk about real proletarians writing masterpieces than to find such masterpieces. As a peasant and proletarian aspirant to literary writing I had come in contact with reams of stuff, pathetic attempts of working people toward adequate literary expression. My sympathy was with them, but my attitude was not mawkish. Because I was also an ordinary worker, without benefit of a classic education. And I had had the experience of the hard struggle and intellectual discipline and purposefulness that were necessary to make a fine stanza of verse or a paragraph of prose. And Michael Gold also knew. He was still intellectually battling up from the depths of proletarian starvation and misery. And like myself he was getting hard criticism and kind encouragement from Max Eastman. But Michael Gold preferred sentimentality above intellectuality in estimating proletarian writing and writers.

I preferred to think that there were bad and mediocre, and good and great, literature and art, and that the class labels were incidental. I cannot be convinced of a proletarian, or a bourgeois, or any special literature or art. I thought and still think that it is possible to have a proletarian *period* of literature, with labor coming into its heritage as the dominating social factor, exactly as we have had a Christian period, a

Renaissance period, and the various pagan periods. But I believe that whenever literature and art are good and great they leap over narrow group barriers and periods to make a universal appeal.

The intelligentsia of our southern states may boycott a Negro's book or a Negro's painting. Hitler may burn the creative work of Jews, liberals and radicals, Mussolini may proscribe literature and art that he considers anti-Fascist, the Pope may index works that he interprets as anti-Catholic, and the Communists may damn works of literature and art that appear to them unfavorable to international Communism. I don't minimize the danger of the obstruction of talent and the destruction of art. But if the works are authentic they will eventually survive the noise and racket of the times, I think.

Michael Gold and I on *The Liberator* endeavored to team along. But that was impossible. Gold's social revolutionary passion was electrified with personal feeling that was sometimes as acid as lime-juice. When he attacked it was with rabbinical zeal, and often his attacks were spiteful and petty. One day I was informed that he had entered the Civic Club (a rendezvous of liberals and radicals) in his shirt sleeves and with an insulting attitude. I remarked that I didn't see any point in doing that to the pacifist Civic Club; that he might have gone instead to the Union League Club.

Someone repeated my comment, and one evening when I was dining with Marguerite Tucker at John's Italian restaurant in Twelfth Street, Gold came in and challenged me to box. He had been a champion of some note on the East Side. I shrugged and said the difference between us was intellectual and not physical, but that I was willing to box, if he thought that would settle it. So we laughed the matter off and drank

a bottle of dago red together. However, I saw clearly that our association could not continue. Shortly after that we called a meeting of *Liberator* editors and I resigned.

Meanwhile I had been devoting most of my time to dramatic criticism. Happy Harlem had come down to Broadway in a titillating musical piece called *Shuffle Along*. The metropolitan critics dismissed it casually at first. There were faults. Technically the piece was a little too rhythmically lazy and loose-jointed. But there were some luscious songs and singing: "Shuffle Along," "Love Will Find a Way," and "Bandanna Land." And there was Florence Mills. Florence Mills was so effortless in her perfect mimicry and elfin brown voice that the Negro impressarios were not even aware that they possessed in her a priceless gold star. For they had given her a secondary rôle in the revue.

Never had I seen a colored actress whose artistry was as fetching as Florence Mills's. After the show I went backstage to see her. I said: "You're the star of the show." No, she said, the stars were Lottie Gee and someone else whose name I don't remember. I said, "You're the star for me, and I'm going to say so in my review." She laughed deliciously.

I thought I'd feature *Shuffle Along* in *The Liberator*. I wanted especially to do this because the Negro radicals of those days were always hard on Negro comedy. They were against the trifling, ridiculous and common side of Negro life presented in artistic form. Radical Negroes take this attitude because Negroes have traditionally been represented on the stage as a clowning race. But I felt that if Negroes can lift clowning to artistry, they can thumb their noses at superior people who rate them as a clowning race.

I asked William Gropper, the cartoonist, to go along with

me to see *Shuffle Along* and make some drawings. Gropper made some excellent things, but they were too savagely realistic for the airy fairy fascination of Negro comedy. Gropper realized this, and didn't mind my asking Hugo Gellert to take a stroke at them, because I thought Gellert's style more suitable to the kind of thing I wanted. I did not rate Gellert's talent anywhere near Gropper's. But Gellert possessed a more receptive mind and cunning hand for illustrative work. Gellert made some clever drawings with a modernistic accent. We printed them with my article, and that issue of *The Liberator* was a sensation among the theatrical set of Harlem.

Florence Mills ran away with the show, mimicking and kicking her marvelous way right over the heads of all the cast and sheer up to the dizzying heights until she was transformed into a glorious star.

Shuffle Along was conceived, composed and directed by Negroes. There had been nothing comparable to it since the Williams and Walker Negro shows. It definitely showed the Negro groping, fumbling and emerging in artistic group expression. When its best artists were bought out by white producers and it was superseded by such elaborate superproductions as *Blackbirds,* which was projected and directed by a white impressario, there was no artistic gain for the Negro group. But the Negro *artistes* made more money, and thoughtless Negroes, like all good Americans, think that the commercially successful standard is the only standard by which Negro artistic achievement may be judged.

I have no prejudice against white persons leading and directing Negroes artistically and otherwise, if they can do it with more than merely technical competence. Negroes using the technique of the white peoples to express themselves must necessarily have to go to school to the whites. But it is no easy

achievement for any outsider to get on the inside of a segregated group of people and express their hidden soul. Many white people see Negroes from a white point of view and imagine that they know all about the Negro soul and can express it even better than the blacks themselves. When I saw the white man's *Blackbirds* in Paris and remembered *Shuffle Along* I was very sad. The *Blackbirds* flashed like a whip from beginning to end, rushing the actors through their parts like frightened animals. There was not a suggestion in it of the inimitably lazy tropical drawl that characterizes Negro life even in the coldest climate. And that was the secret of the success of the charming *Shuffle Along*.

In the midst of my career as a dramatic critic I bumped into one of those acute snags which remain in the memory even as the scar of a bad wound that has been healed remains in the body. It wasn't because I was thin-skinned. When I went to work on *The Liberator* I knew that I would have to face social problems even greater than before, but I was determined to face them out. But what happened to me hurt more because it came from an unexpected source.

I think that instead of rewriting it, I will let the article I wrote at the time (for *The Liberator* of May, 1922) tell the story for me:

"Wouldn't your dramatic critic like to see *He Who Gets Slapped?*" So, very graciously, wrote the Theater Guild's publicity agent to *The Liberator*. Our sometime dramatic critic, Charles W. Wood, having deserted us for the season, I elected myself dramatic critic by acclamation. It would be pleasant to sit in a free front-row parquet seat along with "The Press," instead of buying a ticket for the second balcony. And as for the other seat—free seats come in pairs—I decided to take

along William Gropper, *Liberator* artist of the powerful punch and vindictive line, and master of the grotesque.

So on the appointed night we presented ourselves at the box office of the Fulton. It was with keen pleasure that I anticipated seeing this fantastic play of Leonid Andreyev's, *He, the One Who Gets Slapped*. A curious and amusing theme!

The stubs were handed to Gropper and we started toward the orchestra. But the usher, with a look of quizzical amazement on his face, stopped us. Snatching the stubs from Gropper and muttering something about seeing the manager, he left us wondering and bewildered. In a moment he returned, with the manager. "The—the wrong date," the manager stammered and, taking the stubs marked "orchestra," he hurried off to the box office, returning with others marked "balcony." Suddenly the realization came to me. I had come here as a dramatic critic, a lover of the theater, and a free soul. But—I was abruptly reminded—those things did not matter. The important fact, with which I was suddenly slapped in the face, was my color. I am a Negro—*He, the One Who Gets Slapped*. . . .

Gropper and I were shunted upstairs. I was for refusing to go, but Gropper, quite properly, urged compromise. So, brooding darkly, madly, burnt, seared and pierced, and overburdened with hellish thoughts, I, with Gropper beside me half-averting his delicate pale face, his fingers, run through his unkempt mop of black hair, shading his strangely childlike blue eyes, sat through Leonid Andreyev's play.

Andreyev's masterpiece, they call it. A masterpiece? A cleverly melodramatic stringing together of buffoonery, serio-comic philosophy, sensational love-hungriness and doll-baby impossibilism, staged to tickle the mawkish emotions of the

bourgeois mob! So I thought. I sat there, apart, alone, black and shrouded in blackness, quivering in every fiber, my heart denying itself and hiding from every gesture of human kindliness, hard in its belief that kindliness is to be found in no nation or race. I sat inwardly groaning through what seemed a childish caricature of tragedy. Ah! if the accident of birth had made Andreyev a Negro, if he had been slapped, kicked, buffeted, pounded, niggered, ridiculed, sneered at, exquisitely tortured, near-lynched and trampled underfoot by the merry white horde, and if he still preserved through the terrible agony a sound body and a mind sensitive and sharp to perceive the qualities of life, he might have written a real play about being slapped. I had come to see a tragic farce—and I found myself unwillingly the hero of one. He who got slapped was I. As always in the world-embracing Anglo-Saxon circus, the intelligence, the sensibilities of the black clown were slapped without mercy.

* * * * * * * *

Poor, painful black face, intruding into the holy places of the whites. How like a specter you haunt the pale devils! Always at their elbow, always darkly peering through the window, giving them no rest, no peace. How they burn up their energies trying to keep you out! How apologetic and uneasy they are—yes, even the best of them, poor devils—when you force an entrance, Blackface, facetiously, incorrigibly, smiling or disturbingly composed. Shock them out of their complacency, Blackface; make them uncomfortable; make them unhappy! Give them no peace, no rest. How can they bear your presence, Blackface, great, unappeasable ghost of Western civilization!

* * * * * * * *

Damn it all! Goodnight, plays and players. The prison is vast, there is plenty of space and a little time to sing and

dance and laugh and love. There is a little time to dream of the jungle, revel in rare scents and riotous colors, croon a plantation melody, and be a real original Negro in spite of all the crackers. Many a white wretch, baffled and lost in his civilized jungles, is envious of the toiling, easy-living Negro.

XIII

"Harlem Shadows"

•

MEANWHILE I was full and overflowing with singing and I sang in all moods, wild, sweet and bitter. I was steadfastly pursuing one object: the publication of an American book of verse. I desired to see "If We Must Die," the sonnet I had omitted in the London volume, inside of a book.

I gathered together my sheaf of songs and sent them to Professor Spingarn. He was connected with a new publishing firm. Many years before I had read with relish his little book, entitled *Creative Criticism*. I wrote to him then. He introduced me to James Oppenheim and Waldo Frank of *The Seven Arts,* and they published a couple of my poems under a nom de plume. That was way back in 1917. Now, five years later, I asked Professor Spingarn to find me a publisher.

I had traveled over many other ways besides the railroad since those days. Professor Spingarn was appreciative of me as a Negro poet, but he did not appreciate my radicalism, such as it was! Paradoxically, Professor Spingarn supported and advocated Negro racial radicalism and abhorred social radicalism. Professor Spingarn preferred my racial jeremiads to my other poems. Well, I was blunt enough to tell Professor Spingarn that he was a bourgeois. He didn't like it. Nevertheless he found me a publisher.

When I told a Yankee radical about myself and Professor Spingarn, this radical said that it was impossible for any man to be pro-Negro and anti-radical. He said, he believed that Professor Spingarn was pro-Negro not from broad social

and humanitarian motives, but because he was a Jew, baffled and bitter. I said, "But Oswald Garrison Villard is also pro-Negro, and he is not a radical nor a Jew." The radical said, "Oh, Villard is an abolitionist by tradition." And I said, "Isn't it possible that Professor Spingarn is also an abolitionist, and by even a greater tradition?"

If only individual motives were as easy to categorize and analyze as they appear to be! Anyway, Professor Spingarn got Harcourt, Brace and Company to accept my poems. Max Eastman wrote a splendid preface, and the book was published in the spring of 1922.

Harlem Shadows was a *succès d'estime*. The reviews were appreciative, some flattering, flattering enough to make a fellow feel conceited about being a poet. But I was too broke and hungry and anxious about the future to cultivate conceit. However, I was not discouraged. The publication of my first American book uplifted me with the greatest joy of my life experience. When my first book was published in Jamaica, I had the happy, giddy feeling of a young goat frolicking over the tropical hills. The English edition of my poems had merely been a stimulant to get out an American book. For to me America was the great, difficult, hard world. I had gone a long, apparently roundabout way, but at least I had achieved my main purpose.

The last *Liberator* affair in which I actively participated was an international dance. The winter had been cold on our spirits and our feelings warmed currently to celebrate the spring. We trumpeted abroad our international frolic and the response was exhilarating. All shades of radicals responded, pink and black and red; Left liberals, Socialists, Anarchists, Communists, Mayflower Americans and hyphenated Americans, Hindus, Chinese, Negroes. The spirit of *The Liberator*

magnetized that motley throng. There was a large freedom
and tolerance about *The Liberator* which made such a mixing
possible. (How regrettable that nothing like the old *Liberator*
exists today! Social thinking is still elastic, even chaotic, in
America. Class lines and ideas here are not crystallized to
such an extent as to make impossible friendly contact between
the different radical groups.)

Our spring frolic brought that international-minded multi-
tude into Forty-second Street. But the metropolitan police
resented the invasion. They were aghast at the spectacle
of colored persons mixed with white in a free fraternal revel.
So they plunged in and broke it up, hushed the saxophones,
turned the crowd out of the hall, and threw protesting persons
downstairs, lamming them with their billies.

* * * * * * * *

After leaving *The Liberator* I took a holiday from work.
I had not had one for over a year. I was in a small circle of
friends and we convived together, consuming synthetic gin.
Meanwhile I was thinking about a job. Perhaps I would
return to the railroad. James Weldon Johnson advised me
to make a tour of the South and read my verses. But I
never anticipated with gusto the prospect of appearing as
a poet before admiring audiences.

I was often in the company of a dancer who was making
a study of African masks for choreographic purposes. One
evening while he, my friend, Gladys Wilson, and I were
together in my diggings in Fourteenth Street, a woman
walked in to whom I had been married seven years before.
A little publicity, even for a poor poet, might be an embar-
rassing thing. The dancer exclaimed in a shocked tone, "Why,
I never knew that you were *married!*" As if that should have
made any difference to *him*. I said that nobody knew, except-

ing the witnesses, and that there were many more things about me that he and others didn't know.

All my planning was upset. I had married when I thought that a domestic partnership was possible to my existence. But I had wandered far and away until I had grown into a truant by nature and undomesticated in the blood. There were consequences of the moment that I could not face. I desired to be footloose, and felt impelled to start going again.

Where? Russia signaled. A vast upheaval and a grand experiment. What could I understand there? What could I learn for my life, for my work? Go and see, was the command. Escape from the pit of sex and poverty, from domestic death, from the cul-de-sac of self-pity, from the hot syncopated fascination of Harlem, from the suffocating ghetto of color consciousness. Go, better than stand still, keep going.

PART FOUR

•

THE MAGIC PILGRIMAGE

•

XIV

The Dominant Urge

•

I WENT to Russia. Some thought I was invited by the
Soviet government; others, that I was sent by the Com-
munist Party. But it was not so easy to have the honor of
an invitation or the privilege of being sent. For I was not one
of the radicals abroad, important to the Soviet government;
and I was not a member of the Communist Party. All I had
was the dominant urge to go, and that discovered the way.
Millions of ordinary human beings and thousands of writers
were stirred by the Russian thunder rolling round the world.
And as a social-minded being and a poet, I too was moved.

But money was necessary so that I could go to Russia.
I had none. I mentioned my object to James Weldon Johnson,
then secretary of the National Association for the Advance-
ment of Colored People. He suggested I might raise some
money by selling special copies of my book of poems with
signed photographs. And very kindly he placed at my dis-
posal a select list of persons connected with the N. A. A. C. P.
In that way a small number of copies of *Harlem Shadows*
was sold. The price asked was five dollars. I remember that
about six persons sent checks for ten dollars. One check was
signed by Mrs. Henry Villard. Eugen Boissevain sent me
one hundred dollars. Crystal Eastman gave me a letter as
one of the editors of *The Liberator,* asking any radical who
could to facilitate my getting to Russia. Just before I sailed
James Weldon Johnson gave me a little farewell party at
his residence in Harlem. A few of Harlem's élite came:

Dr. DuBois, Walter White, Jessie Fauset, Rosamond Johnson, and from among downtown liberal intellectuals, Heywood Broun and F. P. A. of the New York *World,* John Farrar, who was then editor of *The Bookman,* and Ruth Hale. It was a pleasant evening and the first of the bohemian-élite inter-racial parties in Harlem which became so popular during the highly propagandized Negro renaissance period.

I signed on as a stoker on a slow freighter going to Liverpool. Just as that time, Crystal Eastman also had booked passage on another boat to go with her children to London to join her husband. We had arranged to have a last meal together on the eve of my sailing. But I waited until near midnight and she didn't appear. So I went out alone in Harlem, visiting the speakeasies and cabarets and drinking a farewell to the illegal bars.

In one joint I met Hubert Harrison and we had together a casual drink. But I did not inform him or any of my few familiars that I was sailing for Europe the next day. Sentimental adieux embarrass me. I took a look in at Sanina's for a brief moment. Late that night, when I got home with just enough liquor to fill me with a mellow mood for my next adventure, I found a tiny scrap of paper thrust into my keyhole:

> Claude dear:
> I just dashed in to give you a hug and say good-bye—Bon Voyage, dear child!
>
> Crystal

I tucked the little note in a corner of my pocket book and have carried it with me all these years, through many countries, transferring it, when one pocket book was worn out, to another.

Six years later, when I was in Spain, I received a copy of *The Nation* containing the announcement of beautiful Crystal Eastman's death. It was sudden and shocking to me. I took her farewell note out of my pocket book and read it and cried. Crystal Eastman was a great-hearted woman whose life was big with primitive and exceptional gestures. She never wrote that Book of Woman which was imprinted on her mind. She was poor, and fettered with a family. She had a grand idea for a group of us to go off to write in some quiet corner of the world, where living was cheap and easy. But it couldn't be realized. And so life was cheated of one contribution about women that no other woman could write.

At Liverpool I left the freighter and went straight to London. There was a reunion with a few intimates of the International Socialist Club. Many of the members had left for Russia the year before to live there permanently. Also a number of British Communists were preparing to travel to Russia for the Fourth Congress of the Communist International.

Arthur McManus, one of the Left labor men from the Clyde, was one of them. I asked if he could assist me to go to Russia. He was not enthusiastic, especially since I was once connected with the Pankhurst group, which was now out of favor at Moscow. McManus said that I should have been recommended by the American Communist Party. The more difficult it seemed, the more determined I was to make my way to Russia. One evening in a barroom, I heard a group of English comrades facetiously discussing Edgar Whitehead, the former secretary to the Pankhurst Group, saying that he was always landing something good in the movement. I heard them mention that Whitehead was in Berlin. He was liaison agent and interpreter for the English-

speaking radicals who were traveling to Russia. Whitehead had studied German in Berlin when he was a schoolmaster. He had been a leader of conscientious objectors during the last war. He was also my friend, and I thought I'd take a chance on his helping.

The next day I took the channel boat to Ostend. Arriving in Berlin, I made inquiries and found Whitehead. He promised to get me through to Russia. That I was not indorsed by any Communist party did not matter to him. He was not a fanatic or dogmatist. In the days of our association together in London we often waxed satirical about Communist orthodoxy and we had often discussed the idea of a neo-radical magazine in which nothing in the universe would be held sacred.

Whitehead started working for me. The intervening time I spent visiting the theaters. Expressionism was setting the pace. I saw the revolving stage for the first time and admired it. Also I visited many of the cabarets, which had sprung up like mushrooms under the Socialist-Republican régime, some of which seemed to express the ultimate in erotomania. The youngsters of both sexes, the hectic pleasure-chasers of the Berlin of that epoch (before Poincaré grabbed the Ruhr), were methodically exploiting the nudist colony indoors, which was perhaps more exciting than the outdoor experiments.

One evening Whitehead announced that all was ready. The next day we drove in a taxicab to a rendezvous. We entered a house and passed into a large room in which there was a group of men. Four of them I identified as Russians. Whitehead introduced me as a *kamarad und neger dichter*. One sitting at a table spoke with a kindly smile. He asked a few questions in effortful English which I promptly answered. I said that I was not a member of the American Communist

Party, but that I was in sympathy with the purpose of the great Russian revolution. I said that it was primarily as a writer that I was interested in Soviet Russia and that I intended to write about it for the Negro press.

I received back my passport and Crystal Eastman's recommendation, which I had consigned to Whitehead. A visa for Russia was attached to the passport. I was told to prepare to travel at once. The next day I traveled with an English-speaking German to Stettin. There I slept that night at a hotel. The following morning I was taken to a pier, whence I embarked for Leningrad.

Petrograd! Leningrad! When I think of that great city like a mighty tree shaken to its roots by a hurricane, yet still standing erect, and when I think of the proud equestrian statue of Peter the Great, proclaiming that dictator's mighty achievement, I feel that the world has lost the poetry and the color rising like a rainbow out of a beautiful name since Petrograd was changed to Leningrad.

Lenin is mightier than Peter the Great. But there is no magic in the name of Leningrad. There is magic in the name of Lenin, as there is splendor in the word Moscow. And perhaps Lenin himself, whose life was devoted to the idea of creating a glorious new world, might have, in appreciation of the will of Peter the Great to remake a nation, preferred Petrograd to remain Petrograd. Perhaps the spirit of Lenin might have been more adequately expressed in the erection of a brand-new city, rising out of that system to which he dedicated his life. Lenin without any suffix—like a perfect ball of pure gold—a city called Lenin.

I saw Petrograd! Like a great tree, shaken to its roots by a hurricane and struck by lightning and somehow still stand-

ing. Petrograd, half empty of its population and somewhat
sad in the autumn. I saw the monuments of czars and nobles
tumbled in the dirt by the proletarian masses. But intact and
untouched they had left the beautifully proud monument of
Peter the Great, a mighty symbol of individual will and
majesty.

MOSCOW

Moscow for many loving her was dead . . .
And yet I saw a bright Byzantine fair,
Of jewelled buildings, pillars, domes and spires
Of hues prismatic dazzling to the sight;
A glory painted on the Eastern air,
Of amorous sounding tones like passionate lyres;
All colors laughing richly their delight
And reigning over all the color red.

My memory bears engraved the strange Kremlin,
Of halls symbolic of the tiger will,
Of Czarist instruments of mindless law . . .
And often now my nerves throb with the thrill
When, in that gilded place, I felt and saw
The simple voice and presence of Lenin.

I felt almost ashamed in those lean hungry years of 1922,
when Russia was just emerging from a great famine, that
Moscow should have stirred me in the way I have expressed
it in this sonnet. Yes, I will admit that my senses were stirred
by the semi-oriental splendor and movement of Moscow even
before my intellect was touched by the forces of the revolution.

After the war, the revolution and the famine, one's mind
had created a picture of a grim, harsh melancholy atmosphere.

But it was all like a miracle, all that Byzantine conglomeration of form and color, shedding down its radiance upon the proletarian masses. It was like an *Arabian Nights* dream transforming the bleak white face of an Arctic waste.

And the crowds tramping and sleighing through the deep snow spreading over all the land were really happier and friendlier than the crowds of New York and London and Berlin. Yet the people in Moscow were generally so poorly clad. There was so much of that Oriental raggedness that one does not see in New York and London and Berlin—at least not on the surface. The scenes were so unexpected and strange that I even doubted at first whether they were not created by Communist discipline and Bolshevik propaganda. But when I mingled with the people I soon perceived that many did not even comprehend the true nature of Communism. Some of them could understand only that Lenin was in the place of the Czar and that he was a greater Little Father.

I was soon brought down out of the romantic feeling of the atmosphere to face the hard reality of the American Communist delegation. Brazenly and bravely I had journeyed to Russia with some members of the British group. But now the American delegation had arrived with a Negroid delegate, a light mulatto. My presence was resented. The American delegation did not want me there. The delegation represented America, and as I had been passed with other Communists as a visitor to the Fourth Communist Congress, it was necessary that I should be indorsed by the delegation as an unofficial visitor. This the chairman refused to do. Instead, he desired that I should be sent out of Russia, back home.

A fight was raging inside of the American delegation. A minority led by James Cannon wanted a legal American

Communist party, to carry on open propaganda among all the American workers. The majority, led by the chairman, was fighting to keep the American party illegal and underground.

Rose Pastor Stokes was the main prop of the chairman. When she arrived in Moscow, still pretty and purring and sly as a puss, she immediately engaged me in conversation and casually asked if I did not think that an illegal Communist party was the best suited for America. I answered no, emphatically. At the time I did not know that the difference in the ranks of the American group was serious. Not being a party member, I was unaware of what was going on inside of the organization.

Rose Pastor Stokes was one of the delegates who had just escaped from Bridgman, Michigan, during the police raid of August, 1922, when the illegal Communist Party held its convention in the open there in a beautiful romantic valley. Some of us of *The Liberator* thought that the Communists, being tired of staying underground, were feeling so pastoral and poetic that they couldn't do better than hold their secret convention in the open air of the lovely Michigan country.

Rose Pastor Stokes had said to me that it was necessary for Communists to take to the woods in summer to escape the iron heel of the capitalists. She was the wife of a millionaire, and perhaps knew more about the iron heel than poor proletarians. She admired that romantic novel of Jack London's, *The Iron Heel,* and once told me that radicals could use it as a textbook of revolutionary organization in America. She was shocked and hurt that a few of us regarded the convention and the raid in Michigan as something like a comic opera.

I remembered Mrs. Stokes's spy mania, when I was on

The Liberator. She was doing secret radical work. She used to tell me stories of being followed by detectives, and of how she fooled them by taking refuge in the Hotel Plaza and the Hotel Astor; because the dicks wouldn't imagine that a guest of such places was red. She was also working with a radical Negro group, and thought she was followed by Negro detectives in Harlem. One night I was at the apartment of my friend, Grace Campbell, when Mrs. Stokes came in to attend a meeting. She was breathless, and sank into a chair, exhausted. She asked for water, and Comrade Campbell hurried to get a glassful. Then Mrs. Stokes explained that a colored man had been watching her suspiciously while she was riding up on the subway, and when she got off the train he had attempted to follow her. She had hurried and dodged through the insouciant Harlem crowd and gone round many blocks to evade the spy.

Said Comrade Campbell, "But Comrade Stokes, there aren't any Negroes spying on radicals in Harlem. That colored man, maybe he was attempting—kind of—to get friendly with you."

Mrs. Stokes jumped right up out of her exhaustion: "What, Comrade? You *shock* me!" In her voice, and her manner, was the most perfect bourgeois expression of the superior person. Comrade Campbell said: "Why Comrade Stokes, I didn't mean to insinuate anything, but any person is likely to be mistaken for something else."

So now in Moscow, before I was fixed in place as an unofficial observer, Rose Pastor Stokes had got it from me that I was opposed to the majority of the American delegation, and that was bad. Mrs. Stokes really believed that we were living through the period of the new Inquisition against radicals in America, and that those who did not believe that

were traitors to the cause. She hinted even that there was something suspicious about my use of my real name in Moscow. For all the American delegates had secret names. Mrs. Stokes's own was Sasha. But some of us unorthodox comrade sympathizers preferred to identify her as The Red Red Rose.

Meanwhile, the committee appointed to seat all delegates to the Fourth Congress was sifting credentials. It was headed by a repulsive type of strutting Prussian whose name is now forgotten, lost in the radical scramble for place and the shuffling and cutting of Communist cards—and Leninist purges. Greater Red names than his have gone like the melted snows of yesterday.

I was soon aware that the Prussian person had his severe blue eye fixed on me, as if I had been specially pointed out to him. I pretended that I had not seen that evil eye, but soon I was being bedeviled. I was thrown out of the Lux Hotel and found myself in a dilapidated house in a sinister *pereulok*. My room was bare excepting for an army cot, and cold like the steppes because of a broken window pane through which poured a Siberian draught. My first thought was to protect myself against pneumonia, and so I hurried to a store and purchased two blankets and a pair of the cheap, warm and comfortable felt boots that reach to the thighs—the kind the Russian peasants wear.

In the room next to mine there was a Russian couple. The man spoke a little English. I complained about the state of my room and he agreed that the window should be fixed; but, said he, "Thousands of Russians are living in worse places." It was a quiet, gentle, perhaps unintentional, rebuke, but immediately I felt confused and altogether ashamed. I became aware of the implications of my grievance, so petty

in the eyes of the "thousands in worse places" who had just come through an eight-year siege of war, revolution, counter-revolution and famine, with fields and farms devastated, factories wrecked, houses in ruins, no time and few funds for repairs.

I remembered breakfasting on the train in Germany a few weeks previously. The countryside, misty brown in the early morning, was peaceful and beautiful; the train ran precisely on time; the coaches and dining car were in elegant shape; the passengers well dressed, the waiters in neat uniform. The breakfast was fine, but the cream that came with the coffee was barely whitened water. I had just come from America, where cream with coffee is a commonplace. And so, without thinking, I asked the waiter for cream. I said I would pay extra for it.

The waiter said: "But Mister, we have no cream at all. They have taken away all our cows from us, and what little milk we have we must give to our babies." Then I remembered that I had read somewhere that under the Treaty of Versailles the Germans had had to give up thousands of heads of cattle to the Allies. But I had never fully grasped the significance of that until I asked for cream with my coffee in Germany. (We are, the majority of us, merely sentimental about the suffering of others. Only when direct experience twists our own guts out of place are we really able to understand. I remember once hearing a nice comfortable bohemian noblewoman ecstatically exclaim: *"J'aime la souffrance! J'aime la souffrance!"* Yes! She loved vicariously the suffering of others.)

". . . Thousands in worse places." A good room was as much of a luxury in Moscow in 1922 as a car is in America. A good room was the chief non-political topic of conversation.

People greeted one another and said: "Do you have a good room?" in the same way we say, "How is your health?" One of the tidbits of those times was the joke that Mrs. Trotsky and Mrs. Zinoviev were at odds because one had a better apartment in the Kremlin than the other.

* * *

Now my position was precarious. I wanted by all means to stay in Moscow and to attend the meetings of the Fourth Congress of the Communist International. But would-be delegates and visitors who were unwanted and undesirable were being ruthlessly dealt with. Some were accused as spies and counter-revolutionists. To the Russians, spying was a real menace. It meant sabotage of revolutionary property, attempted assassination of officials, and working to overthrow the Soviets. They could not understand that when an English or an American Communist accused certain persons of being spies, his idea of spying was romantic and akin to eavesdropping.

Aware of the way in which things were going against radical dissidents, I acted quickly. I had a friend high up in Bolshevik circles in the person of Sen Katayama. Sen Katayama was *the* Japanese revolutionist. He had been a member of the Second International and knew all the big men of the conservative British and continental labor movement. He was an old friend of Lenin, Zinoviev, Bukharin and Radek, and had gone over to the Third International at its inception.

Sen Katayama had been a student at Fisk University, the southern Negro school. He was small, dark-brown, with intensely purposeful features which were nevertheless kindly. I met him when I was working on *The Liberator*. He dropped in one day and introduced himself. He took me to lunch at a Japanese restaurant, and at another time to a

Chinese, and introduced me to the Indian rendezvous restaurant in the theatrical district. His personality was friendly but abounding in curiosity—a sort of minute methodical curiosity. He made me think of a fearless and faithful little hunting dog. When he came up to my office, his little eyes, like brilliant beads, darted rapidly over everything. And like a permanent surprise he invaded my rooms at all hours and talked in his squeaky grandmotherly voice about Negro problems. He demonstrated a vast interest and sympathy for the Negro racialists and their organizations. I liked Sen Katayama immensely. I was fascinated by his friendly ferreting curiosity. I had associated with many Chinese at home in the West Indies and in London, but Sen Katayama was my first Japanese friend. It was exciting to contrast Chinese and Japanese by the types I had known. Sen Katayama was eager and extrovert, almost too much so, while the Chinese, however friendly, seemed aloof and secret.

Sen Katayama was in his glory in Red Russia. He was an honorary colonel of the Red army and always appeared at mass meetings in his uniform. The crowds adored him and applauded frantically. He appeared to me somewhat like a harbinger, a symbol of the far eastern element in the new heart of Russia.

Sen Katayama warmly welcomed me in Moscow and invited me to tea in his nice room in the Lux Hotel. He held an important post in the Eastern Department of the Communist International and because of his extensive traveling and his education and contact with American Negroes he was regarded as an authority on all colored peoples' affairs. He had more real inside and sympathetic knowledge and understanding of American Negroes than many of the white American Communists who were camping in Moscow.

When I explained to Sen Katayama how and why I had come to Russia and of the difficulties I was encountering because of the opposition of the American delegation, he said: "You leave everything to me and we'll see if they can get you out of here and prevent your attending the Congress. I'll talk to the Big Four [1] about you."

[1] Lenin, Trotsky, Zinoviev, and Radek.

XV

An Individual Triumph

•

MEANWHILE, all the Russian folk unwittingly were doing their part for me. Whenever I appeared in the street I was greeted by all of the people with enthusiasm. At first I thought that this was merely because of the curiosity which any strange and distinctive type creates in any foreign environment, such as I had experienced in Holland and Belgium and Germany. But no! I soon apprehended that this Russian demonstration was a different thing. Just a spontaneous upsurging of folk feeling.

The Bolsheviks had nothing at all to do with it. The public manifestation for me took them unawares. But the Bolsheviks have nerves subtly attuned to the currents of opinion and a sense of propaganda values in which they are matched only by French officialdom. So, as soon as they perceived the trend of the general enthusiasm for me, they decided to use it. And I was not averse to that. Never before had I experienced such an instinctive sentiment of affectionate feeling compelling me to the bosom of any people, white or colored. And I am certain I never will again. My response was as sincere as the mass feeling was spontaneous. That miraculous experience was so extraordinary that I have never been able to understand it.

Even the Russian comrades, who have a perfect pat social-economic explanation for all phenomena, were amazed. The comrade who conducted me around (when I hadn't wandered off by myself, which was often) was as intelligent as a

fox and as keen and cold as an icicle. Although a mere youth, he held important positions, open and secret, and today, still young, he holds a most important position in the Soviet government and in the Russian Communist Party. This comrade said: "I don't quite understand. Some of the Indian delegates are darker than you—quite black—yet the people don't carry on about them that way. But there is something very different in your features and that is what the people see."

Never in my life did I feel prouder of being an African, a black, and no mistake about it. Unforgettable that first occasion upon which I was physically uplifted. I had not yet seen it done to anybody, nor did I know that it was a Russian custom. The Moscow streets were filled with eager crowds before the Congress started. As I tried to get through along the Tverskaya I was suddenly surrounded by a crowd, tossed into the air, and caught a number of times and carried a block on their friendly shoulders. The civilians started it. The soldiers imitated them. And the sailors followed the soldiers, tossing me higher than ever.

From Moscow to Petrograd and from Petrograd to Moscow I went triumphantly from surprise to surprise, extravagantly fêted on every side. I was carried along on a crest of sweet excitement. I was like a black ikon in the flesh. The famine had ended, the Nep was flourishing, the people were simply happy. I was the first Negro to arrive in Russia since the revolution, and perhaps I was generally regarded as an omen of good luck! Yes, that was exactly what it was. I was like a black ikon.

The attitude of the non-Bolshevist population was even more interesting. I had been told to be careful about going places alone. But bourgeois persons on the street implored me

just to enter their homes for a glass of tea. I went. I had no fear of even the "whitest" Russians in Russia, although in Paris and Berlin I would not have trusted them. The only persons that made me afraid in Russia were the American Communists. Curiously, even Russian bourgeois persons trusted me. They knew that I was in sympathy with the Communists—was their guest. Yet some of them told me frankly and naïvely that they did not like the Bolsheviks and didn't think their régime would last. The women chattered like parrots, happy that the shops were opened. They wanted to hear about the shops in New York and London and Berlin. When I visited a college with an interpreter, who was certainly a member of the O.G.P.U., one of the language teachers explained the difficulties of working under the new régime. She said she ought to travel abroad to keep up with the languages she taught, and that was impossible now. She said the proletarian students were dull and kept the brighter bourgeois students back. She said that one of her brightest students was the son of a former governor, and that she would not reveal his identity, for if it were known, he could not stay in the college. She said, "I can't let even you know who he is, for you might tell about him." But before I left she introduced me to the lad, explaining that he had specially asked for an introduction. In Petrograd, Korney Chukovsky, the popular author, introduced me to a princess and a countess who were his friends, and to the intellectual élite, who were mainly anti-Bolsheviks. But they crowded a hall to hear me read my poems. One of the professors, who had studied in England and France, was so excited that he invited me to the national library the next day. And what did he do? There was a rare Pushkin book with a photograph of him as a boy which clearly showed his Negroid strain.

(The Negroid strain is not so evident in the adult pictures of Pushkin.) I coveted the book, and told the Professor so. He said he was sorry that he could not make me a present of the volume. But he actually extracted that photograph of Pushkin and gave it to me. Mark you, that professor was no Bolshevik, contemptuous of bourgeois literature. He was an old classic scholar who worshipped his books and was worried about the future of literature and art under the Bolshevik régime. Yet he committed that sacrilege for me: "To show my appreciation of you as a poet," he said. "Our Pushkin was also a revolutionist." Like Crystal Eastman's farewell note, that photograph of Pushkin is one of the few treasures I have.

Oh, I remember that magnificent cartoon in colors, picturing me sailing on a magic carpet over the African jungles to Moscow. The artist made me a gift of the original. An imp swiped it. It was the perfect interpretation of my adventure in Russia. An *Arabian Nights* fantasy transformed into reality. I had been the despised brother, unwelcome at the gorgeous fête in the palace of the great. In the lonely night I went to bed in a cold bare room. But I awoke in the morning to find myself the center of pageantry in the grand Byzantine city. The photograph of my black face was everywhere among the most highest Soviet rulers, in the principal streets, adorning the walls of the city. I was whisked out of my unpleasant abode and installed in one of the most comfortable and best-heated hotels in Moscow. I was informed: "You may have wine and anything extra you require, and at no cost to you." But what could I want for, when I needed a thousand extra mouths and bellies for the importunate invitations to feast? Wherever I wanted to go, there was a car at my disposal.

Whatever I wanted to do I did. And anything I felt like saying I said. For the first time in my life I knew what it was to be a highly privileged personage. And in the Fatherland of Communism!

Didn't I enjoy it! The American comrades were just too funny with envy and chagrin. The mulatto delegate who had previously high-hatted me now began to cultivate my company. It was only by sticking close to me that he could be identified as a Negroid.

I was photographed with the popular leaders of international Communism: Zinoviev, Bukharin, Radek, · Clara Zetkin, Sen Katayama, Roy; with officers of the Soviet fleet, the army and the air forces; with the Red cadets and the rank and file; with professors of the academies; with the children of Moscow and of Petrograd; with delegates from Egypt, India, Japan, China, Algeria.

XVI

The Pride and Pomp of Proletarian Power

•

THE Bolshoi Theater in Moscow presented a pageantry of simple proletarian pride and power on the night of the opening of the Congress of the Communist International. The absence of the primitive appeal of gilded pomp made the manifestation even more sublime and awe-inspiring.

I had received a pass to attend the great opening of the Congress. When I succeeded in getting into the vast Bolshoi auditorium, Martin Anderson Nexö, the author of *Pelle, the Conqueror,* waved to me to come and sit beside him. He was seated in the center front of the hall. But an usher grabbed me, and before I could realize where I was going, I was being handed from usher to usher like an object that was consigned to a special place. At first I thought I was going to be conducted to the balcony, but instead I was ushered onto the platform to a seat beside Max Eastman and just behind Zinoviev. It seems as if the curious interest of the crowd focused upon me had prompted Zinoviev to hoist me up there on the platform.

Zinoviev asked me to speak and I refused. Max Eastman pleaded: "Do speak! See how the people are looking at you; they want to hear you." I said that if they had given me notice beforehand I might have prepared a few phrases, although speaking was not my specialty. But I wouldn't stand up before the Bolshevik élite and that vast eager crowd, without having something prepared to say. Eastman said: "Just

tell them you bring greetings from the Negro workers of America."

"But," said I, "I have no mandate from any American Negro workers to say that. There is an official mulatto delegate; perhaps he has a message from the Negro workers."

I said to Eastman, "Why don't you speak?" He said he would like to if they would ask him. Certainly the American Communists had in Max Eastman the finest platform personality to present. Unlike me, he was as pure a Marxist as any of them there and had given the best of his intellect to serve the cause of Communism and extoll the Soviets in America. But because of petty jealousy they cold-shouldered Eastman in Moscow. Perhaps if they had been a little diplomatic about him, he probably would be one of them instead of a Trotskyist today.

I told Zinoviev that I came to Russia as a writer and not as an agitator. When his messenger interpreted what I said, Zinoviev's preacher face turned mean. He was most angry. But I did not mind. My personal triumph had made me aware that the Russians wanted a typical Negro at the Congress as much as I wanted to attend the Congress. The mulatto delegate was a washout. He was too yellow. I had mobilized my African features and won the masses of the people. The Bolshevik leaders, to satisfy the desires of the people, were using me for entertainment. So why should I worry about Zinoviev's frown? Even though he was president of the great Third International, I knew that there was no special gift I could get from Zinoviev after the entertainment was over and ended. I could never be a radical agitator. For that I was temperamentally unfit. And I could never be a disciplined member of any Communist party, for I was born to be a poet.

And now I was demanded everywhere. Sometimes I had to participate in three different meetings in one day: factory meetings, meetings of soviets, youth meetings, educational conferences in colleges and schools, the meetings of poets and writers, and theatrical performances. I was introduced to interesting sections of the new social and cultural life of Moscow and Petrograd.

I was always asked to speak, and so I prepared a few phrases. The Russians adore long speeches, which it did not interest me to make. And so they lengthened mine by asking a lot of questions. I had listened to the American delegates deliberately telling lies about conditions in America, and I was disgusted. Not only the Communist delegates, but radical American intellectuals really thought it was right to buoy up the Russians with false pictures of the American situation. All the speeches of the American delegates, the tall rhetoric, the purple phrases, conveyed fundamentally a common message, thus: "Greetings from America. The workers of America are groaning under the capitalist terror. The revolutionary organizations have been driven underground. But the American Communist Party is secretly organizing the masses. In a few years we will overthrow American capitalism and join our forces with the Russian Communists. Long live the Revolution. . . ." I heard the chairman of the American delegation say: "In five years we will have the American revolution."

The Russians from these speeches pictured the workers of America as denied the right to organize and the rights of free assembly and free speech, as denied representation in Congress, as ridden down by American cossacks, banished in droves from their homes to the Siberias of the Far West, with their imprisoned and exiled leaders escaping to Canada and

Mexico and working underground to overthrow the capitalist system. Briefly, the American situation, as they understood it, was similar to that of Russia under the Czarist régime just before the revolution.

The police raid on the illegal Communist party meeting in the beautiful woods of Michigan had been spread all over the Russian newspapers. Everything about that funny raid was so Czarist-Russian-like that the Russians really believed that it was typical of American conditions.

Truly, I could not speak such lies. I knew that the American workers in 1922 were generally better off than at the beginning of the World War in 1914. I was aware, of course, that labor organization in this country was far below the standard of labor organization in England, Germany and France, that American labor was not organized as a political weapon, that in some sections of the country and in certain industries labor was even denied the right to organize, and that radicals were always baited. But Leavenworth was not Siberia. And by no stretch of the imagination could the United States be compared to Czarist Russia.

How, then, could I stand before the gigantic achievement of the Russian revolution and lie? What right had I to tell these people, who had gone through a long death struggle to conquer their country for themselves, that the American revolution was also in travail? What could *I* presume to tell them? I told them that it was a great honor for me to be there to behold the triumph of their great revolution. I told them that I felt very insignificant and dumb before that wonderful thing. I said that I had come to Russia to learn something, to see with my own eyes and try to write a little of what I had seen.

Invariably I was questioned: "And what about the Ameri-

can revolution?" When I replied I thought it was a long way off, the audiences did not like me to say that. I must admit that the Russians in those days were eager to be deceived. I remember that I was asked to attend a large and important meeting of Young Communists. When I had finished talking the president got up and said: "Comrade, we appreciate what you feel about our revolution, but we want you to tell us about the American revolution. When will there be the American revolution?"

It was a direct question and I answered directly. I said that I could not prophesy about an American revolution; but that perhaps if the American ruling class started a wholesale suppression of labor organizations, if the people had to read radical literature in secret, if the radicals had to hold all their meetings in secret, if the liberals and radicals who agitated for more civil liberties and the rights of the working class were deported to the Philippines, then possibly in ten or fifteen years America might develop a situation similar to that in Russia in 1905.

The interpreter, a comrade commander in the navy, asked if he should translate me literally. I said "Word for word." And when he had finished there was no sound of applause. That was the first time that I was not applauded when I spoke, but I preferred that.

The young president of the Young Communists took the platform: "Comrade," he said, "you are a defeatist. The American revolution cannot be so far away. But if that is your opinion, we command you at once to do your part and help make the revolution." I said to the interpreter: "Tell the young comrade that I am a poet."

After the meeting my friend Comrade Venko said to me: "You should have told them the American revolution is right

around the corner. That's what they want to hear." (He had lived many years in England and had acquired some Anglicisms.) I said, "You know I read somewhere that Lenin said that it is necessary to face facts and tell the truth always."

"Yes, Comrade," said Venko, "but Lenin is Lenin and we are just ordinary mortals."

Yet in spite of my obstinacy I was still everywhere demanded. When the American Negro delegate was invited to attend meetings and my mulatto colleague went, the people asked: "But where is the *chorny* (the black)?" The mulatto delegate said: "Say, fellow, you're all right for propaganda. It's a pity you'll never make a disciplined party member."

"Bigger shots than you have said the same thing," I replied. Zinoviev had referred to me as a non-partisan. "My destiny is to travel a different road."

We were sitting in on the discussions as to whether there should be an illegal or legal Communist party in America, and on the Negro in American life. I was there not only as a writer, but I was given the privileges of a special delegate. One thing sticks in my memory about that American delegation in Moscow. It had the full support of the Finnish Federation and the Russian Federation of America. The representatives of these organizations voted *en bloc,* rallying to the support of an illegal party. The argument of the Yankee representatives of the legal group was unanswerable, but they were outvoted every time by the foreign federations. The Finnish and the Russian federations were not only the most highly organized units of the American party, but, so I was informed, they contributed more than any other to the party chest. They controlled because they had the proper organization and the cash.

I said to the mulatto delegate: "That's what Negroes need

in American politics—a highly organized all-Negro group. When you have that—a Negro group voting together like these Finns and Russians—you will be getting somewhere. We may feel inflated as *individual* Negroes sitting in on the councils of the whites, but it means very little if our people are not organized. Otherwise the whites will want to tell us what is right for our people even against our better thinking. The Republicans and the Democrats do the same thing. They give a few plum places to leading Negroes as representatives of the race and our people applaud vicariously. But we remain politically unorganized. What we need is our own group, organized and officered entirely by Negroes, something similar to the Finnish Federation. Then when you have your own group, your own voting strength, you can make demands on the whites; they will have more respect for your united strength than for your potential strength. Every other racial group in America is organized as a group, except Negroes. I am not an organizer or an agitator, but I can see what is lacking in the Negro group."

I listened to James Cannon's fighting speeches for a legal Communist party in America. Cannon's manner was different from Bill Haywood's or Foster's. He had all the magnetism, the shrewdness, the punch, the bag of tricks of the typical American politician, but here he used them in a radical way. I wondered about him. If he had entered Democratic or Republican politics, there was no barrier I could see that could stop him from punching his way straight through to the front ranks.

I think Trotsky was the first of the big Russians to be convinced that there should be a legal Communist party in America, then Rakovsky and finally Zinoviev, a little reluc-

tantly. Bukharin was for the illegal group. He said: "Remember what Jack London has told us about the terror and secret organization in America in his *Iron Heel.*" That was so rare that I had to smile. While Cannon was informing the Russians about actual conditions in America, Bukharin was visualizing the America of Jack London's *Iron Heel.* Bukharin always did make me think of that line about some men having greatness thrust upon them. I believe that Lenin said of Bukharin, as Frank Harris said of H. G. Wells, that he could not think. Yet Bukharin was the author of the A B C of Communism, which once had a big vogue among the radicals.

At last even I was asked my opinion of an illegal Communist party in America. I tried to get excused, saying that as I was not an official delegate or a politician, but merely a poet, I didn't think my opinion was worth while. But as my colleague the mulatto was for the illegal party, I suppose they needed a foil. So then I said that although I had no experience of the actual conditions of social life in Czarist Russia, I believed there was no comparison between them and American conditions today. There were certain democratic privileges such as a limited freedom of the press and a limited right of free speech that our governing classes had had to concede because they were the necessary ingredients of their own system of society. And American radicals could generally carry on open propaganda under those democratic privileges. Our Upton Sinclairs, Eugene Debs's, Max Eastmans and Mother Jones's might be prosecuted and imprisoned for a specific offense against the law, but they were not banished for their radical ideas to an American Siberia. And I said I thought that the only place where illegal and

secret radical propaganda was necessary was among the Negroes of the South.

What I said about the Negroes of the South was more important than I imagined, and precipitated the Negro question. The Negro question came under the division of the Eastern Bureau, of which Sen Katayama was an active official. Because of his American experience and his education among Negroes, Sen Katayama was important as a kind of arbiter between black and white on the Negro question. It was an unforgettable experience to watch Katayama in conference. He was like a little brown bulldog with his jaws clamped on an object that he wouldn't let go. He apparently forgot all about nice human relationships in conference. Sen Katayama had no regard for the feelings of the white American comrades, when the Negro question came up, and boldly told them so. He said that though they called themselves Communists, many of them were unconsciously prejudiced against Negroes because of their background. He told them that really to understand Negroes they needed to be educated about and among Negroes as he had been.

Think not that it was just a revolutionary picnic and love feast in Moscow in the fifth year of Lenin! One of the American delegates was a southerner or of southern extraction. An important Bolshevik facetiously suggested to him that to untangle the Negro problem, black and white should intermarry. "Good God!" said the American, "if Jesus Christ came down from Heaven and said that in the South, he would be lynched." The Bolshevik said: "Jesus Christ wouldn't dare, but Lenin would."

Also I remember Walton Newbold who was the first Communist candidate elected to the British House of Commons. Saklatvala, the Indian Parsee, had announced himself a Com-

munist only after he had been elected as an independent, but Walton Newbold was the first candidate of the British Communist Party. Just after his election to Parliament Newbold came to Moscow, while the Fourth Congress of International Communism was in session. For any reader who might not understand why a Communist member of the British Parliament should go to Moscow, I may explain that by the parallel of a cardinal going to Rome after receiving his hat. It was a big day for the little insignificant delegation of British Communists when Newbold arrived in Moscow. Of that triumphant arrival, one incident sticks more in my memory. I was informed that a member of the Chinese Young Communists, who was attending the Congress, met Newbold in the lobby of the Lux Hotel. He went up to Comrade Newbold to congratulate him and began: "Comrade Newbold—"

"Hello, Chink," Newbold cut in.

"But Comrade Newbold, I am not a Chink."

"Who told you that you weren't?" said Comrade Newbold as he turned away.

In a little while the incident had flashed like an arrow through Communist circles in Moscow. The young Chinese was a member of an old Chinese clan and had been educated in America. At that time Bolshevik eyes were fixed on China. Chinese soldiers made up some of the crack units of the Red army when Great Britain was supporting the White war against the Reds and tightening the blockade against Russia. I remember Radek's saying to me: "We are pinning our hopes on China more than any other country. If we can make China Red, we will conquer the world."

I don't know if that incident of the young Chinese and the first Communist member of the British Parliament ever reached the ears of the big Bolsheviks. I do know, however—

I got it from a good source—that the big Bolsheviks gave Newbold a hell of a skating over the Communist ice of Moscow. Newbold returned to the Parliament of British gentlemen and finally drifted over to the capitalist side.

I was asked to write a series of articles on the Negro group for *Izvestia*, the Moscow organ of the Soviets. Thus I came to meet Steklov, the editor-in-chief. Steklov was a huge man with a leonine head, more picturesque than intelligent. He told me that he was interested in Negroes being won over to the cause of Communism because they were a young and fresh people and ought to make splendid soldiers. I didn't relish that remark out of the mouth of a Communist. So many other whites had said the same thing—that Negroes make good cannon fodder when they were properly led—led by whites to the black slaughter. That filled me with resentment. The head of the French General Staff had proclaimed to the world the same thing, that France with its African empire had an army of a hundred millions. When Trotsky, the chief of all the Bolshevik fighting forces talked to me about Negroes he spoke wisely. Trotsky was human and universal in his outlook. He thought of Negroes as people like any other people who were unfortunately behind in the march of civilization.

Karl Radek was one of the Big Five of the Politbureau, which decided Bolshevik policy in those days. He invited me to dinner at his apartment in the Kremlin along with the Negro delegate of the American C. P. Radek wanted to know if I had a practical policy for the organization of American Negroes. I said that I had no policy other than the suggestion of a Negro *Bund*, that I was not an organizer or an agitator and could not undertake or guarantee any practical work of organization.

The Negro delegate said that I was a poet and a romantic. I said I was not as romantic as he and his illegal party with their secret names and their convention in the wilds of Michigan. Radek laughed, and as I looked at his face set in a thick circle of hair I thought how much he resembled a red spider. Radek said that the Communists should adopt a friendly attitude to all writers who were in sympathy with the soviets. For example, Upton Sinclair, he thought, would be a valuable asset to the revolution if the Communists knew how to handle and use him. The mulatto said that Upton Sinclair was a bourgeois Socialist.

"Oh, no, no," said Radek, "I insist that is not the attitude to take. Upton Sinclair is a powerful writer with an enormous influence, and the American Communists should make use of his influence, even though Sinclair is not a Communist. Now with our Gorky—" At this point an infant wailed and Radek said, "My baby comes first." He left the room, to return a few minutes later with the maid, who brought in the baby. Radek and Mrs. Radek kissed and fondled the child. The maid then brought the child to the mulatto, who touched its hand and patted its hair. From the mulatto she brought the child to me, but it shrank away, hid its face, and began to cry. Radek was interested and told the maid to take the child to the mulatto again. The mulatto took the child in his arms and it stopped crying, but when the maid tried me again, the child hid its face and cried. The maid retired with the child, and Radek said: "Now I understand the heart of the difference between white and black in America. It is fear. The Americans are like children, afraid of black complexion, and that is why they lynch and burn the Negro." I told Radek that his deduction was wrong; that in the South, where Negroes were lynched and burned, the black complexion was not a strange

thing to the whites, and that the majority of the children of the better classes of the South were nursed from their birth by black women, and that those children were extremely fond of their black foster mothers. Radek said that that was a strange thing.

XVII

Literary Interest

•

THE Congress ended and with a happy relief I turned from political meetings to social and literary affairs. The majority of the delegates had left, but I remained in Moscow writing. I was magnificently paid for poems and articles and became a front-page feature. Sometimes what I received in rubles for an article amounted when I figured it out to fifty American dollars. I had plenty of money to spend for food and cigarettes and even to frequent the cabarets. And besides, I was saving my fare to return to America.

I had no idea that I was being paid as a literary celebrity until one afternoon when I went to a newspaper office to receive my check. There I met an interesting Russian journalist. He was a titled person, a Count Something. After the revolution he had discarded his title, but since the Nep he had resumed it and signed himself Count. He remarked to me facetiously that perhaps his title of the old economic policy might help him to a better place under the New Economic Policy.

When I drew my check he looked at it and said: "Why, if they paid me one-tenth of what they pay you I would be rich. I could go to the casino and gamble and the cabarets to dance and wine."

"Why," I said, "I thought you got as much as I got."

"No," he said, "I couldn't, for you are a guest writer, a big writer—*bolshoi! bolshoi! bolshoi!*" The interpreter who accompanied me was annoyed and he said something to the

Count, who immediately clamped up. That, *bolshoi! bolshoi! bolshoi!* (big! big! big!) was sweet music in my ears and an inspiration. But it also stirred up a hell of discontent within me. Why should I be "big" translated into Russian? It was because I was a special guest of the Soviets, a good subject for propaganda effect, but inflated beyond my actual literary achievement. That was not enough for me. I felt that if I were to be *bolshoi* as a literary artist in a foreign language, I should first make a signal achievement in my native adopted language, English.

I met some of the notable Russian writers: Chukovsky, Boris Pilnyak, Eugene Zamiatin, Mayakovsky. I was invited to read at literary gatherings. My audiences were always enthusiastic and applauding, and also sometimes critical. *"Tovarish,"* I was often told, "your poems are not proletarian." I replied, "My poetry expresses my feelings." I shocked the pure proletarian intellectuals and I was proud that I was a privileged person in Russia, and in a position to shock them. One night I was invited to the Arbat to hear the proletarian poets read and discuss their compositions. Without understanding the language I was able to appreciate certain poems from their swing and movement and the voice of the reciter. And I had a good interpreter who rendered some into English for me. After each poem was delivered there was a general discussion of it. I was particularly pleased with the poem of a slim young man in a coarse peasant smock buttoned up to his chin, and with a worried, unhappy expression in his sensitive features. I knew at once that he was a peasant become proletarian like myself. He gave a charming poem. Even before translation I knew from its communicative color tone and the soft threne running through it like a silver chord that it expressed an individual

longing for the life of the country, perhaps the ways that nevermore would be.

As soon as the poet had done I clapped my hands heartily. His poem and personality had unusually excited me, because I rarely applaud. I liked that poet with the intellectual anxiety of his face showing clearly that he was a little bewildered by that world-moving social shake-up. That expression was real, more real to me than the automatic enthusiasm of his fellow poets which seemed to me less sincere. They all jumped on him. "Alexis, you are not a proletarian poet!" And they criticized his subject matter. So I asked my interpreter to let me say a word. I said I thought it was natural for a man who had lived in the country to express his longing for it, whether he was a bourgeois or a proletarian.

Mayakovsky was then the premier proletarian poet. Chukovsky, the popular author of *Crocodile* and other children's books, did not have the highest opinion of Mayakovsky. He told me that before the revolution Mayakovsky had been a futurist and that he used to wear fantastic clothes and had proclaimed his poems at the court of the Czar. Now Mayakovsky was a thundering proletarian poet. He recited one of his poems for me. It sounded like the prolonged bellow of a bull. He very kindly presented me with a signed copy of his latest book. Also he presented me to his wife, and said that she desired to dance a jazz with me. She was a handsome woman of an Arctic whiteness and appeared as if she had just stepped proudly out of a Dostoyevsky novel. We went to a gypsy cabaret and danced a little, but I am afraid that I did not measure up to the standard of Aframerican choreography. Mayakovsky told me that his great ambition was to visit America. I said I thought he would be a

big success there in Russian costume, declaiming his poems in his trumpet voice.

The contemporary Russian poetry of the period which I liked best was that of the peasant poet Yessenin. His intimate friend, Zonov, translated some of his poems, and I was enchanted by their lyric simplicity and profundity. Zonov was always hoping that Yessenin and I would meet, but we never did. Just about the time when I disembarked at Petrograd, Yessenin and Isadora Duncan were landing in New York. And Yessenin did not return to Russia until after I had left in June of 1923.

Zonov held a place either executive or artistic at the Meyerhold Theater, which I visited frequently, for there was a congenial gang there. He often invited me to a private little feast in his den, where he served sweet Caucasian wine and caviar and sometimes champagne. Always with him was a little actress whom he fancied, but who did not seem to love him too much. Zonov looked like a tired professor, and he was always bewailing the absence of Yessenin. He exhibited a snapshot of Yessenin that he carried in his pocket book, and I was startled by its resemblance to the strange dancer I had known in New York. Zonov said unlovely things of Isadora Duncan, because she had married Yessenin and taken him from his friends. He said that Yessenin had proclaimed to them all that he did not love Isadora. But he had married her to get out of Russia, to see Europe and America. I said I did not consider love as always necessary, and that sometimes it might be expedient for a woman to save a man from his male friends. Zonov translated what I said to the actress and she screamed with laughter.

Meyerhold's was the revolutionary constructivist theater, which did the most daring things in dramatic production.

There were no curtains. The audience saw clear through to backstage and watched the actors waiting to take their parts and come up to and retire from the front of the stage. The plan was novel. Meyerhold himself was a fanatic crusader in his ardor to make a great revolutionary theater express the revolutionary social system. All the symbols of the machine system were assembled on the stage: dynamos, cranes, scaffolding and turbines, until it resembled a regular workshop. Meyerhold said to me: "We need now great revolutionary plays and playwrights to make my theater the unique dramatic expression of the revolution." I had to talk to Meyerhold through an interpreter, but he impressed me as being more romantic than practical with his idea of making the stage the unique expression of the factory. I felt that after all the worker's life is not limited to the factory and should never be.

I was interested in the Moscow workers' attitude to the Meyerhold Theater. Whole blocks of seats were given to the factories and the barracks, but the theater, which was not very large, was never full. Yet the plays which Meyerhold put on were technically highly interesting. Vastly exciting to me was the presentation of *The Inspector General,* by Gogol. And unforgettable was one realistic scene of another play, in which the Czar was sitting on his chamber pot, with the imperial crown painted big upon it. But the workers and soldiers really preferred the ballet of the Bolshoi theater, the Moscow art theaters, the expressionist theater and the ordinary vulgar theaters. Whenever the workers received free tickets for the above-named theaters they never missed; workers and soldiers always filled them. But the audience of the Meyerhold Theater was of the intelligentsia—students and professional people. While the workers and soldiers

showed a distinct preference for the straight familiar entertainment, it was the intelligentsia that was avid of revolutionary drama. The situation made me think of a Frenchman's saying that most of the work of the experimental artists was not intended to enlighten the working class, but to *"épater la bourgeoisie."*

I was invited to dinner by Lunarcharsky, the Commissar of Education and of Arts. He was one of the most flamboyant orators of the Soviet Union and also a talented playwright. I told him a little of the little I knew about education in general in America and Negro education in particular, and I seized the opportunity to mention the Russian theater and the theater of Meyerhold. I remarked that it was interesting that the workers and soldiers seemed to prefer the old ballet to the new experimental theater. Lunarcharsky said that in the early days of the revolution some had desired to suppress the ballet, but he had held out against it. He considered the ballet a great form of art and what he did was to give the workers and peasants and soldiers the chance to enjoy it, which they hadn't had under the old régime. He had conserved and subsidized the best of the classical theaters for the entertainment of the people. But also he had granted subsidies to the experimental theaters to give them their chance to experiment in creating their best. Lunarcharsky was a wise mediator. It is related that when the Moscow masses, excited to high resentment against the Russian Orthodox Church, attempted to destroy the wonderful Cathedral of Vasilly Blazhenny, they were stopped by the intervention of Lunarcharsky. There was not a day of my stay in Moscow that my eyes failed to be glad in contemplation of Ivan the Terrible's super-byzantine burnt offering to humanity. And Lunarcharsky in Moscow appeared like a guardian angel to me because he had made it possible for my eyes to see that glory.

XVIII

Social Interest

•

MY constant companion and interpreter was Venko, a big, strong, gloriously boisterous and comparatively young Russian. He had lived for years in an English Midland town and had left an English wife and children there to come to Russia after the revolution. The only sentimental thing in his mind was his family in England. Sometimes he was perplexed thinking about them. He said he was sure they wouldn't like living in Russia and he had no desire to return to England. He was not sentimental about his substitute Russian wife. He said she had married him only to get good food and a good apartment to live in. He was of peasant origin and she seemed to be from the poor professional class. Their living room constantly reminded me of that of the poor officer in *The Brothers Karamozov*. It was like a seamstress's place, with a sewing machine installed and scraps of cloth lying carelessly about, from which one's clothes picked up bits of thread, and it had a peculiar odor like that of clothes being washed with brown soap. But she was a good wife. Sometimes I stayed at Venko's house, after we had finished at a meeting and resorted to a café to drink vodka. And however late we got there, his wife would get up to serve food.

Venko was an interpreter in the O. G. P. U. He was not connected with the intelligence work. He didn't like office work. He preferred to agitate crowds. He was a marvelously gesticulating, noisy and frothy agitator, but there was not much substance in his phrases. And if you don't give Russians some

meat to chew on when you talk to them, they soon tire of you, however brilliant your fireworks may be. If you have something to say they will listen for long hours upon hours, as patient as sheep, even if you are speaking in a strange language. And afterward they will ruminate on it with satisfaction through more long hours of interpreting. Venko was a good enough interpreter. My stay in Moscow was a vacation for him, of which we made a picnic. He was unorthodox about life, whether it was old or new, even as I, and he made the most unguarded and biting criticisms of things and personalities in his profane and boisterous Russian way.

The Moscow Soviet made me an honorary member at one of its meetings. A few days later Venko accompanied me to the office of the Soviet, where I was to receive the little red book that would make me even a more privileged personage than I was. The card was made out by a comrade clerk and my photograph was affixed. Then Venko and I were ushered into the presence of Commissar Kamenev, the president of the Moscow Soviet, for him to affix his signature.

Kamenev was extremely dignified and perfectly attired in black, with white collar and black tie, the best-dressed Bolshevik official (according to the smart European standard) that I had met. He welcomed me with a courteous smile, signed my card, shook my hand, and said he was proud to deliver it to me in the name of the Moscow Soviet. Venko translated. The simplicity of Kamenev's official dignity moved me very much, for in his fine-fitting conventional clothes, I might have mistaken him for a responsible banker, or a Protestant clergyman, or a high-ranking continental diplomat, anything but what Venko startled me by suggesting.

For as we got outside Venko exploded: "Good God, Comrade! I have seen the Czar!"

"What do you mean, the Czar?" I said.

"Kamenev in the place of the Czar. The same clothes, the same manner of wearing his beard! Good God, Comrade, a Jew in the place of the Czar!" Kamenev's features were indeed remarkably like the Czar's.

"Why, don't you like Jews?" I asked in astonishment. It was the first anti-Jewish sentiment I had heard from a Russian Communist.

"No, Comrade, I won't lie to you; I don't like Jews."

"Are you a pogromist?" I asked.

"Good God, Comrade, no. I fought the White-guard pogromists in the Ukraine and was wounded. The White guards started pogroms against the Jews. I fought them and fought the pogroms too, for pogroms are a crime against our Communist party. But I don't like the Jews, Comrade. All the Nep men are Jews."

"All?" I exclaimed.

"Well, if not all, nearly all. And all the money changers of the Black Bourse are Jews."

I record this conversation because it was one of the impressive and unforgettable things I heard from a Communist in Russia. I was particularly impressed because, as a member of a minority group in America that was the victim of blind and bitter prejudice, I was interested to know if the prejudice against the Jews had been automatically swept away with the Czarist régime.

I was interested, because I did not hold to the sentimental idea that the deep-rooted prejudices of a people could be eradicated overnight. What the Bolsheviks had accomplished was to put a stop to the vicious political exploitation of group

and race prejudice. I don't think the saintliest human being could ask more. Individual prejudice is one of the most natural sentiments. It is easy enough for an individual prejudice to become a family prejudice, for family ties are real. And it is also easy for such prejudice to spread to a group, for groups exist and the majority of human beings are fundamentally tribal.

I was not at all shocked by Venko's revelation. I was merely enlightened. If he were an intellectual Communist, he could not have spoken to me as he did. I preferred to go around with him, because I could learn more.

One evening Zonov invited me to a party which he did not want Venko to know about, for it was a bourgeois party. The guests were celebrating a holiday of the old régime which had been abolished by the Bolsheviks.

The party of that little remnant of the Russian bourgeoisie was something not to be missed. It was even more Russian, noisy, and elastic than the proletarian parties, for these people did not have to bother about correct Communist conduct. Maybe there was a flickering note of futility, of despair, which made them more reckless, because, unlike the Communists, they had no future. The limited luxury of the Nep for the moment was theirs to enjoy. And they were giving themselves to the moment unforgettably, as you might give yourself to a page of Chekhov.

Russian life seems to blow through space like a big breeze, and this remnant of a bourgeois society was no less a part of that big breeze. How they ate and danced and chattered in loud harmony! Two huge fruit cakes reared themselves like wedding cakes on a sideboard, and there were platters of caviar, sturgeon, salads, cheeses, every delicious food to

tickle the palate, and gallons of Caucasian wine and vodka to wash it down.

I was introduced all round as a guest of Russia. They all knew that I was a guest of the Soviets, and if they wanted to make it a guest of Russia instead, I had no objection to the added distinction. One very beautiful and proud-looking young woman got the back of her hand up to my lips with one of those exquisite gestures that only people who are born to them can make, I guess.

I made the best bow that was natural to me for that honor. But the young woman was not satisfied with my bow. She stamped her foot petulantly, though not unkindly, and rubbed my nose with the perfumed back of her hand. I was convinced that something more was expected of me, so I reached up my hand and took hers.

She led me to a seat and said rapidly in a voice that sounded like fine tinkling glass: "Why did you refuse to kiss my hand? Do you think it is degrading for a Communist to kiss a lady's hand?" She spoke lovely English.

"No, *Tovarish*—"

"Please don't call me by that disgusting name," she interrupted. "I am a *barishna*."

"Well, *Barishna,* then, if that is your preference, I did not kiss your hand simply because I don't know how to do it well. Nobody I know kisses hands in America."

The *Barishna* conceded an indulgent smile. "Tell me," she said, "do you like our Russia—Moscow and Petrograd?" I said that I did.

"As much as London and Paris and Berlin?" she asked.

I said, "More than London and Berlin. But I do not know Paris."

"I believe you," she said. "I know London and Paris and

Berlin, but I love Petrograd more. Now there is no Petrograd." "But you have Moscow. Moscow is more beautiful," I said. "Oh, but Petrograd was magnificent before the revolution." I could never imagine Petrograd being more beautiful than Moscow, but so many Russians said it was.

Said the *barishna*, "I tell you, I don't like the foreign Communists. You come here to gaze at us as if we were strange animals in a zoo, to mock at and insult us in our distress. That is hateful."

"*Barishna*," I said, "I don't understand. What do you mean? The foreign Communists come here bringing greetings from the workers abroad to the workers of Russia. They do not come here to mock and insult, but to praise and learn about the revolution."

"Oh, they do mock at us," she insisted. "My young brother works in one of the important departments and he heard a foreign Communist boasting that he had slept all night with a lady of title for ten cents. Now isn't that a mean and despicable thing to say? If a real man could buy a lady of quality for ten cents, shouldn't he be ashamed to mention it?"

"I guess so, *Barishna*," I said. "I don't care anything about the difference between titled and untitled loving."

"But you do think it was an unspeakable thing for a *civilized* man to say, don't you?" She stressed the word *civilized* as if I were a savage in her sight and she was eager to hear the opinion of a savage upon a civilized person.

"But, *Barishna*," I said, "the men of your class used to do worse things that that to the women of the class of the man who said he possessed a titled lady for ten cents. They did it to weak and ignorant girls and often didn't even pay the price of ten cents."

"Oh no," said the *barishna*, "no *gentleman* does that."

"But they do, *Barishna*. Many of your gentlemen still exercise even the medieval *droits de seigneur* in a different way. That's what Tolstoy's *Resurrection* is all about."

"So you read our Tolstoy? You like our Russian literature? Oh, I am glad that you do. They have destroyed everything, but they cannot destroy our Russian literature."

I was very embarrassed. Most of the bourgeois people I had met had refrained from saying anything against the Communists, even though they did not praise them. Suddenly the *barishna* said, "I want to leave Russia; I have friends in England. Would you marry me so that I could leave the country with you—just a formal arrangement?" I hesitated and said that I didn't know that I could.

"But many of the foreigners have married Russian girls and got them through to Berlin," she said.

"Communists too?" I asked.

"Yes, Communists too."

"*Barishna*," I said, "I am sorry. I couldn't shoulder even the formal responsibility. And besides, I am not a Communist. I don't even know yet how I am going to get out of Russia myself."

In my rare contacts with members of the expropriated classes I felt the weirdest sensations, as if pages out of Tolstoy, Turgenieff, Dostoyevsky, Artzybashev and Chekhov were suddenly patterned and peopled with actual life.

* * *

Many of the people I knew from the International Club in London were in Russia, some as visiting delegates, while others were permanently settled. Arthur McManus was one of the English-speaking delegates whose company I found congenial, and we were often together, although I found it difficult to keep up with his gargantuan boozing, which per-

haps finally knocked him out dead. Both of us were guests
of the Soviet fleet at Kronstadt and were photographed to-
gether. McManus and I had our points of difference, and
sometimes when we were vodka-heated, our tongues flew
sharply at each other.

McManus was one of the men who had gunned the hardest
after Sylvia Pankhurst. He still felt venomous about her.
"Intellectually dishonest," was his pet phrase for describing
her. I said I thought Sylvia Pankhurst was as honest as any
imperial Briton could be. And I really preferred Pankhurst
to persons like Lansbury, and perhaps even to McManus
himself. McManus shot up like a rabbit (he was a tiny man)
and demanded in his remarkably beautiful Glasgow brogue
if I meant to "insinuate" (that was the word he used) that
he was an imperialist. I said that I had not said "imperialist,"
but "imperial," and that all Britons were imperial by birth
and circumstances because of the nature of the political set-up
of Britain. McManus asked if I did not believe that there were
really radical Britons. I said that no man can be more radical
than his system can stand. McManus said I was a bloody
bigoted black nationalist, and his *b*'s had such a wonderful
ring (he stammered a little) that it made me laugh and laugh
until both of us fell into a prolonged fit of black-and-white
laughter. It was a good satisfying feeling to see McManus
laugh aloud, for there was a perpetually crucified expression
on his countenance that all the Scotch whisky and Russian
vodka in the world could not dispel.

McManus did not appear to like my O.G.P.U. friend and
companion, Venko. It was well known among us that Venko
was an interpreter and translator for the O.G.P.U., but had
nothing to do with the department of investigations and
arrests. Anyone with a little knowledge of police organiza-

tion knows that a police clerk has nothing to do with the actual duties of policing. If Venko had been a secret agent of the O.G.P.U. we would never have known that he worked in that department. And I think I can nose out a secret agent whether he is red or white. I spent a year of my early youth in a police department in a position where I was in constant contact with all the branches of the department. For my part I liked to have Venko along whenever I was invited to a carousel among Communists. For Venko could beat anybody carousing and I thought that if any issue were raised about the affair afterward, Venko would be an excellent asset to have. Whenever I went on a drinking bout with comrades I always saw that they got drunker than myself.

It was necessary to do a little thinking while drinking and laughing. For sometimes funny things happened. Some of the foreign comrades seemed to enjoy playing at political intrigue, apparently without fully realizing that political intrigue, to the Russians, was a serious and dangerous thing. For instance, one of the youthful Indian delegates occupied a room next to mine, and we often went down to our meals and also over to the Comintern offices together. One morning when I called for him his room was locked and there was a seal on the door. The O.G.P.U. had arrested him during the night. Months later I met him in Berlin under the most unusual circumstances, which I shall relate in another place. There was also the young Whitechapel Jew whom I used to know slightly at the International Club in London. He had come to Russia as a youth delegate. But he wasn't functioning as anything when I saw him. He told me fretfully that he had been denounced. One evening he and I were on our way to a motion picture when a group of armed police dramatically pounced upon him. They said something in Russian

and he must have answered satisfactorily, for they did not take him. But he was scared, and said, "I am always scared." Shortly after that incident he was gone too, and I never saw him again. When I reached Berlin the following spring I met William Gallacher (now Communist Member of Parliament) and asked him what had become of the boy. "He was a spy," Gallacher said, "and he was fixed."

I said angrily, "But what have you in the little British Communist Party for anybody to spy on?"

"More than you think," said Gallacher, with a mysterious nod of his friendly head.

One night in Moscow I was invited to a celebration given by a minor Communist official. The address had been written down for me and I had to take somebody along to find it, as I did not know my way around Moscow. So I asked Venko; but first we had to attend a meeting of women workers at which he interpreted for me and we did not get to the entertainment until very late. The large apartment was full of comrades when we got there. I think the man who was throwing the treat was a Finn and there were many Baltic types there, blonde and heavy of movement and impassive of spirit. There was plenty of hard drinking, but it was a dull atmosphere, nothing of the stimulating renascent effervescence of the *barishna's* evening. Venko stepped upon the scene with a burst of boisterous enthusiasm, and drinking a big glass of vodka, he took the center of the room and started speechifying, saying there was a time for good comrades to fight, a time to work, and that now was the time to be festive.

Venko was applauded, and from somewhere McManus came swaying like a tipsy little imp, and pointing at Venko cried in a chanting voice: "O.G.P.U.! O.G.P.U.! O.G.P.U.!"

Venko laughed, and all of us. For he and the others thought that McManus was merely putting over a joke, about his working for the O.G.P.U. But then McManus shouted in English, "Spy! Spy! I am not going to stay here, I am going home. Spy!"

"What do you mean, Comrade?" Venko asked in amazement. "Did I ever spy on you? Do you want to say that I am here spying on my comrades?" Venko said something in Russian and everybody looked serious. But McManus repeated "O.G.P.U. spy! O.G.P.U. spy!" A murderous look took possession of Venko's face. "Comrade," he cried in a terrible voice, "if you don't stop, I'll kill you; you hear? You're not drunk and irresponsible. If you don't stop, I'll hit you, as little as you are." But McManus shouted again: "O.G.P.U. spy! O.G.P.U.—"

Venko knocked McManus down with one blow and kicked him straight across the room, where he lay curled up like a half-dead snake. "You dirty little Englishman!" cried Venko. "Go back home and make your own revolution and don't stay in Russia to insult a real Communist." McManus picked himself up and began shouting: "I am not a Communist, I am an Anarchist! Anarchist! Anarchist!" A comrade clapped his hand over McManus' mouth, and lifting him up like a kid, carried him out of the room.

I couldn't understand the meaning of McManus' outburst, except perhaps that he, like some of the other visiting comrades, was afflicted with spy mania. The company settled down again to drinking and toasting and the singing of revolutionary songs.

The carousel ended with me again uplifted in glory. Venko had shed every vestige of the murderous brutality of a moment before and was acting like a commanding master of

ceremonies. With strong exuberant gestures he toasted me to the company. Always a poet in action, he became a poet in words: "Comrade McKay, you must stay in Russia. We want you. All Russia loves you, not we Communists only, but even the damned bourgeoisie. Tell us, Comrade McKay, why is it you have bewitched us? Tell us, Comrade McKay, what is it? Is it the black magic we have heard about? Comrade McKay, we are bewitched, men, women and children. We all love you, we all want you. Oh, do stay with us forever! Comrade McKay, you must leave Moscow and see Russia. We want you everywhere. . . . Comrade McKay, my heart is bold"—here Venko brutally beat his breast with his enormous fist—"and my back is broad and strong"—Venko bent himself over. "Get up on my back and I will carry you all over Russia: from Moscow to Kazan, from Kazan to Samara and all the way down the Volga we will go until we reach the Caspian Sea. . . ."

With a great shout I was hoisted up into the air. And McManus, awaking from his drunken anarcho-communist nightmare, came zigzagging into the room just as I was being carried out upon the shoulders of that gloriously tipsy crew down the stairs and into the street and put into a *droshky* and conveyed to my hotel. My mind was too stimulated and excited to go to sleep, with Venko's picturesque phrases burning in my brain and creating a tumult of thought. I also had under consideration an invitation to join a caravan of comrades from different countries who were planning a tour of Russia with the Caucasus as the ultimate destination. Should I go? Although I had been only in Moscow and Petrograd, I had traveled already so extensively from triumph to triumph. Should I go further and risk anti-climax, or should I make my exit in éclat, cherishing always the richness

of my golden souvenir? The thought of leaving seemed to be the most logical. I knew myself enough to know that I was not of the stuff of a practical pioneer, who could become a link in that mighty chain of the upbuilding of the great Russian revolution. And also I reflected like a stoic poet that it was best not to be too popular. When I contemplated the overwhelming snow of Russia, it appeared not líke snow anywhere else, but like a thing everlasting, petrified like an ocean of ivory. Yet soon even it would disappear when the season changed. And somewhere from far away beyond the cold Russian nights, glorious like fields of white lilies, another season was coming.

Soon after that, Sen Katayama sent me an invitation to visit the Eastern University. I spoke to a group of students, and then proceeded to visit the dormitories. The rooms, in which the students prepared light meals, appeared somewhat like those of Moslem students in the *medersas* of Morocco. Imagine my surprise, as I was passing through a dormitory, to hear a familiar voice call my name. I looked back and it was Mrs. Slova, reclining on a cot. Mrs. Slova had been charming to me when I was in London, frequently inviting me to her house for high tea. She was a seamstress and she and her three pretty daughters were always smartly dressed. Some of the captious comrades styled her the bourgeois lady. At that time she was wildly enthusiastic about Russia and just biding her time to get there.

"But what are you doing here?" I asked.

"Don't you know? I am a student going to school again," she said. Mrs. Slova had gone to Russia with her daughters immediately following my return to New York from London. She was glad once more to be in the land of her birth, where formerly she was ostracized because she belonged to the

Jewish group. But her three daughters, who were born and reared in comparative comfort in London, were frightened of the confusion of the new burgeoning society. Mrs. Slova quickly and expertly arranged a *mariage de convenance* for each of her daughters with English comrades visiting Russia and sent them back to London. But she remained in Moscow.

I asked if she did not miss her children. "I raised them right, until now they are of age to act for themselves," she said. "They couldn't fit into the new conditions here. Young people are not like us older heads." I said I thought the Communist movement was primarily the movement of youth, and if she in middle age could adapt herself to the changed life, it should have been easier for her daughters.

"Pooh!" Mrs. Slova exclaimed. "Youth is all right when guided and led by older heads. They act more from enthusiasm than from thinking and will rush headlong into anything when they are excited, for youth is the time of excitement. That is why they are preferred as soldiers. But they soon get sulky when there is no more excitement to feed on. All the great statesmen are middle-aged experienced men, even in Red Russia." I was amazed at Mrs. Slova. I never considered her bourgeois because she dressed well, but I always thought that she was oversentimental and romantic. But after all she was a wise person.

She had no desire to return to England. Communally living in a dormitory, sleeping on a cot with her belongings in a locker, she did not hanker after her comfortable middle-class home in London. She was studying languages in the Eastern University, with the intention of entering the eastern diplomatic service. She didn't think any revolution was going to take place in Western Europe for a long time, she said. The

Bolshevik leaders would at last wake up to that fact. She believed in the East, the future of Russia in the East, and that was why she had become a student at the Eastern University.

XIX

A Great Celebration

•

OF all the big Bolshevik leaders, I had desired most to
have a personal word from Lenin. I had been amazed
in 1920, when I received in London a message from John
Reed informing me that Lenin had brought the Negro ques-
tion before the Communist Congress and inviting me to visit
Moscow.

I had not gone to Moscow then because I did not consider
myself qualified to do what John Reed had asked, which was
to represent the American Negro group. But now that I was
there, I was anxious to get Lenin's opinion out of his own
mouth. But Lenin apparently had become very ill again after
his couple of speeches at the Communist and Soviet Con-
gresses in the late fall of 1922. At one of the sessions of the
Communist Congress I was seated directly behind Krupskaya,
Lenin's wife, and I was introduced to her by Clara Zetkin
(the first woman member of the Reichstag), who was very
friendly and affectionate to me. I seized the chance to ask
Krupskaya if it were possible to have an interview with
Lenin. She said she would see. But nothing came of that.
Some time after I visited the office of *Pravda* with a Com-
munist sympathizer. He was acquainted with Lenin's sister,
who held a position on the staff, and he introduced me to her.
I told her that I would like to have a word from Lenin
himself and she said frankly that it was impossible, for Lenin
was very sick.

Krupskaya was an extremely plain woman, really ugly.

Max Eastman was so appalled when he saw her that he said, "Lenin would probably get well if he had a pretty girl! "So I said, "Like the Shunamite virgin, who warmed up King David of Israel in his old age, eh?" But we did not think that Lenin was that type of warrior.

I tried to reach some of the other leaders whom I had not yet met. One day as I was passing through the grounds of the Kremlin with Andreyev, one of the young officials of the Foreign Office, he pointed out to me a strikingly big man wearing high black boots. That, he said, was Stalin, who was chairman of the Committee on National Minorities. It was the first time I heard the name of Stalin, and the information was extremely important. I asked Andreyev if I could meet Stalin. Andreyev said that that was difficult, for Stalin was one of the big Bolsheviks and it was not easy to meet him. But he promised to approach Karakhan about it. Perhaps Andreyev was tardy or unsuccessful in his *démarche;* at any rate I heard no more of it, and my request vanished from my thoughts when I came in contact with the magnetic personality of Trotsky.

Trotsky, although apparently so formidable a character, was, with Bukharin, the most approachable of the big Bolsheviks. I was told that any message sent to Trotsky would be certain to receive his personal attention. So I sent in a request to meet the Commissar of War. In a couple of days I got an answer making an appointment and saying that an aide would call to convey me to the Commissary of War.

Exactly at the appointed hour the following day, as I descended the stairs of the hotel, an official automobile drove up with a military aide and I was escorted to the war department. I passed through a guard of Red sentries and was ushered immediately into Trotsky's office. Trotsky was wear-

ing a commander's uniform and he appeared very handsome, genial and gracious sitting at his desk. He said he was learning English and would try to talk to me in that language.

Trotsky asked me some straight and sharp questions about American Negroes, their group organizations, their political position, their schooling, their religion, their grievances and social aspirations and, finally, what kind of sentiment existed between American and African Negroes. I replied with the best knowledge and information at my command. Then Trotsky expressed his own opinion about Negroes, which was more intelligent than that of any of the other Russian leaders. He did not, like Steklov, the editor of *Izvestia,* imagine Negroes as a great army for cannon fodder. And unlike Radek, he was not quick to make deductions about the causes of white prejudice against black. Indeed, he made no conclusions at all, and, happily, expressed no mawkish sentimentality about black-and-white brotherhood. What he said was very practical and might sound reformist in the ears of radical American Negroes.

Trotsky said in effect that the Negro people constituted a backward group, socially, politically and economically, in modern civilization. I remember distinctly that he used the word "backward." And he stressed the point that Negroes should be educated, should receive not merely academic education, but a broad spreading-out education in all phases of modern industrial life to lift themselves up as a group to a level of equality with the whites. I remember again that he used the word "lift" or "uplift." And he urged that Negroes should be educated about the labor movement. Finally, he said he would like to set a practical example in his own department and proposed the training of a group of Negroes as officers in the Red army.

Before I left, Trotsky asked me to make a summary of my ideas, in writing, for him. This I did, and he wrote out a commentary on it and published both either in *Izvestia* or in *Pravda*. Unfortunately I lost the original article and its English translation among other effects somewhere in France. But the gist of it all is given above.

Also, Trotsky gave me a permit to visit some of the training schools of the Soviet forces. I had not the slightest idea that that meant a passport to a series of inspections and elaborate receptions. I thought I was going to make perhaps a couple of quiet and unobtrusive visits to the military schools. What transpired was amazing, but also embarrassing, for, except for the martial music, I have never been vastly thrilled by military demonstrations.

For about a month I was fêted by the military forces. I was introduced to military and naval officers and experts. I was shown the mechanism of little guns and big guns. I did a little target practice. I passed through reviews, receptions and banquets, a glamorous parade of militant Red from Moscow to Petrograd.

It started in Moscow. First I was taken on a visit to the crack Kremlin military schools; then to an ordinary soldiers' barracks where the men were resting or on fatigue duty, and also to an extraordinary one where everything and everybody was shipshape as if for an inspection by the highest authorities. Next I visited the tactics school, the infantry school, the cavalry school, the artillery school. It was almost three weeks before I got through my Moscow military itinerary. There were intervals of days between the various visits, of course. And there was a continuous big feeding, until I thought my belly would burst. I ate in the soldiers' mess. I ate in the officers' mess. I ate with the military professors. I asked for

kasha and was grandly served, with officers and Communist controllers, an elaborate and most appetizing dish comparable to *arroz Valenciana* or Moroccan *cous-cous*. While I was eating it I remembered a long sentimental poem by Rose Pastor Stokes which we had published in *The Liberator,* in which she sang of her desire to share the Russian peasant's bowl of *kasha*. Yet as I remember, her first picturesque gesture in Moscow was the buying of a marvelous mink coat and cap, and she was the smartest woman in the Congress. . . . Thus I learned something new about *kasha:* that it wasn't only the peasant's staple food, but a national food, eaten by all kinds of people, and one which, like rice, may be served in many different and appetizing ways.

The experience of my military induction ended in a mighty students' celebration of the anniversary of the Red army. The vast audience flamed to the occasion as if it were charged through and lit up by one great electric current. Many notables appeared before the illuminated demonstration. And at last I was called to the stage. I made a brief martial speech and was applauded for more. But I hadn't the Russian genius for improvising great appropriate phrases. Someone demanded a poem, and I gave, "If We Must Die." I gave it in the same spirit in which I wrote it, I think. I was not acting, trying to repeat the sublime thrill of a supreme experience. I was transformed into a rare instrument and electrified by the great current running through the world, and the poem popped out of me like a ball of light and blazed.

Now, thought I, the amazing military sensation is ended. It was an enjoyable excitement, but it was also a pleasurable relief to be over and done with it. But this audacious adventurer had reckoned without the Red fleet. From Petrograd came an invitation from the Red fleet, which apparently

meant to rival the Red army in its reception. And so I entrained for Petrograd, accompanied by a military cadet. That was my third going to Petrograd. And each time the city appeared better, revealing more of its grandeur. For, unlike Moscow, Petrograd does not start immediately with color and mazy movement and life compact with a suggestion of Oriental lavishness rioting and ringing upon the senses like the music of golden bells.

Petrograd is poised and proud, with a hard striking strength like the monument of Peter the Great, and a spaciousness like the Neva. In its somber might it appeared brooding and a little frowning of aspect at first. Many streets were desert stretches, and massive buildings still bore the gaping wounds of the revolution. But when one became a little more acquainted with the city, the great half-empty spaces became impressive with a lonely dignity and beauty. And the Petrograd people were splendid, too, in that setting, outlined more clearly than the Moscow folk. They were like clumps of trees growing together for protection at intervals in a vast plain.

We arrived in Petrograd on the eve of the celebration of the twenty-fifth anniversary of the Russian Communist Party. That night I went to the Marinsky Theater to see *Prince Igor* for the first time, and the thumping performance of the ballet stirred me like strokes of lightning with great claps of thunder. It was so much more wildly extravagant than the *Eugen Onegin* one I saw in Moscow. In New York I had attended two performances of the Pavlova ballet (I think in 1916), and now I compared them with this Petrograd magnificence. The Pavlova ballet was like birds flying with clipped wings, but the Petrograd *Prince Igor* was like free birds in full flight. Although I did admire immensely

the dainty precious Pavlova herself, her company appeared so restrained. I never could work up any enthusiasm for the modernistic contempt of the Russian ballet. The technical excellencies alone thrum on the emotional strings of anyone who has a feeling for geometric patterns.

Isadora Duncan and I argued and disagreed on this subject for a whole evening at her studio in Nice. She said the Russian Revolution should have abolished the ballet and established the free-limbed dance. I said I preferred to see both schools of dancing have the same freedom for expression. Isadora was even more severe on Negro dancing and its imitations and derivations. She had no real appreciation of primitive folk dancing, either from an esthetic or an ethnic point of view. For her every movement of the dance should soar upward. She spoke beautifully about that uplifted upward movement, although it was all wrong. But when she danced for me it was all right. I had never seen her in her great glory and couldn't imagine that she could still be wonderful when she was so fat and flabby. But what she did that night was stupendous. I was the only audience besides the pianist. And she danced from Chopin, Tchaikovsky, Wagner and Beethoven. Her face was a series of different masks. And her self was the embodiment of Greek tragedy, *un être* endowed with divinity.

The day following the performance of *Prince Igor,* I paid my respects to the commander of the Baltic fleet. He was a kindly man, and presented me with his photograph. He took me around to the naval preparatory school, the naval gymnasium and the naval academy. The young cadets demanded that I say something. So I told them briefly that I felt singularly honored and happy that my first contact with any fleet should be with the first Red fleet of the world. And that

although it was a strange life of which I was entirely ignorant, I thought that, if I had to be a fighter, I would rather enlist in the navy than in the army.

The applause I received was astounding, since what I said was so brief and simple. But quite unwittingly I had stirred the traditional rivalry between army and navy, which may be a little different but no whit less even though they may be Red. But my military escort from Moscow (the only soldier among that fine body of proud and eager young sailors) was not enthusiastic about my quip. I suppose I should have been a little more tactful about the army, since it had first celebrated me as a guest.

That night started the celebration of the twenty-fifth anniversary of the Russian Communist Party. The opening meeting was held in the Marinsky Theater. Zinoviev presided. The place was packed. As soon as I appeared in the entrance a group of young cadets bore down on me and, hoisting me upon their shoulders, carried me down the length of the aisle and onto the platform, while great waves of cheers rolled down from the jammed balconies and up from the pit. Zinoviev made a great show, greeting me demonstratively on the stage. The Russians are master showmen.

From then on the days of my official visit to Petrograd were a progress of processions and speeches and applause and reviews and banquets. The next day marked my visit to the naval base at Kronstadt. Early in the morning an aviator's fur-lined leather coat and cap and gloves—fit to protect one against the bitterest Siberian blizzard—were brought to my hotel. I breakfasted and togged myself out. Soon afterward a young Red commander called for me in an automobile and we drove to the Petrograd air field. Besides the naval and air officials and photographers, there was quite a crowd gathered

to see me take off. I posed for the photographers with some of the officers and sailors, with the pilot, and also with Mc-Manus, of the British Communist Party, who had come to Petrograd for the anniversary.

Then I climbed up into the airplane. The man who had once saved Lenin's life (so I was informed) fixed me in place, and the plane sped over the vast field of snow and up into the air. A snowstorm was raging, but I was perfectly protected and felt no fear. Only I could not see anything. The pilot missed his bearings and got a little lost in the storm and we had to come down far from our landing place. The pilot and I got out of the plane and started to walk toward the naval base. The blizzard blew hard and we could see nothing. But it was a fine exhilarating tramp, and, warm in my great boots and fur clothes, I enjoyed the sensation of thinking I was doing a little Arctic stunt.

At last an automobile came rolling over the hard snow and took us to our landing place. They had been scouting for us, knowing that something must have happened when we did not arrive. At the landing place I found that a crack squad of sailors, fine handsome fellows, had been waiting for us for hours in the blizzard. They were not rigged out, like myself and the pilot, against the bad weather, and were cold. For the life of me I couldn't understand why a squad of men should have been detailed to await my arrival at the air base, when I was no kind of official. And I had been told that my visit was an informal thing. Right there I remembered my experience in the Pennsylvania railroad service — how often, in the cold steel car out on the track, our crew waited for hours in biting zero weather until the late train arrived and steamed us out. And sometimes we were frost-bitten.

My interpreter said that the sailors were expecting a speech. So I said that although I anticipated with joy my visit among them in Kronstadt, I felt sorry that it had been necessary for them to wait for me all those hours in the cold. All the official routine ceremonials were extremely tiresome to me. Even though they were the expression of the workers' and peasants' united authority and were therefore simplified, they were nevertheless tedious. I can work up no enthusiasm for official ritual, however necessary, whether it be red or pink or black or white. In Russia I was alertly aware that it was something different from anything that ever was, that officially it was the highest privilege I could have in the world, to be shown the inside working of the greatest social experiment in the history of civilization. I was fired and uplifted by the thundering mass movement of the people, their boisterous surging forward, with their heads held high, their arms outstretched in an eager quest for more light, more air, more space, more glory, more nourishment and comfort for the millions of the masses. But the bureaucratic control left me unmoved. Yet I was conscious that it was the axis of the mighty moving energy of the people, that without it their movement would be futile.

So I was actually in Kronstadt, the first fortress fired by the signal of the revolution. The features of the fort were covered up with snow, but the splendid men holding it showed me the inside of battleships and submarines, the loading of big guns, and I saw also the educational classes, Communist meetings, recreation halls with motion pictures and feats of gymnastics and dancing, the new revolutionary spirit animating men and officers alike, the simple dignified discipline of rank and precedence, organization and work.

After a strenuous day, that night I slept soundly on a

flagship. The next day I motored back to Petrograd. In the afternoon I went to tea with Korney Chukovsky and his sympathetic wife. Chukovsky was a popular liberal journalist and author of the old régime, and was now an equally popular fellow-traveler with the new. He was a radical liberal in his political opinions, but consistently non-political in his writings. Under the old régime he was a contributor to the Moscow newspaper, *Russky Slovo,* which had a circulation of over a million. He had recently finished a book for children, called *Crocodile,* which became a best-seller. Chukovsky was a member of a Russian intellectual mission to the Allied capitals, in 1916, I think. He exhibited a large souvenir book of interesting autographs of famous personages: Asquith, Lloyd George, Balfour, Churchill, Poincaré, Millerand, Anatole France, Kipling, H. G. Wells, and many more. I added mine. Chukovsky showed me also a couple of letters from Lenin to Gorky, which he prized highly, and some newspaper cuttings of a critical duel between him and Trotsky over the evaluation of the work of the poet Alexander Blok, who wrote the tragic poem, "The Twelve." This poem evoked in me something of the spiritual agony of "The Hound of Heaven." Chukovsky gave me the gist of the controversy between him and Trotsky. Chukovsky had done a fine literary critique of Blok. Trotsky had overemphasized an inoffensive literary reference to the revolution to score a political point. I thought that Chukovsky was right and Trotsky was wrong. Chukovsky went with me to the House of the Intellectuals and introduced me to some of the writers and artists. I remember the names of Metchnikov, son of the scientist and disciple of Pasteur, and the Princess X, who was rich before the revolution, but expropriated now and living with artists

whom she had befriended during the salad days of the bour-
geoisie.

The next day was fine and clear as crystal. And to make
up for what I had missed when we flew to Kronstadt, the
aviator came and took me up for an hour's ride over Petro-
grad and suburbs. I ended that trip to Petrograd with affec-
tionate farewells from the naval schools. One of them elected
me an honorary officer. There, too, I talked with a very inter-
esting officer. He was a graduate of an exclusive Czarist
academy, young, exceeding handsome, with very sensitive
features. We spoke with difficulty in a kind of lingua franca
or *petit-negre,* to be more precise. He informed me that he
had an American wife and invited me to dinner with them.
I said it might be an embarrassing matter to his wife, that
he should first ask her. He said she knew all about me and
had suggested the invitation.

I wondered about this American wife of the Russian officer.
I had been warned to beware of English-speaking bourgeois
persons, who might try to pump things out of me. But as I
possessed no secrets of any kind and as I desired to experi-
ence all the sensations of the new order struggling to extricate
itself from the old, I never turned aside from anything or
anybody that might possibly add something to the fulness of
my exciting adventure.

I had already met some extraordinary people of the old
régime. Besides the Russians, I had encountered a most won-
derful Englishwoman, who reminded me of a character out
of H. G. Wells's *Food of The Gods.* This woman had been
an English governess in Russia under the old régime and
had married a second- or third-class Russian official. She had
a nice apartment in Petrograd. Her beautiful daughter was a
clerk in one of the Soviet departments, and sometimes the

mother herself was requisitioned as an interpreter. In her sitting room there was a photograph of the late Czar and Czarina, with the Czarina smudged out. It was a bold thing to have the photograph of the Czar in your sitting room in 1922. But she was an Englishwoman first, even though she had been married to a Russian and was now a Soviet citizen. She said to me: "I preserve the photograph of the Czar because he is the cousin of King George. He was a good man, but his wife was a bad German woman." Also she had the picture of King George alongside that of Lenin on another wall. "They are the two big men in the world," she said to me, "and I make my curtsy to them every morning: the ruler of England, my native land, and the ruler of Russia, my adopted country."

She was very proud and pleased with my notorious self because I was born a British subject and had lived in London. She didn't even mind when I said that I did not like the English people as a whole, but admired some individuals. Indeed, she liked it, because that also was her feeling. I spent a long evening in her house and ate very English roast beef and plum pudding. Perhaps too much. For later it was necessary for me to go to the w. c. There I was amazed to see, placed prominently upon the wall, a hand-printed card bearing the motto: "Cleanliness is next to Godliness." When I returned to the sitting room I complimented her on her nice old English calligraphy, but said that I wondered why she had put up the notice in English, when most of her visitors must be Russians, who did not know the English language. She said, "When the Russians don't understand, they will ask, because they are a curious people. I have to have these English hints around to remind them that we are a superior people."

Eliminating my military aide from Moscow and my officer-

interpreter of the Baltic fleet, I went alone to the officer's apartment. His American wife turned out to be a Latin-American. She was unmistakably an octoroon. She was pretty, and, if she had been taller, would have been a great beauty. Nevertheless she had had a pretty time under the old régime and had been celebrated as an exotic flower in smart and expensive bohemian circles. When the revolution overwhelmed the Capital, this exotic creature of the smart set married the young officer who had worshipped her in the hectic pre-revolutionary period, and who had decided, when the revolution came, to serve under the Bolsheviks.

She spoke nice English. Also, she had prepared a good dinner, with that Russian pink cold soup that isn't so good to look at, but most excellent to taste, caviar, ham, some sort of boiled meat, and Caucasian wine. She talked a lot about herself and her husband and their son. His son, really, by a first marriage. He was a lad going to high school, and they were worried about him. They said that the boy would never have a chance under the Bolshevik régime. And the officer said that he himself was having only half a chance, that he was absolutely loyal to the Communists, because he was convinced that they were in Russia to stay and that nothing now could take the power away from them. But the Communists did not trust him because he had been a former Czarist officer. They were training the proletarian youths to become officers, and as soon as the proletarian cadets were trained, the old officers would be superseded. I asked him if he were certain that the Czarist officers who had come over wholeheartedly to the revolution would really be kicked out of their positions when the young proletarian officers were trained to take their place. He said that that was positively true, for it was a Communist policy which had been stated

publicly. I said that I was going to find out, without quoting
him. He said that I might.

However, I did not mention the subject right away to any-
one in Petrograd. After ten fleeting days with the glorious
Red fleet, seeing and hearing all and believing that all was
a dream, I returned to Moscow for the third time. Only when
I came back to Petrograd a month later and for the last time,
to get a boat for Germany, did I speak about the officer's
case to my friend the Red officer, member of the Com-
munist Party and of the Petrograd Soviet. A young man he
was, small, quiet, ordinary-looking and so unobtrusive that
you wouldn't imagine his importance in the Red navy and in
the higher Communist councils unless you could appreciate the
power of his clear, cold blue and all-seeing eyes. I was inter-
ested in what the officer had said because a high-school teacher
in Moscow had said the same thing to me, as had also a lady
of the old régime who was acting as interpreter when I
visited one of the Petrograd courts during a trial.

I wanted to ascertain whether the members of the defeated
bourgeoisie who were working for the Soviets could not
be guaranteed the security of their jobs if they were loyal
to the Soviets. For it seemed to me that if they felt their posi-
tions were insecure and that there was no future for their
children under the new régime, they naturally would sabotage
the Soviets. The Red officer confirmed the statement of
the former Czarist officer: that the bourgeois officers would
be superseded as soon as the proletarian cadets could be
trained to take their place. I said I thought such a procedure
unfair, and that it would make the bourgeois workers enemies
of the Soviet system instead of friends, and force them into
sabotage. The Red commander said that the Communist con-
trollers were alert to detect any tendency toward sabotage

on the part of bourgeois employees of the Soviets, and he accused me of bourgeois sentimentality.

I said that if he had said intellectual sentimentality, he might have been perhaps right, but that I couldn't have the sentiments of a class I was not born into or educated with. I did not think that there was any such thing as intellectual equality, I told him, and that radicals had a sentimental way of confusing social with intellectual equality. I said further, that I did not believe that talent could spring up easily out of a people, like grass under one's feet.

The officer asked who had been talking to me about the matter. I said that nobody in particular, but different persons in Moscow and Petrograd had spoken of it. Which was strictly true. There was a sequel. A year later I was in Paris one afternoon, waiting to cross from the Place de l'Opéra to the Café de la Paix, when I was suddenly touched on the shoulder. I turned and found myself face to face with the officer. We went to the café for a drink. The officer had arrived in France with other officers to recover some Czarist ships which the French government held somewhere down on the North African coast. We reminisced about the splendid Red days we had enjoyed together in Petrograd and Moscow. We talked about our friends of the foreign office and the Comintern. I had already met some of them in Berlin and Paris. And he said, "Do you remember that officer you had dinner with in Petrograd?"

"Yes," I said, "I remember, but I wasn't aware that you knew about my having dinner with him."

"Well, he is sitting in prison now."

"What for?" I asked.

"Sabotage."

When I returned from Petrograd to Moscow I told Sen Katayama that I wanted to go home. It was the beginning of April. Sen Katayama said that, as an unofficial delegate, I would be given my return fare. He was very pleased with my success and the part he had played in making it possible. He said: "I welcome all the Japanese and Chinese who come here. Some are not Communists, but I see that they are treated right, for I want to make them all Communists." He said it had been decided that I should not go back by way of Poland, since some of the delegates had had trouble in passing through. A Japanese had been put in prison and lost all his papers. It was considered better for me to go as I had come, by boat.

I bade my friends goodbye and returned to Petrograd. But the harbor was ice-locked and I had to wait six weeks before a boat could sail. I was put up in the house of the former Grand Duke Alexander, who was a patron of arts. I had the Duke's own bedroom and study, and his valet to wait on me. The valet was a nice old fellow, but he was like a ghost wandering through the palace. He lived entirely in the past and spoke of the sumptuous days in Berlin and Paris with the Grand Duke. He spoke fluently in French and English. He was shocked at the state of my wardrobe. The only thing in it that he thought fitting for a Grand Duke's closet was a fine pair of boots which had been given to me by Eugen Boissevain.

I did not like the palace rooms, especially the study. It reminded me of a cathedral altar. All the walls were rococo, carved and painted in inharmonious brick red. But the cadet who had made himself my orderly thought the rooms very grand. The cadet wanted to do everything, so I dispensed with the valet's services, but tipped him every week.

I got to know Petrograd thoroughly during those weeks. I was shown all the works, among them the great Putilov iron and steel plant and the rubber factory. I liked the visits, but I thought it must have been rather bothersome to the managers of factories who were always pestered by having to take visitors over the plants. I went down into the dungeon of the prison of Sts. Peter and Paul to see the cell in which Prince Kropotkin had been confined. I visited the Department of Nationalities, and Rayeva, the secretary, explained the status of the minority peoples under the Soviets. Also I visited the Department of Woman's Work at the Smolny Institute, where Nicolayeva, the secretary, told me all about the new regulations concerning marriage and divorce and joint individual property, and how the factory workers were cared for during the period of pregnancy and childbirth. She sent me to a meeting of enthusiastic women workers, who passed a resolution asking that a group of colored working girls visit Russia.

May Day in Petrograd was a mighty celebration of workers and soldiers and sailors. Never before or since have I seen such a demonstration. Half-empty Petrograd was filled with the shouting of millions who peopled the streets, marching and singing and holding high their red banners of hope. For hours I stood with Zinoviev and other Petrograd leaders in the reviewing stand in the Uritsky Square. And the demonstration so tremendously swept me along that after attending the People's Theater that night, I could not sleep. I sat down at the table of the Grand Duke Vladimir Alexander, looking out on the Neva, with the gorgeous silver of the beautiful white night of Petrograd shining upon its face, and wrote until dawn. I was happy. Petrograd had pulled a poem out of me.

The poem was published in the Petrograd *Pravda* and re-printed all over Russia. It was the last thing I wrote in Russia. I was overwhelmed with praise. The praise of the Communists was expected. I was their guest. But I was gratified most by the praise of the Petrograd literati. For they were a proud lot, cold or passive to the revolution. The Russian translator of Walt Whitman said that I had composed a classic. But they had it in translation. I think it should be exhibited here in the original.

PETROGRAD: MAY DAY, *1923*

The Neva moves majestically on,
The sun-rays playing on her breast at seven,
From her blue bosom all winter's snow-slabs gone.
Now ripples curl where yesterday lay riven
Great silver oblongs chiselled by the hand
Of Spring that bellies through Earth's happy womb,
To glad and flower the long, long pregnant land!
Where yesternight a veil of winter gloom
Shrouded the city's splendid face,—today
All life rejoices for the First of May.

The Nevsky glows ablaze with regal Red,
Symbolic of the triumph and the rule
Of the new Power now lifting high its head
Above the place where once a sceptered fool
Was mounted by the plunderers of men
To awe the victims while they schemed and robbed.
The marchers shout again! again! again!!!
The stones, where once the hearts of marytrs sobbed
Their blood, are sweet unto their feet today,
In celebration of the First of May.

Cities are symbols of man's upward reach,
Man drawing near to man in close commune,
And mighty cities mighty lessons teach
Of man's decay or progress, late or soon,
And many an iron-towered Babylon,
Beneath the quiet golden breath of Time
Has vanished like the snow under the sun,
Leaving no single mark in stone or rhyme
To flame the lifted heart of man today,
As Petrograd upon the First of May.

Oh many a thoughtful romance-seeking boy,
Slow-fingering the leaves of ancient glory,
Is stirred to rapture by the tales of Troy,
And each invigorate, vein-tingling story
Of Egypt and of Athens and of Rome,
Where slaves long toiled for knights and kings to reap.
But in the years, the wondrous years to come,
The heart of youth in every land will leap
For Russia that first made national the day—
The embattled workers' day—The First of May.

Jerusalem is fading from men's mind,
And sacred cities holding men in thrall,
Are crumbling in the new thought of mankind—
The pagan day, the holy day for all!
Oh, Petrograd, oh proud triumphant city,
The gateway to the strange, awakening East,
Where warrior-workers wrestled without pity
Against the power of magnate, monarch, priest—
World Fort of Struggle, hold from day to day
The flaming standards of the First of May!

XX

Regarding Radical Criticism

•

THUS ended my adventure in Russia. This detailed account should clear up any "mystery" that is entertained about my going and remaining there. I left Russia with one determination and one objective: to write. I was not received in Russia as a politician, but primarily as a Negro poet. And the tremendous reception was a great inspiration and urge to write more. I often felt in Russia that I was honored as a poet altogether out of proportion to my actual performance. And thus I was fired with the desire to accomplish the utmost.

Excepting for the handicap of lack of money, there was nothing to side-track me from my purpose. I had no radical party affiliations, and there was no reason why I should consider myself under any special obligations to the Communists. I had not committed myself to anything. I had remained a free agent.

But recently in an issue of *The New Masses,* the literary organ of the American Communists, I was singled out for a special attack in an article about Negro novelists. The article, under the guise of a critique, was merely a piece of personal spite and slander.

I take these extracts from that article: (1) I had "written an indignant poem, attacking lynching, wholly lacking in working-class content." (2) I "disappeared mysteriously to the Soviet Union and had retired exhausted to the sidewalk cafés

of Montmartre." (3) "The retired radical had grown fat and ill
and indifferent in Paris."

Against the Communist attack my poem still remains my
strong defense:

IF WE MUST DIE

If we must die, let it not be like hogs
Hunted and penned in an inglorious spot,
While round us bark the mad and hungry dogs,
Making their mock at our accursed lot.
If we must die, Oh let us nobly die,
So that our precious blood may not be shed
In vain; then even the monsters we defy
Shall be constrained to honor us though dead!

Oh, kinsmen! we must meet the common foe!
Though far outnumbered let us show us brave,
And for their thousand blows deal one death-blow!
What though before us lies the open grave?
Like men we'll face the murderous cowardly pack,
Pressed to the wall, dying, but fighting back!

First published in Max Eastman's magazine *The Liberator*,
the poem was reprinted in every Negro publication of any
consequence. It forced its way into the Negro pulpit (a most
interesting phenomenon for this black heretic). Ministers
ended their sermons with it, and the congregations responded,
Amen. It was repeated in Negro clubs and Negro schools and
at Negro mass meetings. To thousands of Negroes who are
not trained to appreciate poetry, "If We Must Die" makes
me a poet. I myself was amazed at the general sentiment for
the poem. For I am so intensely subjective as a poet, that

I was not aware, at the moment of writing, that I was transformed into a medium to express a mass sentiment.

The critic also asserted that my novel, *Home to Harlem,* had no "class-conscious action." When Jake in *Home to Harlem* refused to scab, wasn't that class-conscious? And when he refused to pimp, didn't he demonstrate a high sense of social propriety? Perhaps a higher sense than many of us critical scribblers.

I did not come to the knowing of Negro workers in an academic way, by talking to black crowds at meetings, nor in a bohemian way, by talking about them in cafés. I knew the unskilled Negro worker of the city by working with him as a porter and longshoreman and as waiter on the railroad. I lived in the same quarters and we drank and caroused together in bars and at rent parties. So when I came to write about the low-down Negro, I did not have to compose him from an outside view. Nor did I have to write a pseudo-romantic account, as do bourgeois persons who become working-class for awhile and work in shops and factories to get material for writing dull books about workers, whose inner lives are closed to them.

I created my Negro characters without sandpaper and varnish. If the Communists can create a Negro casual better than Jake in *Home to Harlem*—a man who works, lives and loves lustily and even thinks a little for himself, why in the infernal regions don't they?

Jake leaves Europe for America and Harlem and swings through the Black Belt with a clean manly stride. The Communist critic states that the story of Jake was autobiographical, "dilating upon my own love life." The peeping critic seems to know more about my love life than I do myself. Perhaps it is necessary to inform him that I have not lived without

some experience. And I have never wanted to lie about life, like the preaching black prudes wrapped up in the borrowed robes of hypocritical white respectability. I am entirely un-obsessed by sex. I am not an imitator of Anglo-Saxon prudery in writing. I haven't arrived at that high degree of civilized culture where I can make a success of producing writing care-fully divorced from reality. Yet I couldn't indulge in such self-flattery as to claim Jake in *Home to Harlem* as a portrait of myself. My damned white education has robbed me of much of the primitive vitality, the pure stamina, the simple un-swaggering strength of the Jakes of the Negro race.

The critic declares that I "disappeared mysteriously to the Soviet Union and had retired exhausted to the sidewalk cafés of Montmartre." The statement is untrue, but perhaps truth is not vital to the new criticism that they say must replace the old.

Perhaps the Communist critic, who may be closer to the sources of information than others, may have some inside knowledge of just what exhausted me in Soviet Russia. Of course, I had a hell-raising good time in Russia. I was con-stantly occupied in visiting factories and all kinds of institu-tions, making speeches and writing, besides enjoying the relaxation of cabarets and parties. Perhaps I was fatigued, as any person is likely to be after a passionate spell of any great thing. But as for my being exhausted—hell! It is fifteen years since then, and I am still going strong, if the head-in-the-butt Communist critic doesn't know. Exhausted indeed!

I came out of Russia with my head on my shoulders and my pen in my pocket and determined to write at all costs, so long as I had a piece of bread to bite and a room in which I could think and scribble. And in ten years I wrote five books and many poems. Perhaps too many!

I never thought there was anything worth while for me in the bohemian glamor of Montparnasse. "The sidewalk cafés of Montmartre" held no special attraction for me. Attractive as Paris is, I have never stayed there for a considerable length of time. The longest period was over three months, when I was in a hospital. Montmartre I visited when I was invited by generous Americans who had money to treat themselves and their friends to a hectic time. The Montmartre of the cabarets and music halls never excited me. It is so obviously a place where the very formal French allow foreigners who can pay to cut up informally. It has no character of its own. Paris, away from Montmartre and Montparnasse, seemed to me to be the perfect city of modern civilization. It was the only city I knew which provided quiet and comfortable clubs in the form of cafés for all of its citizens of every class. I appreciated, but was not specially enamored of Paris, perhaps because I have never had the leisure necessary to make an excellent clubman. If I had to live in France, I would prefer life among the fisherfolk of Douarnenez, or in the city of Strassburg, or in sinister Marseilles, or any of the coast towns of the department of the Var.

The Communist critic further states that I "had grown fat, and ill, and indifferent in Paris. . . ." I regret that here I am obliged to become clinical. But the clinic is an important department of life, and the fact about it is that I got *well* instead of *ill* in Paris.

In 1922 I left America in perfect health and more completely whole than the day on which I was born. My first accident of illness occurred in Russia. Sanitary conditions were not ideal in Petrograd and Moscow in 1922. No intelligent person expected them to be after eight years of unremitting international war, revolution and civil war. I remem-

ber that every time I received my linen from the laundry I invariably found lice in it. The linen itself was very clean. But the revolution, sweeping away the privileged classes, also had carried along most of their servants. And of the peasants fresh from the country who replaced them, many were neither competent nor clean.

It was very near the end of my visit that I experienced a sort of deadness in my left side and once my face gradually became puffed up like an enormous chocolate soufflé. I have photographs in my possession, taken in Moscow, which authenticate my condition at the time. There was also an American acquaintance who was unable to turn his head; it was cocked stiff to one side like a macabre caricature, as if it were skewered to his shoulder. I consulted a doctor. He thought the climate had affected me and advised me to get heavy woolen underwear. Later, in Petrograd, I became quite ill and had a tooth extracted for the first time in my life, under the most painful conditions.

I arrived in Germany in the early summer of 1923. Three months spent there were an interval of intermittent fevers and headaches. It was hard labor to concentrate upon a series of articles about Russia for a Negro magazine. In the late fall I arrived in Paris. I consulted a French specialist, who advised me to enter a hospital immediately. While I was convalescing in the hospital I wrote this poem, "The Desolate City." The poem was largely symbolic: a composite evocation of the clinic, my environment, condition and mood.

THE DESOLATE CITY

My spirit is a pestilential city,
With misery triumphant everywhere,
Glutted with baffled hopes and human pity.
Strange agonies make quiet lodgement there:

Its sewers bursting ooze up from below
And spread their loathsome substance through its lanes,
Flooding all areas with their evil flow
And blocking all the motions of its veins:
Its life is sealed to love or hope or pity,
My spirit is a pestilential city.

Above its walls the air is heavy-wet,
Brooding in fever mood and hanging thick
Round empty tower and broken minaret,
Settling upon the tree tops stricken sick
And withered under its contagious breath.
Their leaves are shrivelled silver, parched decay,
Like wilting creepers trailing underneath
The chalky yellow of a tropic way.
Round crumbling tower and leaning minaret,
The air hangs fever-filled and heavy-wet.

And all its many fountains no more spurt;
Within the damned-up tubes they tide and foam,
Around the drifted sludge and silted dirt,
And weep against the soft and liquid loam.
And so the city's ways are washed no more,
All is neglected and decayed within,
Clean waters beat against its high-walled shore
In furious force, but cannot enter in:
The suffocated fountains cannot spurt,
They foam and rage against the silted dirt.

Beneath the ebon gloom of mounting rocks
The little pools lie poisonously still,
And birds come to the edge in forlorn flocks,
And utter sudden, plaintive notes and shrill,

Pecking at strangely gray-green substances;
But never do they dip their bills and drink.
They twitter, sad beneath the mournful trees,
And fretfully flit to and from the brink,
In little· gray-brown, green-and-purple flocks,
Beneath the jet-gloom of the mounting rocks.

And green-eyed moths of curious design,
With gold-black wings and rarely silver-dotted,
On nests of flowers among those rocks recline,
Bold, burning blossoms, strangely leopard-spotted,
But breathing deadly poison from their lips.
And every lovely moth that wanders by,
And of the blossoms fatal nectar sips,
Is doomed to drooping stupor, there to die;
All green-eyed moths of curious design
That on the fiercely-burning blooms recline.

Oh cold as death is all the loveliness,
That breathes out of the strangeness of the scene,
And sickening like a skeleton's caress,
Of clammy clinging fingers, long and lean.
Above it float a host of yellow flies,
Circling in changeless motion in their place,
That came down snow-thick from the freighted skies,
Swarming across the gluey floor of space:
Oh cold as death is all the loveliness,
And sickening like a skeleton's caress.

There was a time, when, happy with the birds,
The little children clapped their hands and laughed;
And midst the clouds the glad winds heard their words
And blew down all the merry ways to waft

The music through the scented fields of flowers.
Oh sweet were children's voices in those days,
Before the fall of pestilential showers,
That drove them forth far from the city's ways:
Now never, nevermore their silver words
Will mingle with the golden of the birds.

Gone, gone forever the familiar forms
To which the city once so dearly clung,
Blown worlds beyond by the destroying storms
And lost away like lovely songs unsung.
Yet life still lingers, questioningly strange,
Timid and quivering, naked and alone,
Against the cycle of disruptive change,
Though all the fond familiar forms are gone,
Forever gone, the fond familiar forms;
Blown worlds beyond by the destroying storms.

More than three years after "The Desolate City" was
written, it was published for the first time in the Negro maga-
zine, *Opportunity*. But by then I was a stout black animal,
splashing and floating in the blue Mediterranean. The French
specialist had said: "You are young, with a very won-
derful constitution, and you will recover all right if you will
live quietly and carefully away from the temptations of the
big cities." I certainly did follow that good advice.

PART FIVE

•

THE CYNICAL CONTINENT

•

XXI

Berlin and Paris

•

A T last the soft breath of spring warmed and conquered
the great harbor of frozen ice and our ship cleaved
through. The first of June we arrived in Hamburg. Nothing
here of the fortress-like austerity of Petrograd. Hamburg was
big and full and busy with the business of free unhampered
commerce. Flocks of ships were loading and unloading their
rich cargoes. Sailors reeled through the low-down streets in
drunken irresponsibility, and there were many Negroes show-
ing their white teeth against all that white wealth.

I spent three days among the docks and the Negroes of
different nationalities and languages and then entrained for
Berlin. Startlingly changed was the spirit of Berlin after an
interval of nine months. In the fall of 1922 a dollar was worth
about a thousand marks. There appeared to be plenty of
money in circulation among all classes, and lots of new and
stylish clothes were in evidence. Berlin was by a long way
brisker and brighter than London. I had a comfortable room
with a middle-class family. Said the head to me: "The
workers are better off than we. We have lost three-quarters
of our investments and incomes. But the workers are well
paid and can buy new clothes, while we of the middle class
must wear the old. And the workers have money to go to
the theaters; they ride second-class in the trains, and we must
ride third."

But now all was changed. Premier Poincaré had seized the
Ruhr early in 1923 and the mark had skyrocketed. I cannot

even recall how many thousands I got for my dollar when I returned to Berlin in the summer of 1923. For every minute the dollar became dearer and dearer. But this fact sticks in my skull: From New York, Eugen Boissevain cabled me twenty-five dollars to Berlin in October, 1922. I was to receive payment (I don't know why) in marks. But just before the amount arrived, I was obliged to leave Berlin for Russia. When I returned to Berlin in June, 1923, my twenty-five dollars was worth only twenty-five cents.

Speculation in dollars and pounds and francs and other foreign moneys was mad. The corners of the principal streets were dotted with money-changing kiosks. Many who possessed foreign money developed a close-fisted psychosis. They didn't want to change their bills into marks until obliged to. And when they had to, it was with regret, for the next minute the dollar would be worth a few marks more. A German Communist friend told me about a certain Anglo-American comrade who would delay paying his bills even though long overdue until the dollar climbed to a new high. By that method he paid about one-half only of the cost of what he actually owed. Said the German Communist bitterly: "Even the foreign comrades are exploiting the German people." Nearly everybody was doing it. I remember a so-called radical publisher who had worked out a profitable plan of printing American books in Germany, because labor and material there were so cheap, and exporting them to sell in America.

My Japanese friend, Sen Katayama, had warned me against returning to Germany. He thought I would be molested because for a couple of years the press of Europe and America had been carrying atrocity stories about the doings of the French black soldiers on the Rhine. But I said I would go back to Germany. Personally, I had not sensed any feeling

against me as a Negro in the fall of 1923 because of the black
troops on the Rhine. Everywhere I had been treated much
better and with altogether more consideration than in
America and England. Often when I stepped into a café there
were friendly greetings—"*Schwartz' Mohr*"—and free drinks.
And now I felt that if Negroes were hated and mistreated
by the Germans because of the black troops on the Rhine, I
wanted to authenticate the changed sentiment for myself. I
did not want to report by hearsay that the Germans were mis-
treating Negroes. And that was why I went from the free
port of Hamburg to Berlin, instead of going directly to Paris.

Well, everywhere in hotels, cafés, dancing halls, restau-
rants and trains, on the river boats and in the streets, I met
with no feeling of hostility. In spite of the French black troops
on the Rhine I was treated even better in Berlin in 1923 than
in 1922. Of course, Berlin was mightily depressed because of
the French occupation of the Ruhr. In the hotel where I
stayed there was posted a sign asking the guests not to speak
the French language. The spirit of depression was expressed
more eloquently in the exchanges than anywhere. The work-
ing people were not as prosperous and happy as in the fall
of 1922, because the new inflation caused by the French occu-
pation had cut down their wages to the bone. If Poincaré
of Lorraine, consumed by an overwhelming fear and hatred
of the Germans, had desired to perpetuate the hatred be-
tween the Germans and the French forever, he could not have
devised a better way.

There was something sullen and bitter, hostile and resent-
ful in the atmosphere of Berlin. And I believe Berlin ex-
pressed the resentful spirit of all of Germany. There were
Wandervögel everywhere like a plague of flies. They had
lost their romantic flavor. More imitation than real *Wander-*

vögel, with their knapsacks slung over their shoulders, casually taking to the streets as nature lovers take to the woods, and they gave one a strange impression of Berlin as a futuristic forest.

I do not know of anything that has rendered so perfectly the atmosphere, temper and tempo of the Berlin of that period than George Grosz's *Ecce Homo.* For me that book of drawings is a rare and iconoclastic monument of this closing era even as Rabelais is of the Renaissance. I had the unique and unforgettable honor and pleasure of knowing George Grosz in Moscow. His photograph and two pages of his drawings had appeared in the special pictorial section of *Pravda,* which also carried a photograph of myself. It was the first time I had seen any of Grosz's drawings. They gripped me. I sought an opportunity to meet him in the Congress Hall of the Kremlin.

When I returned to Berlin I hunted him up to ask him to sign a copy of *Ecce Homo,* which I had bought privately. The book was banned by the government of the Social Democracy. Grosz's remarkable personality gave not the slightest hint of the artistic type. And in his little apartment, his pretty and pleasant *frau* had surrounded him with the neatest of bourgeois comforts. He fitted respectably into the frame, and if you did not know he was an artist, you might have taken him for a responsible bank clerk. Yet there was a charming felicity and harmony in the *ménage.* It gave the impression that Grosz needed just that kind of domestic background from which he could swing up and out with his powerful artistic punches.

Grosz in his appearance seemed the perfect type of a conservative Prussian. But a careful study of his nervous-boyish and whimsical eyes revealed the revolutionary artist in him.

He was a real inspiration to other artists. I heard many lyrical appreciations of his work, a fine tribute to the man, for the breed of artists (judging from my experience on *The Liberator* and among the cosmopolites in France) are hell-hard on their contemporaries. They are liberal and lavish in praise of the dead only or the great. Writers are perhaps more generous. Marsden Hartley, whom I happened across in Berlin, was ecstatic in praise of Grosz's work. But the two artists had never met, so I introduced them. Physically, Grosz was as impressive as his amazingly ruthless drawings, and Marsden Hartley was equally as ecstatic in praise of his person.

I met also Pierre Loving, the writer and critic, who spoke German and kindly hunted me up a large room, exactly right to live and work in. He introduced me to Josephine Herbst, who was very kind and helpful in a practical and also artistic way. Soon after I met again the Baroness von Freytag-Loringhoven, selling newspapers in the street. Our meeting surprised both of us. We talked a little, but she had to sell her newspapers, for she said her rent was overdue. So we made a rendezvous for the next evening at the Romanisher Café.

It was a sad rendezvous. The Baroness in Greenwich Village, arrayed in gaudy accoutrements, was a character. Now, in German homespun, she was just a poor pitiful *frau*. She said she had come to Germany to write because the cost of living was cheap there. But she complained that she had been ditched. She didn't make it clear by whom or what. So instead of writing she was crying news. She wished that she was back in New York, she said. I was accompanied by an American student lad whom I had met at the American Express office. He came from one of the western cities. He professed a liking for me, because of my poetry, he said. He had plenty of money and was always treating me to more drinks than

were good for me. I told him that the Baroness was a real poet and that he might give her a couple of dollars. He generously produced five, and we were all very happy for it.

I had completed my plans to go to Paris when, curiously, I began meeting a number of the comrades whom I had known in Moscow. One day in the Unter den Linden I bumped up against the Hindu youth who had vanished so strangely from the Lux Hotel in Moscow. "I thought you were dead!" I cried.

"And I thought I was going to die," he said. He related the story of his arrest by the O.G.P.U. because he had been denounced as a spy by the head of the Indian delegation in Moscow. He said the O.G.P.U. endeavored to get him to confess, but he had insisted that he was not a spy. He had had differences with the head of the Indian delegation and had thought of giving up revolutionary work and returning to student life. (His father had sent him to Europe to study.) He was kept in O.G.P.U. custody for months. Finally he was sent to some place up Archangel way, and from there he had escaped across the border into Finland. He had always been a thin enough fellow; now he looked like a mosquito. I told him I didn't think he had "escaped," as he thought, but that he had simply been allowed to escape. He asked me why, whether I had had any inside information. But I merely nodded my head and looked mysterious. Poor chap! He was so down in spirits, I didn't want to tell him that I thought the O.G.P.U. were convinced that he was not a spy, but merely a perfect specimen of a moron.

The next day, again on the Unter den Linden, I met Roy, the leader of the Indian delegation. Roy was editing a propaganda paper in Berlin, which was distributed in India. He invited me up to his office and asked me to contribute an

article to his paper about Communism and the Negro. I consulted an English friend, a Communist sympathizer, and he advised me to keep away from the Indian movement because it was too "complicated." The advice was just the kind I was fishing for and I didn't write the article or see Roy again before I left Berlin.

It was interesting in Paris to mix in among the cosmopolitan expatriates. The milieu was sympathetic. It was broader than the radical milieu of Greenwich Village. The environment was novel and elastic. It was like taking a holiday after living in the atmosphere of the high pressure propaganda spirit of the new Russia. There in Paris, radicals, esthetes, painters and writers, pseudo-artists, bohemian tourists—all mixed tolerantly and congenially enough together.

Frankly to say, I never considered myself identical with the white expatriates. I was a kind of sympathetic fellow-traveler in the expatriate caravan. The majority of them were sympathetic toward me. But their problems were not exactly my problems. They were all-white with problems in white which were rather different from problems in black.

There were the expatriates who were lured to Europe because life was riper, culture mellower, and artistic things considered of higher worth than in America.

There were those who argued that a florescence of art and literature was impossible in America: the country was too new.

There were those who were in revolt against the puritan conscience and the denial of artistic freedom in America; the lack of public respect for creative art and artists.

There were those who were harassed by complicated problems of sex.

But when I got right down to a ruthless analysis of my-

self, to understand the urge that had sent me traveling abroad, I discovered that it was something very different from that which actuated the white expatriates.

For I was in love with the large rough unclassical rhythms of American life. If I was sometimes awed by its brutal bigness, I was nevertheless fascinated by its titanic strength. I rejoiced in the lavishness of the engineering exploits and the architectural splendors of New York.

I never could agree that literature and art could not flourish in America. That idea was altogether contrary to my historical outlook. I believed that there would be an American art and culture mainly derived from Europe and augmented by the arts and cultures of other countries precisely as there had been a distinct Roman art and culture mainly derived from Greece, but augmented by the arts and cultures of the countries that Rome had conquered. For America appeared to me pre-eminently a vast outpost of European civilization, being, in its relation to Europe, what Northern Europe was to Rome under the empire. When Europeans said to me: "The Americans, they are barbarians," it stirred up a romantic sensation, and I thought that that was exactly the manner in which the ancient Romans spoke of the inhabitants of Iberia and Gaul and Germany and Britain.

Again, I was not oversensitive about the American public taking the writer and artist like the average person instead of isolating him in an ivory tower. I am partial to the idea of an artist being of and among the people, even if incognito. The puritan atmosphere of America was irritating, but it was not suffocating. I had written some of my most vigorous poems right through and straight out of the tumult and turbulence of American life.

And lastly, sex was never much of a problem to me. I played

at sex as a child in a healthly harmless way. When I was seventeen or eighteen I became aware of the ripe urge of potency and also the strange manifestations and complications of sex. I grew up in the spacious peasant country, and although there are problems and strangenesses of sex also in the country, they are not similar to those of the city. I never made a problem of sex. As I grew up I was privileged to read a variety of books in my brother's library and soon I became intellectually cognizant of sex problems. But physically my problems were reduced to a minimum. And the more I traveled and grew in age and experience, the less they became.

What, then, was my main psychological problem? It was the problem of color. Color-consciousness was the fundamental of my restlessness. And it was something with which my white fellow-expatriates could sympathize but which they could not altogether understand. For they were not black like me. Not being black and unable to see deep into the profundity of blackness, some even thought that I might have preferred to be white like them. They couldn't imagine that I had no desire merely to exchange my black problem for their white problem. For all their knowledge and sophistication, they couldn't understand the instinctive and animal and purely physical pride of a black person resolute in being himself and yet living a simple civilized life like themselves. Because their education in their white world had trained them to see a person of color either as an inferior or as an exotic.

I believe that I understood more about the expatriates than they understood of me, as I went along in the rhythm of their caravan; yet, although our goal was not the same, I was always overwhelmingly in sympathy with its purpose. From conventional Americans visiting Europe I used to hear severe criticisms directed at the expatriate caravan. The critics

thought that the expatriates were wasting their time and that American creative artists should stay at home and explore American life. Some of them made an exception of me. They said that because the social life of the Negro was strictly limited in America, it might be better for a Negro who is a creative artist to seek more freedom abroad. But I was not taken in by that specious form of flattery. As I have indicated before, I was aware that if there were problems specifically black, also there were problems specifically white.

I liked the spectacle of white American youngsters of both sexes enjoying the freedom of foreigners with money on the café terraces of Continental Europe. I liked to watch their feats of unprohibited drinking and listen to their elastic conversations and see them casually taking in their stride the cosmopolitan world of people of different races and colors. Even if they were not all intent upon or able to create works of art, I did not see them as idlers and wasters, but as students of life.

My English friend, Mr. Jekyll, had informed me that it was a custom of the English bourgeoisie and aristocracy to let their sons travel by themselves abroad for a year or so after they had finished college. The British Empire must have gained much from that practice. So I felt that America also could gain something from its youngsters circulating abroad and mingling with foreigners on their own ground. Certainly, whatever they were before, they could not be worse Americans after that experience.

James Joyce's *Ulysses* was published when I arrived in Paris. And Ernest Hemingway's first little book of miniature stories *In Our Time* came out that same year. A good friend gave me a copy of *Ulysses*. A bad friend swiped it.

James Joyce incomparably and legitimately was *le maître*

among the moderns. I cannot imagine any modern and earnest student of literary artistry of that period who did not consider it necessary to study James Joyce. I was privileged to have a few acquaintances of radical sympathies among the moderns, and they all advised me to read Joyce before I started to write. So I did. Some of them thought, as I, that *Ulysses* was even greater as a textbook for modern writers than as a novel for the general public.

Yet after reading *Ulysses* I said to my friends, as I had previously said to Frank Budgen, one of Joyce's early admirers in London, that D. H. Lawrence was the modern writer I preferred above any. I thought *Ulysses* a bigger book than any one of Lawrence's books, but I preferred Lawrence as a whole. I thought that D. H. Lawrence was more modern than James Joyce. In D. H. Lawrence I found confusion— all of the ferment and torment and turmoil, the hesitation and hate and alarm, the sexual inquietude and the incertitude of this age, and the psychic and romantic groping for a way out.

But in James Joyce I found the sum of two thousand years, from the ending of the Roman Empire to the ending of the Christian age. Joyce picked up all the ends of the classical threads and wove them into the ultimate pattern in *Ulysses*. There is no confusion, no doubt, no inquiry and speculation about the future in James Joyce. He is a seer and Olympian and was able to bring the life of two thousand years into the span of a day. If I were to label James Joyce I would say that he was (in the classic sense of the word) a great Decadent.

Some of my friends thought I showed a preference for D. H. Lawrence because he was something of a social rebel. But it was impossible for me seriously to think of Lawrence as a social thinker, after having studied the social thinking of creative writers like Ruskin, William Morris, Tolstoy and Ber-

nard Shaw, and other social propagandists. In fact, Lawrence's attitude toward his subject matter, his half-suppressed puritanism, often repelled me. What I loved was the Laurentian language, which to me is the ripest and most voluptuous expression of English since Shakespeare.

If Joyce was *le maître* of the ultra-moderns, Gertrude Stein was the *madame,* and her house was open to all without discrimination. Even Negroes. I cannot remember how often people said to me: "Haven't you been to Gertrude Stein's?" . . . "Everybody goes to Gertrude Stein's." . . . "I'll take you to Gertrude Stein's." . . . "Gertrude Stein does not mind Negroes." . . . "Gertrude Stein has written the best story about Negroes, and if you mean to be a modern Negro writer, you should meet her. . . ."

I never went because of my aversion to cults and disciples. I liked meeting people as persons, not as divinities in temples. And when I came to examine "Melanctha," Gertrude Stein's Negro story, I could not see wherein intrinsically it was what it was cracked up to be. In "Melanctha" Gertrude Stein reproduced a number of the common phrases relating to Negroes, such as: "boundless joy of Negroes," "unmorality of black people," "black childish," "big black virile," "joyous Negro," "black and evil," "black heat," "abandoned laughter," "Negro sunshine," all prettily framed in a tricked-out style. But in the telling of the story I found nothing striking and informative about Negro life. Melanctha, the mulattress, might have been a Jewess. And the mulatto, Jeff Campbell—he is not typical of mulattoes I have known anywhere. He reminds me more of a type of white lover described by colored women. "Melanctha" seemed more like a brief American paraphrase of Esther Waters than a story of Negro life. The original Esther Waters is more important to me.

Ernest Hemingway was the most talked-about of young American writers when I arrived in Paris. He was the white hope of the ultra-sophisticates. In the motley atmosphere of Montparnasse, there was no place for the cult of little hero worship. James Joyce was worshipped, but he had won out with a work that took men's eyes like a planet. But in Montparnasse generally writers and artists plunged daggers into one another. That atmosphere in its special way was like a good tonic, if you didn't take too much of it. Good for young creative artists who have a tendency to megalomania. And many of them do. And also it was an antidote for the older ones who have already arrived and are a little haughty, expecting too much homage from the young.

It was therefore exciting that Ernest Hemingway had won the regard and respect of the younger creative artists and even of the older. I remember Nina Hamnett pointing him out to me at the Dôme and remarking ecstatically that Hemingway was a very handsome American and that he had a lovely son. But it was long after that before I met him for a moment through Max Eastman.

In Our Time, that thin rare book of miniature short stories, was published, and it was the literary event among the young expatriates. I cherish an unforgettable memory of it and of Montparnasse at that time. A cultivated and distinguished American, liberal of attitude and pocket to unpopular causes, was sitting at the Dôme, reading a copy of *In Our Time.* He invited me to his table and offered a drink. He read aloud Chapter III, and wondered whether there was a *double entendre* in that last sentence: "It rained all through the evacuation." I said I did not know and did not think it mattered, and I asked the *garçon* to bring me a double cognac. My friend and host said: "They are talking in a big way about

this Hemingway, but I just can't get him. I like the young radical crowd and what they are aiming to do. But this thing here"—he pointed to *In Our Time*—"I don't like it. It is too brutal and bloody."

"But so is life," I ventured to say, and not too aggressively, because I was expecting my host to come across with a gift of money.

"The only thing I admire about this book is the cover," he said. "That sure is in our time all right. If you like it you can have it." My hand trembled to take it. The book was worth something between thirty and fifty francs, which was more than I could afford. I have it still. It became so valuable that I once consigned it for a loan. But I redeemed it and, excepting my typewriter, I hardly ever trouble to redeem the things I pawn.

Yet I would be lying if I should say here that when I read *In Our Time* in 1924 I thought the author soon would be one of the famous American writers. I liked the style of the book, but I thought more of it as a literary rarity, and that the author would remain one of the best of the little coterie writers.

I must confess to a vast admiration for Ernest Hemingway the writer. Some of my critics thought that I was imitating him. But I also am a critic of myself. And I fail to find any relationship between my loose manner and subjective feeling in writing and Hemingway's objective and carefully stylized form. Any critic who considers it important enough to take the trouble can trace in my stuff a clearly consistent emotional-realist thread, from the time I published my book of dialect verse (*Songs of Jamaica*) in 1912, through the period of my verse and prose in *The Liberator,* until the publication of *Home to Harlem.*

But indeed, yes, I was excited by the meteor apparition of Ernest Hemingway. I cannot imagine any ambitious young writer of that time who was not fascinated in the beginning. In Paris and in the Midi, I met a few fellows of the extreme left school, and also a few of the moderate liberal school and even some of the ancient fossil school—and all mentioned Hemingway with admiration. Many of them felt that they could never go on writing as before after Hemingway.

The irritating pseudo-romantic style of writing about contemporary life—often employed by modernists and futurists, with their punctuation-and-phraseology tricks, as well as by the dead traditionalists—that style so admirably parodied in *Ulysses,* had reached its conventional climax in Michael Arlen's *The Green Hat.* When Hemingway wrote, *The Sun Also Rises,* he shot a fist in the face of the false romantic-realists and said: "You can't fake about life like that."

Apparently Hemingway today is mainly admired by a hard-boiled and unsophisticated public whose mentality in a curious way is rather akin to that of the American who contemptuously gave away Hemingway's first book to me. I don't think that that is any of Hemingway's fault. And what excites and tickles me to disgust is the attitude of the precious coteries toward Hemingway. One is not certain whether they hate Hemingway because of his success or because of his rough handling of some precious idols. The elect of the coteries could not possibly object to the Hemingway style and material. For the Hemingway of *In Our Time* is the same Hemingway of *The Sun Also Rises, A Farewell to Arms,* and the masterpiece of *Death in the Afternoon.* The only difference I see is that whereas Hemingway is a little cryptic in the earlier work, he is clear, unequivocal and forthright in his full-sized books. *In Our Time* contains the frame, the background, and

the substance of all of Hemingway's later work. The hard-boilism—the booze, blood and brutality are all there. The key to *A Farewell to Arms* may be found in *In Our Time*. The critics whose sensibilities were so shocked over *Death in the Afternoon* will find its foundation in the six miniature classics of the bull ring in *In Our Time,* developed and enlarged with riper experience in the big book.

I find in Hemingway's works an artistic illumination of a certain quality of American civilization that is not to be found in any other distinguished American writer. And that quality is the hard-boiled contempt for and disgust with sissyness expressed among all classes of Americans. Now this quality is distinctly and definitely American—a convention-alized rough attitude which is altogether un-European. It stands out conspicuously, like the difference between American burlesque shows and European music-hall shows. Mr. Hemingway has taken this characteristic of American life from the streets, the barrooms, the ringsides and lifted it into the realm of real literature. In accomplishing this he did revolutionary work with four-letter Anglo-Saxon words. That to me is a superb achievement. I do not know what Mr. Hemingway's personal attitude may be to the material that he has used, and I care less. All I can say is that in literature he has most excellently quickened and enlarged my experience of social life.

XXII

Friends in France

•

I HAD been posing naked in Paris studios to earn my daily bread and that undermined my health. The studios were badly heated. My body reacted against the lack of warmth after being for many years accustomed to the well-heated houses of America. I came down with pneumonia. My French friend, Pierre Vogein, looked after me. Josephine Bennett brought me fruit and ordered proper food. Louise Bryant sent a doctor. Clive Weed had told her that I was in Paris.

Louise Bryant was aware that I wanted to write above all things. I first saw her when she returned from Russia after the death of John Reed. I think it was at Romany Marie's in Greenwich Village and she was encircled by a group of nice young men, collegiate-like. At that time she was a pretty woman with unforgettably beautiful eyebrows. She had sent *The Liberator* a pathetic poem about her sorrow, and we had published it. I told her that the poem had moved me more than anything that was written about John Reed's death. For the dead was dead, but I felt that the living who really mourn are the sorriest thing about death.

Louise Bryant and I came together again, I think at Max Eastman's. We talked about John Reed. I asked if she knew that he had invited me to go to Moscow in 1920, when I was in London. She said she didn't know that, but was aware that Reed had become excited about the social problems of the Negro group shortly before he fell ill.

At that time she was doing a brilliant set of articles about

253

Russia for a Hearst newspaper. We talked about writing. I was interested in her opinion of so-called "bourgeois" and so-called "proletarian" literature and art. Externally her tastes were bourgeois enough. She liked luxurious surroundings and elegant and expensive clothes and looked splendid in them. But her fine tastes had not softened her will or weakened her rebel spirit.

Louise Bryant thought, as I did, that there was no bourgeois writing or proletarian writing as such; there was only good writing and bad writing. I told her of my great desire to do some Negro stories, straight and unpolished, but that Max Eastman had discouraged me and said I should write my stories in verse. But my thinking in poetry was so lyric-emotional that I could not feel like writing stories in that vein. She said Max Eastman was too romantic about poetry and that I should write prose. She said she also could never get into her poetry certain things that she got into prose. John Reed had written some early stories about ordinary people with no radical propaganda in them, she said, and suggested that I should do the same about my Negro stories—just write plain tales.

And so now again in Paris, when she was sending me off to southern France for my health. Louise Bryant warned me: "Remember our conversation in New York, and don't try to force your stories with propaganda. If you write a good story, that will be the biggest propaganda." She gave me a check big enough to keep me living simply and working steadily for three months.

I went to Marseilles, and from there visited some of the little towns of the littoral. Finally I chose La Ciotat, a place about midway between Marseilles and Toulon, having some eight thousand folk. Boatmaking and fishing were the two

main industries. The bay was fine, and beautiful in the morning sunshine. But on the quay, where the houses and hotels were, the morning sunshine didn't fall. There was no kind of heat, not even fireplaces. My hotel was cold but I contrived to work, wrapping myself from chest to feet in my Russian blanket and leaving only my hands free.

After a month of it I went down to Toulon to hear *Carmen* by the Opéra Comique Company from Paris. In a *bistro* after the opera I met a girl who spoke English. She was a little strange, different from the average that one meets in sailor bars. She was friendly to me. I found out that she had once been a little friend of artists and writers in Montmartre and Montparnasse. She was the type of girl that seemed more suitable for friendship with younger officers than with common sailors, but she preferred the sailors. She worked too, in a store. She promised to find me a room with a fireplace in Toulon, which she did, and sent me a note about it the following week. But I had already paid another month's rent in advance in La Ciotat.

When that month was ended, I took up residence in Toulon. The girl—her name was Marcelle—had a sailor friend named Lucien, and all three of us became very close friends. Lucien was more than an average sailor. There are many such in the French navy, lads from middle-class and lower middle-class families who choose the navy instead of the army to do their compulsory service. The service is longer in the navy than in the army. Also it is harder, without the privileges offered by the army, in which the educated sons of the better classes can do their compulsory service as cadets.

Lucien had been a cadet, studying to enter the navy as a career, but he had failed his examinations and then decided to do his military service in the navy. He read lots of books,

but he wasn't literary. He gave me my first French lessons. He said I should read Anatole France for good French. He said he read everything of Anatole France's because he wrote the purest and clearest French of any contemporary writer. But he didn't get any kick out of the novels as novels. For stories about French life he preferred Zola and Maupassant. I wondered if there were many French readers who felt about Anatole France as Lucien did. He assured me that there were many who liked Anatole France merely because he wrote classical French.

Lucien was on the battleship "Provence." He invited me to go aboard and introduced me to many of his friends. As Lucien had formerly been a cadet, he had a few extra privileges. Very often he slept in town. And he, Marcelle and I were always together. He loved to walk, and together we explored the environs of Toulon. We hiked to La Seyne, Tamaris, Bandol and Ollioules. I love the Var country more than any part of France, excepting Brittany. Lucien was a Breton and he loved those wonderful bare rugged rocks towering to the skies that make the Var so dramatically picturesque. I told Lucien that I loved those rearing rocks because they somewhat suggested the skyscrapers of New York. But Lucien did not like the comparison; he could not imagine anything American resembling anything French.

When his pals got their week-end vacation from the "Provence" we all went bathing out at Cap Negre in the afternoon, and in the evening we got together for a good time in the *bistros* and *mancebías*. The *mancebías* of Toulon are like recreation halls for the sailors. Many of the sailors who, like Lucien, had their girls in town, went to the *mancebías* to dance and meet their friends for a good time. Sometimes they took their girls with them. There are dancing halls in Toulon,

but these are frequented mostly by the officers. The sailors find it embarrassing to mix with the officers, so they prefer the *mancebías,* where they are freer. The managers of the *mancebías* are a pretty good lot. They are friendly and cater to the whims of the sailors, as if they were aware that they were entertaining a mixed group of the best of the country's youth.

Toulon is dominated by the naval aristocracy, and its administration seemed to me the best of any of the French provincial towns I visited. To a casual observer, the civil administration seems subordinate to the maritime administration. The sailors are protected much more than they are aware. In Toulon there is nothing of that rotten civil complaisance in the exploitation of the sailors which is a revolting feature of life in Marseilles.

Soon after I went to reside in Toulon I received a letter from the secretary of the Garland Fund. It informed me that the officers of the Fund had heard that I was unwell and in need and that they desired to help me for a time, while I was writing. Thus assured of fifty dollars a month, I knuckled down to writing. It was grand and romantic to have a grant to write, and I got going on a realistic lot of stuff. I was sure about what I wanted to write, but I wasn't so sure about the form. My head was full of material in short pieces, but I wanted to write a long piece—a novel.

I returned to Paris toward the end of summer with a heavy portfolio. I met a couple of publishers' scouts who didn't discover anything in my lot. Clive Weed introduced me to Harold Stearns. Stearns's strange tired eyes didn't want to look at me. Remembering something, he excused himself, got up and went to the bar, and there forgot all about me. I wondered why Stearns acted so strangely, as if over there

in Paris I had reminded him too much of civilization in the United States! Another Yankee said that I should not worry about Harold Stearns for I had nothing to offer him, and he had nothing to offer me but tips on horses and booze. While I remained in Paris I saw Harold Stearns again many times and always at the bar. He was something of an institution in Montparnasse, and often I saw him pointed out to American students who were discovering civilization in Europe as the man who had edited *Civilization in the United States*.

Also in Paris I found Eugen Boissevain, who had previously helped me much with encouraging praise of my poetry and with gifts of money. He had been recently married to Edna St. Vincent Millay. I saw them both together at their hotel and she gave me a book of her poems. There was a happy feeling in his face that I never had seen there before he was married, and I felt happy for it because I was fond of him. Miss Millay I saw for the first time. In Greenwich Village I had often heard praise of her, but we had never met, and when I arrived in Paris she had recently left. In the literary circles of Montparnasse I heard her name on the lips of foreigners and Americans, and all in praise of her—a reverent worshipful praise. It was extraordinary: he-men, mere men, and others—all used identical phrases in praising Miss Millay's elusive personality. The only other white woman I knew who was so unreservedly esteemed by all kinds of men was Isadora Duncan. I was puzzled and skeptical of all that chorus of praise. But when I did set eyes on Miss Millay I understood it. There was something in her personality which was Elizabethan—as I imagine the Elizabethans to have been from Shakespeare and history. And I saw her as a Shakespearean woman deftly adapted to the modern machine age.

When I searched for an Anglo-Saxon word to fix her in my mind I could think of "elfin" only.

Sinclair Lewis was in Paris also, and he was very kind. He read some of my stuff. He had been generous to many radically-inclined writers since his first success with *Main Street*, and he hadn't seen any results. But he gave me a sum of money, took me to dinner in a small quiet place, and talked to me a whole long evening. In a shrewd American way (chastising me and making me like it), Sinclair Lewis gave me a few cardinal and practical points about the writing of a book or a novel. Those points were indicative and sharp like newspaper headlines. I did not forget them when I got down to writing *Home to Harlem*. I remembered them so well that some critics saw the influence of Sinclair Lewis in my novel. Scott Fitzgerald, in a note, said that the scenes seemed in the Zola-Lewis line.

I left Paris again for Toulon to see what better I could do. About the time I got back Lucien was just finishing his service and getting ready to leave for Brittany. Marcelle was very sad, and I also. For I had been looking forward to our spending much of our leisure time together as formerly.

On the evening of Lucien's departure a gang of sailors from the "Provence" and some from other boats and a few girls all crowded into my room. Out of their small wages they had eked enough to buy many bottles of ordinary white and red wine. I bought some cognac. My landlady and her husband joined us and we had a great good time.

My friends knew that I was writing, but they knew nothing of my ideas. I never told them that I had been in Soviet Russia. The French friend whom I had met in Moscow had advised me that so long as I was staying in France I should never do or say anything to let the authorities think that I

was making political propaganda. If I followed that line, he said, I would never be bothered. I kept that advice, along with Louise Bryant's, in my head and followed the line.

But toward the end of the evening, when we all began kissing one another on both cheeks, Frenchwise, bidding Lucien a last farewell, a sailor started singing the "Internationale." We all joined our voices with his and heartily sang, I singing in English. One sailor jumped up on my writing table and said: "After the world revolution there will be no more white and black and yellow; we shall all be one fraternity of men." My sense of the distinctive in the difference of color was outraged, and I said, "We can still remain a fraternity of men and guard our complexions." One of the girls said: "That's all well! We wouldn't like you to change your color either."

But the next day I had the honor of a visit from two police officers in plain clothes. They were very courteous. They first satisfied themselves that my French was not worth much and one of them spoke to me in English, which was worth just a little more than my French. I told them all they desired to know about me, except the fact that I had visited Soviet Russia. I explained that the sailors had come to my place to give Lucien a farewell party. "And they sang the 'Internationale'!" commented my inquisitor. I am not sure, but I think there is a government ruling which forbids French sailors and soldiers from singing the "Internationale." "They sang the Marseillaise too," I said, "and I prefer the words and music of the Marseillaise to those of the 'Internationale'." The English-speaking inspector smiled and asked me whether I was a Communist. I said that I was a poet and a great admirer of Victor Hugo. He said, "Well, I wouldn't wonder if a Negro-American had advanced ideas." He excluded the Negro-French of course. But I was courteously left alone and

for the ensuing months I lived happily and as I pleased in Toulon. In the restaurants and cafés that I frequented I was treated even better than before.

Lucien wrote, asking if I could visit Brittany in the summer, because his parents wanted to know me. I replied in ungrammatical French, telling him that I would if I could. I finished a novel and mailed it to New York. I had a group of short stories, which I forwarded to Louise Bryant. I received an enthusiastic letter from Louise Bryant, who said that Robert McAlmon wanted to use one of the stories.

Lucien and I kept up a regular correspondence. He wrote that he had fallen ill, but that it was not serious. In the early summer I left Toulon for Marseilles. There I met Marcelle. I told her that I was expecting to go to Brest to visit Lucien and his people. She thought that was fine, and I asked her why she didn't come along too. That was impossible, she said, because a girl of her sort could not think of visiting the family of her lover. Girls like her, she said, were outside friends for outside purposes, and had no desire to intrude themselves upon their friends' families.

In the company of a white American artist I spent a couple of weeks in low-down Marseilles; then I decided to go to Bordeaux to visit a British West Indian Negro friend and his French West Indian wife before going on to Brittany. I got my ticket and boarded a night train. And while I was waiting for my train to pull out, another pulled in, and there in the next car right up against mine was Max Eastman and his Russian wife!

I got out and asked the station master to make my ticket good for the next day. Max Eastman had just published his book, *Since Lenin Died*. I had left him in Russia before Lenin's death, and we had plenty to talk about. So we spent

the larger split of the night talking, and the next day drove round the Corniche and ate *bouillabaisse* on the quay. In the evening I entrained for Bordeaux.

I wrote from Bordeaux informing Lucien that I would arrive soon in Brest, and was surprised to find the answering letter addressed in a strange handwriting. It was from Lucien's father, stating that his son had died the week before. Lucien had contracted tuberculosis in the navy, and unaware of his serious illness, had not taken any treatment. In Toulon I had noticed that he was rather frail, and, compared to his comrades, unusually quiet, but I never heard him cough, and his physique showed no strain when we went hiking in the country.

In his letter, Lucien's father invited me still to come to St. Pierre. He said his son had talked about my visit up to the moment of his death, and thought that I would like Brittany more than Provence. For the first time in my life I was shocked with the sensation of what "a living dead" might mean. I had seen persons sicken and die after a long illness. I had seen sudden death. But Lucien's passing was weird, like a ghost story. All the time he was regularly writing those healthy letters about the picturesqueness of the wild Breton coast, of the fields full of larks singing in the summertime, of the quaint costumes which the old people still wore naturally, he was actually wasting rapidly away. They say consumptive persons are like that: always optimistic and hopeful of their health. But I had never had any close contact with one.

I wondered if Marcelle had known of the real state of Lucien's health. When I told him that I had come to the Midi mainly for the effect of the sun on my health, he said: "Why should the young think about health? Just live, and that is health." I lingered on in Bordeaux, hesitating about

going to Brittany. But I received another letter, from Lucien's mother, urging me to come, "because Lucien wanted you to be his guest, and now that he is dead we want to receive you for him." I decided to go. I had met many French in cafés, restaurants and other places. And I had been invited to a couple of parlor parties in Montparnasse, but I wasn't sure whether my hosts were really French or what the French call *métèque*. I had never been a guest in a real French family. The French are exclusive in their ideas of family life and seldom invite strangers to their homes.

Lucien's family, which was small, belonged to the prosperous peasant class or the small bourgeoise. It was not a café- or restaurant-owning family. The old father used to be an artisan, of what trade I don't remember. He was a big man, robust, friendly, and loved to play *boule*. The mother was small and compact and resembled a picture of a South European immigrant arriving in New York. There were two daughters and an older son, all married. The son had a clerical position in the maritime service. I noticed that they read *Le Quotidien,* which was a Left liberal paper at that time.

The family possessed a small two-storey stone house in St. Pierre. It was furnished in antique and modern stuff. The father and mother still used the chest-like Breton beds which are now so highly valued by connoisseurs. The dining table also was a large, heavy massive thing, occupying the one large room that served for dining and cooking. But Lucien had modernized his room, so that it was like a room anywhere, even in the Congo, I guess.

I stayed in a hotel in Brest and went often to eat with Lucien's family. After the shock of meeting over Lucien's death, it was a nice visit. I liked the Breton folk more than any other of the French. I spent the summer wandering all

over Finistère. I lay in the gray-green fields and watched the brown larks suddenly soar and sing. I knew then why Lucien loved the Breton fields so dearly, and I understood more of what Shakespeare felt when he wrote:

> *Hark, hark the lark at Heaven's gate sings. . . .*

Lovely are the fields and charming are the towns of Finistère: Brest, Morlaix, Camaret, Plougastel, Morgat, Quimper, Concarneau, Le Pouldu over to Lorient and back to Douarnenez *le Rouge* above all! How I loved Douarnenez with its high wall falling sheerly into the green waters and the big shipping boats with their tall masts hung with nets like blue veils against the misted gray-blue sky, and the fishermen in red dungarees and red-hearted.

I loved the quiet green and subdued grays and browns of Brittany, and although it rained a lot I did not miss the grand sun of Provence. Perhaps because I was sad and felt the need of solitude.

XXIII

Frank Harris in France

●

LATE in the autumn I went south again to Nice. I needed a job and found one as valet to an American.

Paul Robeson and I met on the Promenade des Anglais. He read one of my stories and said he liked it. I said I would like to do a play for him to act in. Paul asked me if I knew Gertrude Stein. I said I didn't, that I hadn't gone to her place. Paul said he had visited Gertrude Stein and that she was all right. I shouldn't neglect such an opportunity, as she knew all the literary people who counted, he told me. I told Paul that although I couldn't abide cliques, I wasn't averse to contact, but from my estimation of Gertrude Stein I felt that she had nothing to offer.

I lived in a spacious room with a French-Italian family. It gave on the old port of Nice, and was cheap. Paul Robeson was staying in Villefranche in the same hotel in which Glenway Westcott lived. I wrote to Paul asking if he could come to Nice on a certain evening, when Max Eastman and his wife would be visiting me. The reply came from Mrs. Robeson. She wrote that she and Paul were coming together, because they just couldn't breathe without each other. Paul Robeson came late with his formidable wife and the more formidable Frank Harris. Robeson and his wife had had either lunch or dinner with Frank Harris at Cimiez and had mentioned that they were coming to see me afterward. Frank Harris hadn't seen me in years, didn't know I was in Nice, and insisted on coming along with the Robesons.

Max Eastman and his wife were already there when the Robesons and Frank Harris arrived. It was a most piquant scene, for I had never seen Max Eastman and Frank Harris together, and I knew how they detested each other. If Frank Harris's dislike was boisterously aggressive, Max Eastman's dislike of him was none the less real because it was veiled and soft.

Frank Harris greeted me with a loud: "You rascal, catting your way through Europe and not letting me know you were in Nice! I knew you would come back to Europe after that first trip. Now give an account of yourself." But before I could get in a word of any account about myself Frank Harris was teasing Max Eastman about his book, *Since Lenin Died*. He said he hoped that Eastman would realize now that politicians are politicians whether they are red or white, that there were certain types of men who were successful politicians and always would be forever and forever. He, Frank Harris, was one of the first to hail the Russian Revolution and he still believed in it. But he had never regarded Lenin and Trotsky or any Bolshevik as a god, but as men with the faults of men. Max Eastman could not reply because Frank Harris did not give him a chance.

I had a case of dry *Graves* under my bed. (I had accompanied a casual acquaintance one day to a big shop in Nice, and in an excess of feeling for my poetry or personality he offered me the case of *Graves* and I accepted it right away before his sentiment had time to change.) So I brought out two bottles. Frank Harris said he was not drinking. But when he saw the *Graves* he examined the bottle and exclaimed: "Oh, it's an excellent brand. I cannot resist trying it." And he grabbed the bottle from me and opened it himself. I got the glasses ready and Frank Harris poured the wine. Soon

he became mellow, and started to tell stories of life and himself. He told us a story of his traveling from London to Rome by the Paris-Rome express train. There was an Italian couple sitting beside him, he said, and the man knew English and started a conversation. The passenger was cultivated, and they passed the time discussing politics and headline news. But the woman got bored. She could not talk English. And suddenly, tigerishly, she turned on Frank Harris, accusing him of monopolizing her husband's interest. Harris was sitting next to Paul Robeson and he gave a dramatic interpretation of the incident, now imitating the man, now the woman, besides portraying his own rôle. And while he was interpreting the woman's part he acted the thing out on Paul Robeson, making him the man. It was all very interesting, but when he had finished, Mrs. Robeson said aside to me: "He was so realistic that I felt afraid for my husband." Frank Harris was also such a great actor that in his talk he actually became the character he was portraying. And that is why some of the readers of his marvelous biography of Oscar Wilde imagine that there was something more than a platonic friendship between the two men.

The Robesons invited the Eastmans and myself to dinner in Villefranche. Glenway Westcott also was their dinner guest. Mrs. Robeson wore a pretty red frock and Paul sang a couple of spirituals. Now that Frank Harris wasn't there, the women had their chance to luxuriate in talking. It was the first time Mrs. Eastman had heard the American Negro voice. Mrs. Eastman (nee Eliena Krylenko) was like a reincarnation of Chekhov's The Darling. She whispered to me that she was fascinated, and like a happy, eager child she engaged Mrs. Robeson in conversation. Presently Mrs. Robe-

son exclaimed to Mrs. Eastman, "But Darling, *where did* you get that *accent?* Oh, I do *adore* your way of using our English language. It is just *lovely!*"

Frank Harris and I met very often in Nice. He lived in Cimiez, but came into Nice almost every day for his mail at the office of the American Express Company. Often we sat in the Taverne Alsacienne to talk. He asked me how my prose was getting along. I told him I thought I had done some good short stories, but failed of my real objective—a novel. I told him my difficulty was devising a plot.

"Don't worry about a plot," he said. "Just get a central idea or a person interesting enough and write around that. Make your writing strong and loose and try to get everything in it."

Once he saw me with a very striking girl at the American Express and he asked me if I would like to bring her to dinner with him. I said, "Very willingly," and we arranged a rendezvous for a few days later. The dinner was in one of the best restaurants. Harris had published his *Life and Loves* and was selling it privately. He told us he had received orders from the United States, England, Germany, the Scandinavian countries and France. It was his practice to send the book and collect afterward, he said, and all the buyers had paid promptly excepting the French.

I said, "Our guest is French." (She spoke perfect English.) Frank Harris was astonished: *"Vraiment! vraiment!"* he said, *"Vous êtes française?"* The girl said, "Yes, but that is nothing." But Frank Harris regretted the *faux pas,* for English enemies, he informed me, were attacking him and working to get him expelled from France for writing a dirty book. Some French journalists of the Left were defending him. He began telling us of his troubles with the English and that he

was banned from visiting England again, ostensibly because of his *Life and Loves,* but he knew that he was being persecuted actually because he had taken a stand against England during the war.

We had a leisurely dinner: aperitifs and excellent white wine with the fish and red wine with the meat. And topping all, a bottle of champagne. Frank Harris told many *Life and Loves* stories, as salacious as possible. The last long one was about his first strange affair in Greece. The French girl said, cryptically, "It had to be Greece."

Outside, while we were walking through the Albert the First Park, Frank Harris declared that although he had passed seventy he was still young and active in every way. To demonstrate this he started to skip and fell down in the first movements. I picked him up. The girl lived about forty minutes down the littoral, and as the last train was due in a few minutes, I said that I had to take her to the station.

Frank Harris said: "Why don't you take her home in a taxicab?" I said that we couldn't afford it, but that if he chose to, there was no objection. Immediately he took up the challenge and called a taxicab. I put the girl in and he said to me: "You, too, get in." I said no, that one escort was enough and we could trust him. And besides, I had to sleep the liquor out of my head to go to work the next morning. So Frank Harris got in beside the girl and they drove off.

I saw him again before I saw her. "Did you have a nice ride?" I asked. An embarrassed look came into his face and he broke out, "You black devil, why didn't you tell me we were riding to the destination of Lesbos?" "Because I thought any destination was a destination for an eclectic person like you," I said, and added that we had warned him that he could be trusted.

"I didn't even have any money left to pay the taxicab," he said, "and had to give the chauffeur a promissory note."

One day Frank Harris told me he had been thinking about doing a book of contemporary portraits of Negroes only, and he could not think of any Negroes but Josephine Baker, Paul Robeson and myself. At that time Paul Robeson was aspiring, but had not achieved his greater fame. And without being unduly modest, but with my mind on the bull's-eye of achievement, I said I thought I would have to do another book first.

Truth to tell, I have always been a little dubious about anthologies of Negro poets and all that kind of stuff. Because there is a tendency to mix up so much bad with the good, that the good is hard to pick out. Of that kind of thing, some critics will say: "Good enough for a Negro," and there is a feeling among some Negro writers and artists that they should be contented with that sort of criticism. It gives us prestige in Negro society. We have been praised by critics and the critics are all white. If I resent that kind of patronizing criticism, and the fact that Negro artists are satisfied with it, it is because I am inspired with a great hope for the Negro group. And I am certain that it cannot find artistic self-reliance in second-hand achievement. Though because of lack of common facilities and broad cultural contacts a Negro's work may lack the technical perfection of a white person's, intrinsically it must be compared with the white man's achievement and judged by the same standards. I think that that is the only standard of criticism that Negro artists can aim at.

Frank Harris and I went to the Taverne Alsacienne to talk over his project. He said that if he wrote a book of contemporary portraits of Negroes, he would expect it to sell. I

said that I hoped it would. I wrote down some names: Marcus Garvey, Florence Mills, Madam Walker of Black Beauty Culture fame, W. C. Handy, composer of the St. Louis Blues. W. E. B. DuBois was the only Negro intellectual who appeared outstanding for that sort of thing. There were quite a few, but none of them glamorous enough for Frank Harris's style. I mentioned Professor Carver, the Luther Burbank type of scientist who had been my beloved teacher at Tuskegee, but Frank Harris objected. He said that he wanted a Negro scientist of the caliber of Thomas Huxley. He said that Booker Washington was inflated as a philosopher, and he hadn't found any system of philosophy in his books. He thought it would be interesting if American Negroes could throw up a full-sized philosopher special to their needs and times—a kind of Aframerican Herbert Spencer. Herbert Spencer, he said, didn't mean anything to him, but meant a lot to the smug English bourgeoisie, and so he had to be reckoned with as an intellectual.

Not long after my conversation with Frank Harris I left Nice for Marseilles. And suddenly bloomed the exotic flower of the Negro renaissance. I never heard what became of Frank Harris's idea. Perhaps Paul Robeson could tell. Frank Harris said he had talked or was going to talk to Paul Robeson, as he intended him to be the big personality of the book.

XXIV

Cinema Studio

•

I HAD visited Rex Ingram's cinema studio in Nice to dance with a group for one of his pictures. Max Eastman introduced my poems to Rex Ingram. Rex Ingram liked my poems. He had written some poetry himself and a few of some that he showed me were good poems. Rex Ingram has a sympathetic mind and an insatiable curiosity about all kinds of people and their culture. He is especially interested in North Africa, has friends among the natives, and has even learned to read Arabic.

Rex Ingram gave me a job. It was a nice, congenial and easy job. I read a lot of fiction and made a summary of any interesting plots. Not only did Mr. Ingram give me a job, but he had the temerity to invite me to dinner at his private table, before the resentful eyes of his American employees. And there were some hard-boiled eggs among the technical staff who were as mean as Satan. A French friend said he heard them muttering threats and that the general manager of the studio had said that perhaps Mr. Ingram was intent upon precipitating a riot.

I went about my business and gave no mind to anybody. For none of the Americans had said anything to me personally. But I could feel the hot breath of their hellish hate. It was vastly interesting to study a group of average white Americans who had carried abroad and were sowing the seeds of their poisonous hate. The young Frenchman enjoyed repeating to me the phrases he overhead. He did not have a

profound understanding of the vileness of some of those phrases in English. *"Ils sont incompréhensibles, ces Américains,"* said the Frenchman. *"Ils sont les vrais barbares."*

The general manager of the cinema studio did not enjoy complicated situations. I had come up against him before I met Mr. Ingram, when I was dancing with the group. The leading dancer had told me that the manager had said I could not continue in the dance, because the motion picture was being made for American consumption.

Said the manager to me one day: "You know, I knew Julius Rosenwald, and he has recently left a pile of money for Negro education and culture. Now don't you think that it is better to have a fortune to give to improve another race under capitalism than to have no fortune under Bolshevism?" The manager had heard about my visit to Russia. I said I thought it was all right to give money for Negro culture, because Negro workers had helped to make Jewish as well as other American capital. The manager was a Jew.

The movie establishment was like a realistic dream of my romantic idea of a great medieval domain. There were gangs of workers engaged in manual work, building up, tearing down and clearing away. Motor cars dashed in and out with important persons and motor buses carried the crowds. Gentlemen and ladies with their pages went riding by on caparisoned horses. The eager extras swarmed like bees together, many costumed and made up like attendants at a medieval banquet. The leading ladies, on the scene or off, were attired and treated like princesses, and the director was the great lord in the eyes of all. I used to think that Negroes lacked organized-labor consciousness more than did any other group. But it was much worse on that movie lot. I saw the worst sort of sycophancy in the world among the extras

crowd, each one hoping that some affected way of acting or speaking might recommend him for a privileged place.

Rex Ingram's inviting me to eat at his table created a little problem. I was literally besieged by employees, extras and aspirants. Some desired to get in personal touch with the director through me: "Oh, the director had you to dinner, and over at his house! What a beautiful gesture, and how proud you must be!" The news reached the café that I frequented in Nice, and the proprietor, waiters and customers all treated me with particular attention. They all thought that I had achieved something marvelous, something special. And as none of them knew anything about the difference between poetry and piggery, it was hard to convince them that Rex Ingram had honored me only because I was a poet; that all I had was an ordinary job and that I was not specially placed to further their ambitions.

Rex Ingram held some very advanced ideas on world politics. He was interested in the life and thought and achievements of minority groups, and whenever he ran into me he had something interesting to say. And each time, as soon as his back was turned, the sycophants besieged me to learn what he had talked about. As that was embarrassing, I did my work and avoided the director as much as possible.

Among the employees there was an Italian who was specially troublesome. He had lived somewhere in America and acquired a smattering of English. He sensed the undercurrent of feeling against me among the American element and desired to show in what direction his sympathy was slanted. The Italian was in charge of the transportation of employees from St. Augustine to Nice. He often had a special remark for me: "Having a good time over here, eh?—*les jolies jeunes filles*. It would be different in America." Two Polish girls, a

Frenchman and myself were rather friendly and always went down together. The Italian always tried to separate us, finding some reason to hold one or two of us behind by putting somebody before and between. The Frenchman hated the Italian and called him the *petit caïd*.

One evening the Italian not only held me back, but kept me waiting and waiting until I lost patience. He let one of the buses go, although there were vacant places. I said, "What's the idea? What game are you playing?" He said, "You know in America, you'd have to wait for the last and ride by yourself." I said, "Yes, you—you have sucked off so much America, that you need some fascist castor oil to purge you." He said, "I think you'll want to box next; all Negroes are boxers." I said, "Look here, I won't defile my hands with your dirty dago skin, but I'll cut your gut out." I went suddenly mad and pulled my knife and he ran around the bus, crying that the Negro was after him with a knife.

In a moment sanity flashed back into me as quickly as it had fled and I put the knife in my pocket. It was a fine clean blade. Lucien had given it to me in Toulon. A friendly fellow took me up on his motorcycle and we dashed away from the damned place. It was the first time I had ever drawn a blade in a fight, and I was ashamed. The Frenchman said: "What are you ashamed of, when you didn't do it? You should have stuck him in his belly and made one Italian less. Italy and France are certain to go to war, and I think they should start right now." That was ten years ago.

The business manager made much trouble for me over the incident. He talked a lot about an intelligent Negro not being able to control himself. And if I had to use a weapon, he wanted to know, why should it be a knife? For it was a

general idea that the Negro race was addicted to the use of the knife. Even though I was on trial, with the judge prejudiced against me, I could not resist saying, "When bad traits are wished upon a whole group of people, it isn't so surprising if the best of us sometimes unconsciously exhibit some of the worst traits."

I thought that when the final decision was handed down, I would surely lose my job. But Rex Ingram's face revealed that he possessed an intuitive understanding of poets. He is Irish. He knew that I had suffered enough from the incident, and didn't punish me further. So I stayed at work all that spring until summer, when the studio closed. Then I decided to go to Marseilles. I had kept out of Rex Ingram's sight most of the rest of the time, because, as I said, I was thoroughly ashamed. But when I was going I sought him out to say goodbye and he encouraged me to go on with my writing, told his bookkeeper to give me a free ticket to Marseilles, and gave me a gift of six hundred francs.

XXV

Marseilles Motley

●

IT was a relief to get to Marseilles, to live in among a great gang of black and brown humanity. Negroids from the United States, the West Indies, North Africa and West Africa, all herded together in a warm group. Negroid features and complexions, not exotic, creating curiosity and hostility, but unique and natural to a group. The odors of dark bodies sweating through a day's hard work, like the odor of stabled horses, were not unpleasant even in a crowded café. It was good to feel the strength and distinction of a group and the assurance of belonging to it.

The Africans came mainly from Dahomey and Senegal and Algeria. Many were dockers. Some were regular hard-working sailors, who had a few days in port between debarking and embarking. Others were waiting for ships—all wedged in between the old port and the breakwater, among beachcombers, guides, procurers, prostitutes of both sexes and *bistro* bandits—all of motley-making Marseilles, swarming, scrambling and scraping sustenance from the bodies of ships and crews.

I rented a room in the Vieux Port and worked rapidly revising my stories. Louise Bryant had written asking me to get all my stories ready, for she was sailing soon to New York. and would take them herself to a publisher. Sometimes I did a little manual work. The Senegalese foreman of the Negro dockers was my friend, and when he had a lot of work of

the lighter kind, such as unloading peanuts or cocoanuts, he gave me an easy job.

There was always excitement in the Vieux Port: men's fights and prostitutes' brawls, sailors robbed, civilian and police shooting. One Senegalese had a big café on the quay and all the Negroes ganged there with their friends and girls. The Senegalese was a remarkable type, quiet, level-headed, shrewd. He had served in France during the World War and had been a sergeant. He went to the United States as soon as he could after the armistice. He got a job such as the average Negro works at and at the same time he ran a rooming house for Africans and Negroid Moslems in New York. He amassed a tidy sum of money, returned to France after six years, and bought the bar in the Vieux Port. His family in Goree was old, large and important. He had a relative in Paris, who was a small functionary in the municipal system. A sister was a graduate nurse in Dakar, and I met in Casablanca a first-class mechanic who was his cousin.

In his social outlook the café owner was an African nationalist. He introduced me to one of his countrymen named Senghor. This Senghor also was a war veteran and a Negro leader among the Communists. He was a tall, lean intelligent Senegalese and his ideas were a mixture of African nationalism and international Communism. Senghor was interested in my writing and said he wished I would write the truth about the Negroes in Marseilles. I promised him that I would some day.

He gave me a little pamphlet he had written about the European conquest of Africa. The sentiment was quaint and naïve, like the human figures stamped on old-fashioned plates. . . . Senghor took me to the international building for seamen in Marseilles. It was newly opened by Communists—a

vast place, complete with bar, kitchen, theater and recreation room. In the reading room there were newspapers in nearly all of the occidental and oriental languages. There were a few seamen, Scandinavian, French, Annamites, Spanish, but no Negroes, present. Senghor talked to the manager and said it was their job to get the Negroes to come to the International Seamen's building. But the building was far out of the center of the town and the Negroes preferred the international bee-hive of the Vieux Port. Yet the Negroes had hard industrial problems to face in Marseilles. On the boats they were employed as stokers only, and they were not employed on those boats making the "good" runs: that is, the short runs, which the white seamen preferred. Also as dockers they were discriminated against and given the hardest and most unpleasant jobs, such as loading and unloading coal and sulphur. The Negroes complained against the unions: Senghor told them the unions were Socialist unions and that they should become Communists.

One afternoon I listened in on a conversation in black and white between Senghor and the café owner. I think it is worth recording here. Senghor had been gassed in the war and he was consumptive. He was married to a Frenchwoman who was devoted to and was dutifully taking care of him.

Said the café owner to Senghor: "But say, listen: I don't see how you can become a great Negro leader when you are married to a white woman." Senghor replied that he felt even more bitterly about the condition of Negroes because he was married to a white woman; and as Communism was international, it was an international gesture for him to be married to a white woman, especially since white chauvinists objected to intermarriage. "And what about you," Senghor

asked the café owner, "aren't you living with a white woman?"

"Yes, but I am not aiming to be a leader," said the café owner. "But you are aiming to be. If you are a real true leader, if the Negroes see it on the outside and feel it on the inside, they will surely follow you, and if the men follow you, their women must follow them. For you can't uplift men without uplifting women. And colored women will not follow Negro leaders who are married to white women. Especially when white women everywhere have more social freedom and privileges than colored women. How many white leaders are there anywhere who are married to colored women? They couldn't be and remain leaders. They love our women, but they don't marry them.

"Now take our Deputy Diagne. Before Diagne, all our leaders used to be mulattoes. But the mulattoes did everything for the whites and nothing at all for the blacks. So we blacks, being more than they, we got together and said: 'Let's elect a black man; he might do better.' But as soon as we elected Diagne and sent him to Paris, right away he married a white woman. Now his mulatto children despise us black Senegalese. Now if Deputy Diagne had a colored wife for his hostess in Paris, wouldn't that be propaganda helping our women and our race? But I think the French preferred Diagne to have a white wife, rather than have a colored woman as a political hostess in Paris. Soon as we tried to do something for ourselves as a group, they did something else to make our action ineffective."

Senghor closed his eyes and scratched his head and opened his eyes and said that his countryman's idea was interesting and he would have to think the subject over from another point of view.

"It's not just a color problem, but a human problem," said the café owner. "Why, suppose all the big Frenchmen took English wives and disregarded the French women! I tell you there would be another French Revolution."

At that moment the French companion of the proprietor entered the café. Embarrassed, the two Senegalese shut up. The woman went over to the proprietor and leaned affectionately upon his shoulder. He reached up and patted her. It was a strange scene, after that strange conversation, and it made me feel queer. Sentimentally, I was confused; intellectually, I was lost.

My stories finished, I mailed them to Louise Bryant who received them on the very morning she was leaving for America. Summer was at its meridian in Marseilles. It was hot, and that was good for me, a straight dry heat and sweet to the skin. Nothing of the sticky, uncomfortable and oppressive summer heat of New York and London and Paris. One gets into the warmth of Marseilles as a West Indian boy burrows into a heap of dried sugar cane after the liquor has been pressed out, and feels sweet and comfortable lying down deep in it.

I took a holiday from thinking out stories and writing and took to the water. Way down at the end of the great Marseilles breakwater, with the black sailors on French leave, dockers and beachcombers, we went in bathing. But I discovered a better bathing place in l'Estaque, fifteen minutes by trolley from Marseilles, and went out there with an American friend for the rest of the summer. Formerly l'Estaque was a fishing village with a big beautiful clean and sheltered bay. Cézanne loved to paint there. But now it is a squalid factory town and the center of the cement

and tile industries. In its population there are many foreigners: Poles, Italians, Russians, North Africans, even some Germans who call themselves Austrians. They live in ugly cabins on the hill and work in the factories and on the new Rhône canal. All the dirty water of the cementing and tiling flows into the bay. But a little outside the town, a little out beyond where the canal enters the bay, there still remains a wonderful wide sheet of splendid deep clean water. There I went every day for the rest of the summer, floating for hours upon my back with the healing sun holding me up in his embrace.

Suddenly there came three days of mistral, and it was fall. I don't like the mistrals of Marseilles. Happily just then I received an invitation from Max Eastman to visit him at Antibes. Soon after I got that letter another came from Louise Bryant. She said she had found a publisher who was interested in printing my stories and that I should soon hear from her again.

I went to Antibes. The next interesting thing was a letter from William Aspenwall Bradley of Paris, telling of his coming down to Antibes to see me about my work. When Bradley arrived he said my stories were accepted for publication as Harlem stories and he suggested that I should do a novel of Harlem instead, because a novel would bring me more prestige and remuneration than a book of short stories.

I seized upon the suggestion, and with the story, "Home to Harlem," as the design I built up a book upon scenes of Harlem life. They were scenes of the Harlem I knew during the many years I lived there and worked as a porter in New York buildings and clubs and as a waiter on the Pennsylvania Railroad.

Many persons imagine that I wrote *Home to Harlem* be-

cause Carl Van Vechten wrote *Nigger Heaven*. But the pattern tale of the book was written under the title of "Home to Harlem" in 1925. When Max Eastman read it he said, "It is worth a thousand dollars." Under the same title it was entered in the story contest of the Negro magazine *Opportunity*. But it did not excite the judges. *Nigger Heaven* was published in the fall of 1926. I never saw the book until the late spring of 1927, when my agent, William Aspenwall Bradley, sent me a copy. And by that time I had nearly completed *Home to Harlem*.

I lived a hermit and ascetic in Antibes and achieved *Home to Harlem*. I finished it in the summer of 1927 and fled to Marseilles. The Negroid colony of the Vieux Port was greatly changed. Many of the foreign Negroes were deported. Some had died of disease.

Also, I had an opportunity to see the Vieux Port from a different angle, from the inside out. Jules Pascin, the painter, had sent me a letter of introduction to his friend, Le Corse, of the Vieux Port. I had seen Pascin in Paris with his Negro model, Aicha. I never care for letters of introduction when I am visiting a new place for the first time, for I like the sensation of being a total stranger in a strange place and sampling the strangeness of it until I find myself a little and get acquainted.

Now, however, as I had already approached Marseilles independently in my own way, and as it was one of those places which stirred me up to creative expression, I was glad to make use of Pascin's letter. Perhaps it would be a means of providing something complementary to my impressions.

I looked up Le Corse and found his wine shop not far from the Rue de la Bouterie, one of the most sordid streets of *mancebías* in the world. Le Corse was a solid man, built

like a bull, with the head of a hog. He read Pascin's letter and was immediately friendly. He poured me a big glass of good red wine and we drank together. He said that any friend of Pascin's was his also, and that I could have all that the Vieux Port had to offer, as much as was in his power—anything I liked.

We talked awhile. I told him a little about my background and the ground I had covered in Europe. He said that Pascin had informed him that I was a writer and he hoped I would find something good in Marseilles to write about. He was a friend of painters and writers. He left his shop in charge of a young man and went around with me, dropping into *bistro* cafés and *mancebías* and introducing a few types of both sexes. He was surprised that I was cordially greeted in a few of the places. I told him I had been in Marseilles before.

Le Corse possessed a *mancebía* of his own and we went there. Also he protected through his gang a number of girls who had their private holes in the walls of the alleys. After going through the Vieux Port, he invited me to his home. His home was ten paces distant from the wineshop. It was a well-furnished apartment with plenty of bric-à-brac, and very noticeable was the cheap Roman Catholic statuary. Le Corse's wife warmly wished me welcome. "Any friend of Pascin is our friend," she also said. She was rather stout, although less formidable than her husband, and all the fingers of her hands, excepting the thumbs, were full of rings of all kinds.

Le Corse entertained me with more wine, and then he proceeded to show me what Pascin meant to him. We went into his front room. On the walls there were many fine Pascin paintings: portraits, scenes and tableaux of girls of the *mancebías* in different attitudes. There was one very fine

thing of the girls: a large canvas with a group of them deftly fixed in tired disgusted ungainly attitudes. The only other painting of that profession that ever impressed me so much was one of a café girl by Picasso which I had seen some years before.

Le Corse knew the value of the picture. He said: "That's a masterpiece."

"Yes," I agreed.

"It's worth about twenty thousand francs in New York," said Le Corse. "Pascin is in the first class. When he invited me to visit Paris, I went to a dealer there and found out what price he could command as a painter. I have collected every scrap of paper he made a drawing on, and made him sign them. Look here!" Le Corse opened a portfolio and displayed a lot of Pascin drawings. Besides Pascin, he had paintings and drawings by other artists, all inscribed to Le Corse in a fine fervor of friendship. And poets also had dedicated their verses to him.

While Le Corse was exhibiting his art treasures, his two daughters entered and he introduced them. They left the room immediately after being introduced. Le Corse said: "I don't allow my daughters to powder and paint and smoke. I am bringing them up in the right way. They go to a convent school. My son goes to a commercial college. We keep our family clear and clean of our business.

"When Pascin and his wife and their friends come to Marseilles, I look out for them," he went on. "They are artists and visit the bordels for material, so I protect them in their business as I protect my boys and the girls in their business. One time Pascin brought a Frenchman here with a Russian lady, and the lady started to dance with one of the bordel girls. I stopped it. I said, 'Pascin's friends are *my* friends and

can't afford to lower themselves.' They are my guests and I treat them like guests, not as customers. I don't like degenerates. Of course, if rich people want to indulge a fantasy, I arrange privately for them, for rich people can afford to be fantastic. But I have no use for plain poor people being fantastic unless they are making money by it."

Le Corse and I went walking along the quay. We passed a group of Senegalese. He said: "They're no good," with a deprecating gesture.

"Why?" I asked. "I am just like them."

"No, you're American. Why should you imagine yourself like them because you are of the same complexion? The Spaniards and Portuguese around here are the same complexion as myself, but I am not in their class! The Senegalese are savages and stupid. They don't understand our system with the girls; the same goes for the Arabs."

The bawdy battle between black and white was sharp in Marseilles. The Negroes and Arabs who had settled in large numbers in the city since the armistice had developed a problem for the European apaches. There was a tendency among the Africans to take the girls out of their business and set up housekeeping with them. That, of course, diminished the income of the procurers.

Said Le Corse: "Do you know an artist whose name is Ivan Opfer?"

"Yes," I said.

"He is also Pascin's friend," said Le Corse. "Is he a big painter? I mean, does he sell for big money?" I said that Opfer was successful and had done portraits of celebrated persons in America and Europe, even titled ones.

A shadow fell upon Le Corse's hog face. He shook his head and said, "Ivan Opfer offered me a large portrait of

myself, but I refused it. I couldn't take it," he said sadly. "Why?" I asked, surprised and interested. "It is worth money. Opfer is not as big a man as Pascin, but he is good."

"I couldn't take it," said Le Corse, "because he made me look so terribly like an apache and I don't really look like that. I couldn't stand it. Pascin and the other artists painted me nice."

"I wish you had kept it," I said. "I should have liked to see it. It's years since I saw any work of Ivan Opfer's."

"It is at the Hôtel Nautique," said Le Corse. "I'll take you there and ask the proprietor to show it, and you'll see for yourself that it is a painting of a criminal."

We went to the Nautique and the friendly proprietor sent a *garçon* with us up to an attic to show us the picture. I had known Ivan Opfer when I was an assistant editor of *The Liberator*. The magazine staff used to be divided in opinion about his work. Some thought it had striking merit; others, that it was tricky. Most of his work that I saw were portraits with a strong caricature element in them. But never had I seen anything by him so gripping as his large portrait of Le Corse. When I saw it I recoiled as if I had been thrust into the presence of an incarnate murderer. It was Le Corse all right—a perfect picture. Opfer had painted it without mercy. Pascin and the other artists had done romantic studies of the man, making him like a picturesque retired sailor of the Marseilles bottoms. But Opfer had penetrated straight into his guts and seized his soul to fix it on that canvas. It was a triumph of achievement, it was so real, so exactly true. And suddenly I felt a little sympathy for Le Corse, a slight kinship of humanity, for I became aware that he was afraid of his real self.

When Le Corse took me into his house and exhibited the

pictorial and literary tributes—those bouquets and wreaths that a vanguard of modern artists and writers had laid at his conquering feet, I felt a sickness in the pit of me, a paralysis of all the fibers of fine feeling. For there was no doubt about the genuine talent of those artists: some of the stuff was high genius. And also there was no doubt about the *intention* of their tribute to Le Corse. They meant a sincere homage to this hero, exalted by the taxes paid for freedom of action by the poor vampires of the waterfront. But I felt better, more hopeful, when I saw Ivan Opfer's portrait of Le Corse, so strangely abandoned there in a little hotel on the Marseilles waterfront.

I said goodbye to Le Corse. "Remember," he said, "if you ever want anything, if you are ever in trouble in Marseilles, just let me know, for you are Pascin's friend." I thanked Le Corse, but I thought that whatever happened to me in Marseilles, I could never bring myself to ask any help of *him*. "I hope you'll write a successful book," he said, as we parted.

I said I'd like to do a good book. And right then I remembered Senghor, the Senegalese, begging me to write the truth. I settled down to work and began *Banjo*.

In the beginning of *Banjo* I was surprised by Bull-frog, who burst into my den one afternoon accompanied by Isadora Duncan. I must go back a little on the trail to pick up and explain Bull-frog. He was a Slav adventurer. We had met in Berlin. A student friend who loathed his way of life called him the Bull-frog. Later in Paris we came together again. He was always traveling between Paris and the Midi and sometimes we met for a brief moment in Nice or Monte Carlo or some other tourist spot. We carried on a regular correspondence. He had to write many letters in his clandestine business and as his English was bad, he often asked

me to write important ones for him: those that he didn't want anybody else to know about.

Bull-frog was making better progress with his contacts in France than in Germany. Most of his correspondence was kittenish letters from old ladies who were apparently amused by a jumping frog. But one day he surprised me at Monte Carlo. He introduced me into a really smart set: an English lady with a high title and an enormous amount of money, a Christian Scientist from New England who had gone Gurdgieff, a futurist poet from Oxford, a cosmopolitan *rentier* and three student-like youngsters. And I heard Bull-frog saying very gravely that humanity had produced only six great men and they were all poets and artists. He named them: the Founder of Christianity, Aristotle, Dante, Shakespeare, Beethoven, Tolstoy. Bull-frog was getting by also intellectually.

I went to Bull-frog's hotel to write a letter for him. As he opened a valise to look for a letter I noticed many other letters in the valise that were not addressed to him. I passed my hand over them. A few were addressed to prominent persons. Some were unopened. I exclaimed in surprise. Bull-frog laughed: "I don't steal money or jewelry from them," he said, "for if you steal you'll get caught some day and lose everything. But I get their letters and find out their private business. And if there's anything bad, I'll know how to make them give money without wasting the energy which I must conserve for the building of my Temple." Bull-frog had informed me in Berlin that his big idea was to build an international Temple of Love.

"But if you steal the letters," I said, "it is equally dangerous. Suppose there is money in them!"

"But I don't steal the letters," he said. "When I am going

to visit people and I notice mail for them at the desk, I say to the clerk, 'I'll take the mail,' and he hands it over in all confidence, because he is informed that I am an invited guest. So—I slip in my pocket a letter I think important. If it were discovered, I could say I forgot."

A few weeks before Bull-frog arrived in Marseilles, he had sent me a letter from a Nordic person, and his answer to it, which he asked me to render into correct English.

The Nordic letter began: "My dear little big Bullsy—At last I am terribly excited about your plans, because of Isadora Duncan's interest in you. Certainly, if she believes in you, I must also. For I do believe in Isadora Duncan and her dancing, which brings a new beauty and meaning into life. I shall do all in my power to help to finance your plans. I wish I was rich. Nevertheless I have influence. I shall send you the money you need. Then you must come quickly to me, my sweet little lamb."

I corrected the English of the letter and returned it to Bull-frog in Nice. Shortly after he and Isadora Duncan arrived in Marseilles. Bull-frog was impeccably dressed in a style befitting an international businessman. He had a brand-new car and loads of money. I had not seen Isadora Duncan since that night when she danced so tragically and beautifully and for me alone in her studio at Nice. I was not surprised that Isadora Duncan was with Bull-frog. For Isadora Duncan was like a great flowing river through which the traffic of the world could pass. I remember, at a café in Nice, overhearing a chauffeur among his equivocal companions: "Oh, I saw the great dancer, Madame Duncan, on the promenade and I spoke to her and said I knew she was the great dancer. And she invited me to come to the studio and bring my friends to see her dance."

I asked Isadora what she thought of Bull-frog. She smiled and said he was at least amusing, and that if the rich folks would not give her money to build a temple of the dance for beautiful children, they could do worse than give it to Bull-frog. Isadora was interested in the *décor* of my Marseilles book, so we visited the Vieux Port. And as we three went wandering through the garbage-strewn alleys, the old girls in their shifts and tights in their holes in the walls were so startled by the picture of Isadora Duncan and her long Grecian scarf floating over the muck and misery of Marseilles, that they forgot their business of snatching hats. Shortly after that, Isadora Duncan was strangled by her ancient Grecian scarf in a modern automobile.

PART SIX

•

THE IDYLLS OF AFRICA

•

XXVI

When a Negro Goes Native

•

IN the Senegalese Bar in Marseilles I was figuring out the ways and means of a holiday somewhere in Africa. Said a Senegalese: "If I had money to go any place, I'd go straight to Paris, where one can amuse himself." I said I didn't feel attracted to Paris, but to Africa. As I wasn't big and white enough to go on a big game hunt, I might go on a little one-man search party.

A Martinique sailor, whose boat had just arrived from Casablanca, said that Africa was all right and Morocco was the best place. He said he had visited every big port in Africa, and he preferred Morocco. He lived there. He said: "If you're going to Africa, come to Morocco."

"What are the harems like?" I asked.

"I've got a harem; I'll show you when you come," he laughed. The Martiniquan spoke Arab and Senegalese, French, Spanish and some English words. He had been a sailor since he was fourteen and had sailed all the seas. He was settled in Casablanca, where, he said, he had two wives. He was illiterate, but full of all kinds of practical knowledge. He looked like a friendly gorilla.

However, instead of Morocco, I went to Barcelona with my friend the Senegalese boxer, who had a bout there. Barcelona took my sight and feelings so entirely that it was impossible for me to leave when the boxer was returning to Marseilles. The magnificent spectacle of the sporting spirit of the Spaniards captured my senses and made me an *aficionado*

of Spain. I had never been among any white people who gave such a splendid impression of sporting impartiality, and with such grand gestures. Whether it was boxing between a white and a black or a duel between man and beast in the arena, or a football match between a Spanish and a foreign team, the Spaniards' main interest lay in the technical excellencies of the sport and the best opponent winning. I pursued the Spanish sporting spirit into the popular theaters, where the *flamenco* is seen and the Andalusian melodies are heard. In no other country have I seen a people's audience so exigent in demanding the best an artist can give, so ruthless in turning thumbs down on a bad artist, and so generous in applauding an excellent performance.

The three days I had intended to spend in Barcelona were increased to over three months in Spain. Then one night, when I was doing the amusement spots of the amazing Barrio Chino in company with a Moslem Negro who claimed to be a Prince of Zanzibar, I met the Martinique sailor again. His boat had brought a cargo from Morocco to Barcelona. He urged me to pay him that visit.

I had lingered long enough in Spain to become aware of the strong African streak in its character. Therefore the second invitation to Morocco was even more interesting. The Prince from Zanzibar wanted to explore more of Europe and Europeans, and so we parted company.

At last I arrived in Casablanca. On the afternoon when the Martiniquan took me to his house in a native quarter, some Guinea sorcerors (or Gueanoua, as they are called in Morocco) were performing a magic rite. The first shock I registered was the realization that they looked and acted exactly like certain peasants of Jamaica who give themselves up to the celebrating of a religious sing-dance orgy which is

known as Myalism. The only difference was in their clothing.

The Gueanoua were exorcising a sick woman and they danced and whirled like devils. In the Moorish yard men and boys squatted in a wide circle around them, and women and girls covered up in white haiks sat looking down from the low flat roofs of the dilapidated cabins. The music was made by a single lute and a big bass drum and sounded like muffled thunder in the belly of the earth. I watched them dance a kind of primitive rhumba, beat their heads against posts, and throw off their clothing in their excitement. But I did not see the end, when the devils would be driven forth, because a dancing woman frightened me by throwing herself in a frenzy upon me. They said I was a strange spirit and a hindrance to the magic working. So I had to get out.

The members of the Gueanoua are all pure black. They are the only group of pure Negroes in Morocco. Men and women marry black, and it is the only religious order that has women members. If one is not a pure black he cannot belong to the Gueanoua. They say the strict keeping of this rule makes the Gueanoua magic powerful. The fetish rites are West African and are transmitted from generation to generation. They have a special place in the social life of Morocco. The wealthiest as well as the poorest families have them in to exorcise devils. Often they are protected by powerful sherifian families, and sultans have consulted them.

The harem of the Martiniquan was not such a hot spot, as I saw when I peeped behind the curtain. Just a long spacious room curtained in two, and two women, one old enough to be his mother and one young, brown and buxom. We all had tea together, because, said the Martiniquan, he did not believe in hiding his women from men. However, the male friends that he admitted into his harem were French West Indian

soldiers and Senegalese, but not Moors. He was the only person in that quarter who could afford two women. This was because, as a French citizen, he was rated as a European worker and received between forty and fifty francs a day— about six times what the native doing the same work got. Thus the black sailor was really living "white" in Africa.

I enjoyed the Martiniquan Moroccan hospitality for awhile. Then, feeling the overwhelming European atmosphere of Casablanca, I departed for Rabat.

Rabat-Salé was delightfully different. Here the native life was the big tree with solid roots and spreading branches, and the European city was like an imported garden, lovely and carefully tended. At Shellah I visited the tomb of the Black Sultan, who, according to the native legend, was the greatest ruler of Morocco, having united all of North Africa under his rule, conquered Spain, built the great monuments of the Giralda at Seville, the Koutabia at Marrakesh, and the Hassan Tower at Rabat.

I stopped long enough in Rabat to finish *Banjo*. Some Moroccan students had said to me: "In Fez you will find the heart of Morocco. It is our capital city. You haven't seen Morocco until you see Fez."

Fez was indeed the heart of Morocco and even more to me. In Moscow they had published a cartoon of me sailing upon a magic carpet over the African jungles to see the miracle of the Soviet. In Fez I felt that I was walking all the time on a magic carpet. The maze of *souks* and bazaars with unfamiliar patterns of wares was like an oriental fantasy. In Fez I got into the inside of Morocco. Hitherto I had been merely a spectator. But the Fassis literally took me in. There I had my first native meal of *cous-cous* in a native house, and the first invitation was the prelude to many.

I was invited to princely marriage feasts, to eat *cous-cous* from a common dish with stately old "turbans," to drink *thé à la menthe* in cool gardens, to the intimate *flamenco* dancing of fatmahs in the *garçonnières* of *fondouks* and to the profane paradise of Moulay Abdallah.

Moulay Abdallah is the unique recreation quarter of the young Fassis. It is a separate little walled town with its own shops and police and musicians. Arrayed in richly flowered and loose robes held in place by enormously broad embroidered belts and squatting with the dignity of queens, the young females who take up residence there charmingly dispense mint tea and witty conversation to circles of eager young men. I thought that that antique African city was the unaware keeper of the cup of Eros containing a little of the perfume of the flower of the passion of ancient Greece.

I liked the Moroccan mosaic, which is beautiful and bright everywhere like a symbol of the prismatic native mind. And nowhere is it so lavish and arresting as in Fez. The Spanish mosaics were interesting, but they did not appear as warm and inevitable and illuminating as the Moroccan.

The mosaics of Morocco went to my head like rare wine. Excited and intoxicated and fascinated by the Fassis and their winning and welcome ways, I went completely native. I was initiated into the practice of living native and cheaply. I moved from my expensive hotel and parked my things in a cheaper one. But I hardly lived in it. For my days were fully occupied in sampling the treasures of the city and its environments; in picking up the trails of the peasants bringing their gifts to the town; following the Afro-Oriental bargaining; feeling the color of the accent of the story-tellers in the market places. And in the evening there was always *divertissement:* a marriage ceremony and feast, an invitation to a *fondouk,*

where a young man would permit the pretty *fatmah* of his profane love-making to dance; and Moulay Abdallah. And I was never tired of listening to the native musicians playing African variations of the oriental melodies in the Moroccan cafés.

For the first time in my life I felt myself singularly free of color-consciousness. I experienced a feeling that must be akin to the physical well-being of a dumb animal among kindred animals, who lives instinctively and by sensations only, without thinking. But suddenly I found myself right up against European intervention and proscription.

A *chaoush* (native doorman and messenger) from the British Consulate had accosted me in a *souk* one day and asked whether I was American. I said I was born in the West Indies and lived in the United States and that I was an American, even though I was a British subject, but I preferred to think of myself as an internationalist. The *chaoush* said he didn't understand what was an internationalist. I laughed and said that an internationalist was a bad nationalist. He replied gravely: "All the Moors call you an American, and if you are British, you should come and register at the Consulate." I was amused at his gravity, reinforced by that African dignity which is so impressive in Morocco, especially as I had said I was an internationalist just by way of a joke without thinking of its radical implications. But I wasn't aware then of how everybody in Morocco (European and native) was looking for hidden meanings in the simplest phrases. The natives imagine (and rightly enough) that all Europeans are agents of their respective countries with designs upon their own, and the European colonists are suspicious and censorious of visitors who become too sympathetic and friendly with the natives. I saw a local French newspaper

which had turned all the batteries of ridicule on a European when he started to wear a fez. I myself had gravitated instinctively to the native element because physically and psychically I felt more affinity with it. I did not go to register at the Consulate. I thought that it was enough that my passport was in perfect order. While scrupulously complying with official regulations regarding passports, identity cards and visas, etc., in all my traveling in strange places, I have always relied on my own personality as the best passport. Not that I was always such a circumspect and model traveler! I got into little difficulties all right. But without claiming special privileges or asking assistance as a foreigner, I submitted to the local authority and always came out on top.

For nearly a week I had not been in my hotel. One morning, after an all-night session of lute-playing and dancing with Andalusian melody makers in a native house, I went to my hotel for a change of clothes. There I found a French police inspector waiting for me. He had been there before. He asked me to show him my passport and other papers. I did. He looked through them and said I must accompany him to the British Consulate. I wondered what I could possibly have done. I had been passing such a jolly time, with no shadow of any trouble. The only thing I could think of was that I had obtained some wine for native friends, because they were not allowed openly to purchase. Then I thought of the *chaoush's* warning and wondered if my failure to register had anything to do with it. I asked the French inspector if he had any charges against me. He said I would hear everything at the British Consulate.

So I went along to the lion's den. As I entered, the Consul greeted me with a triumphant, "I knew you were here!" As if I had been hiding from anything or anybody in

Morocco. The charge against me was that I had left my hotel and was sleeping in native houses. I said I hadn't imagined that it was necessary to ask special permission to stay among people who had voluntarily invited me; that I thought it my right to sleep where I was inclined, since I was not a minor. And, standing there (he did not have even the formal courtesy to offer me a chair), I laughed over the Consul's repulsive pink bald head that was like a white buzzard's. His pink-streaked face turned red, and it was amusing also to watch the mean expression of irritation on the cat face of the little French official. He said: "Let us expel him." I said that I would willingly submit to expulsion on a specific charge, but that, since they said that it was a native affair, they should get a native to make the charge. The petty bureaucrats exchanged embarrassed glances. The Consul said that it was hinted that I was a radical propagandist. I said they could search my effects, and that no one could stand up and accuse me of making any verbal propaganda. The Consul said the colonial people were being actively propagandized by Bolshevik agents since the Russian Revolution. I said that I was not a Bolshevik agent. Finally I was permitted to leave.

The personal unpleasantness opened my eyes a little to the undercurrent of social unrest and the mistakes of mixed authority in Morocco. I'd been so absorbed in the picturesque and exotic side of the native life that I was unaware until authority stepped on my sore toe. I discovered that although the French have established a protectorate over Morocco, many of the natives are also protected by other European powers, mainly Great Britain, Spain and Italy. The British possess unique privileges under a system of capitulations. British subjects, whether they are born British, naturalized or protected, are not liable to local arrest and

trial in the French and native courts. If a British subject has committed any offense he must be taken before a British consul.

The privilege of immunity is sometimes abused by morons, and obviously the French local authority is irritated by the idea of a divided authority. Therefore the local atmosphere is infested with petty intrigues.

The specially-protected natives have certain privileges that the subjects of the Sultan, who are protected by the French, cannot enjoy. For example, the specially-protected ones can buy and drink liquor with impunity. But because of a traditional law the subjects of the Sultan cannot. Therefore they drink surreptitiously, and contemptible European bootleggers secretly sell them the vilest stuff imaginable. The young Moroccans generally are afflicted with a pathetic *malaise*. They're always whining: "I wish I were American or specially protected." And when you ask why, they say: "So that we could have the freedom of men to drink in a bar like the Europeans and the Algerians." The *malaise* is similar to the prohibition pestilence which plagued the spirit of the youth of America.

That incident spoiled my native holiday. I thought back to Europe, of that most miserable of years I spent in London. I remembered my difficulties, when I was studying at the British Museum, to get lodgings in that quarter. The signs were shouting: "Rooms for rent," but when I inquired I was invariably informed that all rooms were rented. Yet when I passed that way again the signs were still there. I became suspicious. I asked English friends from the International Club to make inquiries. They found that the rooms were for rent. But when they took me along and declared the rooms were for me, we were told that Negroes were not desired as

guests. When I left my London hotel I found rooms with an Italian family, and later, a German. And the nearest I got to living quarters close to the British Museum was when I found lodgings with a French family in Great Portland Street.

I felt helpless and wobbly about that black boycott in London. For England is not like America, where one can take refuge from prejudice in a Black Belt. I had to realize that London is a cold white city where English culture is great and formidable like an iceberg. It is a city created for English needs, and admirable, no doubt, for the English people. It was not built to accommodate Negroes. I was very happy when I could get out of it to go back to the Negro pale of America.

And now even in Africa I was confronted by the specter, the white terror always pursuing the black. There was no escape anywhere from the white hound of Civilization.

When I finally left Fez I proceeded to Marrakesh in the far south, the hot city of the plains, vast and wild. The Senegalese in Marseilles often mentioned Marrakesh as the former great *caravansérai* for the traders traveling between West Africa and North Africa, and so I had to see that monumental city, which was founded by a Senegalese conqueror. Marrakesh moved me. It was like a big West Indian picnic, with flags waving and a multitude of barefoot black children dancing to the flourish of drum, fiddle and fife.

When I was going to Morocco, some Europeans on the boat had remarked facetiously that Morocco was not a Negro country. Themselves divided into jealous cutthroat groups, the Europeans have used their science to make such fine distinctions among people that it is hard to ascertain what white is a true white and when a Negro is really a Negro. I found more than three-quarters of Marrakesh Negroid. There were

unimaginably strange contrasts. The city is like an immense cradle of experiment in the marriage of civilized life and primitive life. Here the sun-baked ebony Sudanese and the rude brown Berbers of the Atlas meet and mingle with the refined, learned and skilled city Moors of the north. Marrakesh appeared to be the happiest city of the French Protectorate. The people seemed more contented than in Fez, although they were generally poorer. But poverty in a torrid climate is not anything like poverty in a cold climate. I might say, without poetic license, that in Marrakesh the sun, blazing without being murderous, seemed to consume a lot of the wretchedness and ugliness of poverty.

XXVII

The New Negro in Paris

•

I FINISHED my native holiday in Marrakesh. In Casablanca I found a huge pile of mail awaiting me. The handsomest thing was a fat envelope from a New York bank containing a gold-lettered pocket book. The pocket book enclosed my first grand from the sale of *Home to Harlem*.

There were stacks of clippings with criticisms of my novel; praise from the white press, harsh censure from the colored press. And a lot of letters from new admirers and old friends and associates and loves. One letter in particular took my attention. It was from James Weldon Johnson, inviting me to return to America to participate in the Negro renaissance movement. He promised to do his part to facilitate my return if there were any difficulty. And he did.

The Johnson letter set me thinking hard about returning to Harlem. All the reports stressed the great changes that had occurred there since my exile, pictured a Harlem spreading west and south, with splendid new blocks of houses opened up for the colored people. The reports described the bohemian interest in and patronage of Harlem, the many successful colored shows on Broadway, the florescence of Negro literature and art, with many promising aspirants receiving scholarships from foundations and patronage from individuals. Newspapers and magazines brought me exciting impressions of a more glamorous Harlem. Even in Casablanca a Moor of half-German parentage exhibited an article featuring Harlem

in an important German newspaper, and he was eager for more information.

But the resentment of the Negro intelligentsia against *Home to Harlem* was so general, bitter and violent that I was hesitant about returning to the great Black Belt. I had learned very little about the ways of the Harlem élite during the years I lived there. When I left the railroad and the companionship of the common blacks, my intellectual contacts were limited mainly to white radicals and bohemians. I was well aware that if I returned to Harlem I wouldn't be going back to the *milieu* of railroad men, from whom I had drifted far out of touch. Nor could I go back among radical whites and try to rekindle the flames of an old enthusiasm. I knew that if I did return I would have to find a new orientation among the Negro intelligentsia.

One friend in Harlem had written that Negroes were traveling abroad *en masse* that spring and summer and that the élite would be camping in Paris. I thought that it might be less unpleasant to meet the advance guard of the Negro intelligentsia in Paris. And so, laying aside my experiment in wearing bags, bournous and tarboosh, I started out.

First to Tangier, where four big European powers were performing their experiment of international government in Africa upon a living corpse. Otherwise Tangier was a rare African-Mediterranean town of Moors and progressive Sephardic Jews and Europeans, mostly Spanish.

Through Spanish Morocco I passed and duly noted its points of interest. The first was Tetuán, which inspired this sonnet:

TETUÁN

Morocco conquering homage paid to Spain
And the Alhambra lifted up its towers!
Africa's fingers tipped with miracles,
And quivering with Arabian designs,
Traced words and figures like exotic flowers,
Sultanas' chambers of rare tapestries,
Filigree marvels from Koranic lines,
Mosaics chanting notes like tropic rain.

And Spain repaid the tribute ages after:
To Tetuán, that fort of struggle and strife,
Where chagrined Andalusian Moors retired,
She brought a fountain bubbling with new life,
Whose jewelled charm won even the native pride,
And filled it sparkling with flamenco laughter.

In all Morocco there is no place as delicious as Tetuán. By
a kind of magic instinct the Spaniards have created a modern
town which stands up like a happy extension of the antique
Moroccan. The ancient walls merge into the new without
pain. The Spanish Morisco buildings give more lightness to
the native Moroccan, and the architectural effect of the
whole is a miracle of perfect miscegenation.

I loved the colored native lanterns, illuminating the arch-
ways of Larache. I liked Ceuta lying like a symbolic hand-
clasp across the Mediterranean. And I adored the quaint tile-
roofed houses and cool watered gardens in the mountain
fastness of Xauen. From Gibraltar I was barred by the Brit-
ish. But that was no trouble to my skin, for ever since I
have been traveling for the sheer enjoyment of traveling I
have avoided British territory. That was why I turned down

an attractive invitation to visit Egypt, when I was living in France.

Once again in Spain, I inspected the great Moorish landmarks. And more clearly I saw Spain outlined as the antique bridge between Africa and Europe.

After the strong dazzling colors of Morocco, Paris that spring appeared something like the melody of larks chanting over a gray field. It was over three years since I had seen the metropolis. At that time it had a political and financial trouble hanging heavy round its neck. Now it was better, with its head up and a lot of money in every hand. I saw many copies of my book, *Banjo,* decorating a shop window in the Avenue de l'Opéra and I was disappointed in myself that I could not work up to feeling a thrill such as I imagine an author should feel.

I took a fling at the cabarets in Montparnasse and Montmartre, and I was very happy to meet again a French West Indian girl whom I knew as a *bonne* in Nice when I was a valet. We ate some good dinners together and saw the excellent French productions of *Rose Marie* and *Show Boat* and danced a little at the Bal Negre and at Bricktop's Harlem hang-out in Montmartre.

I found Louise Bryant in Paris. It was our first meeting since she took my manuscript to New York in the summer of 1926. The meeting was a nerve-tearing ordeal. About two years previously she had written of a strange illness and of doctors who gave her only six months to live and of her determination to live a long time longer than that. She had undergone radical treatment. The last time I had seen her she was plump and buxom. Now she was shrunken and thin and fragile like a dried-up reed. Her pretty face had fallen

like a mummy's and nothing was left of her startling attractiveness but her eyebrows.

She embarrassed me by continually saying: "Claude, you won't even look at me." Her conversation was pitched in a nervous hysterical key and the burden was "male conceit." I told her that the female was largely responsible for "male conceit." Often when I had seen her before she had been encircled by a following of admirably created young admirers of the collegiate type. Now she was always with an ugly-mugged woman. This woman was like an apparition of a male impersonator, who was never off the stage. She had a trick way of holding her shoulders and her hands like a gangster and simulating a hard-boiled accent. A witty Frenchman pronounced her a *Sappho-manqué*. The phrase sounded like a desecration of the great glamorous name of Sappho. I wondered why (there being so many attractive women in the world) Louise Bryant should have chosen such a companion. And I thought that it was probably because of the overflow of pity pouring out of her impulsive Irish heart.

I remembered, "Aftermath," the beautiful poem which she sent us for publication in *The Liberator* after John Reed died. Now it seemed of greater significance:

AFTERMATH

Dear, they are singing your praises,
Now you are gone.
But only I saw your going,
I . . . alone . . . in the dawn.

Dear, they are weeping about you,
Now you are dead,
And they've placed a granite stone
Over your darling head.

I cannot cry any more,
Too burning deep is my grief . . .
I dance through my spendthrift days
Like a fallen leaf.

Faster and faster I whirl
Toward the end of my days.
Dear, I am drunken with sadness
And lost down strange ways.

If only the dance could finish
Like a flash in the sky . . . Oh, soon,
If only a storm could come shouting—
Hurl me past stars and moon.

And I thought if I could not look frankly with admiration at Louise Bryant's face, I could always turn to the permanently lovely poem which she had created.

I had spruced myself up a bit to meet the colored élite. Observing that the Madrileños were well-tailored, I had a couple of suits made in Madrid, and chose a hat there. In Paris I added shoes and shirts and ties and gloves to my wardrobe.

The cream of Harlem was in Paris. There was the full cast of *Blackbirds* (with Adelaide Hall starring in the place of Florence Mills), just as fascinating a group off the stage as they were extraordinary on the stage. The *Porgy* actors had come over from London. There was an army of school teachers and nurses. There were Negro Communists going to and returning from Russia. There were Negro students from London and Scotland and Berlin and the French universities. There were presidents and professors of the best Negro col-

leges. And there were painters and writers and poets, of whom the most outstanding was Countee Cullen.

I met Professor Alain Locke. He had published *The Anthology of the New Negro* in 1925 and he was the animator of the movement as well as the originator of the phrase "Negro renaissance." Commenting upon my appearance, Dr. Locke said, "Why, you are wearing the same kind of gloves as I am!" "Yes," I said, "but my hand is heavier than yours." Dr. Locke was extremely nice and invited me to dinner with President Hope of Atlanta University. The dinner was at one of the most expensive restaurants in the *grands boulevards*. President Hope, who was even more Nordic-looking than Walter White, was very affable and said I did not look like the boxer-type drawings of me which were reproduced with the reviews of *Home to Harlem*. President Hope hoped that I would visit his university when I returned to America.

There had been an interesting metamorphosis in Dr. Locke When we met for the first time in Berlin in 1923, he took me for a promenade in the Tiergarten. And walking down the row, with the statues of the Prussian kings supported by the famous philosophers and poets and composers on either side, he remarked to me that he thought those statues the finest ideal and expression of the plastic arts in the world. The remark was amusing, for it was just a short while before that I had walked through the same row with George Grosz, who had described the statues as "the sugar-candy art of Germany." When I showed Dr. Locke George Grosz's book of drawings, *Ecce Homo,* he recoiled from their brutal realism. (Dr. Locke is a Philadelphia blue-black blood, a Rhodes scholar and graduate of Oxford University, and I have heard him described as the most refined Negro in America).

So it was interesting now to discover that Dr. Locke had

become the leading Negro authority on African Negro sculpture. I felt that there was so much more affinity between the art of George Grosz and African sculpture than between the Tiergarten insipid idealization of Nordic kings and artists and the transcending realism of the African artists.

Yet I must admit that although Dr. Locke seemed a perfect symbol of the Aframerican rococo in his personality as much as in his prose style, he was doing his utmost to appreciate the new Negro that he had uncovered. He had brought the best examples of their work together in a pioneer book. But from the indication of his appreciations it was evident that he could not lead a Negro renaissance. His introductory remarks were all so weakly winding round and round and getting nowhere. Probably this results from a kink in Dr. Locke's artistic outlook, perhaps due to its effete European academic quality.

When he published his *Anthology of the New Negro,* he put in a number of my poems, including one which was originally entitled "The White House." My title was symbolic, not meaning specifically the private homes of white people, but more the vast modern edifice of American Industry from which Negroes were effectively barred as a group. I cannot convey here my amazement and chagrin when Dr. Locke arbitrarily changed the title of my poem to "White Houses" and printed it in his anthology, without consulting me. I protested against the act, calling Dr. Locke's attention to the fact that my poem had been published under the original title of "The White House" in *The Liberator.* He replied that he had changed the title for political reasons, as it might be implied that the title meant the White House in Washington, and that that could be made an issue against my returning to America.

I wrote him saying that the idea that my poem had reference to the official residence of the President of the United States was ridiculous; and that, whether I was permitted to return to America or not, I did not want the title changed, and would prefer the omission of the poem. For his title "White Houses" was misleading. It changed the whole symbolic intent and meaning of the poem, making it appear as if the burning ambition of the black malcontent was to enter white houses in general. I said that there were many white folks' houses I would not choose to enter, and that, as a fanatical advocate of personal freedom, I hoped that all human beings would always have the right to decide whom they wanted to have enter their houses.

But Dr. Locke high-handedly used his substitute title of "White Houses" in all the editions of his anthology. I couldn't imagine such a man as the leader of a renaissance, when his artistic outlook was so reactionary.

The Negroid élite was not so formidable to meet after all. The financial success of my novel had helped soften hard feelings in some quarters. A lovely lady from Harlem expressed the views of many. Said she: "Why all this nigger-row if a colored writer can exploit his own people and make money and a name? White writers have been exploiting us long enough without any credit to our race. It is silly for the Negro critics to holler to God about *Home to Harlem* as if the social life of the characters is anything like that of the respectable class of Negroes. The people in *Home to Harlem* are our low-down Negroes and we respectable Negroes ought to be proud that we are not like them and be grateful to you for giving us a real picture of Negroes whose lives we know little about on the inside." I felt completely vindicated.

My agent in Paris gave a big party for the cast of *Black-*

birds, to which the lovely lady and other members of the black élite were invited. Adelaide Hall was the animating spirit of the *Blackbirds.* They gave some exhibition numbers, and we all turned loose and had a grand gay time together, dancing and drinking champagne. The French guests (there were some chic ones) said it was the best party of the season. And in tipsy accents some of the Harlem élite admonished me against writing a *Home-to-Harlem* book about *them.*

Thus I won over most of the Negro intelligentsia in Paris, excepting the leading journalist and traveler who remained intransigent. Besides Negro news, the journalist specialized in digging up obscure and Amazing Facts for the edification of the colored people. In these "Facts" Beethoven is proved to be a Negro because he was dark and gloomy; also the Jewish people are proved to have been originally a Negro people!

The journalist was writing and working his way through Paris. Nancy Cunard's *Negro Anthology* describes him as a guide and quoted him as saying he had observed, in the flesh market of Paris, that white southerners preferred colored trade, while Negro leaders preferred white trade. Returning to New York, he gave lectures "for men only" on the peep-holes in the walls of Paris.

The journalist was a bitter critic of *Home to Harlem,* declaring it was obscene. I have often wondered if it is possible to establish a really intelligent standard to determine obscenity —a standard by which one could actually measure the obscene act and define the obscene thought. I have done lots of menial work and have no snobbery about common labor. I remember that in Marseilles and other places in Europe I was sometimes approached and offered a considerable remuneration to act as a guide or procurer or do other sordid things. While I was working as a model in Paris a handsome Italian model

brought me an offer to work as an occasional attendant in a special *bains de vapeur*. The Italian said that he made good extra money working there. Now, although I needed more money to live, it was impossible for me to make myself do such things. The French say *"On fait ce qu'on peut."* I could not. The very idea of the thing turned me dead cold. My individual morale was all I possessed. I felt that if I sacrificed it to make a little extra money, I would become personally obscene. I would soon be utterly unable to make that easy money. I preferred a menial job.

Yet I don't think I would call another man obscene who could do what I was asked to do without having any personal feeling of revulsion against it. And if an artistic person had or was familiar with such sordid experiences of life and could transmute them into literary or any other art form, I could not imagine that his performance or his thought was obscene.

The Negro journalist argued violently against me. He insisted that I had exploited Negroes to please the white reading public. He said that the white public would not read good Negro books because of race prejudice; that he himself had written a "good" book which had not sold. I said that Negro writers, instead of indulging in whining and self-pity, should aim at reaching the reading public in general or creating a special Negro public; that Negroes had plenty of money to spend on books if books were sold to them.

I said I knew the chances for a black writer and a white writer were not equal, even if both were of the same caliber. The white writer had certain avenues, social and financial, which opened to carry him along to success, avenues which were closed to the black. Nevertheless I believed that the Negro writer also had a chance, even though a limited one,

with the great American reading public. I thought that if a Negro writer were sincere in creating a plausible Negro tale—if a Negro character were made credible and human in his special environment with a little of the virtues and the vices that are common to the human species—he would obtain some recognition and appreciation. For Negro writers are not alone in competing with heavy handicaps. They have allies among some of the white writers and artists, who are fighting formalism and classicism, crusading for new forms and ideas against the dead weight of the old.

But the journalist was loudly positive that it was easy for a Negro writer to make a sensational success as a writer by "betraying" his race to the white public. So many of the Negro elite love to mouth that phrase about "betraying the race"! As if the Negro group had special secrets which should not be divulged to the other groups. I said I did not think the Negro could be betrayed by any real work of art. If the Negro were betrayed in any place it was perhaps in that Negro press, by which the journalist was syndicated, with its voracious black appetite for yellow journalism.

Thereupon the journalist declared that he would prove that it was easy for a Negro to write the "nigger stuff" the whites wanted of him and make a success of it. He revealed that he was planning a novel for white consumption; that, indeed, he had already written some of it. He was aiming at going over to the white market. He was going to stop writing for Negroes, who gave him so little support, although he had devoted his life to the betterment of the Negro.

I was eager to see him prove his thesis. For he was expressing the point of view of the majority of the colored élite, who maintain that Negroes in the arts can win success by clowning only, because that is all the whites expect and will

accept of them. So although I disliked his type of mind, I promised to help him, I was so keen about the result of his experiment. I introduced him to my agent in Paris, and my agent introduced him to a publisher in New York.

Our Negro journalist is very yellow and looks like a *métèque* in France, without attracting undue attention. Yet besides his "Amazing Facts" about Negroes he has written in important magazines, stressing the practical nonexistence of color prejudice in Europe and blaming Negroes for such as exists! Also he wrote in a white magazine about Africa and the color problem under a nom de plume which gave no indication of the writer's origin.

He might have thought that as he had "passed white" a little in complexion and in journalism, it would be just as easy "passing white" as a creative writer. Well, the Negro journalist deliberately wrote his novel as a "white" novelist—or as he imagined a white man would write. But the sensational white novel by a Negro has not yet found its publisher.

The last time I heard about him, he was again a Negro in Ethiopia, interviewing Haile Selassie and reporting the white rape of Ethiopia from an African point of view for the American Negro press.

Nigger Heaven, the Harlem novel of Carl Van Vechten, also was much discussed. I met some of Mr. Van Vechten's Negro friends, who were not seeing him any more because of his book. I felt flattered that they did not mind seeing me! Yet most of them agreed that *Nigger Heaven* was broadly based upon the fact of contemporary high life in Harlem. Some of them said that Harlemites should thank their stars that *Nigger Heaven* had soft-pedaled some of the actually wilder Harlem scenes. While the conventional Negro

moralists gave the book a hostile reception because of its hectic bohemianism, the leaders of the Negro intelligentsia showed a marked liking for it. In comparing it with *Home to Harlem*, James Weldon Johnson said that I had shown a contempt for the Negro bourgeoisie. But I could not be contemptuous of a Negro bourgeoisie which simply does not exist as a class or a group in America. Because I made the protagonist of my novel a lusty black worker, it does not follow that I am unsympathetic to a refined or wealthy Negro.

My attitude toward *Nigger Heaven* was quite different from that of its Negro friends and foes. I was more interested in the implications of the book. It puzzled me a little that the author, who is generally regarded as a discoverer and sponsor of promising young Negro writers, gave Lascar, the ruthless Negro prostitute, the victory over Byron, the young Negro writer, whom he left, when the novel ends, in the hands of the police, destined perhaps for the death house in Sing Sing.

Carl Van Vechten also was in Paris in the summer of 1929. I had been warned by a white non-admirer of Mr. Van Vechten that I would not like him because he patronized Negroes in a subtle way, to which the Harlem élite were blind because they were just learning sophistication! I thought it would be a new experience to meet a white who was subtly patronizing to a black; the majority of them were so naïvely crude about it. But I found Mr. Van Vechten not a bit patronizing, and quite all right. It was neither his fault nor mine if my reaction was negative.

One of Mr. Van Vechten's Harlem sheiks introduced us after midnight at the Café de la Paix. Mr. Van Vechten was a heavy drinker at that time, but I was not drinking liquor. I had recently suffered from a cerebral trouble and a specialist

had warned me against drinking, even wine. And when a French doctor forbids wine, one ought to heed. When we met at that late hour at the celebrated rendezvous of the world's cosmopolites, Mr. Van Vechten was full and funny. He said, "What will you take?" I took a soft drink and I could feel that Mr. Van Vechten was shocked.

I am afraid that as a soft drinker I bored him. The white author and the black author of books about Harlem could not find much of anything to make conversation. The market trucks were rolling by loaded with vegetables for Les Halles, and suddenly Mr. Van Vechten, pointing to a truck-load of huge carrots, exclaimed, "How I would like to have all of them!" Perhaps carrots were more interesting than conversation. But I did not feel in any way carroty. I don't know whether my looks betrayed any disapproval. Really I hadn't the slightest objection to Mr. Van Vechten's enthusiasm for the truck driver's raw carrots, though I prefer carrots *en casserole avec poulet cocotte*. But he excused himself to go to the men's room and never came back. So, after waiting a considerable time, I paid the bill with some *Home to Harlem* money and walked in the company of the early dawn (which is delicious in Paris) back to the Rue Jean-Jacques Rousseau.

Mr. Van Vechten's sheik friend was very upset. He was a precious, hesitating sheik and very nervous about that introduction, wondering if it would take. I said that all was okay. But upon returning to New York he sent me a message from Mr. Van Vechten. The message said that Mr. Van Vechten was sorry for not returning, but he was so high that, after leaving us, he discovered himself running along the avenue after a truck load of carrots.

Among the Negro intelligentsia in Paris there was an in-

teresting group of story-tellers, poets and painters. Some had received grants from foundations to continue work abroad; some were being helped by private individuals; and all were more or less identified with the Negro renaissance. It was illuminating to exchange ideas with them. I was an older man and not regarded as a member of the renaissance, but more as a forerunner. Indeed, some of them had aired their resentment of my intrusion from abroad into the renaissance set-up. They had thought that I had committed literary suicide because I went to Russia.

For my part I was deeply stirred by the idea of a real Negro renaissance. The Arabian cultural renaissance and the great European renaissance had provided some of my most fascinating reading. The Russian literary renaissance and also the Irish had absorbed my interest. My idea of a renaissance was one of talented persons of an ethnic or national group working individually or collectively in a common purpose and creating things that would be typical of their group.

I was surprised when I discovered that many of the talented Negroes regarded their renaissance more as an uplift organization and a vehicle to accelerate the pace and progress of smart Negro society. It was interesting to note how sharply at variance their artistic outlook was from that of the modernistic white groups that took a significant interest in Negro literature and art. The Negroes were under the delusion that when a lady from Park Avenue or from Fifth Avenue, or a titled European, became interested in Negro art and invited Negro artists to her home, that was a token of Negroes breaking into upper-class white society. I don't think that it ever occurred to them that perhaps such white individuals were searching for a social and artistic significance in Negro art which they could not find in their own society, and that

the radical nature and subject of their interest operated against the possibility of their introducing Negroes further than their own particular homes in coveted white society.

Also, among the Negro artists there was much of that Uncle Tom attitude which works like Satan against the idea of a coherent and purposeful Negro group. Each one wanted to be the first Negro, the one Negro, and the only Negro *for the whites* instead of for their group. Because an unusual number of them were receiving grants to do creative work, they actually and naïvely believed that Negro artists as a group would always be treated differently from white artists and be protected by powerful white patrons.

Some of them even expressed the opinion that Negro art would solve the centuries-old social problem of the Negro. That idea was vaguely hinted by Dr. Locke in his introduction to *The New Negro*. Dr. Locke's essay is a remarkable chocolate *soufflé* of art and politics, with not an ingredient of information inside.

They were nearly all Harlem-conscious, in a curious synthetic way, it seemed to me—not because they were aware of Harlem's intrinsic values as a unique and popular Negro quarter, but apparently because white folks had discovered black magic there. I understood more clearly why there had been so much genteel-Negro hostility to my *Home to Harlem* and to Langston Hughes's primitive Negro poems.

I wondered after all whether it would be better for me to return to the new *milieu* of Harlem. Much as all my sympathy was with the Negro group and the idea of a Negro renaissance, I doubted if going back to Harlem would be an advantage. I had done my best Harlem stuff when I was abroad, seeing it from a long perspective. I thought it might

be better to leave Harlem to the artists who were on the spot, to give them their chance to produce something better than *Home to Harlem*. I thought that I might as well go back to Africa.

XXVIII

Hail and Farewell to Morocco

●

I SUPPOSE every man who achieves something worthwhile naturally attracts some woman. I was interested in Carmina, who had a white lover. Carmina was a pretty colored lady who had recently deserted the best circles of Harlem for Paris. I liked Carmina. She had lived her life a lot, even as I, and neither of us could reproach the other about the past. But when Louise Bryant saw us together she scolded me. "That girl is not your type," she said. "Why don't you go on living as you always did? Why do you have to go around with a female on your arm, simply because you have written a successful novel?" I said that perhaps it was nothing more than "male conceit." Louise Bryant laughed and said, "Take care you don't spoil yourself by doing the thing that every man thinks he ought to do because of male conceit."

Louise Bryant and Carmina did not like each other. The three of us were spending a convivial evening together and, feeling gallant, I tried to find something to praise in Louise's appearance. She had been to a hairdresser's that afternoon and her neatly shingled hair was gleaming black. I said, "Louise, your hair is very nice tonight." Louise smiled her appreciation. But Carmina said, in a loud whisper, "Can't you see it's dyed?" A blighting frost descended on the party.

It was a sweet relief to give up for awhile discussing problems of race and art for an atmosphere of pure sensuality and amorous intrigue. Carmina also had been fed up with

too much race in the upper circles of Harlem, which was why she had fled to Paris. One night I was drunk and maudlin in Montparnasse and Louise Bryant shrieked at me in high intoxicated accents, shaking her forefinger at me, "Go away and write another book. Go home to Harlem or back to Africa, but leave Paris. Get a grip on yourself." She looked like the picture of an old emaciated witch, and her forefinger was like a broomstick. Perhaps it was her better unconscious self warning me, for she also could not get a grip on herself and get away from Paris.

I heeded the warning. I started off for Africa. But I lingered a long time in Spain. The weeks turned into months. From Madrid I went to Andalusia and visited Cordova and Granada again, then went back to Barcelona. A French radical friend wrote chidingly about my preference for Spain, so medieval and religion-ridden. I wrote him that I expected radical changes in medieval Spain sooner than in nationalistic France. That was no prophecy. The thing was in the air; students mentioned it to you on the café terraces; waiters spoke of it in the pensions and restaurants; chauffeurs spoke of their comrades murdered in Morocco by King Alfonso; bank clerks said a change was coming soon, and even guides had something to say. That was in the winter of 1929-30. I was in Spain early in 1930 when the dictatorship of Primo de Rivera collapsed. In the spring of 1931 I was in Spanish Morocco when King Alfonso abdicated, and in Tetuán I witnessed a wonderful demonstration of amity and fraternity between the native Moorish and civilian Spanish populations. There in Africa I hankered after Spain again and indited these three sonnets for Barcelona:

BARCELONA

1

In Barcelona town they dance the nights
Along the streets. The folk, erecting stands
Upon the people's pavements, come together
From pueblo, barrio, in families,
Lured by the lilting playing of the bands,
Rejoicing in the balmy summer weather,
In spreading rings they weave fine fantasies
Like rare mosaics of many-colored lights.

Kindled, it glows, the magical Sardana,
And sweeps the city in a glorious blaze.
The garrison, the sailors from the ships,
The workers join and block the city's ways,
Ripe laughter ringing from intriguing lips,
Crescending like a wonderful hosanna.

2

Oh admirable city from every range!
Whether I stand upon your natural towers,—
With your blue carpet spreading to their feet,
Its patterns undulate between the bars,—
Watching until the tender twilight hours,
Its motion cradling soft a silver fleet;
Or far descend from underneath the stars,

Down—to your bottoms sinister and strange:
The nights eccentric of the Barrio Chino,
The creatures of the shadows of the walls,
Gray like the savage caricatures of Goya,

The chulos of the abysmal dancing halls,
And, in the garish lights of La Criolla,
The feminine flamenco of El Niño.

3

Oh Barcelona, queen of Europe's cities,
From dulcet thoughts of you my guts are twisted
With bitter pain of longing for your sights,
And for your hills, your picturesque glory singing,
My feet are mutinous, mine eyes are misted.
Upon my happy thoughts your harbor lights
Are shimmering like bells melodious ringing
With sweet cadenzas of flamenco ditties.

I see your movement flashing like a knife,
Reeling my senses, drunk upon the hues
Of motion, the eternal rainbow wheel,
Your passion smouldering like a lighted fuse,
But more than all sensations oh, I feel
Your color flaming in the dance of life.

I was ready to begin another book, and a Moorish friend had put his house in Fez at my disposal. But as soon as I landed in Fez, toward the end of 1930, the French police pounced upon me. I had arrived there a few days before the official visit of President Domergue of France. The police declared I should leave Fez immediately. They said British authorities had furnished proof that I was a political agent; that I had carried on propaganda among the British military forces and also visited Soviet Russia. I went to the British Consulate for further information. There I was told that they possessed no information about me, but that I must obey the

local authority. They wanted to send me back to Europe. I refused to go. I said I would leave Fez if I were forced to, but I was determined to remain awhile in Africa. So I went to Casablanca and from there to Tangier.

Months later a merchant from Fez came to Tangier and hinted why I had been obliged to leave. He said that Moroccan custom permitted anyone who had a serious grievance to complain to the sultan in person when he made an official visit to a city. And as Morocco was a protectorate of France, any person who desired could present his complaint to the sultan of France during his official visit. But the police had a system of banishing real malcontents for a short period during the sultan's visit. The police had feared that I might seize an opportunity to complain to the French sultan, President Domergue, about the unjust treatment I received during my first visit to Fez! And so they had ordered me to leave.

In Tangier I rented a Dar Hassani (native house) and went to work on *Gingertown,* a book of short stories. Mail for me had accumulated in Paris. When it arrived there was a little pile of letters from Carmina. She chided me for deserting her and said that she, too, wanted to go to Africa; that she was sick of Europe and growing worse. She had met all the leading bohemians, writers and artists, more than I ever met. She was a frequent visitor to the Rue Fleurus and was hooked up with one of Gertrude Stein's young men. But she was disgusted with him; he was just a poor white mouse, she said. She was sick of it all and wanted to come to me.

Come to me! I was exceeding flattered, forgetting all about "male conceit." The idea of Carmina leaving her white man for me was tantalizing. She had introduced him to me in Paris, and he had said, *"J'ai le béguin pour toi."* I said,

"Merci, mais je n'ai pas." His bloodless white skin was nauseating. He had no color.

Carmina had been traveling around a lot herself and confided to me that she was keeping a diary of her *randonnée*. She thought I might help her to publish it.

And so Carmina came to Morocco. It was just at the commencement of *l'Aïd El Kebir* (the Big Feast), when the Moroccans cut the throats of thousands of lambs and the air is filled with their plaintive bleating and the crooked streets are running with their blood. We went to live in my little native house at that time of the Great Sacrifice. In the beginning it was nice, being together and working together. People liked Carmina. She was pretty. The Spanish liked the name Carmina because it had a little of Carmen in it. And the Moors liked Mina because it was a native name derived from the lovely sweet flower, Jasmine, which in Morocco is Yasmina, a name often given to Negresses and Mulattresses. And I liked her being so much admired.

I showed Carmina how to make Moroccan tea with mint and other flavorful shrubs. And a native woman friend cooked us big bowls of *cous-cous* in olive oil with the tenderest pieces of lamb and chicken. The Aframerican honeymoon in Africa was quite happy, until Carmina announced that she desired to marry me. But I couldn't because I wasn't divorced and I expected some day to return to America.

And now there was no peace between us. Carmina insisted she had to marry, to satisfy her mother, who was a Christian church-loving woman. In anger I said indiscreetly: "Why didn't you marry your white man in Paris." She said she would show me she could marry him. And one day she announced that her former white lover was coming to Morocco to marry her. I said I thought that that wasn't a bad idea,

since she had to be married. I meant it. But my attitude turned Carmina raging. She said the right kind of man would be jealous. She was right, I suppose. But even from the angle of pure passion only I couldn't imagine myself being jealous of Carmina's white lover. And frankly I was interested in seeing her marry her white man from a social point of view. Because the story of Negroes in civilization is one of white men loving black women and giving them mulatto children, while they preferred to marry their own white women. Carmina said she was a modern woman and that if I were truly a radical and bohemian, I would not have such reactionary ideas about marriage. I asked her why she was not modern enough to live with a black man as she had lived with a white man. Also I said I was thinking in black-and-white, and that as marriage has a social value and her white man was of the better class, I'd like to see her marry him. Mixed marriages were mostly one-sided, colored men marrying white women; I'd also like to see white men marrying colored women, I told her. White men must have some social reason for not marrying the Negro women in whose flesh they find delight.

My reasoning infuriated Carmina, and our relationship became intolerable. She left me. Perhaps Carmina's white mouse had his special white fascination. I have known women who used to be afraid of mice and who in later years made pets of rats. Carmina's Nordic came, but he didn't marry. After being surfeited with loving, he left her still a spinster. I suppose it is easier for some women (like some men) to have than to hold.

I have read white writers and heard white men who romantically said that Negro women will not be faithful to white men. And there are Negro writers who write vicarious

tales of colored girls ditching rich white men for black sheiks. I wonder what actual experience such colored writers have. All bunk. And my experience is not limited to just one. I know that in the West Indies the black and brown women become the faithful mistresses of Europeans.

So Carmina left me for a white skin. I don't think because it was so hot and I so cold. But the white skin is a symbol of money and power. In North Africa the native social system holds out against the European assault simply because the native women are confined in their harems. To modern thinking minds this is objectionable. Yet it is the native fanaticism in sex and religion which makes North Africa a little more wholesome than the rest of that fatal continent.

Some folk's remedy for lost love is immediately to love again. But if it is a big love, that remedy is like swilling beer to get rid of a champagne hangover. For if one has a passionate love in his system, I don't think indulging in lesser and indiscriminate loving helps to rid one of it. At least not for me. My way is to face it and live it down in hard work, sweat it out of my system. And so to get rid of the feeling and the odor of lost love, I gave up the little house and went for a few months up in the mountain fastness of Xauen in Spanish Morocco. There I finished my book, *Gingertown*.

When I came back I leased a little house in the country by the sea, about three miles out of Tangier. I found a little brown native girl to take care of the house. She brought her mother along, so that she could look her own people in the face without flinching. There also was a boy on a bicycle to run errands. And we all cultivated the garden and lived comfortably on twenty-five dollars each month.

One day when I was not at home, Carmina rode out there and pushed herself into the house. Both mother and daugh-

ter were very nonplussed by the American brown girl, who looked exactly like their own people, yet did not dress like them nor talk their language. Nevertheless, undaunted, they barred the way to my workroom. Carmina fired a volley of Americanisms and departed. Some days later it was reported to me in the Petit Socco of Tangier that she said she had told the woman she ought to be horsewhipped. Also, she had read a great book called *Mother India* about those awfully uncivilized Asiatics, and she wished somebody would write a Mother Morocco about the barbarous Africans.

Twice a week I tramped into town and spent the night in the native cafés listening to the alluring singing of Andalusian songs to the accompaniment of lute and mandolin. It was interesting to note that Spanish and French words and musical phrases were slipping into the native melodies. Some day a wonderful new music is destined to come out of North Africa.

The life was a little lazy. I did not plunge deep enough down into the native ways to touch the depths of that tribal opposition to other opposing groups which gave strength and meaning to their common existence.

So I lived on the edge of the native life, among them, but not one of them. I could have become a member by marrying into a family, as my two Senegalese friends had done. But religion was an obstacle. I did not want to take a backward step in that direction. I had interesting conversations with my friend Sidi Abdallah, a poet, who was educated in Egypt and was conceded by the natives to be the most highly educated and broad-minded Moroccan of the town. He assured me that Islam was all-embracing and could accommodate free-thinkers. It was he who started me off on the great story of Antar, informing me of the high-lights that

were not hinted of in the Encyclopedia Britannica. He told me too that the father of free-thought was the Moslem, Averrhoës, who lived in Spain in the twelfth century; that he was the real founder of pantheism and of modern European free thought. And he told me his story, how he was imprisoned and flogged by the Caliph of Cordova, because he had said that the Caliph had no divine authority.

Sidi Abdallah was very eloquent. He resented the Christian representation of Islam as the religion of the sword. It was the religion of social equality, for all humanity, he said. It was the liberal and liberating religion, when the orthodox Christians were persecuting dissident Christians and pagans. Arabia was a land of refuge for the dissident Christians and Jews and pagans fleeing Christian persecution. "Our great Prophet dreamed of a religion of reconciliation in a world where all men would be like brothers, worshipping the same God," he said. "Take the Guinea fetishists, for example; they are primitive magicians and steeped in superstition, yet we accept and tolerate them as Moslems because they acknowledge Mohammed as the prophet."

All that Sidi Abdallah said was fine and vastly illuminating. I had a better conception of Islam after knowing him. The philosophy was all right, but the fact was that Islam, as it was practiced in North Africa when I observed it, was intolerant and fanatic. The Moors frankly admitted that perhaps Morocco was the most fanatically Islamic country in the West.

It was better, I thought, to live as I did without getting too deeply involved, and thinking too much, because I experienced more of purely physical happiness than at any time in my life.

When Carmina and I separated she circulated the report

that I disliked white people. The natives were puzzled about that, because large numbers of them are as white as some Spanish and French. In the Riff and other mountain regions there are blue-eyed and blonde-haired types resembling Nordics, except that they are rather bronzed. But they are all remarkably free of any color obsessions or ideas of discrimination. They are Africans. The others are *roumi* or Europeans. So they thought that Carmina meant that I did not like the *roumi* or Europeans. And that did not displease them. They opened their doors wider for me. And I did not mind the report, for I was not particularly interested in European society in North Africa.

But I did have "white" friends (if the Moors do not object to the use of that phrase) from the white colony. They were all Americans, some of whom are interestingly friendly to colored people abroad. They delighted in flaunting their intimacy with colored persons in the face of the smug European colony. Also there were visitors from Europe.

My first and oldest French friend, Pierre Vogein, came to see me in 1932. He and his wife had come over the previous summer, but I was away in Xauen. Also Max Eastman and his wife, Eliena Krylenko, visited me the same year. And there came some of the Gertrude Stein young men. Carmina's young man had been a kind of protégé of Gertrude Stein. Carmina said she had been welcome at Gertrude Stein's at first. But when she and the young man became seriously enamored of each other, Gertrude Stein grew cold to them. Carmina said she could not understand Gertrude Stein being a novelist, for she seemed almost incapable of understanding life. She said Miss Stein saw black as black and white as white, without any shades, and so it was impossible to understand one like herself, for she was neither black nor white.

She said Miss Stein did not seem to realize that chameleon was a fundamental feature of life; that serpents shed their skins and even the leopard might change its spots for a woman. But Miss Stein was reactionary: she she did not believe in change.

Carmina was considered one of the most intellectual women in Harlem. Carmina said that Gertrude Stein reproached her young man, telling him that if he were seriously interested in Negroes he should have gone to Africa to hunt for an authentic one. Carmina said she did not know what more authentic than herself Miss Stein desired. For besides having some of the best white blood mingled with black in her veins, which were blue, she came from the best Negroid middle-class stock, and Gertrude Stein was also only middle-class.

An interesting couple of visitors from Paris was Monsieur Henri Cartier-Bresson, and his friend, an American colored woman. He was a Norman, and a painter and photographer. He had studied at Oxford and had a suggestion of upper-class English scmething about him. He had a falsetto voice which was not unpleasant, but it wasn't so pleasant to listen to it reiterating that its possessor could fancy only Negro women because he preferred the primitive. That falsetto voice just did not sound authentic and convincing to me.

And if a white man is fond of black women, why should he be declaring his liking to *me!* The penchant of white men for black women is nothing new. It has given the world an arresting new type of humanity, generally known as mulatto. M. Bresson had hunted all over West Africa in search of the pure primitive. And he had returned to Paris to find an American brown woman nearly twice his age and as sophisticated as Carmina, but not so pretty.

M. Bresson brought his lady over to lunch at my house. I was living alone then like an ascetic, which I found necessary to the completion of a new book. But I asked Mr. Charles Ford over to meet my guests. He came in his bathing suit, walking his way down the peninsular strip which lay between the river and the bay, and swimming over to my house. He took one look at the pair and left. The lady said, "He smells like a down-home." I said, "Yes, but he's not a cracker." Later Ford explained that his precious artistic sense of the harmony of form and rhythm had suffered too great a shock.

Our conversation turned upon M. Bresson's unwillingness to carry on with his father the business of an industrialist. M. Bresson's colored lady thought that he would be more interesting as a business man than as a modern photographer. She said he was not so artistic as he was plain lazy; that he was so lazy he wouldn't even pick up his pajamas from the floor.

I said that there at the head of Africa in Morocco, hard by the ancient civilized Mediterranean, the natives did not worry about pajamas. Going to bed was an effortless thing. And I asked M. Bresson whether among the pure primitives (if there were any left) in the middle or the bottom of Africa, one had to worry about pajamas. Or if one might be satisfied with a broad banana leaf. M. Bresson was not so sure. He had returned all the way to Paris to find his pure primitive and bring her to Morocco to show me. Well, in less than a couple of years I heard of M. Bresson in Mexico with a Mexican girl. Perhaps when his protracted period of adolescence has passed he will finally finish like a cool Norman and practical Frenchman by marrying a woman of his country and his class.

I am a little tired of hearing precious bohemian white men

protesting their admiration and love for Negro women and the rest. Yet many of them are shocked at the idea of intimacy between a black man and a white woman, because of their confused ideas of erotic attraction. Perhaps I am hypercritical in detecting a false accent in their enthusiasm. But it strikes me as being neither idealistic or realistic. I know it is a different thing from the sympathy and friendship that the humane and tolerant members of one group or nation or race of people feel for the members of another. And I know it is different from that blind urge of sexual desire which compelled white men to black women during the age of black slavery in the Occident (and perhaps in Africa today), and created an interesting new type of humanity. The performance of such men was not actuated by false and puerile theories of sex. I have a certain respect for them. But these nice modern faddists—they give me a feeling of white lice crawling on black bodies.

The most interesting visitor of them all was the American writer and protégé of Gertrude Stein, Charles Henri Ford, who published a queer book of adolescence in Paris under the rather puritan title of *The Young and Evil*. Young Mr. Ford suddenly dropped in upon me one day when a group of tribesmen were killing a steer in my garden. They cooked the liver in the yard and roasted some of the meat on skewers and invited him to join us in the feast. He was like a rare lily squatting in among the bearded and bournoused natives, and he enjoyed it. When he left in the evening I gave him a chunk of meat from what had been given to me.

He had been in Italy with a Cuban girl. When they came to Madrid she found a young Spanish lover and the three of them came on to Tangier. He came to see me soon again

and I invited some of the younger Moors and a few fatmahs to meet him. They all rather liked him. They said he looked wonderfully like the cinema portraits of Marlene Dietrich.

He came again and again, evidently liking my little isolated house on the river. He was likable enough, and we gave a few native parties for him. The young men brought their lutes and mandolins and sang Andalusian melodies, and the girls danced. One evening Mr. Ford came over early and excitedly told me that the young men were bringing a very beautiful fatmah—prettier than any he had seen at my place. I said I couldn't think of any pretty girl of that class whom Mr. Ford knew and I had not seen before. He said he felt certain I hadn't seen her. So we waited expectantly until the carriages arrived with the party. When the girl unveiled she turned out to be the first little one who had worked for me when I arrived in Tangier. We were both very surprised. She had lost the quaint native freshness of our earlier acquaintanceship and already she had developed like a fine and hardened cashew-nut. She was not aware that the joy-makers were bringing her to my new place. But she was not in the slightest embarrassed. She established herself as temporary hostess as well as guest and was just as charming in the rôle as she had been efficient as a little housekeeper. . . . Our fiesta lasted two days. The Moroccans are a magical barbaric people, if one isn't too civilized to appreciate the subtlety and beauty of their barbaresques. When at last I decided to return to America, in homage to them I indited: "A Farewell to Morocco."

Oh wistful and heartrending earth, oh land
Of colors singing symphonies of life!
Myself is like a stone upon my spirit,
Reluctant, passing from your sunny shore.
 Oh native colors,
 Pure colors aglow
 With magic light.

Mysterious atmosphere whose elements,
Like hands inspired by a magnetic force,
Touched so caressingly my inmost chords,
How strangely I was brought beneath your spell!
 But willingly
 A captive I
 Remained to be.

Oh friends, my friends! When Ramadan returns
And daily fast and feasting through the night,
With chants and music honey-dripping sweets,
And fatmahs shaking their flamenco feet,
 My thoughts will wing
 The waves of air
 To be with you.

Oh when the cannon sounds to break the fast,
The children chorus madly their relief,
And you together group to feast at last,
You'll feel my hungry spirit there in your midst,
 Released from me
 A prisoner,
 To fly to you.

And when you go beneath the orange trees,
To mark and serenade the crescent growth,
With droning lute and shivering mandolin
And drop the scented blossoms in your cups!
 Oh make one tune,
 One melody
 Of love for me.

Keeping your happy vigil through the night,
With tales and music whiling by the hours,
You may recall my joy to be with you,
Until the watchers passed from house to house
 And bugle call
 And muffled drum
 Proclaimed the day!

When liquid-eyed Habeeb draws from the lute
A murmur golden like a thousand bees,
Embowelled in a sheltering tropic tree,
With honey brimming in the honeycomb,
 The tuneful air
 Will waft the sound
 Across to me.

Notes soaked with the dear odor of your soil
And like its water cooling to my tongue,
Haunting me always like a splendid dream,
Of vistas opening to an infinite way
 Of perfect love
 That angels make.
 In Paradise.

Habeeb, Habeeba, I may never return
Another sacred fast to keep with you,
But when your Prince of months inaugurates
Our year, my thoughts will turn to Ramadan,
 Forgetting never
 Its tokens
 Unforgettable.

 —Mektoub.

XXIX

On Belonging to a Minority Group

•

I T was in Africa that I was introduced to Nancy Cunard
—an introduction by mail. Years before, when I saw her
at a studio in Paris, she had been mentioned as a personage,
but I had not been introduced. In Africa I received a pam-
phlet from Miss Cunard entitled *Black Man and White
Ladyship*. The interesting pamphlet gave details about the
Cunard daughter establishing a friendship with a Negro
musician, of which the Cunard mother had disapproved.

Miss Cunard wrote that she was making a Negro anthol-
ogy to dedicate to her Negro friend, and asked me to be a con-
tributor. I promised that I would as soon as I found it possi-
ble to take time from the novel I was writing. That started
an interesting correspondence between us.

Although I considered the contents of the Nancy Cunard
pamphlet of absorbing interest and worthy of publication, I
did not admire the style and tone of presentation.

After some months, Miss Cunard informed me that she
was traveling to New York, and from there to the West
Indies, including Jamaica. She asked me if I could introduce
her to anybody in Jamaica who could put her in touch with
the natives. I addressed her to my eldest brother, who is well-
placed somewhere between the working masses and the con-
trolling classes of Jamaica and has an excellent knowledge of
both. From Jamaica Miss Cunard wrote again that she had
landed in paradise after the purgatory of New York, where
she was put in the spotlight by the newspapers, when it was

discovered that she was residing in Harlem among the Negroes. My brother invited her to his home in the heart of the banana, chocolate, and ginger region of Jamaica, and she stayed there two weeks with her Negro secretary. Both she and her secretary wrote extolling my brother's hospitality and the warmth and kindliness of the peasants. Miss Cunard said she particularly liked my brother's face, and she sent me a snapshot of him.

Meanwhile I had come to the point of a breakdown while working on my novel in Morocco; and besides I was in pecuniary difficulties. Nevertheless I wrote an article for Miss Cunard's anthology and forwarded it to her on her return to France. Miss Cunard extravagantly praised the article and said it was one of the best and also that I was one of the best, whatever that "best" meant. She said she would use it with a full-page photograph of myself which was done by a friend of ours, the photographer, Berenice Abbot.

However, she did not accompany her praise by a check, and I requested payment. I was in need of money. Miss Cunard replied that she was not paying contributors and that my article was too long after all. She was doing the book for the benefit of the Negro race and she had thought that every Negro would be glad to contribute something for nothing. She had suffered and sacrificed a fortune for Negroes, she said.

I comprehended Miss Cunard's way of reasoning. Yet in spite of the penalty she had to pay for her interest in the Negro, I did not consider it my bounden duty to write for her without remuneration. Miss Cunard would have been shocked at the idea of asking the printers and binders to print and bind her charitable book without remuneration. But in spite of her ultra-modern attitude toward life, appar-

ently she still clung to the antiquated and aristocratic and very British idea that artists should perform for noble and rich people for prestige instead of remuneration.

I might say that I too have suffered a lot for my knowledge of, and contact with, the white race. Yet if I were composing an anthology of the white hell, it never would have occurred to me that all sympathetic white writers and artists owed me a free contribution. I suppose it takes a modern white aristocrat to indulge in that kind of archaic traditional thinking.

As Miss Cunard would not pay for my article, I requested its return. She said she was going to take extracts from it. I forbade her to touch it. That made her mad, *comme une vache enragée.* My brother also was supposed to do an article on the Jamaica banana industry for Miss Cunard. He decided not to. And suddenly Miss Cunard did not like his face any more. She wrote that he was big and fat.

In her pamphlet *Black Man and White Ladyship* the reader gets the impression that the Cunard daughter enjoys taking a Negro stick to beat the Cunard mother. Miss Cunard seemed to have been ultra-modern in ideas and contacts without alarming Lady Cunard, who was a little modern herself. Then Miss Cunard became aware of the Negro by way of jazz in Venice. And soon also she was made aware that her mother would not accept her friendship with a Negro. Other white women have come up against that problem. It is not merely a problem of people of different races; people of different religions and of different classes know the unreasonableness and the bitterness of it. The mother Cunard drastically reduced the income of the daughter Cunard. The daughter replied with the pamphlet *Black Man and White Ladyship,* which was not published for sale but probably for spite. In telling the story of her friendship, Miss Cunard

among other things ridicules her mother's American accent. Yet the American Negroes she professes to like speak the same language as her mother, with slight variations.

Writing in her strange, heavy and ineffectual giant of a Negro anthology, Miss Cunard has this to say of me: "His people [the characters of my novels] and himself have also that wrong kind of race-consciousness; they ring themselves in."

The statement is interesting, not so much from the narrow personal as from the broader social angle of a minority group of people and its relationship to friends who belong to the majority group. It leaves me wondering whether it would be altogether such a bad thing if by ringing itself in closer together, a weak, disunited and suppressed group of people could thereby develop group pride and strength and self-respect!

It is hell to belong to a suppressed minority and outcast group. For to most members of the powerful majority, you are not a person; you are a problem. And every crusading crank imagines he knows how to solve your problem. I think I am a rebel mainly from psychological reasons, which have always been more important to me than economic. As a member of a weak minority, you are not supposed to criticize your friends of the strong majority. You will be damned mean and ungrateful. Therefore you and your group must be content with lower critical standards.

A Fannie Hurst who is a best seller is interested in Negro literature. She is nice to Negro writers and artists. She visits among Negroes. She engages a Negro secretary. And finally she writes a trashy novel of Negro life. Negro critics do not like the novel. Fannie Hurst thinks they are ungrateful. I suppose the only way Negro critics could get around the

dilemma would be to judge Fannie Hurst by social and sentimental instead of artistic standards. But that wouldn't help the Negro literature that Fannie Hurst desires to promote. I think Negro writers might benefit more by the forthright criticism of such southern gentlemen as H. L. Mencken and Joseph Wood Krutch than by the kindness of a Fannie Hurst.

A southern white woman who is married to a black journalist says, in a critique entitled, *Don'ts for My Daughter*, that she would not "want her to read *Home to Harlem*, which overemphasizes the carnal side of the Aframerican." I will confess that I may fall short of that degree of civilization which perfects the lily-white state of mind of the gentle southern lady. And that was why as a creative writer I was unable to make nice distinctions between the carnal and the pure and happened perhaps to sin on the side of the carnal in *Home to Harlem*.

Yet I once read in a Negro magazine some stanzas entitled, Temptation, by a certain Young Southern White Lady, and attributed to my pure critic, which sound like a wild jazz page out of *Nigger Heaven*. I remember some of those stanzas:

> *I couldn't forget*
> *The banjo's whang*
> *And the piano's bang*
> *As we strutted the do-do-do's*
> *In Harlem!*
>
> *That pansy sea!*
> *A-tossing me*
> *All loose and free, O, lily me!*
> *In muscled arms*
> *Of Ebony!*

I couldn't forget
That black boy's eyes
That black boy's shake
That black boy's size
I couldn't forget
O, snow white me!

Now to the mind of this black sinner this piece of sophisticated lily-white lyricism is more offensively carnal than the simple primitive erotic emotions of the characters of *Home to Harlem*. But I reiterate it is possible that I am not civilized white enough to appreciate the purity of the mind which composed the above stanzas and to which *Home to Harlem* is carnal.

The white lady is raising her mulatto daughter on a special diet and periodically the child is featured as a prodigy in the New York *Herald Tribune*. But it is possible that when that child has grown up out of the state of being a prodigy she might prefer a plain fare, including *Home to Harlem*. I have not had the time to be an experimentalist about life, because I have been occupied always with facing hard facts. And this I know to be a fact: Right here in New York there are children of mixed parentage, who have actually hated their white mother after they had grown up to understanding. When they came up against the full force of the great white city on the outside and went home to face a helpless white mother (a symbol of that white prejudice) it was more than their Negroid souls could stand.

I think it would be illuminating to know the real feelings of that white mother, who was doubtlessly devoted to her colored children. . . . I myself have had the experience of a fine friendship with a highly cultured white woman, when

I first arrived in the United States—a friendship which was turned into a hideous nightmare because of the taboos of the dominant white community. I still retain a bitter memory of my black agony, but I can only try to imagine the white crucifixion of that cultured woman. . . .

I do not think the author of *Don'ts for My Daughter*, felt personally antagonistic to me, when she wrote in the leading Negro magazine that she did not want her child to read my novel. It is possible that like myself she has faith in literary and artistic truth. Perhaps she even desires to contribute something to the growing literature of Negro life. I have read an interesting article by her on "America's Changing Color Line," which emphasizes the idea that America is steadily growing darker in complexion, and is informing about the increasing numbers of white Negroids who are absorbed by the white group.

Without the slightest feeling of antagonism to my critic, I would suggest to her that vicarious stories of "passing white" are merely of slight importance to the great group of fifteen millions who are obviously Negroes. I would suggest to her that if she really desires to make a unique contribution to American literature, she has a chance of doing something that no Negro can—something that might be worthwhile for her daughter to read: she might write a sincere account of what it means for an educated and sensitive white woman to be the wife of a Negro in America.

Gertrude Stein, the high priestess of artless-artful Art, identifies Negro with Nothingness. When the eternal faddists who exist like vampires on new phenomena become fed up with Negro art, they must find a reason for their indifference. From being disappointed in Paul Robeson, Gertrude Stein

concludes that Negroes are suffering from nothingness. In the ineffable Stein manner she decided to take Paul Robeson as *the* representative of Negro culture. Similarly, any other faddist could arbitrarily make Chaliapin or Al Jolson or Maurice Chevalier or Greta Garbo the representative of Russian, Jewish, French and Swedish culture respectively. When Gertrude Stein finds that Paul Robeson knows American values and American life as only one in it and not of it could, when she discovers that he is big and naïve, but not quite naïve enough to please Gertrude Stein, she declares: "The African is not primitive; he has a very ancient but a very narrow culture and there it remains. Consequently nothing can happen." Not long after she published this, something was happening: Negro Americans were rendering her opera *Four Saints in Three Acts* to sophisticated New York audiences.

Well, whatever the white folks do and say, the Negro race will finally have to face the need to save itself. The whites have done the blacks some great wrongs, but also they have done some good. They have brought to them the benefits of modern civilization. They can still do a lot more, but one thing they cannot do: they cannot give Negroes the gift of a soul—a group soul.

Wherever I traveled in Europe and Africa I was impressed by the phenomenon of the emphasis on group life, whether the idea behind it was Communist co-operative or Fascist collective or regional autonomy. I lived under a Communist dictatorship in Russia, two Fascist dictatorships in Europe, and the French colonial dictatorship in Morocco. I don't like any dictatorship.

Yet even the dictatorships were making concessions to the strong awakened group spirit of the peoples. Soviet Russia

was hard at work on the social problems of its many nation-alities. Primo de Rivera in Spain had organized two grand exhibitions: one for discontented Catalonia and another for unhappy Andalusia. Regional groups such as that in Brittany and in the Basque country were reviving their ancient cul-ture. Labor groups and radical groups were building up their institutions and educating their children in opposition to re-actionary institutions.

But there is very little group spirit among Negroes. The American Negro group is the most advanced in the world. It possesses unique advantages for development and expan-sion and for assuming the world leadership of the Negro race. But it sadly lacks a group soul. And the greatest hin-drance to the growth of a group soul is the wrong idea held about segregation. Negroes do not understand the difference between group segregation and group aggregation. And their leaders do not enlighten them, because they too do not choose to understand. Negro institutions and unique Negro efforts have never had a chance for full development; they are haunted by the fear of segregation. Except where they are forced against their will, Negroes in general prefer to patron-ize white institutions and support white causes in order to demonstrate their opposition to segregation.

Yet it is a plain fact that the entire world of humanity is more or less segregated in groups. The family group gave rise to the tribal group, the tribal group to the regional group, and the regional group to the national group. There are groups within groups: language groups, labor groups, racial groups and class groups. Certainly no sane group desires public seg-regation and discrimination. But it is a clear historical fact that different groups have won their social rights only when they developed a group spirit and strong group organization.

There are language groups and religious groups in this country that have found it necessary to develop their own banks, co-operative stores, printing establishments, clubs, theaters, colleges, hotels, hospitals and other social service institutions and trade unions. Yet they were not physically separated from other white groups as much as are Negroes. But they were in a stronger position to bargain and obtain social and political privileges by virtue of the strength of their own institutions.

But Negro institutions in general are developed only perfunctorily and by compulsion, because Negroes have no abiding faith in them. Negroes wisely are not wasting thought on the chimera of a separate Negro state or a separate Negro economy within the United States, but there are a thousand things within the Negro community which only Negroes can do.

There are educated Negroes who believe that the color line will be dissolved eventually by the light-skinned Negroids "passing white," by miscegenation and final assimilation by the white group. But even if such a solution were possible in the future, it is certainly not a solution for the great dark body of Negroids living in the present. Also if the optimistic Negro advocates of futility would travel and observe or study to learn something of the composition and distribution of white racial, national and regional groups that are more assimilable than Negroes, and of their instinctive and irrational tenacity, they might be less optimistic and negative about the position of their own.

The Negro intelligentsia cannot hope to get very far if the Negro masses are despised and neglected. However poor it may be, the Negro intelligentsia gets its living directly from the Negro masses. A few Negro individuals who obtain im-

portant political and social positions among whites may delude themselves into thinking they got their jobs by individual merit alone against hungry white competitors who are just as capable.

But the fact is that the whites in authority give Negroes their jobs because they take into consideration the potential strength of the Negro group. If that group were organized on the basis of its numerical strength, there would be more important jobs and greater social recognition for Negroes.

And Negroes will have to organize themselves and learn from their mistakes. The white man cannot organize Negroes as a group, for Negroes mistrust the motives of white people. And the Negro whom they consider an Uncle Tom among the whites, whose voice is the voice of their white master, cannot do it either, even though he may proclaim himself a radical!

Many years ago I preserved a brief editorial from the *Nation* on the Woman's Party which seemed to me to be perfectly applicable to the position of the Negro—if the word Negro were substituted for "woman" and "whites" for men. It said in part: "We agree that no party, left to itself, will allow women an equal chance. Neither labor nor the farmer nor the business man nor the banker is ready to assume executive and political ability in women. They will steadily, perhaps instinctively, resist any such belief. They will accede to women's demands only so far as they wish to please or placate the woman vote. For every party job, for every political office, for every legal change in the direction of equality, women will have to fight as women. Inside the party organizations, the women will have to wage their own battle for recognition and equal rights. . . .

"After all, women are an indivisible part of this country's

population; they cannot live under a women's Congress and
a special set of feminine laws and economic conditions. They,
as well as men, suffer when our government is prostituted,
and lose their employment when economic hardship sweeps
the country. They, like men, have a vote, and like men they
will in the long run tend to elect people and parties who rep-
resent their whole interest. To be sure, apart from men they
have a special group interest. . . ."

It would be altogether too ludicrous to point out that white
women are by far more an indivisible part of this country's
population than Negroes! Yet the advance guard of white
women realize that they have a common and special group
interest, different from the general interests of their fathers
and brothers and their husbands and sons.

It goes without saying that the future of the Negro is
bound up with the future system of world economy. And all
progressive social trends indicate that that system will be
based on the principle of labor for communal instead of pri-
vate profit. I have no idea how the new system will finally
work out. I have never believed in the infallibility of the social
prophets, even though some of their predictions and calcula-
tions have come true. It is possible that in some countries
some of the captains of capitalist industry might become labor
leaders and prove themselves more efficient than many reac-
tionary labor leaders. Who knows?

Anyway, it seems to me that if Negroes were organized as
a group and as workers, whatever work they are doing (with
or without the whites), and were thus getting a practical
education in the nature and the meaning of the labor move-
ment, it might even be more important and worth-while than
for them to become members of radical political parties.

A West Indian charlatan came to this country, full of antiquated social ideas; yet within a decade he aroused the social consciousness of the Negro masses more than any leader ever did. When Negroes really desire a new group orientation they will create it.

Such is my opinion for all that it may be worth. I suppose I have a poet's right to imagine a great modern Negro leader. At least I would like to celebrate him in a monument of verse. For I have nothing to give but my singing. All my life I have been a troubadour wanderer, nourishing myself mainly on the poetry of existence. And all I offer here is the distilled poetry of my experience.

Books by Claude McKay
available in Harvest paperback editions
from Harcourt Brace & Company